Independent Filmmaking and Digital Convergence

Transmedia and Beyond

Vladan Nikolic

Routledge
Taylor & Francis Group

NEW YORK AND LONDON

First published 2017
by Routledge
711 Third Avenue, New York, NY 10017

and by Routledge
2 Park Square, Milton Park, Abingdon, Oxon OX14 4RN

Routledge is an imprint of the Taylor & Francis Group, an informa business

© 2017 Taylor & Francis

Library of Congress Cataloging in Publication Data
Names: Nikolic, Vladan, 1965– author.
Title: Independent filmmaking and digital convergence : transmedia and beyond / Vladan Nikolic.
Description: New York : Routledge, 2017. | Includes bibliographical references and index.
Identifiers: LCCN 2016024529 (print) | LCCN 2016040086 (ebook) |
 ISBN 9781138938120 (hardback) | ISBN 9781138938106 (pbk.) |
 ISBN 9781315675862 (e-book) | ISBN 9781315675862 (E-book)
Subjects: LCSH: Independent films—Production and direction. |
 Motion pictures—Technological innovations. | Mass media—
 Technological innovations.
Classification: LCC PN1995.9.P7 N53 2017 (print) | LCC PN1995.9.P7 (ebook) |
 DDC 791.4302/32—dc23
LC record available at https://lccn.loc.gov/2016024529

ISBN: 978-1-138-93812-0 (hbk)
ISBN: 978-1-138-93810-6 (pbk)
ISBN: 978-1-315-67586-2 (ebk)

Typeset in Warnock Pro
by Apex CoVantage, LLC

Contents

Foreword

Has technology altered what kinds of stories we tell and why? Has the audience changed, and what are their expectations? What are current and developing aesthetic and storytelling trends in digital cinema and media productions? What are the various niche markets for independent producers and creators in new and emerging media? What are new models for independent media financing and distribution? How can we reach an audience and create a sustainable model for the future when we are arguably facing the problem of diminishing returns for creators in a digital economy?

There have been many discussions about the far-reaching changes in media production, exhibition, and distribution, and a lot of speculation about possible outcomes. It is evident that digital technology has opened unprecedented floodgates of content—not only new productions, but also renewed access to older media, such as old movies and TV shows. This unprecedented glut of available content—along with other forms of information, communication, and entertainment, such as social media, gaming, and the staggering, ever-increasing amount of Internet files and websites—is competing for the audience's time and attention. A variety of new media practices have emerged—from "second screens," using social media to share and comment on experiences from mainstream film and TV, to various trans- or cross-media marketing, branding, and storytelling concepts. Both the industry and academia are trying to catch up with these new developments and to explain and forecast how they will affect the media landscape in the coming years.

While most observers agree on the wide-ranging nature of these changes, they discuss their developments and impact mainly in relation to the mainstream and big media conglomerates. How these changes affect independent producers and content creators and how they often pose an entirely different set of issues, challenges, and opportunities for independents is rarely examined in depth. Various forms of low- and no-budget digital filmmaking, web videos, and, more recently, trans- or cross-media series and projects, along with virtual and augmented reality experiments, have been

mushrooming over the past decade. It has become a fertile ground for young film- and media-makers to prove themselves, but also to experiment with new stylistic forms and content, and novel ways to reach audiences. Some creators and producers who have been successful in this environment were able to move on to careers in mainstream media; others have built their own niche brands, but apart from making it a showcase for upcoming talent, it is still a challenge to create financially sustainable models for independent producers and creators within this new system. It is a shifting and unstable environment, which provides for many uncertainties, but also for new ways of thinking about media production and audience interaction.

Having been an independent filmmaker for over twenty years—who has worked with new and emerging technologies as they became available—and an educator for almost as long, I intend here to bring a fresh perspective and deeper context to the understanding of how independent filmmaking has transformed into digital film- and media-making. In 1996, I directed one of the first digital feature films, *Burn*; in 1998, I taught the first digital film-making class at The New School and subsequently also at New York University. In 2009, I made the feature film *Zenith*, which was part of an elaborate transmedia project. In 2011, I taught the first transmedia storytelling class at The New School. My filmmaking practice has always informed my teaching, and vice versa. I have talked to and collaborated with some outstanding fig-ures in the independent film and media world, such as seminal independent producers, numerous independent filmmakers, and digital film and trans-media pioneers. I have drawn on their experiences, as well as my own, for this book, intended to be of use to independent producers, content creators, as well as students and educators.

During the past two decades, the technology of independent filmmaking has transitioned almost entirely to digital video. Increasingly, higher-quality but lower-cost digital technology has enabled virtually anybody to become a film- or media-maker. Technological changes have opened new strategies and practices not only in media production but also in exhibition and distri-bution. The Internet, social media, crowdsourcing, and crowdfunding have unlocked new ways of communication and collaboration between creators and their audiences. It has never been easier to make a film, a video, or even a "multi-platform story-experience"—progressively all simply termed "content" for the various online services and channels where they can be streamed or downloaded. However, regardless of how brilliant that content may be, the sheer volume of available media has also made it increasingly

harder to reach an audience for independents—at least through traditional mass media distribution methods and channels.

Based on research, case studies, and practitioners' experiences, *Independent Filmmaking and Digital Convergence: Transmedia and Beyond* discusses and analyzes outcomes of recent film and media projects, and it bridges the gap between professional media-makers and amateurs by focusing on new and emerging models and practices. Providing a holistic view, this book also offers practical advice on producing content in the new multi-platform media environment. It focuses on some of the key questions for independent media creators: how to maintain a diversity of content and production, and be able to reach an audience at a time when, on one hand, media conglomerates and their products dominate the market and, on the other, there is an overabundance of media content competing for viewer time and exposure.

I hope that the book can provide a solid framework to understanding the issues at hand and guide the reader to further Internet searches and texts. It is, of course, impossible to write a definite book about a technology that is changing almost daily. Many models and inventions that were hailed as groundbreaking a few years ago have already been abandoned and forgotten, while other unexpected solutions have emerged. When we were working on the *Zenith* transmedia project in 2009, MySpace was still fighting with Facebook for dominance, Kickstarter did not exist, and the concept of online crowdfunding was virtually unheard of. This is why I believe that technology should be thought of only as a tool for the stories we want to tell, and not the other way around.

Section 1

Independent Media and Digital Convergence

1

Introduction: Independents vs. the Mainstream

The traditional definition of independent film by Roger Ebert is that it is a film made outside of the studio system, with independent financing, which remains true to the director's vision. So, you have three areas: financing, production and artistry. There have been a lot of cycles within independent film, what it meant throughout the last couple of decades, until 2001, when the bubble collapsed.

—Anthony Kaufman, film writer, teacher and festival programmer[1]

In 2012, the young filmmaker Benh Zeitlin made his first feature film, *Beasts of the Southern Wild*. The screenplay was adapted by Zeitlin and Lucy Alibar from Alibar's one-act play *Juicy and Delicious*. Made in the style of magical realism, the film tells the story of a six-year-old girl in a forgotten but defiant Louisiana bayou community, cut off from the rest of the world by an expansive levee. The film was financed through a grant from Cinereach, a non-profit film funding organization, at a reported budget of $1.8 million.[2] Zeitlin made the film with a close-knit group of artists and collaborators, who call themselves "Court 13," shooting on 16mm film, and using non-professional actors.

The film won numerous awards and accolades, including the Camera d'Or at the 2012 Cannes Film Festival and the Grand Jury prize at the 2012 Sundance Film Festival, and was nominated for four Academy Awards. The one award it did not win, however, was the Independent Spirit Award. That award—which, according to its organizers, the Los Angeles–based non-profit organization Film Independent, is dedicated to independent filmmakers—went to the film *Silver Linings Playbook*, a $21 million production, starring Hollywood celebrities Jennifer Lawrence, Bradley Cooper, and Robert De Niro. Film Independent even raised the budget level eligibility in order for *Silver Linings Playbook* to qualify for the award. All this created considerable controversy: "*Silver Linings* is an Oscar movie, a big crowd pleaser featuring three major movie stars, and it accordingly posted up eight Oscar nominations. It shouldn't have been at the Spirits, where its Best Picture prize could've gone to the far more traditionally independent *Beasts of the Southern Wild*."[3] The Independent Spirit Awards were established in 1984 to celebrate independent filmmakers, but, as many commentators observed, over the years they have increasingly become indistinguishable from the Oscars. This once again prompted the discussion about what makes a film truly "independent."

Historically, it has been difficult to define "independent filmmaking" and, by extension, the now broader term "independent media production." Filmmaking as a business in its structure does not differ much from other types of business. The centralization of capital and power, and their contestants, the "independents," run throughout its history. At various points in time, independent has had different meanings, and still has diverse implications among theorists, the industry, and practitioners. The term usually implies, "work different from the dominant or mainstream, whether this relationship is defined primarily in economic terms (production and distribution) or in aesthetic or stylistic terms."[4] However, this definition is often problematic. Many films with ten- or hundred-million-dollar budgets are named independent by the industry. These movies were made not inside the studios but through contractual arrangements with large, independently owned companies. The films feel and look like studio movies and are distributed by the studios. Recent examples include films such as *The Matrix* (1999) or *Lord of the Rings* (2001), which had sequels and were big box-office hits. Many low-budget independent films, on the other hand, are often genre or exploitation formula movies: escapist entertainment without any artistic aspiration or merit. If the difference is aesthetic, independent cinema should depart from the conventions of the mainstream, such as common,

clearly defined traditional narrative structures with causal relationships and narrative closure. There have certainly been numerous independent films that have challenged some of these mainstream conventions, but the vast majority is still firmly grounded within the traditional model.

Factually, independent film is as old as its first industrial infrastructure, dating back to the beginning of cinema. Ironically, the first "independents" actually created the Hollywood film industry. In 1908, Thomas Edison and the Biograph Company formed the Motion Picture Patents Company (MPPC) in order to monopolize film production, distribution, and exhibition. Through Edison's patents on various film equipment and raw film stock, they tried to control all aspects of early filmmaking and distribution. A number of companies, however, refused to abide by the MPPC's rules, and continued business through "illegal" means either by building their own cameras and projectors and importing film stock or by eventually relocating to Southern California. The physical distance to MPPC's New Jersey base made it difficult for Edison to bring legal action against them.

The term "independent" here signifies purely the economic business model, where a variety of companies refused to accept the monopoly of the MPPC, but there was almost no distinction in terms of content or artistic merit of the films. The exception to this was that the independent companies did experiment with the introduction of multi-reel films, leading up to the feature film format, and tailoring stories to popular performers, whereas the MPPC considered content to be irrelevant, charging fees according to feet of film used rather than substance.

This model of market consolidation and dominance by one company, and the challenges from outside competitors, is, of course, not unique to the film business. At this time, however, as film was an emerging new business, this struggle resulted in a power shift, and the laying of the groundwork of the studio system. Once the studio system was firmly established, the companies comprising this system became the new monopolists, while other nascent companies were struggling to compete with them, now becoming the new "independents."

By 1915, the Supreme Court struck down all MPPC patents, and by 1920 the outlines of the classical Hollywood studio system began to emerge. A few of the successful film companies matured into conglomerates, integrating horizontal and vertical aspects of the business. They had their own

studios, where they could film the movies; their own distribution divisions, through which they could market and distribute those films; and their own theaters, where they could screen them. Actors and filmmakers were employees of the studios, working under contract. The top studios were 20th Century Fox, RKO Pictures, Paramount Pictures, Warner Bros., and Metro-Goldwyn-Mayer, known as the "Big Five" or the "majors." The other three smaller studios, dubbed the "little three," were Universal Pictures, Columbia Pictures, and United Artists.

The remainder of the movie business at the time consisted of a slew of smaller film companies, such as Republic Pictures, Monogram Pictures, Producers Releasing Corporation, Grand National, and others. While they occasionally tried to compete with the studios' high-concept productions, for the most part they produced "B movies": comedies, western, or action movies, which had low production values, lesser known actors, and fast turnarounds. While they could be considered independent of the studio system, they still had to use the same horizontally and vertically integrated systems for distribution, which the studios controlled. In this sense, independent film production became an "umbrella term, defined negatively, to denote any production practice that is not under the aegis of the major studios of a given period."[5] Some US independent filmmakers with unique voices did emerge during these early years (such as Oscar Micheaux, who is generally considered the most successful African-American filmmaker of the first half of the twentieth century) or visual artists working with film, such as Man Ray, but due to the prohibitive cost of filmmaking and film distribution, experiments and alternative approaches to filmmaking within mainstream cinema were mostly peripheral.

United Artists, formed by actors and filmmakers Douglas Fairbanks, D. W. Griffith, Charles Chaplin, and Mary Pickford in 1919 eventually became a prime distributor for high-concept independent producers and their films. These producers were unwilling to work within the major studios, because they either wanted more creative control or disagreed with the studios' practices. They were able to produce commercially successful, high-concept movies on their own. Their films were often pushing the boundaries of the practices established by the studios, including narrative and technological confines, as well as the decency rules formulated through the moral guidelines set by the Motion Picture Producers and Distributors of America (MPPDA)—known as the "Production Code"—defining what is morally acceptable to be shown in a motion picture and what is not. Examples of

FIGURE 1.1 Charlie Chaplin signing a contract with United Artists[6]

such breakout films were Samuel Goldwyn's *Best Years of Our Lives* (1946), directed by William Wyler, Howard Hughes' *The Outlaw* (1943), or the top box-office hit of its time, David O. Selznick's *Gone with the Wind* (1939), which was supposed to be a United Artists release but ended up being distributed by MGM. After 1940, high-concept independent productions became more accepted by the majors, which eventually led to United Artists losing its unique standing.

Although the big five studios did not control the majority of all movie theaters, they owned most of the first-run and second-run cinemas. This monopoly, and the practices of "block booking" and "blind-bidding," ensured that the studios were maximizing their profits, while at the same time controlling the market. Block-booking forced all theatres, with the exception of the studio-owned ones, to buy the studios' films in large blocks, sometimes as many as fifty; blind-bidding forced independent theaters to buy a studio's films without having any information about the film, its actors, or the quality of the production.

By 1941 some of the leading film producers and filmmakers of the time (Orson Welles, Samuel Goldwyn, Walt Disney, Charles Chaplin, Mary Pickford, David O. Seltznick, and Alexander Korda) formed the Society of Independent Motion Pictures Producers (SIMPP) in order to challenge the monopoly of the five major studios. The SIMPP filed an antitrust suit against Paramount in 1942, which eventually resulted in the 1948 US Supreme Court Decision to break up the studios. The lawsuit's primary intent was to stop the studios' distribution monopoly, but it also aimed to separate film production from distribution and exhibition in order to foster competition. This opened demand by the theaters for a variety of new movies, many of which were produced by the smaller companies comprising Hollywood's "Poverty Row". Low-budget films became more popular, prompting the majors, as well as the large independent production companies, who now no longer needed to rely on the studios for distribution, to start producing them as well. All these changes eventually put an end to Hollywood's Poverty Row.

The year when Hollywood and the film business started to fundamentally change is generally considered to be 1948. The difference between "mainstream" and "independents" in these first decades of filmmaking was mostly characterized by business practices, profit margins, and access to distribution. Content-wise, there was no significant distinction between the studios and the high-concept, independently produced movies. The large independent companies, such as the Samuel Goldwyn Company, Selznick International, Howard Hughes, Hal Roach, et al. produced big-budget prestige films, based on best-selling novels, plays, or historical subjects, in order to maximize audience interest. They relied on top stars and high production values, and conformed to the rules of traditional narrative mainstream cinema, as it had been developed during the studio system. Because of budgetary constraints, the Poverty Row companies catered to the more populist "lowbrow" genres, which later turned into low-budget horror, action, and exploitation movies, and eventually the "straight-to-video" and late-night cable TV film productions of the 1970s and onward.

Throughout this period, filmmaking developed not only as business but also as a new form of storytelling. The first movies were merely recordings of real or staged events in a single continuous shot and noteworthy only as a novelty of its time. A few decades later, however, filmmaking had its own clearly defined tools, techniques, and language. In this respect, theorists usually distinguish different types of cinematic approaches to storytelling,

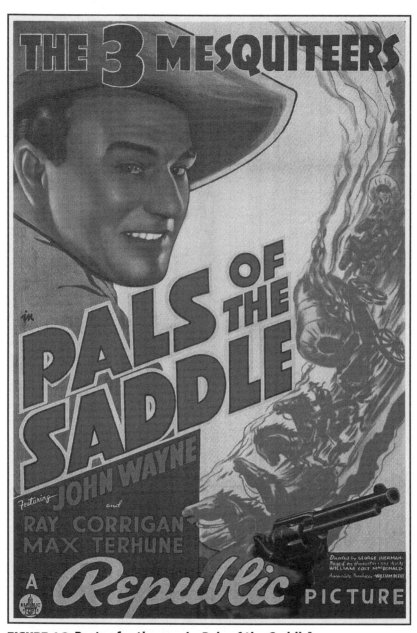

FIGURE 1.2 Poster for the movie *Pals of the Saddle*[7]

characterized as conventional mainstream cinema, or traditional Hollywood style, versus art cinema, as well as the various styles of independent, experimental, and avant-garde film.

The narrative conventions of Hollywood are grounded in the profit-based requirement to entertain the audience, which means that the viewer needs to be stimulated, and his or her interest maintained. Story-wise, this is achieved by placing obstacles in front of a strong, active *protagonist*, whom the audience can identify with. This sets in motion a plot, which feeds the audience's expectations as to how the story will progress and end (*latent expectation*). The principles of cause and effect, as well as time and space, are strictly observed, making it easy for the viewer to follow the story. The protagonist is defined by his or her goal (*the objective*) and desire (*motivation*) to achieve the objective. The *antagonist* (whether it is a person, group, or event) stands in the way of the protagonist achieving his or her goal, creating conflict, which the protagonist needs to overcome and resolve; this conflict, in turn, leads to dramatic tension. Throughout the story, the stakes get progressively higher, until the climax, and eventual resolution. In most cases the film ends with *closure*: the protagonist achieves the goal, or fails— although in the majority of mainstream narratives, even if the character fails, the movie ends on a hopeful note that the future will be better.

While the dramatic construction of film is similar to that of a play, film can obviously rely much more on visuals than dialogue, and also on editing in order to manipulate time and to emphasize actions, character reactions, and relationships. What is specific to Hollywood narratives is that meanings are often conventionalized and simplified, so that the vast majority of viewers can relate to and comprehend the protagonist and his or her goals. Some theorists have argued that the dramatic framework of most mainstream movies is much closer to populist lowbrow entertainment—such as Vaudeville and slapdash melodramas—than to classical drama, substituting sentimentality for emotions, and banality for profound insight.[8]

Given the strict priority of cause-and-effect-driven storylines and strong, active characters, all technical means used in Hollywood movies have to function for this purpose. In other words, camera technique, lighting, art design, editing, etc. may be highly sophisticated and virtuosic, but only insofar as they strengthen the story and enhance the viewer's immersion and entertainment. The film has to flow seamlessly, so that the viewer remains absorbed by the story; anything that would distract from this goal

FIGURE 1.3 Screen capture from the movie *The Exterminating Angel*, directed by Luis Buñuel[9]

would be considered unnecessary, or a mistake. For example, in a foreign art-film—which are usually state subsidized and hence not dependent on profit—the director could choose to deliberately emphasize long takes, in which little action occurs, to convey a symbolic meaning or aesthetic statement; whereas in a Hollywood movie, this would be considered a disruption to the story, pulling the viewer out of the narrative, and thus a mistake. While stylistic elements, such as camera technique and fast-paced editing, have evolved over time, most of the traditional Hollywood storytelling conventions have continued in today's mainstream cinema.

By the 1920s, Hollywood produced and exported over 80 percent of the world's movies. During these early years, various international film movements and filmmakers began to emerge, especially in France, Germany, Italy, and Russia. By 1948, theaters were looking for new products, and the US Supreme Court's anti-trust ruling opened US markets significantly to foreign films. Simultaneously, new, inexpensive film cameras made it possible for artists to make films on a lower budget, and outside of the studio system. These developments ushered in the emergence of new filmmakers,

who would re-define independent filmmaking, in terms of its subject matters, aesthetics, and financial practices. This resulted in some critically acclaimed experimental films, such as Maya Deren's *Meshes of the Afternoon* (1943) or Kenneth Anger's *Fireworks* (1947). Arguably, the most significant narrative independent film of that time was *Little Fugitive* (1953), by Morris Engel, Ruth Orkin, and Ray Abrashkin. It was the first independent film to be nominated for an Academy Award, and it considerably influenced François Truffaut's seminal film *400 Blows* (1959). Made for only $30,000, *Little Fugitive* broke new ground with its use of realism, hand-held cameras, and non-professional actors in leading roles.

These and other independent filmmakers of the time wanted to make films as works of art, rather than entertainment. The most radical of them defined themselves by their opposition to the mainstream cinema. This attitude marked the strongest open challenge to the film industry and film as a commodity up to that time. These filmmakers proclaimed the mainstream film industry to be "morally corrupt, aesthetically obsolete, thematically superficial, temperamentally boring."[10] Writing in the manifesto of the New American Cinema Group (later renamed the Filmmakers' Cooperative) in 1962 by renowned experimental filmmaker Jonas Mekas, along with other avant-garde and experimental filmmakers of the time, they concluded: "In joining together, we want to make it clear that there is one basic difference between our group and organizations such as United Artists. We are not joining together to make money. We are joining together to make films. We are joining together to build the New American Cinema."[11]

The popularity and impact of European art films continued to grow in the ensuing years. The concept of art house cinema emerged: foreign films in which each director was considered to have a unique personal vision and style. At the forefront of this movement were Federico Fellini, Roberto Rossellini, Vittorio De Sica, Michelangelo Antonioni, Ingmar Bergman, François Truffaut, Akira Kurosawa, et al. With its dramatic structures and aesthetics markedly different from the Hollywood classical narrative, foreign art cinema strongly influenced American independent film of the time.

In film theory and criticism, mainstream Hollywood movies and art cinema have been generally considered to be polar opposites. Film theorists David Bordwell, Janet Staiger, and Kristin Thompson devised the term "classical Hollywood cinema," while Bordwell emphasized that art cinema defined itself explicitly against this classical Hollywood narrative structure.

According to this view, Hollywood mainstream cinema is linear, with clear, goal-orientated characters, driven by cause and effect, while art film centers on more complex characters, random events, ambiguity, and where aesthetics and style often become as important, or even more important, than narrative structure and consistency.[12] This view, however, can be contested, as there are evident connections between these two theoretically opposed models. Art films often operate within similar narrative structures as mainstream movies, and, while they do often emphasize style and aesthetics, they rarely abandon completely the time-space continuum and cause-effect aspect of conventional narrative storytelling.

Independent film is often equated with art film and, through this equation, similarly positioned as polar opposite to mainstream cinema. Film theorist Geoff King argues that there are three main points of how independent film and filmmaking can be defined: "(1) their industrial location, (2) the kinds of formal / aesthetic strategies they adopt and (3) their relationship to the broader social, cultural, political or ideological landscape."[13] King's

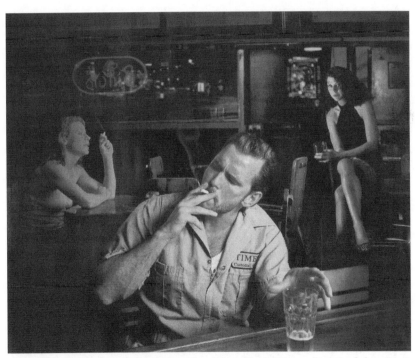

FIGURE 1.4 Poster image for the film *Factotum*, directed by Bent Hamer, produced by Jim Stark[14]

arguments position independent cinema as low-budget filmmaking, far from the confines of Hollywood, incorporating a formal aesthetic that disrupts or abandons Hollywood conventions and, unlike Hollywood, deals with challenging themes and social issues. Similar to Bordwell's view on art cinema, King's observation defines independent film primarily by its opposition to mainstream narrative cinema. This definition of independent film again emphasizes its relation to the industry—or lack thereof—rather than delineating it as an autonomous field.

It is true that independent filmmaking has adopted many diverse, sometimes controversial themes, as well as the aesthetics of art cinema, which often results in fresh, new, creative, and sometimes groundbreaking films. However, throughout film history, the relationship of the film industry and the independents has been varied and blurred; during some of these periods, it has been hard to distinguish independents from the mainstream in terms of content and aesthetics. Creative, challenging films have been made for relatively big budgets, under contractual arrangements with the studios (e.g., *Birdman* [2014], *There Will Be Blood* [2007], *Inception* [2010], et al.), while some independent films look and feel like Hollywood movies (*Silver Linings Playbook* [2012], *Little Miss Sunshine* [2006], *Juno* [2007], et al.)

Another way to look at independent filmmaking is as a practice, where the primary motive is not necessarily business and mass entertainment. Independent film gives the filmmakers a level of freedom that is not present within the studio system: to freely choose whether they want to follow the traditional narrative structure, or to disrupt it. If independent films and practices become economically successful, they are usually adopted and co-opted by the industry. Independent filmmakers, however, have the choice to what extent they want to engage with the mainstream industry's practices, while studio-based filmmakers do not. Money and expensive technology have been an integral part of the filmmaking process since its beginnings. This has often limited what kinds of films can be made or distributed, especially within the realm of low-budget independent filmmaking. As technology has advanced, however, the budgets required to produce high-quality-looking content kept shrinking. For the first time in the history of filmmaking, financing has now arguably become the least challenging aspect of making a film.

The current explosion of digital video production and online video streaming is closely related to the various concepts of independent filmmaking.

While the 1948 studio monopoly break-up and introduction of cheaper, lightweight technology gradually expanded independent filmmaking, digital technology, the Internet, and the rise of broadband streaming have ushered in an entirely new paradigm. This has resulted in the digital convergence between the various filmmaking conventions and styles, and video technologies. It has also created an overall unstable media market, with an oversupply of available content. This has shaped an entirely new environment, which both industry and independents have to contend with.

▶ NOTES

1 Anthony Kaufman (writer, teacher, festival programmer), Interview with the Author. New York City. May 21, 2015.

2 "Beasts of the Southern Wild," Internet Movie Database, last modified April 25, 2016, http://www.imdb.com/title/tt2125435/.

3 John Bailey, "This Year's Independent Spirit Awards Barely Differed from the Oscars—Here's How to Fix Them," *Flavorwire*, February 23, 2013, http://flavorwire.com/506146/this-years-independent-spirit-awards-barely-differed-from-the-oscars-heres-how-to-fix-them.

4 Jim Hillier, ed., introduction to *American Independent Cinema: A Sight and Sound Reader* (London: British Film Institute, 2008), ix.

5 Matthew Bernstein, "Hollywood's Semi-Independent Production." *Cinema Journal* 32, no. 3 (Spring, 1993): 41.

6 "United Artists Contract Signature 1919," digital image, Wikipedia, February 4, 2009, accessed December 15, 2015, https://upload.wikimedia.org/wikipedia/commons/3/39/United_Artists_contract_signature_1919.jpg.

7 Republic Pictures, "Pals of the Saddle," digital image, Wikipedia, October 15, 2014, accessed December 16, 2015, https://en.wikipedia.org/wiki/File:PalsOfSaddlePoster.jpg.

8 Charles Eidvick, *Cineliteracy: Film among the Arts* (New York: Random House, 1978), 112.

9 *The Exterminating Angel*, dir. Luis Buñuel, perf. Silvia Pinal and Enrique Rambal (Mexico: Gustavo Alatriste, 1962), DVD.

10 "The First Statement of the New American Cinema Group, September 30, 1962," accessed June 11, 2015, http://www.film-makerscoop.com/about/history.

11 Ibid.

12 David Bordwell, "The Art Cinema as a Mode of Film Practice," *Film Criticism,* Fall '79, Vol. 4: 56.

13 Geoff King, *American Independent Cinema* (London: I.B. Tauris/Bloomington, Indiana University Press, 2005), 2.

14 *Factotum,* Dir. Bent Hamer (New York, Bulbul Films, 2005) photo credit: Mark Higashino, courtesy of Jim Stark.

▶ BIBLIOGRAPHY

Bailey, Jason. "This Year's Independent Spirit Awards Barely Differed from the Oscars—Here's How to Fix Them." *Flavorwire.* February 23, 2015. http://flavorwire.com/506146/this-years-independent-spirit-awards-barely-differed-from-the-oscars-heres-how-to-fix-them.

Bazin, André. *What Is Cinema?* 2nd ed. Berkeley: University of California Press, 2004.

Belton, John. *American Cinema/American Culture,* 3rd ed. New York: McGraw-Hill, 2009.

Berliner, Todd. *Hollywood Incoherent: Narration in Seventies Cinema.* Austin: University of Texas Press, 2010.

Bernstein, Matthew. "Hollywood's Semi-Independent Production." *Cinema Journal* 32 (Spring 1993): 41–54. doi:10.2307/1225878.

Bordwell, David. "The Art Cinema as a Mode of Film Practice." *Film Criticism* 4 (Fall 1979): 56–64. http://connection.ebscohost.com/c/articles/31286128/art-cinema-as-mode-film-practice.

Bordwell, David. *Narration in the Fiction Film.* Madison: University of Wisconsin Press, 1985.

Bordwell, David, Staiger, Janet, and Thompson, Kristin. *The Classical Hollywood Cinema: Film Style & Mode of Production to 1960.* New York: Columbia University Press, 1985.

Bordwell, David, and Thompson, Kristin. *Film Art: An Introduction,* 9th ed. New York: McGraw-Hill, 2009.

Chatman, Seymour Benjamin. *Story and Discourse: Narrative Structure in Fiction and Film.* Ithaca, NY: Cornell University Press, 1980.

Cook, Pam. *The Cinema Book*, 2nd ed. London: BFI Publishing, 1999.

Dyer, Richard, and Ginette Vincendeau. *Popular European Cinema*. London: Routledge, 1992.

Eidsvik, Charles. *Cineliteracy: Film among the Arts*. New York: Horizon Press, 1978.

Elsaesser, Thomas, and Adam Barker. *Early Cinema: Space, Frame, Narrative*. London: BFI Publishing, 1990.

Epstein, Edward Jay. *The Hollywood Economist: The Hidden Financial Reality behind the Movies*. Brooklyn, NY: Melville House, 2010.

Genette, Gérard. *Narrative Discourse: An Essay in Method*. Ithaca, NY: Cornell University Press, 1980.

Gray, Tim. "Is '12 Years a Slave' an Indie? Here Are the Spirit Awards Rules of Eligibility." *Variety*. November 26, 2013. http://variety.com/2013/film/awards/is-12-years-a-slave-an-indie-here-are-the-spirit-awards-rules-of-eligibility-1200883428/.

Hillier, Jim, ed. *American Independent Cinema: A Sight and Sound Reader*. London: British Film Institute, 2008.

King, Geoff. *American Independent Cinema*. Bloomington: Indiana University Press, 2005.

Maltby, Richard. *Hollywood Cinema: An Introduction*. Oxford: Blackwell Publishers, 1995.

McDonald, Paul, and Janet Wasko, eds. *The Contemporary Hollywood Film Industry*. Malden, MA: Blackwell Publishing, 2008.

Mekas, Jonas. "History." *The Film Makers Cooperative*. Accessed October 16, 2015. http://film-makerscoop.com/about/history.

Merritt, Greg. *Celluloid Mavericks: The History of American Independent Film*. New York: Thunder's Mouth Press, 2000.

Metz, Christian. *The Imaginary Signifier: Psychoanalysis and the Cinema*. Bloomington: Indiana University Press, 1981.

Monaco, James. *How to Read a Film: The World of Movies, Media, and Multimedia: Language, History, Theory*, 3rd ed. New York: Oxford University Press, 2000.

Moul, Charles C., ed. *A Concise Handbook of Movie Industry Economics*. Cambridge: Cambridge University Press, 2005.

Neupert, Richard John. *The End: Narration and Closure in the Cinema*. Detroit: Wayne State University Press, 1995.

Obenson, Tambay A. "How Do You Define 'Independent Film' in 2014?" *Shadow and Act*. January 2, 2014. http://blogs.indiewire.com/shadowandact/how-do-you-define-independent-film-in-2014.

Salt, Barry. *Film Style and Technology: History and Analysis*. London: Starword, 1992.

Schatz, Thomas. *The Genius of the System: Hollywood Filmmaking in the Studio Era*. New York: Pantheon Books, 1988.

Schatz, Thomas, ed. *Hollywood*. London: Routledge, 2004.

Schillacid, Sophie. "'Silver Linings Playbook': Is It an Indie?" *The Hollywood Reporter*. February 25, 2013. http://www.hollywoodreporter.com/race/silver-linings-playbook-is-an-424424.

Schindel, Daniel. "Just How Independent Are the Film Independent Spirit Awards?" *Los Angeles Magazine*. February 17, 2015. http://www.lamag.com/culturefiles/independent-film-independent-spirit-awards-really/.

Singer, Ben. *Melodrama and Modernity: Early Sensational Cinema and Its Contexts*. New York: Columbia University Press, 2001.

Smith, Murray. *Engaging Characters: Fiction, Emotion, and the Cinema*. Oxford: Clarendon Press, 1995.

Smith, Nigel M. "How to Improve the Independent Spirit Awards: Top Producers Weigh In." *Indiewire*. February 27, 2015. http://www.indiewire.com/article/how-to-improve-the-independent-spirit-awards-top-producers-weigh-in-20150227.

Staiger, Janet. "Janet Staiger Responds to Matthew Bernstein's 'Hollywood's Semi-Independent Production' ('Cinema Journal', Spring 1993)." *Cinema Journal* 33 (January 1994): 56. doi:10.2307/1225517.

Street, Sarah. *British National Cinema*. London: Routledge, 1997.

Tzioumakis, Yannis. *American Independent Cinema: An Introduction*. Edinburgh: University Press, 2006.

▶ FILMOGRAPHY

400 Blows. Directed by François Truffaut. 1959. New York, NY: Criterion Collection, 2009. DVD.

Beasts of the Southern Wild. Directed by Benth Zeitlin. 2012. Los Angeles, CA: Fox Searchlight, 2013. DVD.

The Best Years of Our Lives. Directed by William Wyler. 1946. Los Angeles, CA: MGM, 2000. DVD.

Birdman. Directed by Alejandro G. Iñárritu. 2014. Los Angeles, CA: 20th Century Fox, 2015. DVD.

Fireworks. Directed by Kenneth Anger. 1947. Los Angeles, CA: Fantoma, 2007. DVD.

Gone with the Wind. Directed by Victor Fleming. 1939. Los Angeles, CA: Warner Home Video, 2009. DVD.

Inception. Directed by Christopher Nolan. 2010. Los Angeles, CA: Warner Home Video, 2010. DVD.

Juno. Directed by Jason Reitman. 2007. Los Angeles, CA: Fox Searchlight, 2008. DVD.

Little Fugitive. Directed by Morris Engel, Ruth Orkin and Ray Abrashkin. 1953. New York, NY: Kino Lorber Films, 2008. DVD.

Little Miss Sunshine. Directed by Jonathan Dayton and Valerie Faris. 2006. Los Angeles, CA: Fox Searchlight, 2006. DVD.

Lord of the Rings. Directed by Peter Jackson. 2001. Los Angeles, CA: New Line Cinema, 2002. DVD.

The Matrix. Directed by Lily and Lana Wachowski. 1999. Los Angeles, CA: Warner Brothers, 2000. DVD.

Meshes of the Afternoon. Directed by Maya Deren and Alexander Hammid. 1943. New York, NY: Microcinema International, 2007. DVD.

Silver Linings Playbook. Directed by David O. Russell. 2012. New York, NY: The Weinstein Company, 2013. DVD.

The Outlaw. Directed by Howard Hughes. 1943. Los Angeles, CA: Legend Films, 2009. DVD.

There Will Be Blood. Directed by Paul Thomas Anderson. 2007. Los Angeles, CA: Warner Brothers, 2008. DVD.

2

Rise of the Independent Filmmaker

My first film "The Unbelievable Truth" was quite a big film at the Toronto Film Festival, which was the first time that I had to ask people what indie means, because that's when I heard about the term. It was a tag invented by people whose work is to market films. It immediately struck me it reminded me of the interview I read with Elvis Costello, where he said, people labeled him as punk. He said "whatever". That's how I felt about indie films.

Hal Hartley, Filmmaker[1]

The convergence of technological advances with more experimental and improvisational filmmaking methods in the late 1950s and early 1960s led to the first significant departure from Hollywood mainstream narrative cinema. New technologies included faster film stock and lighter, crystal sync sound cameras that enabled hand-held camerawork with simultaneous sound recording. Various influences from European art-house and avant-garde cinema (the Nouvelle Vague, Cinéma Vérité, Free Cinema, etc.) further influenced the evolution of American film aesthetics. Often called the "New American Cinema," it was exemplified best by the work of John Cassavetes (*Shadows* [1959], *Faces* [1968], *Husbands* [1970], et al.). Cassavetes used hand-held cameras and improvisational techniques to create

realistic, cinema-vérité-style narrative films, often partially self-financing them through his acting work in Hollywood movies.

The 1960s and early 1970s marked a time of profound cultural shifts and changes in audience tastes, fueled by a new generation with radically different views than their parents, new rebellious music, the Vietnam War, the civil rights movement, student unrests, and drugs. The studios did not know how to respond to this new audience. They finally opened their doors to young filmmakers, who mostly used an art cinema aesthetic, causing the curious outcome of studios producing films that looked and felt like independent films, breaking various rules and conventions. These films were both critically acclaimed and successful at the box office, resulting in the studios ceding unprecedented levels of creative control to the filmmakers. This "New Hollywood" from the late 1960s and early 1970s is possibly the most creative period of American mainstream cinema, and certainly the most distinct. Notable films of this time included *Bonnie and Clyde* (1967*)*, *The Graduate* (1967), *Dont Look Back* (1967), *Easy Rider* (1969), *Midnight Cowboy* (1969), *The Wild Bunch* (1969), *MASH* (1970), *A Clockwork Orange* (1971), and many others.

Starting in the mid-1970s, the film studios became parts of business conglomerates through mergers and acquisitions. Mainstream cinema shifted again to the production and distribution of blockbuster franchise films, which could be exploited further through various auxiliary markets and merchandise. The huge box office successes of Steven Spielberg's *Jaws* (1975) and George Lucas's *Star Wars* (1977) confirmed that the mass audience's preferences had shifted back from unconventional stories and art cinema aesthetics to more traditional Hollywood narratives and escapist entertainment. The surviving independent cinema soon consisted mostly of low-budget genre (such as horror or action) and exploitation movies, sustained through cable TV distribution and VHS video rentals. By the end of the decade, the major media corporations dominated that market as well. They achieved this through more company acquisitions, and soon controlled 90 percent of the total film market.

The media conglomerates appointed new business executives, who started measuring audience tastes, preferences, and viewing habits. The collected data affected decisions about films green-lit for production. Increasingly dependent on research reports and charts, this resulted, not surprisingly, in more unoriginal and formulaic films. Once again, the lack of distinct and

different voices and stories in mainstream cinema, along with a variety of other factors—alternative modes of financing, video rentals, and foreign distribution, as well as the possibility of making films on increasingly lower budgets—led to a new wave of independent filmmakers. The new independent cinema that emerged in the 1980s defined itself in opposition to the entertainment conglomerates and its primary focus on film as escapist entertainment.

Although still grounded within the conventional narrative film structure, independent filmmakers once again took on different, often difficult issues and controversial subject matter, which the studios avoided. Sometimes because of budgetary constraints, but often also because of aesthetic choices, these independent films also looked different than the studio movies. Influential and critically acclaimed films of that time include John Sayles's *Return of the Secaucus Seven* (1980), Jim Jarmusch's *Stranger than Paradise* (1984), Spike Lee's *She's Gotta Have It* (1986), Joel and Ethan Coen's *Blood Simple* (1984), the unique *Eraserhead* (1977) by David Lynch, John Waters's *Polyester* (1981), the documentary *The Thin Blue Line* (1988) by Errol Morris, Michael Moore's *Roger and Me* (1989), and others. Many of these films were self-financed by the filmmakers, and each had a unique voice, style, and vision.

John Sayles worked as screenwriter for Roger Corman's legendary exploitation genre film company, New World Pictures. Some of the films Sayles

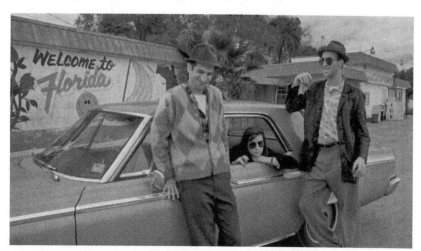

FIGURE 2.1 Screen capture from the movie *Stranger than Paradise,* directed by Jim Jarmusch[2]

wrote the scripts for became very successful commercially (*Piranha* [1978], *The Howling* [1981]). Sayles used the money from these jobs to finance *Return of the Secaucus Seven* (1979), which he wrote, directed, and edited. Sayles even rejected outside financing offers, including Corman's, in order to retain complete creative control. The film's story is loosely structured around the reunion of seven former college friends, who gather at a summerhouse in New Hampshire to ruminate about their activist past, when they got arrested on the way to a protest in Washington, DC. The film does not follow the classical mainstream narrative structure, with clear objectives, motivations, rising tension, and conflict resolution. Instead, it is structured around the characters' exchanges, allowing the viewer to gradually discover their relationships, and how they have changed over time. The lifelike dialogue and shooting on actual locations gives the film a strong sense of realism. Many other independent filmmakers have followed this stylistic approach. The film was well received by critics and won several awards. It was released by small distributors, and, while not immediately successful, the film's reputation grew through audiences' word-of-mouth recommendations. Made for $60,000, the film eventually grossed over $2 million in its initial theatrical run.

The gradual discovery of small independent films has allowed these films to thrive. The films, and their distributors, usually did not have advertising budgets. Many independent films in the 1980s and 1990s had the benefit of playing in art house theaters over weeks and months, slowly building their audiences, primarily through word-of-mouth recommendations. The flood of films and content in the recent decade has made this practice impossible to sustain. Now a film has to find its audience much faster. Art house theaters book independent films on short turnarounds—often only for a week—while multiplex cinemas generally prefer to show Hollywood movies or high-concept specialty films.

David Lynch's *Eraserhead* (1977) initially premiered to insignificant audiences and bad reviews but eventually became a successful and influential cult film (later with excellent reviews). In spite of the film's initial poor reception, Cinema Village, a small local theater in New York, still agreed to run the film as a midnight feature. *Eraserhead* continued midnight screenings there for a year, which again built word-of-mouth publicity for the film. After Cinema Village, another small New York theater, Waverly Cinema, also booked it as a midnight movie. The film ran for ninety-nine weeks there, followed by a year of midnight screenings at the Roxie Theater in San Francisco, and a

three-year run at the Nuart Theater in Los Angeles. Made for a reported $10,000, the film ended up grossing $7 million in the United States alone.

Lynch, who had originally studied to become a visual artist, switched to study film at the American Film Institute. His work did not fit any conventional film narrative framework, which caused some conflicts with his professors. He was about to drop out when he was offered to produce his own script and use the campus to build his sets. The script eventually became *Eraserhead*, a film that was made on and off over a period of five years and financed by Lynch and his actors, friends, and supporters. Inspired by the writers Franz Kafka and Nikolai Gogol, the film is a surrealist story that centers on the daydream of a strange man's head being taken to a pencil factory by a boy. Set in a menacing industrial landscape, *Eraserhead* explores a permanent sense of dread and anxiety, strong sexual themes, and disturbing visuals. Lynch later explained that his own experiences of living in a crime-riddled and run-down area of Philadelphia also inspired the look and feel of the film.[3] *Eraserhead* combines captivating black-and-white imagery and strikingly original and powerful sound design. True to surrealist style, the film uses cause-and-effect storytelling techniques but warps the logic of the scenes, making them closer to dream logic than reality. It leaves the viewer to decode and connect the meaning of the images. The film is now considered a classic; it launched Lynch's directing career, and he has remained one of the most idiosyncratic American filmmakers throughout his career.

A lively low-budget horror and exploitation film scene thrived during the 1970s and 1980s. As with the earlier examples of Hollywood's Poverty Row movies, these films were made fast and cheap, and did not depend on stars; audiences were watching them for the fright and the gore they displayed. Filmmakers, bound by their enthusiasm for the genre, often worked together on these movies, working in different crew positions from one project to the next. In 1981, independent filmmaker Sam Raimi made his second low-budget horror feature, *Evil Dead*, which became a cult hit and started Raimi's filmmaking career. After a string of horror movies, he later wound up directing Hollywood blockbusters, most notably the first *Spider-Man* franchise.

To raise money for *Evil Dead*, Raimi shot a trailer-like short film for $1,600 on Super 8 film stock. He wore a suit and packed a briefcase to look respectable, and he took the trailer around the Detroit area to successful professionals, such as lawyers and dentists, asking them to invest in the film. He

raised almost $90,000 this way and started production (although they ran out of money during the shoot and had to borrow more).[4] Two young filmmakers, the brothers Joel and Ethan Coen, who had worked with Raimi on *Evil Dead*, followed this example to finance their own first feature, *Blood Simple*. They made a two-minute trailer on 35mm film and eventually managed to raise $750,000 from more than sixty individual investors. As Joel Coen later explained: "The trailer emphasized the action, the blood and guts in the movie. . . . We had a very effective soundtrack, which was cheap to do. And we schlepped that around for about a year to people's homes and projected it in their living rooms and then got them to give us money to make the movie."[5]

Critics have labeled *Blood Simple* as a "neo-noir" movie. The film uses the conventions of the hard-boiled 1940s genre and combines it with strong violence and dark comedy. These elements became the hallmark of the Coen brothers' style, along with extreme attention to detail, strong imagery, and often-unusual camera angles. The story is simple: a bar owner hires a private detective to follow his wife, and, when he finds out that she is cheating on him, he pays the detective to kill his wife and her lover. While the plot is conventional, the precision of the film's execution and its visual aesthetic is strong and distinctive, which has earned the film substantial critical praise.

Blood Simple won the Grand Jury Prize at the 1985 Sundance Film Festival. This prompted a slew of extremely positive reviews, hailing the discovery of the Coens as major new filmmakers. In spite of the praise, however, the film had difficulty finding a distributor. All the major Hollywood companies passed on it; later that year it was shown at the New York and Toronto Film Festivals, and it was eventually picked up by a small distributor, Circle Films. The film grossed almost $4 million at the US box office during its initial release; it launched the Coen brothers' careers and remains another cult favorite. Over the years, the Coen brothers gained more and more mainstream recognition and awards, including Oscars. Although their films have become bigger in scope and size, their stylistic approach is still very deliberate and faithful to their early years.

That same year, Spike Lee started work on his first feature film, *She's Gotta Have It* (1986). After graduating from NYU's film school, Lee shot the feature for $175,000 in twelve days. He wrote, directed, edited, and starred in the movie, which features an all-African-American cast. The film's story switches gender roles in dating and sexual partners, showing a woman

juggling relationships with three men, instead of the other way around. It was a significant film for African-American cinema because it changed the representation of African-American characters in movies, "depicting men and women of color not as pimps and whores, but as intelligent, upscale urbanites."[6] *She's Gotta Have It* made over $7 million at the US box office in its initial release.

Spike Lee's production company, 40 Acres and a Mule, has produced dozens of films since then. His third feature—*Do the Right Thing* (1989), which examines race relations, set in Brooklyn on a hot, sweltering day—was an even bigger success; it firmly established him as one of the most important filmmaking voices of the time. The film was shot entirely in the Bedford-Stuyvesant neighborhood of Brooklyn. The film's production design deliberately heightened and saturated the street colors in order to accentuate the heat, underlying tension, and themes of the film. The film's finale, which shows the eruption of a race riot, was controversial with some commentators, who questioned whether the movie was inciting violence, but the film received strong and almost universal critical praise. The screenplay for *Do the Right Thing* was nominated for an Academy Award, with some observers remarking that the film deserved to be nominated for best film as well. A

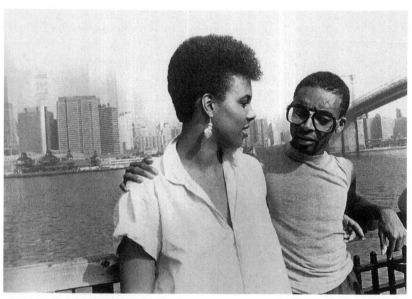

FIGURE 2.2 Screen capture from the movie *She's Gotta Have It*, directed by Spike Lee[8]

more conventional studio movie, *Driving Miss Daisy* (1989), won the Oscar for best picture that year. Lee later claimed that *Driving Miss Daisy's* success was based only on its portrayal of "safe stereotypes."[7] Many of Lee's subsequent films have continued to examine race relations, as well as urban crime and poverty and other political issues, although he has also made Hollywood high-concept genre movies (*Inside Man* [2006] and *Oldboy* [2013]).

Critics and scholars have noted that *Do the Right Thing*, along with Jim Jarmusch's feature *Stranger than Paradise* (1984), ushered in the renewed independent film movement of the 1980s. Jarmusch was also a graduate of NYU's film school, where he shot his first feature, *Permanent Vacation* (1980), as his thesis film. He spent the next four years making *Stranger than Paradise*. The film was made for $100,000 and shot on black-and-white film, in a succession of uninterrupted long takes, separated by interludes of a black screen. This stylistic approach was taken in part because of budgetary constraints but was also a deliberate choice, which related to the themes and ideas behind the film.

Stranger than Paradise has a minimalist storyline, presenting only selected moments and character interactions without much conflict or dramatic action. The film follows Willie, played by Jazz musician John Lurie, who lives on New York's Lower East Side and is forced to take in Eva, his cousin from Hungary. Together with his pal Eddie (played by former Sonic Youth drummer Richard Edson), Willie mostly engages in mundane tasks and sparse exchanges. Later, Eva leaves and goes to Cleveland to stay with her aunt Lotte and work at a hot dog stand. In the finale of the film, Willie and Eddie join Eva in Cleveland, where Eddie comments that the city's empty slums and environments look "just the same."

The film is slow-paced, with offbeat humor, deadpan exchanges, and almost no plot; it uses this style to look at America through the eyes of outsiders. As Jarmusch commented, "Films must find new ways of describing real emotions and real lives without manipulating the audience in the familiar, maudlin ways."[9] Instead, the film relies on a story told in fragments, stylized like a "semi-realist black-comedy in the style of an imaginary Eastern-European film director obsessed with [Japanese director Yasuhiru] Ozu and familiar with the 1950's American television show 'The Honeymooners.'"[10]

The film premiered at the 1984 Cannes Film Festival, where it won the Caméra d'Or award for best first film, which was followed by numerous

other festival awards and accolades. Producer Jim Stark, who worked with Jarmusch on this and other of Jarmusch's films, comments: "I didn't really understand the business then. The film was accepted to Cannes and they went to Cannes and called me in the middle of the night to tell me it won the Palme D'Or. I knew very little of the importance of that award. The film beat *Gandhi* from the national film critic society. It was a great adventure making that film. It is very weird, unusual and ironic and I should feel very special that that was my first experience in making movies."[11]

Stranger than Paradise made $2.5 million at the box office and became a hugely influential landmark independent film. Jarmusch's next three features (*Down by Law* [1986], *Mystery Train* [1989], *Night on Earth* [1991]) became even bigger successes. Throughout his career, the themes and stories of Jarmusch's films have changed, but his directorial approach remained within the framework he had established in his early films; his trademark off-beat humor and long takes are present even in his most commercial movie, *Broken Flowers* (2005). In 2009, he made the feature *Limits of Control*, arguably his most contentious film, which split critics and audiences with its decidedly more experimental approach to film structure and storytelling.

There were many other talented, original, and unique filmmakers who emerged during the 1980s and 1990s. Some of them managed to continue their careers by gradually moving closer to the mainstream and Hollywood; others gradually disappeared from the rapidly changing independent film scene of the late 1990s and into the 2000s. Asked if it would be possible for such a distinctly different film like *Stranger than Paradise* to have that big of an impact nowadays, Jim Stark's response was quick: "Well, let's be clear what we're talking about. Do I think a film like that could play at a major festival like Cannes and win an award—YES—Play 18 months in New York cinemas—NO. So, things have changed."[12]

The rise of these filmmakers was accompanied by the inception of new film companies and a new support structure, with the distribution company Miramax (est. 1979) and the Sundance Institute and film festival (est. 1978) having the biggest impact on the growth, development, and branding of independent film. The watershed moment for independent cinema is generally considered to be Steven Soderbergh's *Sex, Lies, and Videotape* (1989), which garnered multiple major film festival awards and acclaim, but also a $24 million box office return on its $1.1 million investment. This lead to

FIGURE 2.3 Screen capture from the movie *Sex, Lies, and Videotape*, directed by Steven Soderbergh[13]

increased interest in independent films, both in terms of public recognition and as a profit opportunity for Hollywood media conglomerates.

The 1990s saw further growth of independent cinema and the emergence of a plethora of new voices (such as Hal Hartley, Todd Haynes, Julie Dash, Kevin Smith, Ang Lee, Allison Anders, Robert Rodriguez, Alexandre Rockwell, Gregg Araki, David O. Russell, Christopher Nolan, Todd Solondz, Harmony Corine, and many others). Business-wise, independent production and distribution companies moved closer to the "majors," being either purchased by the studios or signed on for distribution deals. Foreign sales and pre-sales of films became increasingly important for financing independent films, whose budgets started to grow.

Sundance gradually changed into a celebrity-studded festival, attended by Hollywood agents and powerbrokers, where distributors bought independent films for increasingly larger amounts of money. In 1993, Miramax was acquired by Disney. While Miramax preserved creative control over its projects, the merger and the subsequent films they produced blurred the lines between studio and independent productions even further. Miramax and other "independent" highly capitalized mega-companies, such as Lionsgate and New Line, were usually referred to as "mini majors," competing with the major studios. In 1994, Miramax released Quentin Tarantino's *Pulp Fiction*, which became its greatest financial and critical success up to that time.

The film was produced on a relatively low budget ($8.5 million), with major stars, and, for the mainstream at least, an unconventional non-linear structure, intersecting different stories in various timeframes. The film earned $214 million at the worldwide box office in its initial release.[14]

By the 2000s the independent cinema of the 1990s was largely co-opted by the industry. The conglomerates opened specialty divisions (Warner Independents, Paramount Vantage, Sony Classics, etc.) and marketed independent films as "niche" or "art house" cinema, increasingly prompting critics to lament that "independent" had become a euphemism for a small-studio production.[15] Many independent filmmakers—such as Ang Lee, Christopher Nolan, Sam Raimi, David O. Russell, and others—started directing studio blockbusters.

As their budgets were growing, it became standard practice for independent companies to use similar methods like the studios and "mini majors" in order to finance their films. They would attach star actors to a project and finance it through a combination of foreign pre-sales, auxiliary market placements (TV, video rentals), and bank loans against distribution guarantees. Many independent production companies also had access to private equity funds. Those were often capitalized through real estate or other investors, who enjoyed tax breaks by investing their "passive income" from their core businesses—income derived from rentals, capital gains, profit, or interest payments—into movies.

Successful independent companies (Killer Films, Shooting Gallery, This Is That, Focus Features, etc.) started creating structures similar to the much bigger Hollywood "independents" (such as the companies of Steven Spielberg, George Lucas, James Cameron, Clint Eastwood, et al.), only with smaller budgets. This usually meant the guarantee of multiple picture deals, spread over the period of several years. These companies had their own development and acquisitions personnel, and various distribution arrangements with independent distributors (October Films, Artisan, ThinkFilm, IFC, etc.), the mini-majors (Miramax, Lions Gate, etc.), or the studio specialty divisions.

As independent cinema became more commercial and primarily a niche product of the mainstream, it also became stylistically more conventional in order to attract a larger audience. This brought it much closer to

traditional Hollywood narratives in terms of stories and aesthetics. In turn, the mainstream industry appropriated many techniques from the independents and re-packaged them in Hollywood movies and mainstream TV (handheld cameras, jump-cut editing, fragmented storylines, etc.). These now-glossy independent films, with celebrity actors and higher production values, continued being premiered and sold to distributors at the Sundance Film Festival. Many new filmmakers now considered their first Sundance-backed film merely a stepping-stone to a Hollywood career. Other notable independent filmmakers from the 1980s and 1990s who were unable to adapt to the new models, or who continued to make films like they did before, insisting on more difficult stories or aesthetics, slowly faded from the spotlight. These filmmakers could not reach a large enough audience and thus had increasingly more difficulty in securing financing and distribution for their films (such as Alexandre Rockwell, Hal Hartley, Julie Dash, Allison Anders, Todd Solondz, et al). By 2005, about 15 percent of the US domestic box office revenue was from the "mini majors" (Miramax, Summit, Lions Gate, IFC Films, etc.), competing with the studios' specialty divisions.[16] The conglomerates, meanwhile, stayed focused on formulaic blockbuster franchise event movies, relying ever more on audience research and special effects.

▶ NOTES

1 Hal Hartley (filmmaker), Interview with the Author. New York City. May 25, 2015.

2 Figure 2.1. *Stranger than Paradise*, dir. Jim Jarmusch, perf. John Lurie (United States: The Samuel Goldwyn Company, Inc., 1984), DVD.

3 Greg Olson, *David Lynch: Beautiful Dark* (Lanham: Scarecrow Press, 2008), 60.

4 Bruce Campbell, *If Chins Could Kill: Confessions of a B Movie Actor* (Los Angeles: L.A. Weekly Books, 2002), 83–91.

5 Scott W. Smith, "The Coen Brothers on Raising Money," *Screenwriting from Iowa* (blog), April 26, 2011, https://screenwritingfromiowa.wordpress.com/2011/04/26/joel-coen-on-raising-money/.

6 D.J.R. Bruckner, "She's Gotta Have It (1986)," *The New York Times*, accessed October 9, 2015, http://www.nytimes.com/movies/movie/44229/She-s-Gotta-Have-It/overview.

7 Logan Hill, "How I Made It: Spike Lee on 'Do the Right Thing'," *New York Magazine*, April 7, 2008, http://nymag.com/anniversary/40th/culture/45772/.

8 Figure 2.2. *She's Gotta Have It*, dir. Spike Lee, perf. Tracy Camilla Johns (United States: Island Pictures, 1986), DVD.

9 Jim Jarmusch, "Some Notes on Stranger than Paradise," March 1984, transcribed by Ludvig Hertzberg, http://jimjarmusch.tripod.com/notes.html.

10 Jarmusch, "Some Notes on Stranger than Paradise."

11 Jim Stark (producer), Interview with the Author, June 26, 2015.

12 Ibid.

13 Figure 2.3. *Sex, Lies, and Videotape*, dir. Steven Soderbergh, perf. James Spader and Andie MacDowell (United States: Miramax Films, 1989), DVD.

14 "PULP FICTION," Box Office Mojo, accessed November 27, 2015, http://www.boxofficemojo.com/movies/?id=pulpfiction.htm.

15 Janet Wasko, *How Hollywood Works* (London: Sage, 2003), 78.

16 "2005 DOMESTIC GROSSES" *Box Office Mojo,* accessed October 19, 2015, http://www.boxofficemojo.com/yearly/chart/?yr=2005&p=.htm.

▶ BIBLIOGRAPHY

"2005 Domestic Grosses." *Box Office Mojo.* Accessed October 19, 2015. http://www.boxofficemojo.com/yearly/chart/?yr=2005&p=.htm.

Bruckner, D.J.R, "She's Gotta Have It (1986)." *The New York Times.* August 8, 1986. http://www.nytimes.com/movies/movie/44229/She-s-Gotta-Have-It/overview.

Campbell, Bruce. *If Chins Could Kill: Confessions of a B Movie Actor.* Los Angeles: L.A. Weekly Books, 2002.

Enticknap, Leo. *Moving Image Technology.* London: Wallflower, 2004.

Figgis, Mike. *Digital Filmmaking.* New York: Faber and Faber, 2007.

Hill, Logan. "How I Made It: Spike Lee on 'Do the Right Thing." *New York Magazine.* April 7, 2008. http://nymag.com/anniversary/40th/culture/45772/.

Jarmusch, Jim. "Some Notes on Stranger than Paradise." March 1984. Transcribed by Ludvig Hertzberg. http://jimjarmusch.tripod.com/notes.html.

King, Geoff, Claire Molloy, and Yannis Tzioumakis. *American Independent Cinema: Indie, Indiewood and Beyond.* New York: Routledge, 2013.

Olson, Greg. *David Lynch: Beautiful Dark.* Lanham: Scarecrow Press, 2008.

Prince, Stephen, ed. *American Cinema of the 1980s: Themes and Variations.* Oxford: Berg, 2007.

"PULP FICTION." *Box Office Mojo.* Accessed November 27, 2015. http://www.box officemojo.com/movies/?id=pulpfiction.htm.

Schatz, Thomas, ed. *Hollywood.* London: Routledge, 2004.

Schatz, Thomas. "The New Hollywood." In *Hollywood: Critical Concepts in Media and Cultural Studies,* Vol. 1, edited by Thomas Schatz, 285–314. New York: Routledge, 2004.

Smith, Scott W. "The Coen Brothers on Raising Money." *Screenwriting from Iowa* (blog). April 26, 2011. https://screenwritingfromiowa.wordpress.com/2011/04/26/joel-coen-on-raising-money/.

Tzioumakis, Yannis. *American Independent Cinema: An Introduction.* Edinburgh: Edinburgh University Press, 2006.

Tzioumakis, Yannis. "Entertainment in the Margins of the American Film Industry: 'Orion Pictures Presents a Filmhaus Production of a David Mamet Film'." In *The Business of Entertainment,* edited by Robert C. Sickels, 153–178. Westport, CT: Praeger Publishers, 2009.

Wasko, Janet. *How Hollywood Works.* London: SAGE, 2003.

Wasser, Frederick. *Veni, Vidi, Video: The Hollywood Empire and the VCR.* Austin: University of Texas Press, 2001.

▶ FILMOGRAPHY

Blood Simple. Directed by Joel Cohen and Ethan Coen. 1984. New York, NY: MGM Home Entertainment, 2008. DVD.

Bonnie and Clyde. Directed by Arthur Penn. 1967. Burank, CA: Warner Home Video, 2008. DVD.

Broken Flowers. Directed by Jim Jarmusch. 2005. Universal City, CA: Focus Features, 2006. DVD.

A Clockwork Orange. Directed by Stanley Kubrick. 1971. Burbank, CA: Warner Home Video, 2007. DVD.

Do The Right Thing. Directed by Spike Lee. 1989. Universal City, CA: Universal Studios, 2012. DVD.

Dont Look Back. Directed by D.A. Pennebaker. 1967. New York, NY: Criterion Collecttion, 2015. DVD.

Down by Law. Directed by Jim Jarmusch. 1986. New York, NY: Criterion Collection, 2002. DVD.

Driving Miss Daisy. Directed by Bruce Beresford. 1989. Burbank, CA: Warner Home Video, 2010. DVD.

Easy Rider. Directed by Dennis Hopper. 1969. Los Angeles, CA: Columbia Pictures, 1999. DVD.

Eraserhead. Directed by David Lynch. 1977. New York, NY: Criterion Collection, 2014. DVD.

Evil Dead. Directed by Sam Raimi. 1981. Troy, MI: Anchor Bay Entertainment, 2007. DVD.

Faces. Directed by John Cassavetes. 1968. New York, NY: Criterion Collection, 2009. DVD.

Graduate, The. Directed by Mike Nichols. 1967. New York, NY: MGM, 2005. DVD.

Howling, The. Directed by Joe Dante. 1981. New York, NY: MGM, 2003. DVD.

Husbands. Directed by John Cassavetes. 1970. Culver City, CA: Sony Pictures, 2009. DVD.

Inside Man. Directed by Spike Lee. 2006. Burbank, CA: Universal Studios, 2006. DVD.

Jaws. Directed by Steven Spielberg. 1975. Universal City, CA: Universal Studios, 2012. DVD.

Limits of Control. Directed by Jim Jarmusch. 2009. Universal City, CA: Focus Features, 2009. DVD.

MASH. Directed by Robert Altman. 1969. Century City, CA: 20th Century Fox, 2004. DVD.

Midnight Cowboy. Directed by John Schlesinger. 1969. New York, NY: MGM, 2000. DVD.

Mystery Train. Directed by Jim Jarmusch. 1989. New York, NY: Criterion Collection, 2010. DVD.

Night on Earth. Directed by Jim Jarmusch. 1991. New York, NY: Criterion Colletion, 2007. DVD.

Oldboy. Directed by Spike Lee. 2013. Culver City, CA: Sony Pictures Home Entertainment, 2014. DVD.

Permanent Vacation. Directed by Jim Jarmusch. 1980. New York, NY: Criterion Collection, 2007. DVD.

Piranha. Directed by Joe Dante. 1978. Los Angeles, CA: Shout! Factory, 2010. DVD.

Polyester. Directed by John Waters. 1981. Los Angeles, CA: New Line Home Video, 1997. VHS.

Pulp Fiction. Directed by Quentin Tarantino. 1994. Santa Monica, CA: Miramax Lionsgate, 2011. DVD.

Return of the Secaucus Seven. Directed by John Sayles. 1980. New York, NY: MGM, 2003. DVD.

Roger and Me. Directed by Michael Moore. 1989. Burbank, CA: Warner Home Video, 2014. DVD.

Sex, Lies, and Videotape. Directed by Steven Soderbergh. 1989. Culver City, CA: Sony Pictures Home Entertainment, 1998. DVD.

Shadows. Directed by John Cassavetes. 1959. New York, NY: Criterion Collection, 2008. DVD.

She's Gotta Have It. Directed by Spike Lee. 1986. New York, NY: MGM, 2008. DVD.

Star Was. Directed by George Lucas. 1977. Century City, CA: 20th Century Fox Video, 2006. DVD.

Stranger Than Paradise. Directed by Jim Jarmusch. 1984. New York, NY: Criterion Collection, 2007. DVD.

Thin Blue Line, The. Directed by Errol Morris. 1988. New York, NY: Criterion Collection, 2015. DVD.

Wild Bunch, The. Directed by Sam Peckinpah. 1969. Burbank, CA: Warner Home Video, 2010. DVD.

3

Technology Changes

I think it's important that we all try to give something to this medium, instead of just thinking about what is the most efficient way of telling a story or making an audience stay in a cinema.

Lars von Trier, film director[1]

From its beginnings, filmmaking as form and practice has depended on and been defined by its technology. Changes in film technology have changed film as a medium throughout its history—its expressive abilities as well as business and distribution practices. A major impact of new technology on filmmaking was the introduction of sound in the 1920s. This expanded the medium and also ended many careers of early movie stars, whose voices did not match their on-screen personas. The first "talking feature film" or "talkie" was *The Jazz Singer* (1927), produced by Daryll F. Zanuck and directed by Alan Crosland. It became a major box office hit and ushered in the era of "synchronized sound" film production. Already by 1930, talking pictures were the norm.

Synchronous sound recording complicated film production and often made it unwieldy. Film cameras typically did not record sound internally; a separate audio device, which had to be in some way synchronized with

the camera, recorded sound. This practice is referred to as double-system recording. It continues even nowadays in professional productions with digital cameras, as it provides higher quality of sound recording. Amateur film formats, such as Super 8mm film and single-system 16mm film cameras, used primarily for news and documentaries, had pre-striped magnetic strips on the film itself in order to record audio.

Prior to the "sound era," many filmmakers experimented with camera movement, but now the sheer size and bulkiness of the cameras and their connection to sound recorders made these techniques difficult to accomplish. This fact, along with relatively "slow" film stock—film stock that needed a lot of light for proper exposure—created the look of 1930s–1950s cinema: elaborate sets and camera angles, as well as high-key, stylized lighting techniques. Even in *noir* films, where the look was more dramatic and the shadows deep, lighting was still bright and heightened. Besides the limitations of the film stock, this was also a result of the studios' demands to show everything in the frame, with special emphasis on the movie stars. Early 35mm film cameras were big and noisy, so they had to be covered with "blimps" in order to be able to record sound simultaneously with picture. Sound recording devices were often unreliable, further complicating the process of film production. Many sounds were synchronized later in the editing room, to include ambient sounds, sound effects, and dubbed dialogue.

Filmmakers experimented with various technologies in order to solve these problems, introducing pilot-tone technology in the 1950s. Pioneered by the German NWDR studio, it was designed to serve 16mm TV news and documentaries. This was followed with the invention of the *Nagra III NP* sound recorder in 1961, which could be synchronized with film cameras. The synchronization between picture and sound was achieved by connecting a pulse cable from the camera to the audio recorder, sending a 50 or 60 Hz signal to the recorder. The invention of crystal-controlled motors on cameras and audio recorders soon thereafter made the cable connection eventually unnecessary; the "crystal-synch motors" guaranteed accurate synchronization. Usually, a slate with clap-sticks would be used to mark the beginning of each take, so that the picture and sound could be later synched-up in the editing room. Until the 1980s and the implementation of time-code and digital technology, this was the common way of professional sound recording in film.

FIGURE 3.1 Nagra III Tape Recorder[2]

In the 1960s, the new wireless crystal controlled sound recording technology, along with lighter sync-sound cameras and more light-sensitive film stock, brought about a new way of filmmaking. For the first time it was possible to record film with synchronous sound instantaneously. Filmmakers could "capture the moment," without having to extensively plan, pre-mediate, and organize the complex technology of early cinema. While there had been few films like this before—most notably Dziga Vertov's classic *Man with the Movie Camera* (1929)—this was the first time that such films could be made with synchronous dialogue and sound.

This new technology spawned the influential movements in documentary cinema, most commonly known as *cinéma vérité* in France, *direct cinema* in the US, and *candid eye* in Canada. It also presaged a new way of fiction filmmaking, to be embodied in the films of Jean-Luc Godard, François Truffaut, and the French New Wave, as well as the films of the US independent filmmakers, such as Morris Engel, John Cassavetes, Jonas Mekas, and Andy Warhol. As the prominent cinematographer John Bailey points out, "It is the storied legacy of this 16mm camera that anticipated the even more immediate and 'democratized' use of smaller digital camcorders for today's personal documentaries."[3]

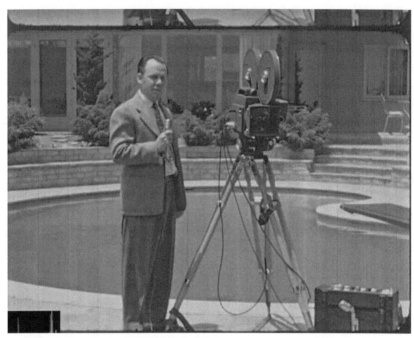

FIGURE 3.2 Walter Bach demonstrates Auricon Pro 1200[4]

Primary (1960), the first direct cinema documentary, produced by Robert Drew, shot by Richard Leacock and Albert Maysles, and edited by D. A. Pennebaker, documented the competition between John F. Kennedy and Hubert Humphrey for the Democratic Party's presidential nomination. The film introduced a new bare-bones approach to news stories and documentary film: one with no voice-over, narration, or interviews. Instead, the filmmakers told the story through images and sound, with minimal interference or manipulation. There were no scripted or set-up situations; the camera just followed the characters and events as they unfolded, creating a sense of intense realism, rarely before seen on film.

Inspired by the freedom of photography and still cameras to capture the moment, Robert Drew—a writer/editor at *Life* magazine—set out to make a film camera that would make documentaries look more interesting and impactful. With the help of Leacock and Pennebaker, he re-designed the thirty-pound 16mm single-system sound Auricon camera into a stripped down hand-held version, using pilot-tone for sound synchronization. Many notable documentaries followed his invention, such as *Dont Look Back*

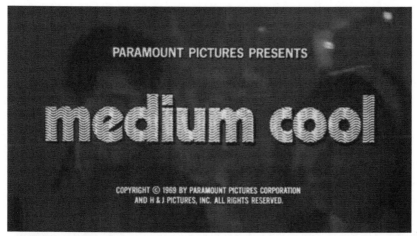

FIGURE 3.3 Screen capture from the movie *Medium Cool*, directed by Haskell Wexler[5]

(1967) about Bob Dylan, *Gimme Shelter* (1970) about the Rolling Stones' 1969 US tour (which ended with the tragic Altamont Concert), and many others. Various filmmakers explored and expanded the styles of cinéma vérité and direct cinema, like Cassavetes in his improvisational fiction films, or the cinematographer Haskell Wexler in *Medium Cool* (1969), which he also directed. This was a rare film that combined fictional story and characters with actual events, filming everything in direct cinema style. Shot during the 1968 Democratic National Convention and the ensuing riots, *Medium Cool* explored contentious political issues of its time.

The question that has been raised in various contexts is whether the new technologies produced the new filmmaking style, or if the desire to make films in new ways spurred the development of the new technologies. This is a relevant question to re-ask in our time, as digital technology has once again opened opportunities to push the boundaries of cinematic storytelling and blur the lines between "professional," "personal," and "amateur" film and media-making. In the case of direct cinema or cinéma vérité of the 1960s, it appears that the discovery of new technologies was primarily the result of filmmakers looking for new ways to capture stories and express themselves, rather than the other way around.[6]

Another technology, which developed in parallel to film, would eventually have an immense impact on filmmaking and media production and

distribution. Video was first developed in 1951 by the Ampex corporation in order to capture live images from TV cameras. It did so by recording the camera's electronic feed as information onto magnetic tape. The first video tape recorders and tapes were prohibitively expensive and used only by TV stations. In the early 1970s, Sony, JVC, and Matsushita Electric (Panasonic) were competing against each other to develop various low-cost video systems aimed at consumers. By 1980, JVC's VHS (Video Home System) finally won the drawn-out and often acrimonious competition with Sony's Betamax video format. VHS was not suitable for high-end video production, as its quality was limited and would deteriorate quickly in editing and dubbing. However, it became hugely popular as a way to record or rent movies and TV shows. This created the home video market, which, in turn, changed the entire film and television business.

Home video rentals generated a new distribution outlet, which was significant both for the studios and for the independents. This occurred alongside the rise of cable TV channels, creating a substantial increase in demand for content. At the time, the conglomerates were not producing enough new films to satisfy these demands. Initially, they tried to re-license their old movies for home video and cable TV. The audience, however, was primarily interested in new content, resulting in considerable growth of independent

FIGURE 3.4 Ampex AV3 Videotape[7]

film production in the 1980s. Many of these films were low-budget genre movies: horror, action, and exploitation pictures, reminiscent of the Hollywood Poverty Row films, now in a new environment, made straight-to-video or for-cable TV. Films like *The Texas Chainsaw Massacre* (1974), *Cannibal Holocaust* (1980), or Sam Raimi's *The Evil Dead* (1981) achieved cult status thanks to the home video market. A number of new independent distribution companies were formed, specializing in home video distribution. By the mid-1980s, over 50 percent of US households had VCRs and cable TV.[8]

Independent filmmakers could now explore new ways to finance their films, as well. The robust growth of home video and constant demand for new product allowed the independents to pre-sell their films to these outlets in order to fund their productions. At the same time, they could retain all other distribution rights, such as theatrical, TV, and foreign sales, which they could exploit later, once the film was completed. One of the many examples of this type of pre-sales financing was Steven Soderbergh's *Sex, Lies and Videotape*. Half of its $1.2 million budget was financed through a pre-sale to RCA/Columbia Home video in exchange for US home video rights, and the rest of the money was raised through pre-sales for foreign distribution rights.[9] During the 1990s, foreign pre-sales became another common way of financing independent productions, along with the maturing home video and cable TV markets. Cable channels, such as HBO and Showtime, increasingly financed original productions, as well as home video distributors, such as Vestron and New World Pictures.

When the DVD (Digital Versatile Disc) format was introduced in the late 1990s and gradually replaced VHS in the home video market, it did not significantly change the video distribution model. Many older films were now not available in the new format, but only on VHS; those films would have to be re-mastered and could be re-sold on DVD. For a while, new films were released both on VHS and on DVD. DVD became the dominant video rental format in the early 2000s, eliminating VHS, but its sales soon declined as well due to the competition from online streaming video.

In terms of low-budget video formats suitable for production, there were several formats introduced in the late 1980s, intended to improve on the quality of VHS. The goal was to advance the quality but to remain in the affordable price range for amateurs and small production houses, specializing in event or corporate videography. The most notable formats were Super

VHS (S-VHS), introduced by JVC in 1987, and Video8, created by Sony in 1985 (soon upgraded to Hi-8 video). As these formats were considered to be in between consumer and professional in terms of quality and features they offered, they were usually referred to as "prosumer" video. The cameras gave the user the choice to override the automatic settings—which were typical for consumer electronics—with manual controls, such as exposure, focus, sound levels, etc.

While there were some examples of these prosumer video formats being used for creative independent productions (for instance, the feature film *Love God* by Frank Grow, shot on Hi-8 video and made for $22,000, premiered at the Sundance Film Festival in 1997), for the most part they still remained on the periphery of filmmaking. S-VHS and Hi-8 were typically used by beginners, amateurs, or corporate videographers. The one extraordinary exception to this was the hugely successful horror film *The Blair Witch Project* (1999), which was shot on Hi-8 video and 16mm film. Using the limitations of the format to its advantage, the film created a simulated cinéma vérité look, telling a horror story through "found footage." Made for only $35,000, and accompanied by a clever and innovative marketing campaign, the film became a unique phenomenon, grossing $250 million worldwide.[10]

FIGURE 3.5 Screen capture from the movie *The Blair Witch Project*, directed by Daniel Myrick and Eduardo Sanchez[11]

The video format that eventually changed everything was digital video. It captures imagery using CCD (charge-coupled device) or CMOS (complementary metal-oxide-semiconductor) chips and records the images electronically, just like analog video cameras, but stores the information as digital data. Originally designed to record the data onto magnetic tape, as technology advanced to accommodate the large memory requirements of digital video, it became possible to record onto file-based media: flash-memory cards and hard drives. Digital video uses compression during data encoding in order to reduce the file size, which affects image quality and resolution. However, once the data is recorded, there is no further quality loss during editing and video duplication; even the furthest removed copy will be identical to the original. The various digital video formats use different levels of compression, but, even with the lower-end, high-compression formats, the quality tends to be better than analog video. Digital technology advanced at a remarkable pace, soon progressing to higher-resolution, high-definition digital video, as well as the RAW format, which records the highest quality uncompressed digital video.

Introduced in the mid-1990s, digital video featured various professional formats, such as DVCPRO and DVCAM; however, the format that initially had the greatest impact on independent filmmaking and the adoption of digital video in filmmaking was MiniDV. It was a "lossy" high-compression format, with picture quality comparable to S-VHS and Hi-8 video. However, it allowed for loss-less editing, which made the quality of the final product superior to other prosumer video formats. MiniDV was initially marketed in Japan to the consumer market and intended for the prosumer market in the US and internationally. However, because the quality of MiniDV was acceptable for professional productions, and the cameras were inexpensive compared to the higher-end DVCPRO and DVCAM formats, filmmakers started using MiniDV for professional productions—first for documentaries and some TV content, and soon for feature films as well. DVCPRO and DVCAM, which were originally aimed at the TV market for "electronic news gathering" (ENG), soon also started adjusting and incorporating features that would make their images look closer to film.

The popularity of MiniDV and digital video technology spread much faster among independent filmmakers than within Hollywood, as it was primarily a budgetary choice. The adoption of digital cameras within the mainstream film industry really started when George Lucas informed Sony that he was considering using a digital camera to shoot his Star Wars prequel,

FIGURE 3.6 Sony VX1000 Camera[12]

Star Wars: Episode II—Attack of the Clones (2002). He would do this only if Sony could design a camera comparable to the industry-standard Panavision 35mm film camera, and if it could use the same film lenses. For Lucas, the advantage of shooting digitally lay in the fact that his film relied on computer-generated special effects and animation. As long as the quality was acceptable, it would be more convenient to acquire the original footage in digital as well. This resulted in Sony designing the first high-end digital camera for filmmaking, the Sony HDW-F900, aka the CineAlta in 1999.[13]

The second important development that led to the propagation of digital video for filmmaking was the introduction of computer-based non-linear editing systems. Some non-linear editing systems already existed in the 1970s and 1980s, but it was the Avid Media Composer, introduced in 1989, that soon became the most popular computer-based editing platform. Avid designed its own hardware and software, and it installed them in Apple's Macintosh computers. Initially, users had to convert analog video to digital files in order to edit on Avid, but digital video came with a high-speed, loss-less interface between the camera or digital VCR and the computer:

FireWire, or IEEE 1394. This interface allowed for video data to be transferred without additional hardware or compression.

While Avid used its own proprietary hardware, making it still relatively expensive, Adobe launched a software-only based editing system, Premiere, in 1991. Originally designed more as a multi-media editing application than a professional video editing tool, it could only handle limited amounts of video. Final Cut Pro, Apple's software-only editing program, launched in 1998, became the first real competitor to Avid. It was much cheaper, as it did not require any additional hardware, and it was aggressively marketed by Apple. While Avid retained its dominance within the industry, Final Cut Pro became the most commonly used editing software among independent filmmakers and in the prosumer market. In 2003, Adobe released Premiere Pro, a stronger, more professional version of its original Premiere software, becoming another competitor to Final Cut Pro and Avid.

Aesthetically, video used to be considered film's unattractive, lower-level relative. As the technology was initially developed only to record live TV, so that it could be re-broadcast later, it was not engineered for artistic expression. The look of video, defined by its electronic nature and interlaced scan-lines, was markedly different from film. Before the advent of digital video, video was mostly used for TV news, daytime television, and corporate and

FIGURE 3.7 Screen capture of the Final Cut Pro video editing software[14]

event videos. While some artists used video to create art installations in galleries, museums, and film festival sidebars (Nam Jun Paik, Fluxus, Bill Viola, et al.), and some filmmakers used it for documentaries, it was a world apart from film.

This all changed with the advent of digital video. As filmmakers used the format increasingly for creative filmmaking like they would use a film camera, it prompted the manufacturers to revamp the cameras. They gradually incorporated more film features, like the ability to shoot at the film speed of twenty-four frames per second (achieved through a sophisticated electronic frame-pull-down process)—which made capturing movement on video look closer to film—as well as cinematic color reproduction, and the use of mechanical film lenses instead of electronic ones. Each new generation of digital video cameras would come closer to film, simulating film camera functions more faithfully, and almost blurring the lines completely. This, along with sophisticated post-production color correction and computer generated "film looks" makes it often difficult to distinguish between digital video and film, sometimes even for film professionals.

Other factors contributed to digital video becoming the dominant format of independent filmmaking. As previously mentioned, for low-budget independent filmmakers, Mini DV's low price was a crucial aspect in general, but another was that it allowed for more flexibility in production and post-production; digital video allows for shooting more coverage than film, and it gives more options in editing. The small cameras are unobtrusive and ideal for filming instantaneously, and in difficult situations. Also, as the overall environment transitioned to digital—from computers to the various screens we use to consume content—it became easier and more efficient to generate content in digital form as well. These developments were similar to what had happened to photography by the mid-2000s, where digital still cameras had almost completely replaced the mechanical still cameras, which had used conventional film stock. When the storage capacities and processing power of computer-based hardware increased to be able to handle high-quality digital video with its large memory requirements efficiently, the same shift occurred in filmmaking.

These changes have ushered in the catchphrase "digital filmmaking," which some theorists have considered to be contradictory. However, the phrase is meant to refer not to film as the physical film stock but rather to the aesthetic and storytelling conventions of filmmaking, now adopting digital

FIGURE 3.8 Arriflex D 21 A camera[15]

video as its technology. Another way to put it is that digital filmmaking became a new hybrid, merging the technology of video with filmmaking forms and conventions.

The ubiquity of digital video and non-linear editing, its low cost, and its easy accessibility had also various other consequences. It narrowed the difference between professional filmmakers and amateur videographers. Many people who would have never had the means to make a film now were able to do so with digital video. This caused an exponential growth in content being produced, expanding the traditional forms of narrative, documentary, and experimental film to various hybrids and fusions. Another aspect of the changes that digital filmmaking has brought about is that in many cases the clear delineations in film production roles have disappeared. In traditional film production, the crew specialized in specific tasks, such as operating cameras, lights, sound, editing, etc. Nowadays, because of the convenience and relative ease of digital technology, one person can—and is often expected to be able to—handle multiple tasks. As competition and product abundance have increased, the unique value of professional film-making has decreased. These changes have opened many questions about

the new economics of production, distribution, as well as individual value and pay in professional media production, which will be discussed later.

The early digital films of the 1990s have generally adopted something close to a cinéma-vérité-style look. Filmmakers often used the imperfections and limitations of the early MiniDV format—such as the more flat and electronic look—inventively, and they adjusted their stories and visual framing accordingly. Some filmmakers used the formal stylistic approach of shaky, hand-held cameras and digital video to imply realism within the traditional film narrative structure, while others experimented with both form and content. A watershed moment for early digital filmmaking was the formation of Dogme 95, by Danish filmmakers Lars von Trier and Thomas Winterberg in 1995. Together, they crafted a tongue-in-cheek ten-point manifesto about how films should be made in order to bring them back from the "empty artificiality of Hollywood." Their rules included shooting only on location with hand-held cameras and without the use of special effects, music, superficial action, etc.[16] The manifesto had an unexpected impact worldwide and inspired numerous filmmakers to follow its guidelines. To some critics, it was just a publicity stunt, or a justification for films to look bad or amateurish. To many independent filmmakers, however, it was a way to legitimize the use of lower-end technology, including MiniDV, for feature filmmaking. It was also a statement of opposition to the bland aesthetics of the mainstream cinema industry

The breakthrough for digital filmmaking came in 1998 with Thomas Vinterberg's film *The Celebration*, which won the Cannes film festival jury prize. Shot with a simple one-chip MiniDV consumer camcorder, it went on to win numerous other awards and accolades, creating a precedent. Similar to Lars von Trier's films, *The Celebration* had a classical narrative structure, but a new visual aesthetic. A wrenching family drama was deliberately shot like a home movie, albeit highly stylized. In the United States, inspired by the Dogme movement, Harmony Korine made the features *Gummo* (1997) and *Julien Donkey-Boy* (1999), which were much more effusive and experimental in both form and content. Other notable films shot on DV include Lars von Trier's *Dancer in the Dark* (2000), a musical drama, starring the singer Bjork, merging the narrative format of classical tragedy with a shaky hand-held DV camera style; Steven Soderbergh's star-studded *Full Frontal* (2002), following a cast of characters in Hollywood during one day, while muddling lines between fiction and reality; the hugely popular documentary *Buena Vista Social Club* (1999), which featured, and subsequently resurrected the

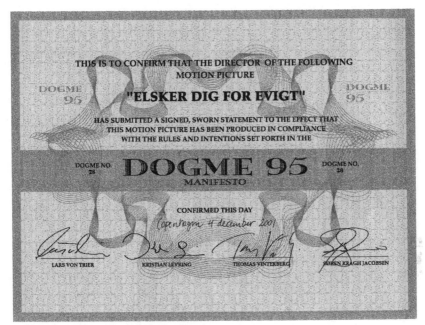

FIGURE 3.9 Dogme 95 Manifesto[17]

careers of, once-legendary but now forgotten Cuban musicians; *The Cruise* (1998), a documentary following a quirky New York City double-decker bus tour guide in black-and-white MiniDV; et al. While the content and narrative structures of these films varied, most of them shared the cinéma vérité stylistic approach of hand-held cameras and unmitigated realism.

In 1999, director Gary Winick, entertainment attorney John Sloss, and IFC Productions, a division of the Independent Film Channel, formed the company InDigEnt (Independent Digital Entertainment). The idea behind InDigEnt was to produce feature films on prosumer digital video, each with a budget of $100,000, attracting established directors and well-known actors by giving them creative control and co-ownership of the films. During the first few years, the company was quite successful. Five of its first films were sold to the major distributor Lionsgate. The 2002 films *Tadpole* and *Personal Velocity* followed, winning awards and selling for millions each, and their feature *Pieces of April* (2003) earned actress Patricia Clarkson an Oscar nomination for Best Supporting Actress. By 2006, however, InDigEnt had made a series of poorly received films, and the company closed shortly after in January 2007.

This once again highlighted the problems of a business model relying solely on low-budget films, showing that such a model cannot compete in the long run with the much-higher-funded mainstream industry. InDigEnt was successful with its innovative formula for a short time while DV film production was still new and not taken seriously by the mainstream. Once the market matured and became more profitable, the industry moved into it, not only as distributors, but also as producers of "independent" films themselves, transforming the term into a broad specialty genre. As Winnick had observed:

> The studios are more interested in using their specialty divisions, which otherwise serve as distributors for little films, to produce modestly budgeted "indie" pictures like *Brokeback Mountain* and *Capote*. They want the $8 million film to make $100 million instead of the $1 million to make $10 [million].[18]

As we are deliberating—with some even heralding it as "unprecedented"—the openness and possibilities of the Internet, digital video, and online streaming, it is important to keep in mind the recurring historical trends of competition and co-option between the independents and the mainstream. In that respect, while it is tempting, it would be rash to presume that the present circumstances are entirely different from anything we have seen before. This is especially true today because of increased corporatization, globalization, and company mergers, creating ever-growing conglomerates, and less actual competition within the industry.

By the end of the decade, digital video had become ubiquitous, from films and TV to short web videos and consumer cell phones. The video rental market and distribution system had also changed, with Netflix arguably being the company most responsible for these changes. Netflix was the brainchild of entrepreneur Reed Hastings, who came upon the idea of creating a subscription-based mail-order DVD rental business with no late fees for overdue rentals. Within a few years, Netflix crushed all competing brick-and-mortar video rental stores, including its prime competitor, Blockbuster, and eventually drove them out of business. In 2007, Netflix introduced video-on-demand streaming through the Internet, becoming a pioneer in video distribution through online streaming. This allowed Netflix to grow while the popularity and sales of DVDs started declining from 2007 onward. Netflix also developed a unique and detailed personalized

video-recommendation system, based on customer ratings, which allowed the company to cater more successfully to its audience than film or TV companies that relied on traditional market analysis. Using its own algorithm to measure their customers' viewing habits, Netflix decided to adjust its model to prioritize TV series over movies. It also successfully used its analysis to create the Netflix hit series *House of Cards* (2013), extrapolating its customers' favorite genre (political drama), favorite actor (Kevin Spacey), and favorite director (David Fincher).[19]

Along with YouTube and Amazon, Netflix has become a major competitor to the traditional film and media conglomerates. Starting as "dot-coms" and providing platforms for services and hosting content, these companies have now moved into producing proprietary new programs. In turn, the conglomerates have each opened their own online platforms (Hulu, Vudu, Crackle, HBO Go, etc.), while a host of new—and to a various degree independent—online distributors, services, and platforms keep opening (and shutting down) every few months. The over-supply of channels, as well as content, continues to expand. In 2012, for the first time ever, more people (legally) watched movies online than on physical media, such as DVDs or Blu-Ray discs.[20] Online video streaming is assuredly on its way to win over other forms of film and video delivery and distribution, turning distributors into "content aggregators" and media devices into "streaming platforms."

▶ NOTES

1 Jan Lumholdt, ed. *Lars von Trier: Interviews* (Jackson: University Press of Mississippi, 2003), 157.

2 Figure 3.1. Ivan Nador, "NAGRA III Tape Recorder," digital image, Wikipedia, August 8, 2012, accessed December 16, 2015, https://commons.wikimedia.org/wiki/File:Magnetofon_Nagra_1958.JPG.

3 John Bailey, "The Camera(s) That Changed the World," *John's Bailiwick Blog| The American Society of Cinematographers*, September 9, 2013, http://www.theasc.com/site/blog/the-cameras-that-changed-the-world/.

4 Figure 3.2. *Walter Bach Demonstrates Auricon Pro 1200*, Poolside, Hollywood, Early 1950s. Kinetta Scan Test., perf. Walter Bach, YouTube, August 22, 2012, accessed December 16, 2015, https://www.youtube.com/watch?v=6qpE5aeG5cY.

5 Figure 3.3. *Medium Cool,* dir. Haskell Wexler, perf. Robert Forster and Verna Bloom (Los Angeles, CA: Paramount Pictures, 1969), VHS.

6 Mandy Chang, *The Camera that Changed the World,* July 26, 2011 (Los Angeles, CA: BBC Four, 2011), Television broadcast.

7 Figure 3.4. Magnus Manske, "Ampex AVR 3," digital image, Wikipedia, December 3, 2007, https://commons.wikimedia.org/wiki/File:Ampex-avr3.jpg.

8 Michael Wiese, *Film & Video Financing* (Studio City, CA: Michael Wiese Productions, 1991), 143.

9 Ibid.

10 John Young, "'The Blair Witch Project' 10 Years Later: Catching up with the Directors of the Horror Sensation," *EW.com,* July 9, 2009, http://www.ew.com/article/2009/07/09/blair-witch.

11 Figure 3.5. *The Blair Witch Project,* dir. Daniel Myrick and Eduardo Sanchez, perf. Heather Donahue and Michael C. Williams (Los Angeles, CA: Artisan Entertainment, 1999), DVD.

12 Figure 3.6. Sony VX1000 digital image screen capture; Sony, accessed June 2, 2015, http://www.sony.net/Fun/design/history/product/1990/dcr-vx1000.html.

13 Joe Foster, "How George Lucas Pioneered the Use of Digital Video in Feature Films with the Sony HDW F900," May 11, 2016, http://www.redsharknews.com/technology/item/2990-how-george-lucas-pioneered-the-use-of-digital-video-in-feature-films-with-the-sony-hdw-f900.

14 Figure 3.7. "Final Cut Pro," digital image, accessed December 16, 2015.

15 Figure 3.8. Schlaier, "Arriflex D 21 A," digital image, Wikipedia, February 4, 2011, https://commons.wikimedia.org/wiki/File:Arriflex_D_21_a.jpg.

16 Richard Raskin, ed, "Aspects of Dogma," *P.O.V. A Danish Journal of Film Studies 10, (December 2000),* http://pov.imv.au.dk/Issue_10/POV_10cnt.html.

17 Figure 3.9. Dogma 95, "Dogme 95 Manifesto," digital image, Wikipedia, May 13, 2015, https://commons.wikimedia.org/wiki/File:Dogme28.jpg.

18 Christopher Campbell, "InDigEnt Shuts down in January," *Moviefone.com,* December 5, 2006, http://news.moviefone.com/2006/12/05/indigent-shuts-down-in-january.

19 Andrew Leonard, "How Netflix Is Turning Viewers into Puppets," *Salon.com,* February 1, 2013, http://www.salon.com/2013/02/01/how_netflix_is_turning_viewers_into_puppets/.

20 Bob Ankosko, "Breakthrough Year for Online Movies," *Sound & Vision*, December 24, 2012, http://www.soundandvision.com/content/breakthrough-year-online-movies#rLtDqsWau7JwL870.97.

▶ **BIBLIOGRAPHY**

Ankosko, Bob. "Breakthrough Year for Online Movies." *Sound & Vision*. December 24, 2012. http://www.soundandvision.com/content/breakthrough-year-online-movies.

Bailey, John. "The Camera(s) that Changed the World." *John's Bailiwick Blog*. September 9, 2013. http://www.theasc.com/site/blog/the-cameras-that-changed-the-world/.

The Camera that Changed the World. Directed by Mandy Chang. Performed by Jot Davies. United Kingdom: BBC Four, 2011. Film.

Campbell, Christopher. "InDigEnt Shuts down in January." *The Moviefone Blog*. December 5, 2006. http://news.moviefone.com/2006/12/05/indigent-shuts-down-in-january.

Chatmon, Peter. "Crowdfunding Chronicles W/ Pete Chatmon—The Road to $50." *Shadow and Act*. Last modified October 16, 2013. http://blogs.indiewire.com/shadowandact/crowdfunding-chronicles-w-pete-chatmon-the-road-to-50-000-issue-i.

Chion, Michel. *Film, a Sound Art*. New York: Columbia University Press, 2009.

Enticknap, Leo Douglas Graham. *Moving Image Technology: From Zoetrope to Digital*. London: Wallflower, 2005.

Evans, Russell. *Practical DV Filmmaking*, 2nd ed. Amsterdam: Elsevier Focal Press, 2006.

Lumholdt, Jan. *Lars Von Trier: Interviews*. Jackson: University Press of Mississippi, 2003.

"Non-linear Editing System." *Wikipedia*. Accessed November 15, 2015. http://en.wikipedia.org/wiki/Non-linear_editing_system.

Raskin, Richard, ed. "Aspects of Dogma. " *P.O.V. A Danish Journal of Film Studies* 10 (December 2000). http://pov.imv.au.dk/Issue_10/POV_10cnt.html.

Rosen, David. "YouTube's Aggressive Move into Original Content." *Filmmaker Magazine*. April 8, 2013. http://filmmakermagazine.com/68152-youtubes-agressive-move-into-original-content/.

Schenk, Sonja, and Ben Long. *The Digital Filmmaking Handbook*, 5th ed. Boston, MA: Cengage Learning PTR, 2015.

Shaw, Lucas. "Paradigm Partners with LittleCast to Help Stars Sell Videos on Facebook (Exclusive)." *The Wrap*. October 16, 2013. http://www.thewrap.com/paradigm-partners-littlecast-help-stars-sell-videos-facebook-exclusive.

Silverman, Jason. "DV Studio Can't Make a Buck." *WIRED*. January 26, 2006. Accessed October 21, 2015. http://archive.wired.com/science/discoveries/news/2006/01/70074.

"VHS." *Wikipedia*. Accessed November 15, 2015. https://en.wikipedia.org/wiki/VHS.

"VHX—Launch Your Own Video Streaming Service." *VHX*. Accessed October 29, 2015. http://vhx.tv.

Weis, Elisabeth, and John Belton, eds. *Film Sound: Theory and Practice*. New York: Columbia University Press, 1985.

Welsh, Josh. "Studying the Economics of Independent Film: A Proposal." *The Huffington Post*. October 22, 2011. http://www.huffingtonpost.com/josh-welsh/studying-the-economics-of_b_1026877.html.

Wiese, Michael. *Film & Video Financing*. Studio City, CA: Michael Wiese Productions, 1991."Why Filmmaking Cannot Be a Hobby." *Filmmaker Magazine*. July 19, 2011. http://filmmakermagazine.com/25958-why-filmmaking-cannot-be-a-hobby.

Young, John. "'The Blair Witch Project' 10 Years Later: Catching up with the Directors of the Horror Sensation." *Entertainment Weekly*. July 9, 2009. http://www.ew.com/article/2009/07/09/blair-witch.

YouTube. "Filmmakers Wanted." *YouTube*. January 22, 2010. https://youtu.be/LEt0i4aVDg4.

"YouTube Original Channel Initiative." *Wikipedia*. Last modified October 2013. https://en.wikipedia.org/w/index.php?title=YouTube_Original_Channel_Initiative&oldid=578635236.

▶ FILMOGRAPHY

Blair Witch Project, The. Directed by Daniel Myrick and Eduardo Sánchez. 1999. New York, NY: Lions Gate, 1999. DVD.

Brokeback Mountain. Directed by Ang Lee. 2005. Universal City, CA: Focus Features, 2012. DVD.

Buena Vista Social Club. Directed by Wim Wenders. 1999. Santa Monica, CA: Artisan, 2001. DVD.

Cannibal Holocaust. Directed by Ruggero Deodato. 1980. Los Angeles, CA: Grindhouse Releasing, 2005. DVD.

Capote. Directed by Bennett Miller. 2005. Culver City, CA: Sony Pictures Home Entertainment, 2006. DVD.

Celebration, The. Directed by Thomas Vinterberg. 1998. Universal City, CA: Universal Studios, 2004. DVD.

Cruise, The. Directed by Bennett Miller. 1998. New York, NY: Lions Gate, 2006. DVD.

Dancer in the Dark. Directed by Lars Von Trier. 2000. Los Angeles, CA: New Line Home Video, 2005. DVD.

Dont Look Back. Directed by D.A. Pennebaker. 1967. New York, NY: Criterion Collection, 2015. DVD.

Evil Dead, The. Directed by Sam Raimi. 1981. Troy, MI: Anchor Bay Entertainment, 2007. DVD.

Full Frontal. Directed by Steven Soderbergh. 2002. Santa Monica, CA: Miramax, 2003. DVD.

Gimme Shelter. Directed by Albert Maysles, David Maysles and Charlotte Zwerin. 1970. New York, NY: Criterion, 2000. DVD.

Gummo. Directed by Harmony Korine. 1997. Burbank, CA: Warner Archive Collection, 2013. Film.

House of Cards. Directed by David Fincher. Netflix, 2013.

Jazz Singer, The. Directed by Alan Crosland. 1927. Burbank, CA: Warner Home Video, 2007. DVD.

Julien Donkey-Boy. Directed by Harmony Korine. 1999. Los Angeles, CA: New Line Home Video, 2001. DVD.

Love God. Directed by Frank Grow. 1997. New York, NY: Good Machine. Film.

Man with the Movie Camera. Directed by Dziga Vertov. 1929. New York, NY: Kino Lorber Films, 2003. DVD.

Medium Cool. Directed by Haskell Wexler. 1969. New York, NY: Criterion Collection, 2013. DVD.

Personal Velocity. Directed by Rebecca Miller. 2002. New York, NY: MGM, 2003. DVD.

Pieces of April. Directed by Peter Hedges. 2003. New York, NY: MGM, 2004. DVD.

Sex, Lies and Videotape. Directed by Steven Soderbergh. 1989. Culver City, CA: Sony Pictures Home Entertainment, 2008. DVD.

Star Wars: Episode II Attack of the Clones. Directed by George Lucas. 2002. Culver City, CA: 20th Century Fox, 2005. DVD.

Tadpole. Directed by Gary Winick. 2002. Santa Monica, CA: Miramax Home Entertainment, 2003. DVD.

Texas Chainsaw Massacre, The. Directed by Tobe Hooper. 1974. Orland Parl, IL: Dark Sky Films, 2014. DVD.

4

A New Paradigm

By 2008, the financial crisis, along with other factors, had a significant impact on mainstream independent film production. Many banks started to pull out of film financing, and DVD sales and rentals started shrinking due to online streaming and piracy. The market became much more volatile and unpredictable. Foreign sales for US independent films evaporated as well, since foreign markets re-focused on purchasing local product and Hollywood movies.

Independent producers and distributors struggled as their financing models largely disappeared. For the most part, the studio conglomerates closed their specialty divisions and fully dedicated themselves to blockbuster franchise movies and TV entertainment. While the international marketplace overall had grown, this growth had been dominated by Hollywood blockbusters, local productions, and a comparably small number of high-profile US independents.[1] In his keynote speech at the 2008 Los Angeles Independent Film Festival, former Miramax distribution executive Mark Gill summarized the situation this way:

> There's a glut of films: 5000 movies got made last year. Of those, 603 got released theatrically here. And there's no room in the market—as there used to be—for even 400 of those. Maybe there's room for 300.

> So everything else just dies. Most of these pictures are pre-ordained
> flops from independent distributors who forgot that their odds would
> have been better if they'd converted their money into quarters and
> taken the all-night party bus to Vegas.[2]

The competition for viewers' time and attention is no longer based solely
on new content. The expansion of streaming technology has also opened a
floodgate of old films and TV shows from the past, which had been unavail-
able or hard to find before the advent of online streaming. This content
started competing with current productions. In addition, new alternatives—
like online and video games, YouTube, and social media—started contend-
ing and usurping the audience's leisure time as well. These new media
alternatives and surplus in available content have led to more choices for
consumers, which, in turn, has led to more competition among producers
and distributors. The sheer amount of accessible films and videos has inten-
sified the likelihood of audience fragmentation. In addition, online stream-
ing and peer-to-peer networking has also enabled rampant "piracy"—free
and unauthorized sharing and downloading of content. These changes have
affected studios and independents alike. Studios have responded to these
developments by focusing almost exclusively on "high-concept" blockbust-
ers, which can be franchised and re-made.

For industry movies, the domestic box office only provides about one third
of the revenue, while most income is generated from foreign sales and
merchandising. By relying on blockbusters, and spreading the same con-
tent across multiple media platforms, studios are able to spend enormous
amounts of money on publicity and advertising and thereby overcome con-
sumer segmentation. While there have been discussions on whether this
model will eventually yield to an "infinite choice/ultimate fragmentation"
scenario, as Webster and Ksiazek argue, it is more likely that the "hit-driven
culture" will continue. They offer three arguments as to why audiences will
likely remain concentrated around mainstream industry blockbusters: "the
differential quality of media products, the social desirability of media selec-
tions, and the media measures that inform user choices."[3]

The current media landscape might suggest that old media practices have
successfully undermined the promise made by new technologies and pre-
served old viewing habits. For the time being, the studios have managed
to consolidate their power through blockbusters and franchises. However,
experienced film establishment insiders, even Steven Spielberg and George

Lucas, have been warning their peers: "because of the increasingly huge budgets of these projects, a few simultaneous flops could bring the whole industry down."[4] Furthermore, online piracy and shifting consumer habits can put significant pressure on the present studio business model in the long run. Declining revenues in the music industry over the past decade have already demonstrated how technological innovations and changing audience consumption patterns can reshape a market in a matter of years and swallow those who will not or cannot adapt to the new order.

For the independent filmmakers who had created a niche-business model in the 1990s and early 2000s, the picture had become quite dire. As they were no longer able to rely on foreign pre-sales and niche-distribution outlets, many high-profile independent producers had to close their companies and work on a project-by-project basis, while others moved to television or left the business altogether. The few remaining niche-distributors had to scale down, cut overhead costs, and target a small core audience in order to survive. On the surface, the changes in the media landscape have not truly benefited the independents, apart from a few superstars that had already established their brand names and carried it over into this new environment. Independents are not able to compete with the studios in terms of publicity and advertising spending. The increased competition and audience fragmentation hit them considerably harder.

Online exhibition platforms—such as Netflix, YouTube, and various video-on-demand providers—are the ones that profited most during this increase in media competition, while the low-budget filmmakers generally saw only diminishing returns. The availability of online streaming video led the audience to expect content for free or on the basis of a low-cost subscription service. When media consumption is channeled through these exhibition windows that give a competitive edge to studio entertainment and equalize everything else, it becomes ever harder for independent content to reach an audience.

Since this new reality created problems in terms of acquiring financing and distribution, and declining revenues, it ultimately also affected the choices in film and video content that would get produced. Most producers who still work in the mindset of independent film from the 1980s and 1990s now believe an independent film has to copy the studios' mass-appeal model and become a "scalable" property in order to be successful. According to this logic, art house film is dead, while some independent genre

films—most notably, horror and teenage or slacker comedies—can become a success if they gain a substantial following and are remade or franchised as studio properties. Lena Dunham's no-budget feature debut *Tiny Furniture* (2010) is a good example of that model, as it led the filmmaker to become a celebrity with her subsequent HBO series *Girls*. The most successful "scalable property" so far has been the *Paranormal Activity* (2009) franchise, and its many thematic spin-offs, which itself owes a lot to *The Blair Witch Project* (1999). But these success stories are exceptions rather than the rule. According to these metrics of success, most independents nowadays are failures.

Consequently, many veteran producers have lamented the death of independent cinema. This is, however, a very limiting view. Today, there is no shortage of new independent films and filmmakers—virtually everybody has become a filmmaker. An ever-increasing number of independent filmmakers and producers are entering the field, producing shorts, features, documentaries, and online and transmedia content. Most of these projects do not score huge audience numbers, and very few manage to create a sustainable model for production and distribution because the sheer volume of low- and no-budget films has saturated the market.[5] However, this mostly indicates a failure of traditional market, exhibition, and distribution options, rather than the "death of independent film."

While digital technology has enabled filmmakers to produce films on low or no budgets for a while now, they still had to depend on specialized mainstream distributors in order to reach a wider audience. With the breakdown of these distribution models, many low-budget independent producers had to start searching for viable alternative distribution strategies, experimenting with various hybrid distribution and self-distribution models.

The online video world has matured simultaneously with these changes. Streaming video is now ubiquitous, from video-on-demand, web channels, mobile, download- and subscription-based websites, to pervasive bittorrent piracy. Videos and/or films—these terms have increasingly become interchangeable in the digital world—are being watched on various platforms and devices, from big plasma screens to phones and tablets. With the addition of ever-expanding social media channels, crowdfunding, and crowdsourcing platforms, a new paradigm has developed. Not only is it possible to make films and videos in different ways now; it has become feasible to finance, show, and distribute them in other ways, too.

▶ NOTES

1 Peter Knegt, "From the iW Vaults | Mark Gill: 'Yes, The Sky Really Is Falling,'" *Indie Wire*, July 4, 2011, http://www.indiewire.com/article/from_the_iw_vaults_mark_gill_yes_the_sky_really_is_falling.

2 Ibid.

3 James G. Webster and Thomas B. Ksiazek, "The Dynamics of Audience Fragmentation: Public Attention in an Age of Digital Media," *Journal of Communication* 62, no. 1 (2012): 18, doi: 10.1111/j.1460–2466.2011.01616.

4 Ben Child, "Steven Spielberg and George Lucas Predict Film Industry 'Implosion,'" *The Guardian*, June 13, 2013, http://www.theguardian.com/film/2013/jun/13/steven-spielberg-george-lucas-film-industry.

5 Manohla Dargis, "Declaration of Indies: Just Sell It Yourself!" *The New York Times*, January 14, 2010, http://www.nytimes.com/2010/01/17/movies/17dargis.html.

▶ BIBLIOGRAPHY

Chatmon, Peter. "Crowdfunding Chronicles W/ Pete Chatmon—The Road to $50." *Shadow and Act*. Last modified October 16, 2013. http://blogs.indiewire.com/shadowandact/crowdfunding-chronicles-w-pete-chatmon-the-road-to-50–000-issue-i.

Child, Ben. "Steven Spielberg and George Lucas Predict Film Industry 'Implosion.'" *The Guardian*. June 13, 2013. http://www.theguardian.com/film/2013/jun/13/steven-spielberg-george-lucas-film-industry.

Dargis, Manohla. "Declaration of Indies: Just Sell It Yourself!" *The New York Times*. January 14, 2010. http://www.nytimes.com/2010/01/17/movies/17dargis.html.

Dixon, Louise. "David Victori's 'The Guilt' Wins First-Ever YouTube 'Your Film Festival.'" *The Huffington Post*. Last modified September 2, 2012. http://www.huffingtonpost.com/2012/09/02/david-victori-the-guilt-youtube-your-film-festival_n_1850394.html.

Knegt, Peter. "From the iW Vaults | Mark Gill: 'Yes, the Sky Really Is Falling.'" *IndieWire*. July 4, 2011. http://www.indiewire.com/article/from_the_iw_vaults_mark_gill_yes_the_sky_really_is_falling.

"Lessons Learned from YouTube's $300M Hole." *Hank's Tumblr* (blog). Last modified March 25, 2013. http://www.edwardspoonhands.com/post/46305605617/lessons-learned-from-youtubes-300m-ho.

McDuling, John. "The Music Industry Has Hit Its Rock Bottom." *Quartz*. April 14, 2015. http://qz.com/383109/the-music-industry-has-hit-its-rock-bottom/.

Rosen, David. "YouTube's Aggressive Move into Original Content." *Filmmaker Magazine*. Last modified April 8, 2013. http://filmmakermagazine.com/68152-youtubes-agressive-move-into-original-content/.

Sorensen, I.E. "Crowdsourcing and Outsourcing: The Impact of Online Funding and Distribution on the Documentary Film Industry in the UK." *Media, Culture & Society* 34, no. 6 (2012): 726–743. doi:10.1177/0163443712449499.

Susman, Gary. "Can Kickstarter Save the Movie Business?" *Rolling Stone*. Last modified August 5, 2013. http://www.rollingstone.com/movies/news/can-kickstarter-save-the-movie-business-20130805.

"VHX—Launch Your Own Video Streaming Service." *VHX*. Accessed October 29, 2015. http://vhx.tv.

Webster, James G., and Thomas B. Ksiazek. "The Dynamics of Audience Fragmentation: Public Attention in an Age of Digital Media." *Journal of Communication* 62, no. 1 (2012): 18. doi:10.1111/j.1460–2466.2011.01616.

YouTube. "Filmmakers Wanted." *YouTube*. January 22, 2010. https://youtu.be/LEt0i4aVDg4.

"YouTube Original Channel Initiative." *Wikipedia*. Last modified October 2013. https://en.wikipedia.org/w/index.php?title=YouTube_Original_Channel_Initiative&oldid=578635236.

▶ FILMOGRAPHY

Blair Witch Project, The. Directed by Daniel Myrick and Eduardo Sánchez. 1999. New York, NY: Lions Gate, 1999. DVD.

Paranormal Activity. Directed by Oren Peli. 2009. Hollywood, CA: Paramount, 2009. DVD.

Tiny Furniture. Directed by Lena Dunham. 2010. New York, NY: Criterion Collection, 2012. DVD.

5

Emerging Models and Practices

From the beginning the thought wasn't, 'Hey! This is going to get us boatloads of money!' The thought was, 'Hey! Here's a space where we as directors and creative people can do our thing without worrying about the various other concerns of filmmaking. . . . That's what was most important, being able to commit to this full time, without a full understanding what lies ahead, but with a knowledge that if you build an audience, that will be helpful, whatever you do in the film world.

Freddie Wong, filmmaker[1]

▶ DIY & NO-BUDGET PRODUCTION MODELS

In 2007, Oren Peli, an Israeli-born video game designer, wrote, directed, co-produced, and edited his first feature film, *Paranormal Activity*. Made for $11,000 and shot on consumer camcorders, the film followed in the footsteps of *The Blair Witch Project* (1999), using found footage to tell the story of a young couple, haunted by a supernatural presence in their home.[2] As opposed to the shaky hand-held cameras of *The Blair Witch Project*, *Paranormal Activity* used static camera angles, set up by the movie's couple themselves in an attempt to find out who or what was haunting them.

The film was shot over seven days in Peli's house in San Diego. It cleverly played with the concepts of tension, latent expectation, and suspense, once again using low-end consumer video to its advantage. The film screened at the 2007 Screamfest Horror Film Festival in Hollywood, which showcases new horror films from American and international independent filmmakers. There, it caught the attention of an agent's assistant, working for one of the most powerful Hollywood agencies, CAA (Creative Artists Agency). This eventually led to CAA signing on to represent Peli and sending out the DVD of *Paranormal Activity* to various industry executives and insiders for consideration. The DVD also reached producer Jason Blum, who was, coincidentally, the senior executive at Miramax Films at the time *The Blair Witch Project* appeared, and who rejected the title then. He later admitted that that decision was the biggest mistake of his career—one that the head of Miramax, Harvey Weinstein, never let him forget.[3] He was determined not to repeat his slip with *Paranormal Activity*. Blum convinced Peli to give him a chance to try to get a bigger distribution deal for the film than what Peli had already secured, which was a modest straight-to-video release. Blum eventually was able to get the DVD to DreamWorks, where the executives recommended it to Steven Spielberg. Though DreamWorks was enthusiastic about the film, it was unsure of what to do with it, so it decided to do a remake on a bigger budget, with Peli directing the movie. The original film was only supposed to be included as an extra on a future DVD release.

Blum and Peli, however, were able to negotiate a test screening before proceeding with the remake, in the belief that the original film would be well received by an audience. During the test screening, viewers started walking out. The DreamWorks executives thought that viewers were bored, but it turned out that they were leaving because they were too scared to continue watching. The audience's strong response finally convinced DreamWorks to release the original film rather than remake it. It took another two years for the film to be released, as Paramount acquired DreamWorks in 2005 and took over distributing the company's films. By 2007, the relations between the two companies became increasingly arduous, putting the release of many DreamWorks projects on hold. When the dispute was finally settled, Paramount bought the film and rights to its sequels for $350,000. The studio re-edited several scenes, changed the ending, and released the film in 2009. The re-edited version was initially screened on September 25, 2009, in thirteen college towns across the United States, followed by a limited release in major cities.

FIGURE 5.1 *Paranormal Activity—The Ghost Dimension* poster[4]

Paramount began screening trailers of the film, which would not show actual scenes from the movie, but audience reactions, as they were screaming while watching the film in theaters. The studio also started an inventive marketing campaign, using the website Eventful.com—an online platform where fans could "demand" a band to play at a venue in their town: if there were enough online demands, the venue would book the band. Paramount decided to try a similar strategy for the release of *Paranormal Activity*. The film was already creating substantial buzz online when Oren Peli asked users on Eventful to demand a screening of the film; if the website could accumulate a million demands, Paramount announced that it would give the film a wide release. This was the first time a Hollywood studio used "viral marketing" strategies to promote a movie. The millionth request on Eventful.com was posted on October 10. Paramount followed up with a wide release in the United States, and worldwide by November 2009.

On September 20, 2009, John Horn wrote in the *Los Angeles Times*: "While it's highly unlikely *Paranormal Activity* can come close to the success of 1999's 'The Blair Witch Project' (a $35,000 production that grossed almost $250 million worldwide), Peli and Blum hope the film can teach the old dogs of Hollywood a new trick."[5] *Paranormal Activity* eventually grossed over $193.4 million worldwide at the box office, and became a successful franchise for Paramount.

Similar to *Blair Witch*, *Paranormal Activity* is another best example of a hugely successful "scalable property." As Jason Blum said, however, "There are about 3,000 of these movies made every year, so this film is about one in 15,000."[6] This illustrates why the financial success of these types of independent productions cannot be foreseen, quantified, or standardized, and why Hollywood is generally wary of them.

Another example of successful "scaling" from DIY independent filmmaking to mainstream industry is Lena Dunham's career. Coming from an affluent background and raised in New York's Tribeca neighborhood by her successful artist parents, Dunham, like Peli, did not have any formal filmmaking training. She made several short films with her friends, many of them exploring personal and sexual themes, with some of them going viral on YouTube. She also appeared in and worked on various web series. In 2010, she made her first feature film, *Tiny Furniture*, which premiered at the SXSW Film Festival, where it won the Best Narrative Feature award. The film is semi-autobiographical, centered on the relationship of the protagonist (Dunham)

with her mother (her real mother, the photographer Laurie Simmons) and on the protagonist's ambivalent relations to her friends, dating, sex, and future.

The film's themes and voice struck a chord with the millennial audience, prompting IFC to buy and distribute the film. Made for $65,000 and shot on a Canon 7D DSLR camera, the film earned almost $400,000 at the box office. More significantly for Dunham, the film's resonance with the young audience attracted the attention of HBO, which offered her a blind script deal prompting the creation of Dunham's hit show *Girls*. Premiering in 2012, the half-hour "dramedy," which Dunham also stars in, follows a group of twenty-somethings living in New York City. That same year, Dunham signed a $3.5 million publishing deal with Random House for her book *Not That Kind of Girl: A Young Woman Tells You What She's Learned*, which reached number two on the *New York Times* bestseller list. Outspoken, provocative, and often deliberately controversial, Dunham had become a brand name and celebrity within a very short time span.

Both of these different examples show a similar trajectory, where the success of micro-budget DIY productions has led to industry recognition and mainstream media success. In both of these cases, the audience reception and commercial success of the projects could not have been anticipated. As is generally the case with independent productions, they were a result of the right timing and confluence of a variety of factors beyond the makers' control. In both of these cases, however, it is safe to assume that the filmmakers created their projects because of their own interests, and in their own, personal, unique voices, rather than only calculating their commercial potential.

Both Peli's *Paranormal Activity* and Dunham's "twenty-something projects" deal with subjects that are quite popular and have defined audiences. In terms of genre, horror films have proven time and again that small, low- or no-budget productions can become huge commercial hits, from *Halloween* (1978 [made for $300,000, grossed $47 million at the US box office]) or the original *Friday the 13th* (1980 [made for $500,000, grossed $37 million]), to *The Blair Witch Project* and *Paranormal Activity*. On the other end, coming-of-age films dealing with adolescent angst and youth relationships, if told in the right voice and style, can also have substantial audiences. This had been demonstrated by many successful Sundance films—such as *Slacker* (1991),

Clerks (1994), *Napoleon Dynamite* (2004), etc.—and now through YouTube channels and its "personalities."

One of the forms of independent filmmaking that has been hit the hardest during the last years is the so-called independent art house film. The term in itself is not even a genre but an umbrella phrase used to define a variety of art-cinema approaches for films, which are usually screened in art house cinemas in limited releases. Already during the 1990s, Harvey Weinstein, the head of Miramax—a champion of art house cinema at the time—proclaimed that art house films are "dead."[7] As the market had changed, it became much harder to find financing for these films over the years, unless it was a vehicle for a Hollywood celebrity to prove themselves in a dramatic role.

The DIY model has become a significant way for new filmmakers with unique voices to emerge onto the larger independent film scene. They usually do not have the resources and industry connections to access celebrity stars or significant film financing, but they now have the tools to make a film much more easily. Much has been written about Robert Rodriguez making his first feature film *El Mariachi* for only $7,000 on 16mm film in 1992; that fact alone became a marketing tool for Columbia Pictures, which put in an additional half-million dollars to release the film nationwide.[8] Today, digital technology has enabled anybody with basic film knowledge and an interesting concept to do the same for even less.

The DIY model was the beginning for the careers of Peli and Dunham, but also for many others. The Duplass brothers—Mark and Jay Duplass—similarly started with no-budget DIY movies, *The Puffy Chair* (2005), made for $15,000, and *Baghead* (2008), which opened the doors for them to go on to bigger film and TV careers. Another independent filmmaker with a similar aesthetic, Andrew Bujalski, started this wave of US independent filmmaking with his feature debut *Funny Ha Ha* (2002), casting amateur actors, improvising dialogue, shooting on no budget, and aiming for a naturalistic look. Similar films include *Humpday* (2009), *Hannah Takes the Stairs* (2007), and others. Critics often refer to this style as "mumblecore." Supported by Sundance, these films were praised by critics and had significant festival runs, although they were not big box office successes. In 2015, the Duplass brothers produced the feature *Tangerine*, directed by Sean Baker, entirely shot on an iPhone 5S, which premiered at the Sundance film festival to critical acclaim.

A different example of DIY is Hal Hartley's feature *Ned Rifle* (2014). Hartley is very familiar with no-budget filmmaking; he started his career with the low-budget films *The Unbelievable Truth* (1988) and *Trust* (1990), which got him noticed at Sundance and praised by critics, and which opened the door to bigger films and budgets. Hartley had already started using digital video (MiniDV) in 1998, on his feature *The Book of Life*. His career steadily grew throughout the 1990s, culminating with the feature *Henry Fool* (1997), for which he won the Best Screenplay Award at the Cannes Film Festival and which went on to become his biggest commercial success. After that, Hal applied his unique, stylized, dialogue-driven, and often deliberately stilted style to a variety of genres, but his later efforts were not well received. In spite of these disappointments, Hartley did not waver in his aesthetic, and he continued making films in his trademark style. Finding it increasingly more difficult to get financing for his films, in 2011 he made a sixty-minute film, *Meanwhile*, which he crowdfunded through the Kickstarter crowdfunding platform, and self-released it on DVD. This was a test-run for the feature to follow, *Ned Rifle*, for which he raised the entire budget—$386,000—through Kickstarter.

FIGURE 5.2 Screen capture from the movie *Ned Rifle*, directed by Hal Hartley.[9]

While Hal Hartley is not a mainstream commercial filmmaker with a huge fan base, he has developed a devoted and sufficiently large set of followers over time. This allowed him to engage them through social media and rally them to give money in support of the making of the film. *Ned Rifle* premiered at the Toronto Film Festival in 2014, went on to other festivals, and was distributed through a limited theatrical release, booked directly by Hal Hartley's assistants. The film was also released through his own website, halhartley.com, and through a series of other online video-on-demand platforms. It is interesting to note that Hal owns the rights to all of his films— which is rare in the film business—and has been very involved and active in their distribution, even before web streaming and video-on-demand made this easier and more feasible. He also often composes the music for his films. For Hartley, although he is an established independent filmmaker, the DIY model offered the only opportunity to make and distribute the film the way he wanted, and to keep creative as well as financial control, which would have otherwise been impossible.

DIY models have become increasingly more essential for filmmakers who do not work within mainstream narrative conventions. Government-based funding in the United States for these types of films has withered. As younger audience tastes have moved away from art cinema, and traditional film financing sources are now looking almost exclusively for more conventional and commercial genres, it has been increasingly difficult for these filmmakers to create their work.

Shane Carruth, a software developer with an undergraduate math degree, wrote, directed, produced, acted, and composed the music for his first feature film, *Primer* (2004), which he made for $7,000. Although it was an unusual film about time travel, with an experimental story structure, philosophical discussions, and complex technical dialogue, it won the Grand Jury Prize at the Sundance Film Festival and garnered a cult following. After being named "someone to watch"[10] by the film industry, Carruth spent the next years trying to develop his next film in Hollywood, only to realize that no one had any real interest in the type of films he wanted to make.

Almost a decade later, in 2013, Carruth wrote, directed, produced, edited, composed the music for, designed, and starred in his second feature, *Upstream Color.* Arguably even more idiosyncratic than 2004's *Primer,* it explores identity through the stories of a man and a woman, who are connected through the life cycle of a mysterious organism and trying to

re-assemble their lost individualities. The film was made for an estimated $50,000,[11] and Carruth shot the film on a $2,000 Panasonic GH2 digital camera, creating exquisitely beautiful imagery. He self-distributed the film, which had a limited theatrical run, as well as on DVDs and through numerous online video-on-demand platforms. The film premiered at the 2013 Sundance film festival to wide critical acclaim. It made $415,000 at the US box office alone. To Carruth, it was important that he was able to control all the aspects of the film's release:

> It's been really satisfying to contextualize and craft and frame the way the audience will see this. . . . There's a way to approach this where you want to make as much money as possible. I get that. But I think if we're willing to just have some integrity and some earnestness, we get to do something better and something we can be proud of. It's a continuation of storytelling.[12]

For independent documentaries, the DIY model has become quite ubiquitous. It works on numerous levels and for various purposes—from Bennet Miller's *The Cruise* (1998), shot on MiniDV on basically no budget, to Laura Poitras' Oscar winning *Citizenfour* (2014) about whistleblower Edward Snowden, where the DIY model granted the filmmaker the liberty to work on a politically controversial story without mainstream interference or limitations. Over the past decade, there have been dozens of notable and

FIGURE 5.3 Screen capture from the movie *Upstream Color*, directed by Shane Carruth[13]

successful DIY documentaries. Documentaries have generally always had smaller budgets than fiction films; now with digital technology, they could be made for even less. They are dependent not on stars or celebrities— although a voice-over or cameo by a celebrity might help sell the film—but mostly on interesting stories, characters, and a competent execution.

The primary market for documentaries is not a theatrical release. It can help in terms of marketing and press coverage, but TV, DVD, and video-on-demand are usually the main distribution channels. Most of the DIY documentaries nowadays are financed through a combination of grants, crowdfunding, and personal investments. While independent art films have declined in popularity and mass appeal, independent documentaries have had a renaissance. Ever since the appearance of MiniDV in the mid-1990s, the number of independent documentaries being made has continually expanded. While it is presently still considered a more rewarding genre for no- or low-budget independents than fiction films, documentaries have also become an overcrowded field. Thousands—or even tens of thousands, if one includes short and online-only documentary videos—of productions compete for a few spots in the mainstream TV and video market. Even if they self-distribute, documentary filmmakers still have to fight for the audience's attention, facing the same problems as everyone else—a fragmented, distracted audience with too many choices.

It can be argued that every truly independent film is a DIY effort. As film producer Jim Stark points out: "Independent movies are DIY films. I have an idea, get the money and crew together to make that film. Then it's up to me to distribute it, sell it and have people see it."[14] If one agrees with this assessment, digital technology can be viewed as simply another step forward in making independent film production more accessible, which had started with the introduction of 16mm film cameras, cheaper technology, and easier access to it. This perspective can certainly be supported if one looks at the practices of earlier independents—such as Morris Engel, John Cassavetes, or the cinéma vérité documentary filmmakers—and compares them to contemporary filmmakers like Hal Hartley, Joe Swanberg, or Shane Carruth, who now work with digital video.

Many of these extremely low-budget independent films would have never been made without the advent of digital technology—or, even if they were made, would have had a much harder time reaching an audience. Mainstream distributors—and even specialized independent distribution

companies—nowadays consider these films too small in scope and size of audiences to be worthwhile investing time and energy into promoting, marketing, and distributing them. In that sense, the advantages of the DIY model appear to be obvious—not only can filmmakers now make high-quality looking films on small budgets; they can also distribute them more easily through a variety of online channels and platforms. The question that is harder to answer is whether DIY models can be more than individual methods and practices, and become long-term workable solutions and strategies in the digital online environment.

▶ CROWDFUNDING & CROWDSOURCING

The basic concept of online crowdfunding emerged in 2005, and its impact and popularity have grown substantially ever since. Crowdfunding is usually defined as a way of fundraising by asking for financial contributions from a large number of individuals through an Internet platform. Today there are numerous crowdfunding websites providing the infrastructure for this type of fundraising. Each of them has slightly different rules, although the basic principles are the same. There are four basic kinds of crowdfunding: reward-based crowdfunding, investment- or equity-based crowdfunding, donation-based crowdfunding, and lending through crowdfunding. Donation-based crowdfunding serves charitable giving, while lending is a peer-to-peer lending and borrowing platform. For film and media, the two most significant crowdfunding concepts are reward- and equity-based crowdfunding.

The reward-based crowdfunding model is generally the most common model for funding independent film and media projects. Individuals contributing their money to the project are doing so not because they expect to make a profit but to support the project or the creators. In return, they get a reward or token—for example, premier digital downloads of the project, a screen credit, some memorabilia, or an experience like one day on the set of the production. This has become a workable model, which not only helps independent media creators raise money but also aids the project in gaining more visibility. Crowdfunding a project creates a fan base and following; people who support the project become its core fans, spreading the word. Crowdfunding campaigns sometimes finance an entire project from development to distribution, but, more commonly, they fund certain stages of productions, whether it is development, actual production, or post-production and distribution.

Investment or equity-based crowdfunding relies on the same concept, allowing many investors to put money into a project. However, here the investors hope that, if the project is successful, they will get a profit return on their investments. This type of fundraising has become possible only after the passage of the Jumpstart Our Business Startups (JOBS) act in 2012 by the US Congress. Before that, Security and Exchange Commission (SEC) regulations prohibited public advertising in order to raise investments (so-called general solicitation), with complex and prohibitively expensive fundraising rules. Usually only large companies, listed with the stock exchange, could afford to follow these procedures. The initial purpose of these strict SEC regulations was to protect investors from possible fraud. However, it also limited how small and start-up enterprises could raise money, especially in the early stages of their business.

Equity crowdfunding had been approved initially for accredited investors only—individuals who have $1 million in net worth or make over $200,000 a year for at least three consecutive years, or for entities with over $5 million in assets. By adopting a set of new exemptions to the securities regulations in March 2015, the SEC expanded the JOBS act to also allow non-accredited investors to invest in equity crowdfunding. The implementation of these rules has been slow and fraught with opposing views from regulators and legislators. While equity crowdfunding is more complex than reward-based crowdfunding, it offers advantages to business models that expect growth and profit, and to their potential investors: "Imagine *Uber* or *AirBnb*, instead of going to big institutions for capital, now offering their stock directly to their drivers, riders, renters and tenants as well as the general public."[16]

One of the most popular reward-based crowdfunding websites, Kickstarter, was launched in 2009 in New York. With its stated mission to help crowdfund creative projects through an "all-or-nothing" model, it distinguished itself from other websites that would follow. By 2015 Kickstarter grew into a global crowdfunding platform, having received more than $2 billion in pledges from over ten million backers, successfully funding over ninety thousand projects in various disciplines. Contributions for film and video rank fourth, after games, technology, and design projects, with a total of over $300 million raised. Successfully funded film and video projects rank second, after music, totaling over twenty thousand (which is still only ca. 40 percent of all film and video projects listed on Kickstarter).[17]

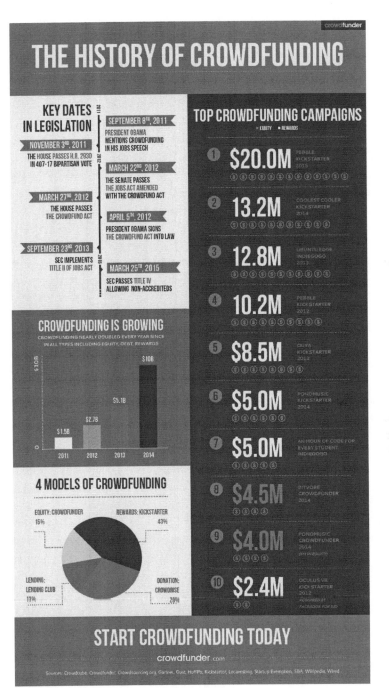

FIGURE 5.4 The history of crowdfunding[15]

Kickstarter project creators choose a funding period between one and sixty days and a funding goal. If the goal is not met by the deadline, all the pledged funds revert to the backers. Project creators design a project page on Kickstarter's website, with a video and project description, as well as the rewards the backers will receive, and continuously post updates about the further development of the project. As Kickstarter's website makes clear, the key for the creators is to set a realistic goal of how much money they think they can raise. This is closely related to how many people who will actually pledge money to support the project the creator can reach. Once the project is listed, it might spread further and attract new backers and followers, but most successful crowdfunding campaigns focus on "core fans" first. Film or media-makers that have cultivated a large following and a loyal fan base will clearly have an advantage, as well as projects that have a strong and clear social or community aspect, such as documentaries. Kickstarter takes a 5 percent fee from the total funds pledged, and the payment processor (in the United States, this is Amazon.com) another 3–5 percent fee.

The most common reasons why crowdfunding projects are not successful are that the filmmakers do not know their audience well, or do not invest enough time, energy, and resources in outreach and user engagement. Plastering messages randomly on Facebook or Twitter in the time of information overload does not help; on the contrary, it will most likely have the opposite effect, with users switching off their social media feeds. Crowd-based communication and fundraising used by independent film and media-makers has to be—or at least appear to be—leveled and genuine. Creators have to engage users and fans in a conversation, rather than one-way communication and feedback adulation, as is typically common with mass media celebrity worship and followings. Talking down to one's audience, or treating them as anonymous consumers, does not work in this environment. The other mistake creators can make is to overestimate their reach. This is why it is generally better to initially fundraise for one stage of a project rather than the entire production. If the campaign is successful, the filmmakers can raise much more than what they aimed for, sometimes many times over their initial funding goal.

Successful crowdfunding campaigns mostly run over a course of ca. thirty days, employing a few full-time staff members or volunteers throughout the campaign. They create compelling stories and reward tiers, with an extended preparation time and realistic primary goals. It is important not only how

much money is raised but also how many backers have pledged to the campaign. The backers become the principal fans of the project, which is also the first target audience. The creators can use these core fans to spread their message further and expand their reach through social media and targeted online marketing, without having to spend large amounts of money on advertising and promotion. Many observers, including Kickstarter's staff, attribute the success of this type of crowdfunding to its "all-or-nothing" model, which allows the creators to rally the supporters toward the deadline. Most contributions spike at the beginning of the campaign, and then again toward the deadline.

Other crowdfunding websites, such as Indiegogo or Rocketfuel offer creators the option to do "flexible" crowdfunding campaigns, without having to meet a specific fundraising target. This model allows project creators to keep whatever they are able to raise during their campaigns. While this makes the campaign less stressful for the creators, results have shown that these types of campaigns generally raise less money than the "all-or-nothing" ones.[18] This insight confirms that the psychological effect of having to meet a specific goal makes people more likely to support a project and contribute money. The websites' fees for flexible crowdfunding campaigns are also higher, usually charging 8–10 percent plus the payment processor's fee. While making such campaigns less tense and taxing, flexible fundraising also often makes them less rewarding.

Many crowdfunded films and projects have gone on to festivals, critical acclaim, and successful distribution. For example, documentary filmmaker Jennifer Fox raised $150,456 for the distribution of her documentary *My Reincarnation* (2012), shot over a period of twenty years, about the relationship between a Tibetan lama and his son, who live in Italy. Alison Klayman shot her DIY documentary on the famous Chinese dissident artist AiWei-Wei while living in China for next to nothing, then raised $52,175 for the film's post-production (*AiWeiWei Never Sorry* [2012]); the film played at Sundance and was released commercially. Husband-and-wife filmmaking team Sara Nodjoumi and Till Schauder did two campaigns for their documentary, *The Iran Job* (2012), about a US professional basketball player playing a season in Iran and becoming part of a social revolution. In early 2012 they raised $100,466 to finish the film, and another $66,105 in the fall using a second Kickstarter campaign in order to put the film into distribution. Hal Hartley raised $56,433 for his film *Meanwhile* (2012) and $395,292 for his feature *Ned Rifle* (2014). Popular YouTube filmmaker, gamer, and

visual effects artists Freddie Wong raised $273,725 for his *Video Game High School* web series in 2011, and $808,341 for its second season in 2014. The transmedia project and web series *The Lizzie Bennet Diaries* (2013) by Hank Green and Bernie Su raised $462,405 for the series' DVD release; the initial goal of the campaign was $60,000, but the popularity of the series topped the initial funding goal by 770 percent.[19]

When it initially appeared, crowdfunding was scoffed upon by the industry as a tool for amateurs only. No "serious" filmmaker would dare to mention crowdfunding as a viable option to finance his or her film. With the rapid success of crowdfunding, all that changed, and accomplished professionals, even celebrities, started using crowdfunding to finance their projects. This generated substantial controversies, as these creators were industry insiders and had access to other sources of financing not available to most independent filmmakers using Kickstarter or Indiegogo. Second, these campaigns were funded in the millions of dollars by thousands of backers, and due to the celebrity names attached to them the projects would have significant commercial distribution. This would generate millions of dollars in revenue for the project creators, while the backers would get only a DVD or a sticker for the money they put into it. Finally, there was significant concern that these types of projects would distract backers from other smaller independent campaigns, which truly depended on crowdfunding.

Using Kickstarter, actor and filmmaker Zach Braff raised $3,105,473 from 46,520 backers for his feature *Wish I Was Here* (2014); Rob Thomas raised $5,702,153 from 91,585 backers to make his feature film *Veronica Mars* (2014), based on the same TV series he wrote from 2004–2007; while Spike Lee raised $1,418,910 from 6,421 backers for his film *Da Sweet Blood of Jesus* (2014). The backlash in the media to these crowdfunding campaigns prompted Kickstarter to defend itself. On their blog, Kickstarter staff wrote that these projects "brought thousands of new people to Kickstarter who have since pledged more than $1 million to 6,000 other projects (film projects have received most of those pledges)."[20] In other words, Kickstarter claims that celebrity or industry player-backed projects are actually beneficial—they do not take away from other filmmakers but actually bring new potential backers to the website. The debate over this has not been settled, however, and, as more and more creators turn to crowdfunding to raise money for their projects, it remains to be seen how it will develop further (as an interesting side note, celebrity actor James Franco did not manage to

reach his $500,000 crowdfunding goal on Indiegogo for his film *Palo Alto Stories*, raising only $325,929).[21]

Kickstarter's basic argument in support of industry insiders using the crowdfunding site is that their model represents a type of patronage given to the artists, and it is not relevant whether the artist is already famous or not. The more troubling, less discussed issue here, however, is the financial rewards for backers on these projects. Kickstarter again defends this type of fundraising practice, stating, "backers are supporting Spike [Lee] not to buy into the potential profits of the film, but because they connect with his body of work."[22]

This might be true, but it is questionable how many backers actually fully understand the entire concept: that they are making it possible for Spike Lee or Zach Braff to make a film without owing any money to investors, and that Braff and Lee are able to keep all profits from the films for themselves. In any other traditional film financing structure, this would not be possible. Another potentially troubling question is whether these creators really choose crowdfunding because they cannot get any financing from traditional industry sources for these particular projects, or because, for them, it is actually a more profitable way to make a film.

Contentious examples of similar crowdfunding practices can also be found in Kickstarter's Gaming, Design, and Technology categories. Probably the most controversial is the case of *Oculus Rift*, a virtual reality headset, which raised $2,437,429 from 9,522 backers for its development on Kickstarter in 2012 (its initial goal was only to raise $250,000).[23] The backers would receive various prototype kits for the headsets and games in return. On March 25, 2014, Facebook announced that it had acquired Oculus Rift for $2 billion. The early Kickstarter backers of Oculus Rift did not get any of those profits.[24]

The Oculus Rift example has prompted many observers to comment that a more appropriate type of crowdfunding for these, more commercial, types of projects would be equity- or investment-based crowdfunding. This could also be applied to established commercial filmmakers and their media projects, at least as an option. Only then would it actually be feasible to see how many backers would really opt for reward-based funding instead of profit-based investment. It would also allow for more transparency into why these filmmakers use crowdfunding in the first place. The hope remains that

these controversies and the constant expansion of more and more projects using crowdfunding will not eventually render the practice unusable. If the somewhat unruly expansion of different crowdfunding models can be better structured and organized in the future, it can continue to grow as an important fundraising and audience-building tool for independent media-makers.

The basic idea behind crowdfunding is the concept of "crowdsourcing." Crowdsourcing essentially means obtaining something by soliciting contributions from a large group of people rather than a specialized service provider or supplier. In this context, crowdfunding is defined as a form of crowdsourcing—crowdsourcing funds online. However, other things can be crowdsourced as well, such as services, ideas, or content. It is an ideal strategy in order to engage an audience with a project and to build a loyal following, fan base, and community. Although crowdsourcing has been used in some forms long before the invention of the Internet and social media, these technologies have made it exceptionally effective.

Trans- or cross-media projects, spanning multiple media platforms, often rely on the use of crowdsourcing. Serialized projects frequently engage viewers to participate, comment, and contribute to their next installments. Sometimes different tasks are crowdsourced, such as the design of a particular element, or ideas for a character or plot point in a story. Interactive elements, such as viewer or user feedback to a story or character, can be incorporated into the next episode or plot development of the next installment of a series or film. The film parodies *Iron Sky* (2012) and its 2016 sequel both use crowdfunding and crowdsourcing to fund the films and create the look and design of their far-fetched story-worlds.

Other projects utilizing crowdsourcing include *The Cosmonaut* (Nicolas Alcala, 2013), a crowdfunded and crowdsourced science-fiction feature film and transmedia project; *Life in a Day* (2011) by Kevin Macdonald, a ninety-five-minute documentary showing events around the world occurring on the same day, selected from eighty thousand video clips submitted to YouTube; *Star Wars Uncut* (Casey Pugh, 2010), a shot-by-shot recreation of the 1977 original *Star Wars* movie, consisting of 473 fifteen-second segments, which were created and submitted online by fans, as well as many YouTube channels and web series. Seed&Spark, a website created by Emily Best in 2012, incorporates both crowdfunding and crowdsourcing concepts with online distribution. The platform shows potential backers a budget based on what items and services are needed at what cost to

create a production, and it allows backers to buy or donate these items or services. Instead of just donating money, backers can, for example, donate a prop, a camera, or their editing services. If a campaign is successfully funded, films are shown to the backers for free in the platform's video stream section.

Crowdfunding and crowdsourcing are often cited as examples of a new "shared" economy and creative experience. A lot of people collaborate, comment, and contribute to a project, instead of one creator controlling all of its aspects. This raises many exciting new—and also challenging—prospects. The exchange between the initial project creator and the funders and collaborators is not primarily based on money; instead, various other awards are offered, and the collaboration succeeds if it is a mutually satisfactory, shared experience. In order for this to happen, the creator has to give up control over many aspects of the project to his or her collaborators and core audiences. However, if there are no guidelines and no one to maintain a central vision, the whole enterprise can easily disintegrate into chaos. The models of "sharing" between the initial creator, core fans, and collaborators can vary and will, no doubt, continue to develop further, but it is important to acknowledge these new models as essential principles for new and emerging media practices.

▶ CROSS-DISTRIBUTION MODELS

Traditional film distribution models generally operate with the terms "distribution rights," "territories," and "release windows." Distribution rights usually refer to the exclusive right to distribute a film on the major media platforms, which are considered to be theatrical releases, video-on-demand, DVD, broadcast and pay TV, and the Internet; smaller, or ancillary, rights include non-theatrical screenings and educational use. For example, a distributor might take "all rights" to a film, meaning it could distribute a film in all media—this is often the case with bigger distributors, such as the studios or the "mini-majors"—but it could also choose to distribute a film only in certain media, like pay TV and video-on-demand.

What rights a distributor will be interested in will depend on what it perceives to be the commercial value of a film. The film's initial reception, either at film festivals, or through screenings to test audiences, as well as other market and audience research, usually measures the potential demand for

a film. For a bigger release, the distributor is generally expected to pay for publicity and advertising, as well as expenses for theaters, screenings, etc. There are no set rules to how much money a distributor will pay for the rights to distribute a film; it will depend on whether the film has any stars, and what the perceived market demand for the particular type of film is at any given time.

The amount being offered by the distributor might not cover the budget of the entire production of a movie. If so, the producer will have to decide whether to accept such an offer anyway (if there are no other offers), to hold out for a better bid, or to self-distribute the film. Sometimes a distributor might acquire a film but decide that it is not worthwhile to advertise and promote it. In these cases, the distributor might just "dump" the film to a lower-tier straight-to-video release or something similar in order not to incur any further costs. Despite all projections and market and audience research, there are no guarantees a film will perform well at the box office, even if it has major stars, or was well received critically. The film business has generally been, and remains, highly speculative, risky, and, when compared to other forms of business, quite uncertain.

Territories usually refer to the geographical territories where the film is being sold—for example, the United States, Japan, Germany, France, China, etc. Based on the size of the market, the industry usually splits territories into "North American" (US and Canada) and "International," lumping together the rest of the world. These two zones are considered roughly equal in terms of distribution revenue, although many films perform better in some countries than others, depending on subject matter and audience tastes. The international market has become increasingly important for Hollywood, as many Hollywood movies now manage to break even or earn a profit in these markets. Spectacle-driven Hollywood movies are especially popular in emergent foreign theatrical markets, such as China. China also has quotas on importing foreign films, which are dominated by the Hollywood studios. It is common for independent films to go unsold in big media markets, such as Germany, the UK, France, Italy, Japan, etc., where competition from locally made films and Hollywood dominance are cutting down on the need for US independent films. Films that have major film festival recognition, critical praise, and a distinguished actor or director attached can still sell in some of these markets, but the price they will get will vary widely, from a few thousand to tens or hundreds of thousands of dollars per sale.

Release windows is a distribution strategy that was introduced in the 1980s with the rise of home video and cable TV in order to maximize the profit of releasing the film in different media at different times. It also prevents competition between the releases of the same film on different media channels. Typically, a movie would first be released theatrically (the "theatrical window"), then, after a few months, on Blu-Ray and DVD ("video window"), followed by video-on-demand and pay TV (cable TV), and lastly finishing with a broadcast TV release. While the studios' major blockbusters still follow this distribution pattern, many films are now being released using various different timetables.

Today, most independents, and even smaller studio-backed films, are released simultaneously in theaters and on premium VOD channels. In the industry, this practice has been termed "collapsing the release windows."[25] Its purpose is to maximize the publicity efforts during the theatrical release and make the film available to audiences who might not be able to see the film in the limited amounts of theaters where it is showing. By the time the film becomes available on other media platforms, which, following the traditional model, would be a few months later, the audience would have moved on, being able to choose from the oversupply of content they are now being offered.

Sales and distribution have generally been the bottleneck for independent filmmakers. Of the many films being produced, only a few would get substantial offers from the studios' specialty divisions or independent distributors. Unless a film has major stars and/or has won the Sundance or Cannes film festivals, it would generally be unthinkable nowadays for it to be picked up by a major distributor, receive a substantial amount of money, and get a relatively wide release. Occasionally, a major distributor might still pick up a "small" independent film straight from Sundance or another acclaimed festival in the hope that it will become the next breakaway hit. The payments they offer to the filmmakers, however, have generally declined, compared to the 1990s and early 2000s.

For independent producers, if they are able to "package" and pre-sell a film, they can take a lesser risk and have better chances to make a profit. While a pre-sale provides some distribution guarantees, it also serves the purpose to finance the actual production of the movie. The most common way to pre-sell a film is to sell the international rights to sales companies, who specialize in international sales. These sales companies then license the various

rights to distributors and broadcasters in individual countries. International pre-sales are more common than US pre-sales, as the sales prices can be more accurately estimated (the "sales projections"). The producer would still keep the US distribution rights to the film, which is where the filmmakers might make a profit later, if the film sells well. The "package" generally has to include a script that is considered to have commercial potential (for example, based on a bestselling novel), one or more known movie stars, and a director with a track record.

A variation of this practice is called a "negative pick-up deal." Based on the package, the distributor contractually agrees to buy all the rights to the movie from the producer for a fixed sum of money, once it is completed. With that guarantee, the producer then usually finances the production by borrowing money from a bank or other lender against the value of the negative pick-up agreement. Pre-sales and negative pick-up deals are two common ways in which most higher-budget independent, or specialty, films are being financed and produced. Clearly, these practices are more common for high-profile films and experienced filmmakers and producers, and not for novices and industry outsiders, who usually lack access to top agents and celebrities.

Many—or, more accurately, most—independent films get into production without having any distribution deal on hand. Even if they feature a recognizable actor or director, and even if they are within a commercial genre, they are usually considered too big of a risk by the industry to commit to distribution up front. Instead, distributors will wait until the film is finished and see how it plays in front of an audience or critics first—thereby putting the burden on the filmmakers to prove that the film has an audience and can in fact make money. A handful of independent films become huge success stories every year, triggering bidding wars between distributors at Sundance, but the majority struggle to find ways to get distributed and released. This is not surprising if one considers the sheer amount of independent films being produced each year in the United States. In 1993, the Sundance Film Festival had 250 feature film submissions; in 2015 it had received 12,218 submissions (4,057 features and 8,161 shorts).[26]

Common strategies for independent filmmakers to release their films also include "service deals" and self-distribution strategies. In both cases, the filmmakers themselves control and finance the distribution. The difference is that in the service model, a distribution company, a "booker," or a

consultant gets hired to coordinate and manage the release, while, in the second case, the filmmakers do it themselves. The advantages of these models are that the filmmakers are in control of everything, including release plans, schedules, expenses, and revenues. They can reach their audiences directly and are able to be more flexible with their release strategies than a distributor would be. The disadvantages of self-distribution and service-deals are that they are costly and time-consuming. Filmmakers need to have—or raise—substantial funds for marketing and publicity, theater rentals, video master deliverables, etc. Until the advent of digital technology and online streaming, this was an arduous process, involving 35mm film prints and DVD manufacturing—but this has changed dramatically over the past decade.

Filmmakers nowadays have various new tools at their disposal, allowing them to distribute their films directly to viewers. They can sell the film through various online aggregator and subscription services, as well as their own online platforms, while still being able to release it through more traditional means and channels as well (theatrical, DVD, TV, etc.). Described as cross-distribution or hybrid distribution models, many independent feature films combine these methods in order to create customized release plans and strategies that best fit each film's content and target audience. For example, filmmakers might work with a service company to do a small theatrical release in several major cities in order to get reviews in newspapers and magazines. Theatrical releases for small independent films are generally expensive and do not lead to much revenue but provide publicity for the film. Alongside the theatrical release, and using the publicity it generates, the film can appear on premium cable TV, video-on-demand, and some prime streaming websites. Gradually, the video-on-demand can expand to more online platforms, using social media and blogs to continue building the film's audience and its reach. The filmmakers can simultaneously sell the film directly through their own website for streaming or download and/or offer additional perks, like original material, related to the film.

Online streaming and social media have certainly opened extraordinary new possibilities for filmmakers to distribute their work, but, while some commentators have hailed this as an unprecedented time that will solve all distribution issues for independent film- and media-makers, it still does not mean that every film will find an audience. The oversupply of content, in terms of both online streaming and social media communication overload,

has once again put the burden on the filmmakers to find ways to reach and grow their audiences. Expecting that a film will become a success just by posting it online is like throwing a message in a bottle into the middle of the ocean in the hope that someone will read it.

Examples of successful cross-distribution strategies include the afore-mentioned films *Ned Rifle* (2014) and *Upstream Color* (2013), where the filmmakers used a combination of theatrical releases, video-on-demand and various streaming services to maximize audience reach and revenues. Many documentaries have used such distribution models and strategies as well: *AiWeiWei Never Sorry* (2012); *My Reincarnation* (2012); Marshall Curry's Oscar-nominated *Street Fight* (2005), about the fraught 2002 mayoral election in Newark, NJ; *Exit through the Gift Shop* (2010), by and about the famous and elusive street artist Banksy; *Don't Think I've Forgot-ten* (2014), retracing Cambodia's music scene against the backdrop of the genocidal Khmer Rouge; *The Yes Men Are Revolting* (2014), another film in the "Yes Men" series, made by the activist comedy duo in order to highlight contemporary problems and corporate greed; and many others. In all of these examples—whether working with their own teams or using various consultants and service providers—the filmmakers had complete control over the distribution process.

FIGURE 5.5 Screen capture from the movie *Exit through the Gift Shop,* directed by Banksy[27]

Some films choose individual and unique approaches. Such is the case with *For Lovers Only* (2011), a simple romance inspired by 1960s French new-wave films, shot on no budget over twelve days in black-and-white, with a Canon 5D digital camera. After playing it at a small festival, the filmmakers put the film on iTunes and marketed it only through Facebook and Twitter. The lead actress, Stana Katic, known for some big Hollywood movies and TV series (the James Bond movie *Quantum of Solace* [2008]; *Castle* [2009]) alerted her five hundred thousand Twitter followers to the film. Within a few weeks the film surpassed $100,000 in sales on iTunes alone. After spreading to other online platforms, the film eventually grossed over half a million dollars, without ever having a theatrical release or significant festival play.

Online-only distribution is especially effective for special-interest topics: motivational, religious, politics, sports, and utilitarian topics, which have some practical use for the viewer, are able to make substantial revenues this way. A sports documentary like *We Are Blood* (2015), which follows skateboarders around the world, became one of the top-selling films on iTunes without a big marketing and advertising campaign, or any theatrical or festival play. Examining the bestselling lists of iTunes or Amazon streaming and downloads, one will find many titles that most people have never heard of—specific topics, playing to very particular audiences. These films do not need to spread their marketing efforts to a broader, more general public as they have clearly and easily defined niche audiences that they cater to: skateboarders, golfers, pilots, hobbyists, etc.

Journalist Robert Greenwald and his company Brave New Films had created a distinctive model by fundraising from donors through the website moveon.org, and delivering politically engaged films to them, even before streaming became ubiquitous. Arguably, these films are more activist than documentary, as they advocate specific liberal points of view from the political left: *War on Whistleblowers* (2015), *Koch Brothers Exposed* (2014), *Iraq for Sale: The War Profiteers* (2006), etc. On the right, a similar, reciprocal, approach has been used to make and distribute conservative political agenda films, catering to the views and predisposition of its viewers: *America: Imagine the World without Her* (2014), *2016: Obama's America* (2012), *Michael Moore Hates America* (2004), etc. The list of specialized topics, from food and dieting to yoga and exercising, is too long to elaborate here. From a business perspective, these are the most lucrative genres for independent producers, lending themselves well to integrating social media marketing, video streaming, product placement, and sales. Online

platforms, along with direct sales tools and new media, are ideal instruments for these endeavors. They allow the producers to eliminate the need for intermediaries. Now the creators can reach their audience directly and retain complete control over the production, distribution, and revenue creation and collection.

The decline of the DVD market has greatly altered the landscape of film distribution. It has significantly diminished revenues from video rentals and sales, which still have not been offset by video-on-demand and online streaming. As Roger Jackson, co-founder of the streaming service Kino-Nation, notes: "VoD is, in the short term, not going to pick up the slack that has been lost on the DVD sales side. . . . [T]he question that gets asked all the time is, is Video on Demand going to provide a viable income stream for filmmakers, so they can actually make a living out of making movies? The answer is yes, for some, but no for most. We are living in a world of an over-abundance of supply, so it's very difficult to hit the home run . . . but not impossible."[28]

Video-on-demand and online streaming platforms are usually divided into "transactional" and subscription-based. In a transactional model, the viewer pays a set price to stream the film, or to download and own it (iTunes, Amazon on Demand, pay-per-view cable, etc.). In the subscription model, the viewer pays a monthly subscription fee to access the available content on the service (Netflix, Hulu, Amazon Prime, etc.) As these channels and platforms have proliferated, they have increasingly become less likely to purchase single films from individual producers; rather, they buy multiple films at once. Thus, a new distribution entity has emerged, called "aggregators." These services or companies aggregate content from a multitude of producers and encode and deliver that content to the various streaming platforms.

Some aggregators are selective about the content they choose. They work more like traditional distributors and have specific deals and arrangements with various platforms. They usually strategize timing and release plans on different channels, according to exclusivity and audience reach, and take a percentage from each sale. Other aggregators serve more as a film collection and distribution hub only, providing a service for a fixed fee. They encode and spread the content to the various streaming platforms for that fee and do not take additional percentages from each sale. They usually do not have exclusive contractual arrangements with the platforms, so their

reach is generally more limited. Filmmakers can choose to release their films still through various windows, territory by territory, or all at once—globally.

In theory, filmmakers can use these services to sell their films and social media to market them, and completely bypass traditional distribution methods and companies. Compared to traditional distribution (theatrical, DVD, etc.), VOD and streaming are much more cost-effective: After paying the initial digital encoding fees, there are no manufacturing and shipping costs. The use of social media for marketing is also much cheaper than traditional advertising and can engage millions of potential viewers in a flash. While this is true for filmmakers and films that already have a following or a clearly defined target audience, which they know how to reach—as in the examples above—it is much harder for novices without a loyal fan base or clear objective.

In 2010, the Sundance Film Festival attempted a non-exclusive distribution experiment with YouTube, which made five small independent feature films available for rental at the same time as the films were playing at the festival. The idea was to use the films' festival exposure and publicity and then allow a worldwide audience to see these films for $3.99 immediately. The results were highly disappointing: the films managed to generate a total of only 240 to 300 rentals each, prompting Sundance and YouTube to abandon the idea.[29] Other tryouts, using similar traditional transactional distribution methods in the new online environment, did not fare much better. Many online platforms and services that were hailed as new solutions for online independent distribution quickly crashed and failed (Babelgum, Dynamo player, Neoflix, KoldCast, etc.). It still remains to be seen how other existing services—such as Vimeo-on-demand, Distrify, VHX, Kino-Nation, or Indiegogo distribution—will perform in the long run.

Much has been written about the fact that the online environment has changed users' habits and expectations. Audiences increasingly want their content for less money, or for free. This issue has already deeply affected other media, such as publishing and music, causing steep declines in incomes and changes in production practices. Popular music streaming services, such as Pandora or Spotify, allow users to listen to music for free or for low subscription fees. Artists, who have their music on these services, receive diminishing returns for that allowance—even if they have millions of streams, in the end they will receive only what amounts to 0.01 cent for each stream.[30] For musicians, their recorded songs and music videos have

become mostly promotional tools, replaced by concert performances as main revenue generators. Even so, it is contested to what extent these practices can generate livable incomes for most artists.[31] As bandwidths grow and online video proliferates, these monetizing problems are increasingly spreading to the film and video business.

VOD and streaming are fields that are highly unstable and in flux, with many practices, services, and companies emerging and disappearing within the timespan of a few years or less. It is almost certain that online streaming will continue to develop and spread; it is already on its way to becoming the dominant mode of film distribution. However, it is essential for filmmakers to be informed of the current distribution situation and practices at the time of their production, as these realities change with staggering speed. Present practices will be different by the next year. This is a time of transition and significant changes in media production, so it is also important to keep an open mind to alternative methods and approaches. As will be discussed later, some independent filmmakers have disrupted the distribution process even further, by giving their films away for free and making money in other ways.

Before using online distribution and marketing tools, much like with crowd-funding and crowdsourcing platforms, filmmakers have to define their goals in relation to the content they want to produce and the audience they want to reach. Not every independent film has to make tons of money, nor does every film have to aspire to be a work of art, but one should not think about digital and online tools being in a vacuum—in other words, unrelated to what the film is about. Comedy that relates to millennials can have millions of views and downloads, but an experimental art film is unlikely to achieve the same result. Does that mean experimental art films should never be made? A Hollywood executive might think so, but that is exactly why independent filmmaking exists. Tools like Kickstarter, Indiegogo, social media, Vimeo, iTunes, VHX, etc. empower the independent filmmaker, but they are still only tools. The filmmakers are the ones who have to conceptualize how they will use them, why, and to what purpose.

▶ WEB VIDEOS & ONLINE STARS

Short films have existed for as long as cinema itself, but before the appearance of online video channels, they did not have a platform for wide distribution or a commercial market. Traditionally, short films were to features what

short stories are to novels; in terms of content, they operate within the same genres (fiction, documentary, experimental, etc.) and storytelling conventions, limited only by length (anywhere between one and thirty minutes). The short form usually dictates a simpler storyline with fewer characters and only one main story arc, which, much like in a written short story, often ends with a twist or surprise.

Short films are generally screened at film festivals, serve as learning tools for film students, and sometimes end up in collections and anthologies. There have been attempts to distribute them commercially, but, because of their short format, they did not lend themselves well to such endeavors. Short films could be packaged either into an "omnibus series" of several shorts, which never quite managed to attract an audience, or, more commonly, as intermission "fillers" on TV, in-between the main programs. Arguably, the short-film form has now become the dominant format in the world of online streaming video. Though contemporary young creators and audiences have altered some of its formal features, the intimate connection between web videos, short films, and independent filmmaking is quite evident.[32]

A variety of online video platforms appeared in 2005, including MySpace, iTunes, Blip, Dailymotion, Metacafe, etc. By 2010, YouTube had established itself as the undisputed leader in the field: "[YouTube was] reaching nearly three times as many users as the next biggest video destination, Yahoo; and when you count total videos served, the company was 14 times bigger than the next on the list, Hulu."[33] Online video, in its beginning, was mostly amateur, home-video-style, user-generated content, dominated by shaky, slightly out-of-focus shots of babies stumbling, cats behaving strangely, etc.—much in the vein of *America's Funniest Home Videos.*

While funny homemade videos still exist on YouTube, the majority of the platform's content has changed remarkably, expanding to a variety of forms from original content to mash-up and remix videos, along with some pirated programs. YouTube has become the ubiquitous first stop in the search for any online video subject. From the independent filmmaker's perspective, it has opened a whole new way of producing content and reaching an audience. This content primarily caters to young audiences; the creators use hybrid forms, usually one- to seven-minute-long serialized videos, featuring genre or comedy fiction, documentary-style "reality videos," or a young, engaging host, talking directly to the audience about topics and issues they share. One of the key aspects of success on YouTube is the sense of "community"

and familiarity between the YouTube stars and their audiences. Mainstream media stardom is based on a mass audience worshiping a remote celebrity's carefully crafted image, while an online star's appeal is based on familiarity and closeness with the audience: "Stardom used to be predicated on a mystique derived from scarcity; you don't really know much about George Clooney."[34] The teen-age beauty vlogger (video blogger) Bethany Mota, on the other hand, speaking at VidCon (YouTube's gathering of creators and fans), referred to her legion of subscribers as "six million best friends that are all around the world!"[35]

YouTube creators usually have their own channels where they post content. Viewers can subscribe to the channels and get updates as new videos become available. While the videos are free, the creators receive revenue from YouTube ads, as well as other sources, such as corporate and brand sponsorships, and merchandise sales. By 2014, hundreds of YouTube channels had surpassed a million subscribers each.[36] Many of the YouTube creators were making tens or hundreds of thousands of dollars per year, with the top YouTube stars crossing into the millions. In 2014, the number-one YouTube star was Swedish gamer PewDiePie, whose viewers can watch him as he plays and comments on video games. He has close to forty million subscribers, and makes over $4 million per year from ad revenues alone.[37]

Many in the mainstream media industry were caught by surprise by the results of a 2014 survey, commissioned by the trade magazine *Variety*; the goal of the survey was to find out who the most influential media celebrities were among the industry's prime consumer target group—Americans ages thirteen to eighteen. They found that the top five stars were not film or TV celebrities but YouTube stars. The comedy duos Smosh and The Fine Brothers ranked number one and two respectively, followed by PewDiePie. There were only four non-YouTube stars among the top ten: the actors Paul Walker (who tragically died in a car accident [the first non-YouTuber at number six]), Jennifer Lawrence, Katy Perry, and Steve Carell.[38]

Another YouTube creator of note is Freddie Wong. Wong attended film school at the University of Southern California and gained filmmaking experience by working on straight-to-video or cable TV genre films. Together with his friends, he started making short videos, combining video game themes, martial arts spoofs, and special effects, and posting them on YouTube. His YouTube channel, FreddieW, soon had millions of views. As Wong states in an interview with business magazine *Fast Company*: "From

the beginning the thought wasn't, 'Hey! This is going to get us boatloads of money!' The thought was, 'Hey! Here's a space where we as directors and creative people can do our thing without worrying about the various others concerns of filmmaking . . . we are going to be able to sustain ourselves.' "[39]

Together with his partners Desmond Dolly and Matt Arnold, Wong decided to expand to serialized, longer-form content, forming the production company RocketJump in 2011 and raising $273,000 on Kickstarter for their web series *Video Game High School*. The initial show's run was followed by two more seasons, with $808,000 and $898,000 support from Kickstarter fans respectively. The RocketJump YouTube channel has over 7.5 million subscribers, and most of their main videos garner millions of views. Wong's success has led to offers from the online platform Hulu to develop an original show for them, as well as a partnership with the studio Lionsgate for a "multi-year film, television and digital content alliance."[40]

As the popularity and reach of YouTube creators spread, YouTube opened more resources to them—from creating real-life gatherings for fans, like VidCon, to opening studio facilities in LA and New York. Multichannel networks (MCN) emerged, aggregating YouTube channels in order to increase their ad revenues, while Hollywood agencies started signing up successful YouTubers to represent them. Brands and companies began courting YouTube "personalities" for endorsements, while marketing and ad agencies introduced new liaisons, whose job was to mediate between brands and these online "influencers."

The big media conglomerates were initially slow to realize the commercial potential of this new world. Google acquired YouTube in 2006, for $1.6 billion. While the conglomerates saw YouTube primarily as a repository of home videos with small ad revenues (at least compared to TV), YouTube grew at an exponential rate, in terms of both content and commercial potential. Another newer platform, Vine, established in 2013, quickly became popular among its young users but was acquired by Twitter before the conglomerates could even react. Generally, technology companies have responded faster to new media forms and young audiences' tastes and needs than the big media conglomerates. To compensate, the conglomerates started buying the multichannel networks—Disney bought Maker Studios for over half a billion dollars, DreamWorks Animation bought AwesomenessTV for $107 million, while AT&T and the Chernin Group bought a majority stake in Fullscreen for more than $200 million.[41]

While YouTube, along with other online platforms and various new upstarts and services, are charting new ground, the media conglomerates are mostly looking at YouTube "personalities" and channels that already have mass followings as possible "scalable properties"—meaning, they are trying to transition or connect them to more traditional forms, such as film and television. Given the different nature of audience interaction and media consumption in these distinctive environments, it remains to be seen how successful such transitions would be. Many YouTube celebrities are keenly aware that they depend on the trust of their young audience, and that a more programmed and calculated appearance in mainstream media might damage that trust. Celebrity brand strategist Jeetendr Sehdev, who conducted the 2014 *Variety* survey among teenagers, observed: "If YouTube stars are swallowed by Hollywood, they are in danger of becoming less authentic versions of themselves, and teenagers will be able to pick up on that. That could take away the one thing that makes YouTube stars so appealing."[42]

Now over a decade old—which, in the terms of technology and Internet media time, is equivalent to being ancient—and having a massive audience, YouTube is still the dominant online media platform. However, since 2013, new contenders have started to compete with it—primarily Facebook, but also Vine, Instagram, WeChat, and other emerging services. In 2014, Facebook was already delivering ca. 40 percent of YouTube's video volume to an audience equivalent to 57 percent of YouTube's users.[43] This becomes even more significant when one considers that this data measures only "desktop views," and not mobile, where Facebook claims to have more video views than YouTube.[44]

With its established architecture, sheer size in numbers of creators, massive audiences, and multi-channel networks, YouTube has been constantly expanding its reach toward brands and advertisers. Looking only at the numbers, we see that television still dominates over the online platforms in terms of traditional advertising revenues. In 2014, YouTube made ca. $3.4 billion from advertising, while CBS alone earned close to $9 billion from ad revenues.[45] However, this view is limiting, since it acknowledges only how much money was spent on ads, and not how many viewers actually watched the ads or how much impact they had. Newer technologies from DVRs to ad blockers make it easier than ever for viewers to skip advertising, especially within the younger demographics, which most advertisers are trying to reach: "everybody zaps past the ads, and kids don't watch TV anymore.... [I]ndeed, Nielsen reports that, while people over sixty-five watch about forty-seven hours of television a week, most teens watch only about nineteen."[46]

YouTube and online personalities and channels offer other opportunities for advertising, from "branded content" to product endorsements and sponsorships, where the brands become an integral part of an online channel or show. New advertising and marketing agencies specializing in branded content have appeared, connecting brands with hundreds or thousands of creators in a more targeted and systemic way (for example, Grapevine, Campfire, Mozaic Branding, etc.).[47] Most other big advertising agencies, such as Saatchi and Saatchi or Ogilvy and Mather, have started specialty divisions, focusing on developing branded content and connecting to online creators. While big advertisers have generally been slow to adjust to these new, individual, and targeted methods, still preferring to reach a mass audience with a thirty-second TV spot during a big event like the Super Bowl, companies targeting specific market groups—especially young consumers—adjusted to these new realities much faster.

Current YouTube competitors' advantages are not in the quality of the videos or numbers of users, but mostly that they are more mobile-centered, with shorter content, which is more convenient for social media sharing. The video sharing service Vine was initially intended as a "lifecasting" tool, allowing users to make six-second-long videos of things they see and immediately send to other users. However, the service really became successful once it introduced a front-facing camera, allowing users to make and share videos of themselves. "Vine became a kind of mobile, social MTV, with a soundtrack of hits to rock out to or mock, and with kids as the stars."[48] What followed soon was the creation of "Vine celebrities": Cameron Dallas and Nash Grier aka Cam and Nash, Andrew Bachelor aka King Bach, Jerome Jarr, etc. They are followed by millions and spread their short, usually funny and self-depreciating, content from Vine, through Instagram, Snapchat, and YouTube. Wherever they physically appear, they are greeted by thousands of enthusiastic, screaming fans, reminiscent of early Beatlemania from the 1960s.[49] Both Vine and Instagram are services used mainly on mobile phones rather than laptops. While Vine videos automatically loop, Instagram's do not, and its recording time is fifteen seconds rather than six. Content on both services is obviously extremely short, must be shareable to be successful, and has to evoke responses from the community of over forty million (and growing) Vine and Instagram users.

Another slightly different service is Snapchat, where users broadcast themselves to their followers in ten-second videos, often creating a string of videos connected with text and still images to create longer stories. The feature

that makes Snapchat different is that all the content disappears after twenty-four hours, prompting users to check in every day in order to not miss out. Older services—such as Dailymotion, AOL, or MSN—also still stream videos, although they tend to target a more mature audience. Other platforms—such as Twitter, WhatsApp, and LinkedIn—are expected to move more and more into the video streaming field as well. All these services, along with Facebook, are considered social media applications first rather than video streaming platforms. However, the ubiquity and popularity of online streaming, along with pictures and shorthand emoticons, is increasingly becoming the most common form of sharing and communication, primarily through mobile devices.

All these applications allow for active user engagement with content—from commenting, to re-sharing, or even re-purposing and remixing—but, of course, also severely limit what kind of content can be produced, both in terms of length and in terms of subject matter. Some stories just cannot fit into six or fifteen seconds. Many creators use a combination of these platforms and applications to tell compelling stories, using each medium for its primary strength—for example, a YouTube channel can stream a serialized show to a mass audience, while Twitter, Facebook, Snapchat, Instagram, and Vine allow for short-form updates, commentaries, user engagement, and building a fan following. Many of these strategies are employed in cross- or transmedia storytelling, which will be discussed in the following chapters.

Longer-form online content, which is closer to traditional film and TV, streams on websites like Netflix, Hulu, iTunes, or Amazon, which are trailed by an increasing number of new platforms. These platforms are spawned by TV channels and movie studios, which have finally realized that they need to expand into the online world, not just for marketing purposes and re-runs of their old TV shows, but for original programming. Many studies have documented how TV viewing habits are changing dramatically. Less than 50 percent of all viewers now watch TV during its scheduled broadcast, with that percentage shrinking as the audience gets younger. More than 80 percent of the young audience "binge watch" TV, watching a series' episodes back-to-back, streaming them on their laptops, tablets, or phones—or beaming content through their devices onto larger screens. Millennials and younger audiences are increasingly expecting to watch what they want, when they want it, and how they want it—not according to

broadcast schedules or distribution calendars. This is the trend not only in the US but worldwide.[50]

▶ NOTES

1 Kevin Ohannessian, "How Freddie Wong Went from Viral Videos to TV Shows," *Fast Co.Create*, July 2, 2015, http://www.fastcocreate.com/3047979/then-and-now/how-freddie-wong-went-from-viral-videos-to-tv-shows.

2 Owen Gleiberman, "'Paranormal Activity': A Marketing Campaign So Ingenious It's Scary," *Entertainment Weekly*, October 7, 2009, http://www.ew.com/article/2009/10/07/paranormal-activity-marketing-campaign.

3 Scott Macaulay, "Producer Jason Blum @SXSW: 'If I Had to Make Kicking and Screaming Today, I'd Make It for $50,000 . . . ,' " *Filmmaker Magazine*, March 12, 2014, http://filmmakermagazine.com/84952-producer-jason-blum-sxsw-if-i-had-to-make-kicking-and-screaming-today-id-make-it-for-50000/.

4 Figure 5.1. Digital image, Paranormal Activity—The Ghost Dimension Poster Author: BryanMartinez12354, accessed December 15, 2015, https://commons.wikimedia.org/wiki/File:Paranormal_Activity_The_ghost_dimension_Poster.jpg.

5 John Horn, "The Haunted History of 'Paranormal Activity,' " *Los Angeles Times*, September 20, 2009, http://articles.latimes.com/2009/sep/20/entertainment/ca-paranormal20.

6 Ibid.

7 Craig Lindsey, "On Culture: Are Indie Films Dead?" *newobserver.com*, January 24, 2015, http://www.newsobserver.com/entertainment/arts-culture/article10230821.html.

8 Peter Broderick, "A Film for a Song," *Filmmaker Magazine*, Winter 1993, accessed November 29, 2015, http://www.filmmakermagazine.com/archives/issues/winter1993/film_for_song.php#.VltOQMqrPMM.

9 Figure 5.2. *Ned Rifle*, dir. Hal Hartley, perf. Parker Posey, screen capture (United States: Hal Hartley, Possible films, 2014).

10 Brian Raftery, "Buckle Your Brainpan: The Primer Director Is Back With a New Film," *wired.com*, March 19, 2013, http://www.wired.com/2013/03/primer-shane-carruth/.

11 *Upstream Color* at Internet Movie Database, http://www.imdb.com/title/tt2084989/, April 26, 2016.

12 Sam Adams, "Shane Carruth on Self-Distributing Upstream Color and 'Life in the Pig Corral,'" *A.V. Club*, April 5, 2013, http://www.avclub.com/article/shane-carruth-on-self-distributing-iupstream-color-96097.

13 Figure 5.3. *Upstream Color*, dir. Shane Carruth, perf. Shane Carruth, Amy Seimetz, screen capture (United States: Shane Carruth, erbp, 2013).

14 Jim Stark, Interview by Author, July 26, 2015 New York: NY.

15 Figure 5.4. "The History of Crowdfunding," digital image, Crowdfunder, accessed January 11, 2016, https://www.crowdfunder.com/blog/wp-content/uploaded-files/History-of-Equity-Crowdfunding.pdf.

16 Kiran Lingam, "The Reg A+ Bombshell: $50M Unaccredited Equity Crowdfunding Title IV takes Center Stage," *Crowdfund Insider*, March 25, 2015, http://www.crowdfundinsider.com/2015/03/65007-the-reg-a-bombshell-50m-unaccredited-equity-crowdfunding-title-iv-takes-center-stage/.

17 "Kickstarter Stats," *Kickstarter*, last modified October 20, 2015, https://www.kickstarter.com/help/stats.

18 "Kickstarter Vs IndieGoGo: Choosing Your Crowdfunding Platform," *Crowdfunding Dojo*, last modified November 30, 2015, http://crowdfundingdojo.com/articles/kickstarter-vs-indiegogo-choosing-your-crowdfunding-platform.

19 Marama Whyte, "'Lizzie Bennet Diaries' DVD and Mini-series Kickstarter Raises $462,405," *Hypable*, April 23, 2013, http://www.hypable.com/lizzie-bennet-diaries-kickstarter-closes/.

20 Perry Chen, Yancey Strickler, and Charles Adler, "The Truth About Spike Lee and Kickstarter," *Kickstarter Blog*, August 19, 2013, https://www.kickstarter.com/blog/the-truth-about-spike-lee-and-kickstarter.

21 "Palo Alto Stories by James Franco," *Indiegogo*, last modified July 2015, https://www.indiegogo.com/projects/palo-alto-stories-by-james-franco#/story.

22 Chen, Strickler, and Adler, "The Truth about Spike Lee and Kickstarter."

23 "Oculus Rift: Step Into the Game," *Kickstarter*, last modified September 24, 2015, https://www.kickstarter.com/projects/1523379957/oculus-rift-step-into-the-game/description.

24 Chance Barnett, "$2B Facebook Acquisition Raises Question: Is Equity Crowdfunding Better?" *Forbes*, May 1, 2014, http://www.forbes.com/sites/

chancebarnett/2014/05/01/2-billion-facebook-acquisition-raises-question-is-equity-crowdfunding-better/.

25 Clay Risen, "Collapsing the Distribution Window," *New York Times*, December 11, 2005, http://www.nytimes.com/2005/12/11/magazine/collapsing-the-distribution-window.html.

26 Sundance Institute, "30 Years of Sundance Film Festival," *sundance.org*, accessed October 5, 2015, http://www2.sundance.org/festivalhistory/.

27 Figure 5.5. *Exit through the Gift Shop*, dir. Banksy, perf. Banksy (United Kingdom: Paranoid Pictures. USA: Oscilloscope Laboratories, 2010), DVD.

28 Nikki Baughan, "The Realities of Video on Demand," *Moviescope*, October 18, 2013, http://www.moviescopemag.com/market-news/featured-editorial/the-realities-of-vod.

29 The Film Collaborative, Jon Reiss, and Sheri Candler, *Selling Your Film without Selling Your Soul Presented by Prescreen: Case Studies in Hybrid, DIY and P2P Independent Distribution* (Los Angeles, CA: The Film Collaborative, 2011), 16–18.

30 Jeff Price, "Why the Music Industry Doesn't Care About Selling Music Anymore . . . ," *Digital Music News*, October 2, 2013, http://www.digitalmusicnews.com/2013/10/02/doesntcare.

31 Paul Resnikoff, "The 13 Most Insidious, Pervasive Lies of the Music Industry," *Digital Music News*, September 25, 2013, http://www.digitalmusicnews.com/2013/09/25/lies/.

32 Christiana J. Aymar, "Beyond Big Video: The Instability of Independent Networks in a New Media Market," *Continuum: Journal of Media & Cultural Studies* 26 (January 2012): 75, doi: 10.1080/10304312.2012.630137.

33 Dror Ginzberg, "What You Need to Know about Online Video Platforms," *Techcrunch*, July 6, 2015, http://techcrunch.com/2015/07/06/what-you-need-to-know-about-online-video-platforms/.

34 Tad Friend, "Hollywood and Vine," *The New Yorker*, December 15, 2014, http://www.newyorker.com/magazine/2014/12/15/hollywood-vine.

35 Ibid.

36 "Top 500 YouTubers by SB Score," *Social Blade*, https://socialblade.com/youtube/top/500.

37 Eric Kain, "YouTuber 'PewDiePie' Is Making $4 Million a Year," *Forbes,* June 18, 2014, http://www.forbes.com/sites/erikkain/2014/06/18/youtuber-pewdiepie-is-making-4-million-a-year/.

38 Susanne Ault, "Survey: YouTube Stars More Popular than Mainstream Celebs among U.S. Teens," *Variety,* August 5, 2014, http://variety.com/2014/digital/news/survey-youtube-stars-more-popular-than-mainstream-celebs-among-u-s-teens-1201275245/.

39 Kevin Ohannessian, "How Freddie Wong Went from Viral Videos to TV Shows," *Fast Co.Create,* July 2, 2015, http://www.fastcocreate.com/3047979/then-and-now/how-freddie-wong-went-from-viral-videos-to-tv-shows.

40 Brent Lang, "Lionsgate Partners with Freddie Wong's RocketJump Studios," *The Wrap,* April 14, 2014, http://www.thewrap.com/lionsgate-partners-freddie-wongs-rocketjump-studios/.

41 Todd Spangler, "New Breed of Online Stars Rewrite the Rules of Fame," *Variety,* August 5, 2014, http://variety.com/2014/digital/news/shane-dawson-jenna-marbles-internet-fame-1201271428/.

42 Susanne Ault, "Survey: YouTube Stars More Popular than Mainstream Celebs among U.S. Teens." *Variety,* August 5, 2014, http://variety.com/2014/digital/news/survey-youtube-stars-more-popular-than-mainstream-celebs-among-u-s-teens-1201275245/.

43 "comScore Releases March 2014 U.S. Online Video Rankings," *comScore,* April 18, 2014, http://www.comscore.com/Insights/Press-Releases/2014/4/comScore-Releases-March-2014-US-Online-Video-Rankings.

44 Ibid.

45 Tad Friend, "Hollywood and Vine," *The New Yorker,* December 15, 2014, http://www.newyorker.com/magazine/2014/12/15/hollywood-vine.

46 Ibid.

47 "comScore Releases March 2014 U.S. Online Video Rankings."

48 Friend, "Hollywood and Vine."

49 "comScore Releases March 2014 U.S. Online Video Rankings."

50 Frank Rose, "Behind the Cable Frenzy: The Shift in Viewing Goes Big," *Deep Media Online* (May 2015), http://www.deepmediaonline.com/deepmedia/2015/05/behind-the-cable-frenzy.html.

▶ BIBLIOGRAPHY

Adams, Sam. "Shane Carruth on Self-Distributing Upstream Color and 'Life in the Pig Corral.'" *A.V. Club*. April 5, 2013. http://www.avclub.com/article/shane-carruth-on-self-distributing-iupstream-color-96097.

Ault, Susanne. "Survey: YouTube Stars More Popular than Mainstream Celebs among U.S. Teens." *Variety*. August 5, 2014. http://variety.com/2014/digital/news/survey-youtube-stars-more-popular-than-mainstream-celebs-among-u-s-teens-1201275245/.

Bacle, Ariana. "'Broad City,' and Other Web Series That Made Successful Jumps to TV." *Entertainment Weekly*. January 28, 2015. http://www.ew.com/article/2015/01/14/web-series-television-broad-city.

Barnett, Chance. "$2B Facebook Acquisition Raises Question: Is Equity Crowdfunding Better?" *Forbes*. May 1, 2014. http://www.forbes.com/sites/chancebarnett/2014/05/01/2-billion-facebook-acquisition-raises-question-is-equity-crowdfunding-better/.

Barr, Alistair. "YouTube Creates Stars. Can It Keep Them?" *Wall Street Journal*. July 24, 2015. http://www.wsj.com/articles/youtube-creates-stars-can-it-keep-them-1437768942.

Baughan, Nikki. "The Realities of Video on Demand." *Moviescope*. October 18, 2013. http://www.moviescopemag.com/market-news/featured-editorial/the-realities-of-vod.

Bilton, Nick. "Jerome Jarre: The Making of a Vine Celebrity—The New York Times." *The New York Times*. January 28, 2015. http://www.nytimes.com/2015/01/29/style/jerome-jarre-the-making-of-a-vine-celebrity.html.

Bloom, David. "Can USC's Edison Project Turn the Light on in a Struggling Hollywood?" *Deadline*. September 27, 2013. http://www.deadline.com/2013/09/edison-project-usc-research-entertainment-study/.

Bogle, Ariel. "Vine Is the Hollywood of the App Store." *Mashable*. October 3, 2015. http://mashable.com/2015/10/03/vine-shawn-mendes-brittany-furlan-money.

Broderick, Peter. "Declaration of Independence." *Paradigm Consulting*. September 21, 2009. http://peterbroderick.com/writing/writing/declarationofindependence.html.

Broderick, Peter. "A Film for a Song." *Filmmaker Magazine*. Winter 1993. http://www.filmmakermagazine.com/archives/issues/winter1993/film_for_song.php.

Broderick, Peter. "Welcome to the New World." *Paradigm Consulting*. September 16, 2008. http://peterbroderick.com/writing/writing/welcometothenewworld.html.

Broderick, Peter, Mark Stolaroff, and Tara Veneruso. "DV Films Guide." *Next Wave Films Bulletins from the Front*. June 26, 2002. http://www.nextwavefilms.com/moviemaking/bullfront.html.

Campbell, Christopher. "InDigEnt Shuts Down in January." *The Moviefone Blog*. December 5, 2006. http://news.moviefone.com/2006/12/05/indigent-shuts-down-in-january/.

Carr, David. "For 'House of Cards,' Using Big Data to Guarantee Its Popularity." *The New York Times*. February 24, 2013. http://www.nytimes.com/2013/02/25/business/media/for-house-of-cards-using-big-data-to-guarantee-its-popularity.html.

Chen, Perry, Yancey Strickler, and Charles Adler. "Who Is Kickstarter for?" *Kickstarter*. May 9, 2013. https://www.kickstarter.com/blog/who-is-kickstarter-for.

Christian, Aymar J. "Beyond Big Video: The Instability of Independent Networks in a New Media Market." *Continuum: Journal of Media & Cultural Studies* 26 (January 2012): 73–87. doi:10.1080/10304312.2012.630137.

Christian, Aymar J. "How Does a Web Series Jump to TV?" *Indiewire*. February 25, 2015. http://www.indiewire.com/article/television/how-does-a-web-series-jump-to-tv.

"comScore Releases March 2014 U.S. Online Video Rankings." *comScore*. April 18, 2014. http://www.comscore.com/Insights/Press-Releases/2014/4/comScore-Releases-March-2014-US-Online-Video-Rankings.

Dargis, Manohla. "As Indies Explode, an Appeal for Sanity." *The New York Times*. January 9, 2014. http://www.nytimes.com/2014/01/12/movies/flooding-theaters-isnt-good-for-filmmakers-or-filmgoers.html.

"Disrupted: Indie Filmmakers." *SubGenre* (blog). May 29, 2012. http://www.subgenre.com/2012/05/29/disrupted-indie-filmmakers/.

Edwards, Gavin. "How the Duplass Brothers Became Hollywood's Most Low-Key Power Players." *Rolling Stone*. January 5, 2015. http://www.rollingstone.com/tv/features/how-the-duplass-brothers-became-hollywoods-most-low-key-power-players-20150105.

Edwards, Jim. "Yes, You Can Make Six Figures as a YouTube Star . . . And Still End Up Poor." *Business Insider*. February 10, 2014. http://www.businessinsider.com/how-much-money-youtube-stars-actually-make-2014-2.

Eig, Jonathan. "The Tail Wags: Hollywood's Crumbling Infrastructure." *Jump Cut: A Review of Cotemporary Media* 56 (Fall 2012). http://www.ejumpcut.org/currentissue/eigHollywood.

Erbland, Kate. "Why Jason Blum Isn't Afraid of a Changing Distribution Landscape." *Indiewire.* July 10, 2015. http://www.indiewire.com/why-jason-blum-isnt-afraid-of-a-changing-distribution-landscape.

"Filmed Entertainment: Segment Data Insights: Global Entertainment and Media Outlook 2015–2019: PwC." *PwC.* 2015. http://www.pwc.com/gx/en/industries/entertainment-media/outlook/segment-insights/filmed-entertainment.html.

"For Lovers Only (film)." *Wikipedia.* Last modified April 18, 2014. https://en.wikipedia.org/w/index.php?title=For_Lovers_Only_(film)&oldid=608778169.

"'For Lovers Only': Michael and Mark Polish's No-Budget Digital Dream Project | Creative Planet Network." *Creative Planet Network.* February 14, 2012. http://www.creativeplanetnetwork.com/news/news-articles/lovers-only-michael-and-mark-polishs-no-budget-digital-dream-project/423655.

Friend, Tad. "The Stars of YouTube and Vine." *The New Yorker.* December 15, 2014. http://www.newyorker.com/magazine/2014/12/15/hollywood-vine.

"The Future Will Be Streamed and Downloaded." *GoldRush Entertainment* (blog). July 10, 2014. http://goldrushentertainment.com/the-future-will-be-streamed-and-downloaded/.

Galllagher, Brenden. "The 25 Best Web Series Right Now." *Complex.* March 4, 2013. http://www.complex.com/pop-culture/2013/03/25-best-web-series-right-now/.

"Game Theory: How PewDiePie Conquered YouTube." YouTube video. Posted by *The Game Theorists.* July 20, 2013. https://www.youtube.com/watch?v=EgMqhEMhVV8.

Ginzberg, Dror. "What You Need to Know about Online Video Platforms." *TechCrunch.* July 6, 2015. http://techcrunch.com/2015/07/06/what-you-need-to-know-about-online-video-platforms/.

Gleiberman, Owen. "'Paranormal Activity': A Marketing Campaign So Ingenious It's Scary." *Entertainment Weekly.* October 7, 2009. http://www.ew.com/article/2009/10/07/paranormal-activity-marketing-campaign.

Grove, Elliot. "10 Film Distribution Basics." *Raindance.* June 28, 2015. http://www.raindance.org/10-film-distribution-basics/.

"Here's How Much YouTube Celebrities Make ... Don't Worry, We Cried Too." *Notable*. April 21, 2015. http://notable.ca/nationwide/yp-life/Heres-How-Much-YouTube-Celebrities-MakeDont-Worry-We-Cried-Too/.

Horn, John. "The Haunted History of 'Paranormal Activity." *Los Angeles Times*. September 20, 2009. http://articles.latimes.com/2009/sep/20/entertainment/ca-paranormal20.

"Independent Film." *Wikipedia*. Accessed November 15, 2015. https://en.wikipedia.org/wiki/Independent_film.

Jacobs, Harrison. "We Ranked YouTube's Biggest Stars by How Much Money they Make." *Business Insider*. March 10, 2014. http://www.businessinsider.com/richest-youtube-stars-2014-3.

Jarvey, Natalie, and Benjamin Svetkey. "THR's Top 25 Digital Stars." *The Hollywood Reporter*. July 10, 2015. http://www.hollywoodreporter.com/person/andrew-bachelor-viner.

Kain, Eric. "YouTuber 'PewDiePie' Is Making $4 Million a Year." *Forbes*. June 18, 2014. http://www.forbes.com/sites/erikkain/2014/06/18/youtuber-pewdiepie-is-making-4-million-a-year/.

Kazmark, Justin. "Kickstarter before Kickstarter." *Kickstarter*. July 18, 2013. https://www.kickstarter.com/blog/kickstarter-before-kickstarter.

Kelly, Alexander R. "Will the Mighty Blockbuster Fail and the People Be saved?" *Truthdig*. May 18, 2014. http://www.truthdig.com/arts_culture/item/will_the_mighty_blockbuster_fail_and_the_people_be_saved_20140518.

"Kickstarter Stats." *Kickstarter*. Last modified October 20, 2015. https://www.kickstarter.com/help/stats.

"Kickstarter Vs IndieGoGo: Choosing Your Crowdfunding Platform." *Crowdfunding DoJo*. Last modified November 30, 2015. http://crowdfundingdojo.com/articles/kickstarter-vs-indiegogo-choosing-your-crowdfunding-platform.

Kleinman, Alex. "Netflix Wants to Replace the Movie Theater." *The Huffington Post*. October 28, 2013. http://www.huffingtonpost.com/2013/10/28/netflix-movies_n_4169752.html.

Knegt, Peter. "From the IW Vaults | Mark Gill: 'Yes, the Sky Really Is F." *Indiewire*. July 4, 2011. http://www.indiewire.com/article/from_the_iw_vaults_mark_gill_yes_the_sky_really_is_falling.

Lang, Brent. "Lionsgate Partners with Freddie Wong's RocketJump Studios." *The Wrap*. August 14, 2014. http://www.thewrap.com/lionsgate-partners-freddie-wongs-rocketjump-studios/.

Lee, Dave. "YouTube to Launch Subscription Service." *BBC News.* October 21, 2015. http://www.bbc.com/news/technology-34596219.

Lehner, Sandra. "Why Viners Are the New Video Stars." *MIPBlog.* September 29, 2014. http://blog.mipworld.com/2014/09/sandra-lehner-vine-stars/.

Lindsey, Craig. "On Culture: Are Indie Films Dead?" *New Observer.* January 24, 2015. http://www.newsobserver.com/entertainment/arts-culture/article10230821.html.

Lingam, Kiran. "The Reg A+ Bombshell: $50M Unaccredited Equity Crowdfunding Title IV Takes Center Stage." *Crowdfund Insider.* March 25, 2015. http://www.crowdfundinsider.com/2015/03/65007-the-reg-a-bombshell-50m-unaccredited-equity-crowdfunding-title-iv-takes-center-stage/."

Macaulay, Scott. "Producer Jason Blum @SXSW: 'If I Had to Make Kicking and Screaming Today, I'd Make It for $50,000 . . .'" *Filmmaker Magazine.* March 12, 2014. http://filmmakermagazine.com/84952-producer-jason-blum-sxsw-if-i-had-to-make-kicking-and-screaming-today-id-make-it-for-50000/.

Manly, Lorne. "Can 20 Million YouTube Fans Make 'Smosh: The Movie' a Hit?" *The New York Times.* June 27, 2015. http://www.nytimes.com/2015/06/28/movies/can-20-million-youtube-fans-make-smosh-the-movie-a-hit.html.

Nagarkar, Vikram. "Google vs Facebook: Why Facebook Is a Serious Threat." *Amigobulls: Technology Stock Analysis.* February 15, 2015. http://amigobulls.com/articles/google-vs-facebook-competition-heats-up-in-online-video-advertising.

Nicholson, Amy. "Can Low-Budget Producer Jason Blum Prove the Way Hollywood Makes Movies Is Horrifyingly Wrong?" *L.A. Weekly.* October 19, 2015. http://www.laweekly.com/arts/can-budget-slasher-jason-blum-prove-the-way-hollywood-makes-movies-is-horrifyingly-wrong-6176088.

Oculus Rift: Step into the Game." *Kickstarter.* Last modified September 24, 2015. https://www.kickstarter.com/projects/1523379957/oculus-rift-step-into-the-game/description.

Ohannessian, Kevin. "How Freddie Wong Went from Viral Videos to TV Shows." *Fast Co.Create.* July 2, 2015. http://www.fastcocreate.com/3047979/then-and-now/how-freddie-wong-went-from-viral-videos-to-tv-shows.

"Palo Alto Stories by James Franco." *Indiegogo.* Last modified July 2015, https://www.indiegogo.com/projects/palo-alto-stories-by-james-franco#/story.

Price, Jeff. "Why the Music Industry Doesn't Care about Selling Music Anymore . . ." *Digital Music News.* October 2, 2013. http://www.digitalmusicnews.com/2013/10/02/doesntcare.

Raferty, Brian. "Buckle Your Brainpan: The Primer Director Is Back with a New Film." *Wired*. March 13, 2013. http://www.wired.com/2013/03/primer-shane-carruth/.

Reiss, Jon, Sheri Candler, and The Film Collaborative. *Selling Your Film without Selling Your Soul: Presented by Prescreen & Area 23a Movievents: Case Studies in Hybrid, DIY & P2P Independent Distribution*. Los Angeles, CA: Film Collaborative, 2011.

Resnikoff, Paul. "The 13 Most Insidious, Pervasive Lies of the Music Industry." *Digital Music News*. September 25, 2013. http://www.digitalmusicnews.com/2013/09/25/lies/.

Risen, Clay. "Collapsing the Distribution Window." *New York Times*. December 11, 2005. http://www.nytimes.com/2005/12/11/magazine/collapsing-the-distribution-window.html.

Roettgers, Janko. "Web TV Pioneer KoldCast TV Is Shutting down after Losing Millions on Original Content." *Gigaom Research*. March 6, 2014. https://gigaom.com/2014/03/06/web-tv-pioneer-koldcast-tv-is-shutting-down-after-losing-millions-on-original-content/.

Rose, Frank. "Behind the Cable Frenzy: The Shift in Viewing Goes Big." *Deep Media*. May 26, 2015. http://www.deepmediaonline.com/deepmedia/2015/05/behind-the-cable-frenzy.html.

Silverman, Jason. "DV Studio Can't Make a Buck." *Wired*. January 26, 2006. http://archive.wired.com/science/discoveries/news/2006/01/70074.

Spangler, Todd. "From Shane Dawson to Jenna Marbles: Online Stars Rewriting Fame." *Variety*. August 5, 2014. http://variety.com/2014/digital/news/shane-dawson-jenna-marbles-internet-fame-1201271428/.

Speiser, Matthew. "The Film Industry Is on the Precipice of a Fundamental Shift." *Business Insider*. June 5, 2015. http://www.businessinsider.com/the-film-industry-is-on-the-precipice-of-a-fundamental-shift-2015-6.

Stewart, Andrew, and Alexandra Cheney. "CinemaCon: Hollywood Tested by New Distribution Models." *Variety*. March 24, 2014. http://variety.com/2014/film/features/new-distribution-models-create-tug-of-war-between-studios-theaters-1201144965/.

Strange, Adario. "Kickstarter Backlash: Early Oculus Supporters Hate Facebook Deal." March 25, 2014. http://mashable.com/2014/03/25/kickstarter-oculus-facebook/.

Sundance Institute. "30 Years of Sundance Film Festival." *Sundance*. Accessed October 5, 2015. http://www2.sundance.org/festivalhistory/.

Taplin, Jon. "Tyranny of Choice." *Jon Taplin's Blog*. May 8, 2014. http://jontaplin.com/2014/05/08/tyranny-of-choice/.

Thompson, Derek. "The Big Business of Big Hits: How Blockbusters Conquered Movies, TV, and Music." *The Atlantic*. October 13, 2013. http://www.theatlantic.com/business/archive/2013/10/the-big-business-of-big-hits-how-blockbusters-conquered-movies-tv-and-music/280298/.

"Top 500 YouTubers Filtered by SB Score." *SocialBlade*. Accessed November 28, 2015. http://socialblade.com/youtube/top/500.

Witt, Stephen. "You Won't Steal Our Music Anymore: The Fraction of a Cent That Saved the Major Labels." *Salon*. June 19, 2015. http://www.salon.com/2015/06/19/you_wont_steal_our_music_anymore_the_fraction_of_a_cent_that_saved_the_major_labels/.

Whyte, Marama. "'Lizzie Bennet Diaries' DVD and Mini-series Kickstarter Raises $462,405." *Hypable*. April 23, 2013. http://www.hypable.com/lizzie-bennet-diaries-kickstarter-closes/.

▶ FILMOGRAPHY

2016: Obama's America. Directed by Dinesh D'Souza and John Sullivan. 2012. New York, NY: Lionsgate, 2012. DVD.

Ai Weiwei: Never Sorry. Directed by Alison Klayman. 2012. Orland Park, IL: MPI Home Video, 2012. DVD.

America: Imagine the World without Her. Directed by John Sullivan and Dinesh D'Souza. 2014. New York, NY: Lionsgate, 2014. DVD.

Baghead. Directed by Jay Duplass and Mark Duplass. 2008. Culver City, CA: Sony Pictures Home Entertainment, 2008. DVD.

Blair Witch Project, The. Directed by Daniel Myrick and Eduardo Sánchez. 1999. New York, NY: Lions Gate, 1999. DVD.

Book of Life, The. Directed by Hal Hartley. 1998. New York, NY: Fox Lorber, 2000. DVD.

Castle. Directed by Andrew W. Marlowe. 2009—Present. New York, NY: ABC Studios, 2009. TV Series.

Clerks. Directed by Kevin Smith. 1994. Santa Monica, CA: Miramax, 1999. DVD.

Da Sweet Blood of Jesus. Directed by Spike Lee. 2014. Troy, MI: Anchor Bay, 2015. DVD.

Don't Think I've Forgotten. Directed by John Pirozzi. 2014. New York, NY: Virgil Films and Entertainment, 2015. DVD.

El Mariachi. Directed by Robert Rodriguez. 1993. Culver City, CA: Sony Pictures Home Entertainment, 2003. DVD.

Exit through the Gift Shop. Directed by Banksy. 2010. New York, NY: Oscilloscope Laboratories, 2010. DVD.

For Lovers Only. Directed by Mike Polish. 2011. New York, NY: FilmBuff, 2015. DVD.

Friday the 13th. Directed by Sean S. Cunningham. 1980. Hollywood, CA: Paramount, 1999. DVD.

Funny Ha Ha. Directed by Andrew Bujalski. 2002. New York, NY: Fox Lorber, 2005. DVD.

Halloween. Directed by John Carpenter. 1978. Troy, MI: Anchor Bay, 2007. DVD.

Hannah Takes the Stairs. Directed by Joe Swanberg. 2007. Santa Monica, CA: Genius Products, 2008. DVD.

Henry Fool. Directed by Hal Hartley. 1998. Culver City, CA: Sony Pictures Home Entertainment, 2003. DVD.

Humpday. Directed by Lynne Shelton. 2009. New York, NY: Magnolia Home Entertainment, 2009. DVD.

Iran Job, The. Directed by Till Schauder. 2012. New York, NY: Paladin Video, 2012. DVD.

Iraq for Sale: The War Profiteers. Directed by Robert Greenwald. 2006. Culver City, CA: Brave New Films, 2006. DVD.

Koch Brothers Exposed. Directed by Robert Greenwald. 2012. Culver City, CA: Brave New Films, 2012. Film.

Life in a Day. Directed by Kevin MacDonald, Natalia Andreadis, Soma Helmi, Joseph Michael and Joaquin Montalvan. 2011. New York, NY: Virgil Films, 2011. DVD.

Meanwhile. Directed by Hal Hartley. 2012. Chicago, IL: Olive Films, 2013. DVD.

Michael Moore Hates America. Directed by Michael Wilson. 2004. New York, NY: FilmRise, 2007. DVD.

My Reincarnation. Directed by Jennifer Fox. 2011. New York, NY: Docurama, 2012. DVD.

Napoleon Dynamite. Directed by Jared Hess. 2004. Century City, CA: Fox Searchlight, 2004. DVD.

Ned Rifle. Directed by Hal Hartley. 2014. New York, NY: Possible Films, 2015. DVD.

Paranormal Activity. Directed by Oren Peli. 2009. Hollywood, CA: Paramount, 2009. DVD.

Primer. Directed by Shane Carruth. 2004. Los Angeles, CA: New Line Home Video, 2005. DVD.

Puffy Chair, The. Directed by Jay Duplass. 2005. New York, NY: Magnolia Home Entertainment, 2009. DVD.

Quantum of Solace. Directed by Marc Forster. 2008. New York, NY: MGM, 2015. DVD.

Slacker. Directed by Richard Linklater. 1991. New York, NY: Criterion Collection, 2013. DVD.

Street Fight. Directed by Marshall Curry. 2005. New York, NY: Magnolia Home Entertainment, 2009. DVD.

Tiny Furniture. Directed by Lena Dunham. 2010. New York, NY: Criterion Collection, 2012. DVD.

Trust. Directed by Hal Hartley. 1990. Chicago, IL: Olive Films, 2013. Film.

Unbelievable Truth, The. Directed by Hal Hartley. 1988. Chicago, IL: Olive Films, 2013. DVD.

Upstream Color. Directed by Shane Carruth. 2013. New York, NY: Flatiron Film Company, 2013. DVD.

Veronica Mars. Directed by Rob Thomas. 2014. Burbank, CA: Warner Home Video, 2014. DVD.

War on Whistleblowers. Directed by Robert Greenwald. 2013. Culver City, CA: Brave New Films, 2013. DVD.

We Are Blood. Directed by Ty Evans. 2015. Jackson, WY: Brainfarm, 2015. Film.

Wish I Was Here. Directed by Zach Braff. 2014. Universal City, CA: Universal Studios, 2014. DVD.

Yes Men Are Revolting, The. Directed by Mike Bonanno and Andy Bichlbaum. 2014. Owensboro, KY: Team Marketing, 2015. DVD.

6

The Big Picture

> Consumers demand that content be free, but then are willing to shell out thousands for the hardware to play it on. The hardware manufactures and the rights aggregators get rich and the creators get pennies.
> Ted Hope, independent film producer[1]

In August 2015, the *New York Times Magazine* published Steven Johnson's article "The Creative Apocalypse That Wasn't," which triggered an extraordinary flood of readers' comments, as well as responses from other journalists and commentators. In the article, Johnson outlines the idea that, contrary to many other observers' claims, the digital economy did not negatively affect the creative class. Tracing the development of digital technology and its impact on creative work from the appearance of the music file-sharing service Napster onward, Johnson starts by quoting Lars Ulrich, the drummer of the band Metallica, condemning Napster. In his now notorious testimony in front of the Senate Judiciary Committee in 2000, Ulrich explained the negative impact of digital reproduction on works of art—particularly on their commercial exploitation and their creators' incomes.[2]

Although Napster was shut down soon after, it quickly became clear that it was only the precursor of much bigger changes to come. The expansion of

peer-to-peer file sharing networks, online piracy, and broadband Internet in general,

> signaled a fundamental rearrangement in the way we discover, consume and (most importantly) pay for creative work. In the 15 years since, many artists and commentators have come to believe that Ulrich's promised apocalypse is now upon us—that the digital economy, in which information not only wants to be free but for all practical purposes is free, ultimately means that "the diverse voices of the artists will disappear," because musicians and writers and filmmakers can no longer make a living.[3]

Drawing on statistical data analysis, Johnson tries to show that although revenues from the sales of recorded music have fallen, musicians were able to compensate for this through live performances and other means. While the music industry as a whole has indeed suffered significant revenue losses, movies, television, and books have actually increased overall earnings, allowing for new opportunities for filmmakers, actors, screenwriters, et al. Johnson goes on to dispute journalist Jason Bailey's assessment of the decline of the "economics of quality"—how low- or mid-budget dramatic films with an "adult-themed sensibility," such as *Blue Velvet* (1986), *Do the Right Thing* (1989), or *Pulp Fiction* (1994), would not be able to be made in today's cultural climate.[4] Johnson refutes Bailey's claim by stating that box-office numbers and film critics' responses prove that there is no drop in quality films being made now, compared to pre-2000. Johnson does note that while Hollywood studios have moved away from artistically challenging films, the increase in quality television production, as well as the arrival of independent film financiers who have put their money behind such movies as *12 Years a Slave* (2013), *Dallas Buyers Club* (2013), *American Hustle* (2013), and *The Wolf of Wall Street* (2013) have more than compensated for this.[5] Johnson's article portrays quite an encouraging picture: according to his assessment, the pessimistic predictions that artistic work as a professional activity will decline—and eventually perhaps even become obsolete—within a digital economy have not materialized. His arguments are based on the facts that consumers still pay for creative work and that there are now actually more ways in which viewers can access and pay for content than ever before: through numerous devices, online, and through mobile platforms, as well as live events and traditional mass-media channels. There are now also more ways for creators to be compensated for making their work, beyond the traditional mass media channels.

While Johnson acknowledges that inexpensive production methods and new distribution channels are blurring the lines between amateurs and professionals, he argues that these new economic and technological trends are not undermining artists' livelihoods but actually making them more attainable. He concedes that not all creators will have the entrepreneurial energy that this new environment requires—such as finding new ways to market, publicize, and sell their work—but concludes that those artists "who are particularly adept at inventing new career paths rather than single-mindedly focusing on their craft"[6] will be able to thrive.

The responses to Johnson's article, as logged in the *New York Times* comments section, were swift and overall very negative. Many commenters, who apparently belonged to the creative class discussed in the article, were infuriated, blasting the article's claims and accusing Johnson of being out of touch with reality. Perhaps the responders' mood could best be summed up by this comment: "What planet does this author live on? Has he ever known any of the sorts of creative people he's talking about? Perhaps this article was written by a piece of software that did a Google search to locate a bunch of statistics, and then assembled them into an 'article.' "[7]

Most commenters maintained that the incomes for professional creative work have drastically declined in the new digital economy and that artists were now struggling to make a living, rather than benefitting from this new environment. Jason Bailey, who was quoted in Johnson's article, also added his own criticism in his response to the piece: "according to Johnson, 'creative careers are thriving,' a point he argues by ignoring pundits (including yours truly), experts, and anecdotal evidence, instead focusing on the inarguable evidence of Data Journalism. In doing so, Johnson vastly inflates the conclusions of such number-crunching—and . . . frequently misses the point of the arguments he's refuting."[8]

The initial optimism regarding the digital economy in relation to the commercial valuation of creative work has become increasingly subdued, and in the past few years it has often been challenged by vigorous complaints. These opposing views could easily be explained away as the difference between the advocates for old production and distribution models, who refuse to change, and the ones who embrace the new realities—such as Johnson— advocating for a new concept, where traditional mass media practices coexist with new, emerging ones, dictated by technological changes. The reality, however, is somewhat more nuanced: many creative practitioners still work

in traditional professional roles within mainstream mass media—such as the television or movie industry—while others, who would not have had access to the mainstream industry before, are now able to create their own career paths, whether through web videos, DIY filmmaking, or other new means and media channels. The questions of how these new realities relate to "monetizing"—especially for creative individuals rather than conglomerates—have become a fluid and contentious subject, where all creators have to find their own individual best practices in relation to the work they produce. This is, of course, a central question for independent film and media-makers that aspire to make a living from what they do.

It is not always useful to compare different forms of artistic and media practices, but many commentators have drawn effectual analogies between the changes that have already occurred in the music business and the current transformations in the film and video market. Thus, it is worthwhile to look closer at how the music business has changed, what that change has meant for the creative practitioners involved, and how this relates to the current changes in film, TV, and video production and distribution.

As has been stated, the music industry has seen the biggest transformation of all the media industries so far and also, on average, the greatest loss of revenue over time. There are many factors that have contributed to this, from online piracy to the reluctance of the media conglomerates to adapt their business models to new realities, but that is only one part of the story. In spite of Ulrich's senate testimony about the abysmal effects of the spread of digital technology and online streaming on the music industry, some commentators did not initially consider this to be an entirely negative development. Instead, they believed this would diminish the monopoly of the labels and liberate the artists. As record sales plummeted in the early 2000s, record companies were in fact left with less control over the market and the music business. Except for a handful of mega-stars, who were able to set their own terms, most artists had long complained that record companies and other intermediaries were receiving an unjustly large percentage of all revenues, leaving only pennies on the dollar for the music creators.

The new technology was forcing inevitable changes, and, according to its supporters and advocates, some of these changes promised to be for the better. The new digital tools were hailed as a way in which artists could reach their audiences directly, without intermediaries, retaining more control over the distribution process, as well as revenues. Even if online piracy

would impact the sales of recorded music overall, artists could compensate that loss through live concerts and other means, such as merchandising, multi-platform streaming, as well as crowdfunding and direct audience support. Furthermore, with the major labels' powers declining, the Internet and social media would make it easier for audiences to discover new artists. In 2004, writer and journalist Chris Anderson formulated the "long tail" market theory,[9] which was, at that time, enthusiastically hailed as a cutting-edge concept, matching the promises of the new digital online environment with the empowerment of independent creators, helping them reach smaller niche audiences.

Anderson's concept could be summed up as follows: while a media conglomerate's blockbuster generates the majority of its revenue immediately upon its release and declines quickly thereafter, a niche-market release starts small, gains popularity over a much longer time—the "long tail"—through word-of-mouth and similar means, and in the end can match the success of the blockbuster, or even have a more enduring value. One could certainly support this argument by looking to the past: The successful independent films of the 1970s, 1980s, and 1990s—for example, *Eraserhead* (1977), *The Blair Witch Project* (1999), or *Blood Simple* (1984)—had initially been released in only a few theaters but accrued their box office over months, even years, and are still being sold and remain prominent today. The majority of Hollywood movies, on the other hand, get simultaneously released in thousands of theaters, generate most of their revenue within the first few weeks, then fall off sharply, and are forgotten soon thereafter.

The problem with the long tail theory, however, was that it could not anticipate how further technology developments would affect media distribution and consumer behavior. By 2008 it was already becoming clear that the evolution of the Internet would actually enable the growth of the blockbuster rather than niche markets and the long tail. As Google CEO Eric Schmidt then remarked in an interview:

> While you can have a long tail strategy, you better have a head, because that's where all the revenue is. And in fact it's probable that the Internet will lead to larger blockbusters, and more concentration of brands, which doesn't make sense to most people, because it's a larger distribution medium [but] when you get everybody together they still want to have one superstar. It's a bigger superstar. It's no longer a US superstar; it's a global superstar.[10]

The growing oversupply of new content and online media channels and platforms have made the long tail theory essentially unworkable; as the renowned independent film producer Ted Hope wrote in 2013: "The long tail is crushed by the weight of the herd of the new, buried under the tsunami of the now that is constantly being generated."[11]

The initial optimism about how artists would benefit from the digital economy turned sour quickly, with many commentators increasingly becoming dispirited and joining the lament for the "good old days" of the music industry. Music blogs and publications now started criticizing and debunking the "myths" that were propagated by the advocates of the new digital environment: social media and digital platforms did not increase the number of new artists who are being discovered; the major record labels, although weakened, still played the lead role in pushing and promoting artists because of the labels' money and resources; without the support of a major label, artists just cannot compete in the crowded marketplace, and even though they can self-record and self-distribute their work, that is a time-consuming, expensive, and cumbersome effort, which mostly results in meager financial returns; digital sales figures do not match physical sales figures of records and CDs; most musicians and composers struggle to make a living in the digital economy, or have to have other jobs to support their art. In most of these statements, one could easily swap the words "musician," "CD," and "label" with "filmmaker," "DVD," and "distributor" and reach the same—or very similar—conclusions.

These assessments are valid if, according to these critics, this "internet-powered disintermediation" was supposed to build a "middle class" of artists—"good musicians that can support families and pay their bills."[12] The same views hold that this promise has remained unfulfilled and that the music industry has instead "devolved into a third world country, with a wide gulf between the rich and struggling/starving poor."[13] However, one could also argue that making a living as a professional musician has never been easy, and the digital economy has not changed that. Top artists thrived before, as they do now; new artists succeed once they gain a following; and the ones in the middle always had to struggle to make a living from their music. The changes in the way music is produced, distributed, and consumed has not made life generally easier or harder for artists as a rule; it has just changed the circumstances. It can also be disputed whether the "good old days" were really that good, as most musicians complained that

the record labels' monopolies were preventing them from being discovered, or fairly compensated for their work.

Another frequent complaint, however, is worth looking at closer and does point to some troubling developments, which could actually threaten to undercut independent artists and their potential revenue streams in the long run: the ubiquity of online download and streaming services, most of which pay miniscule fees to the creators, as well as the trend of mergers and dominance of very few companies, providing consumers with a centralized, vast multitude of services and products. These practices generally favor content produced by the conglomerates with their huge marketing budgets over smaller, independent work. Mega-companies like Apple's iTunes service or Amazon.com do not depend on the actual sale of music—or other creative content—but use it as a way of attracting customers to its multitude of other services and products. Streaming services like Spotify and Pandora, on the other hand, are primarily interested in growing their subscription base in order to eventually be able to sell their companies to one of the media conglomerates for a billion dollars, in the vein of most start-up Internet businesses. Although the music on these streaming services is part of this calculation, the artists will not make any money from these business models:

> The incentive for a store to sell music and make money from that sale is gone. Instead, music is used to sell smartphones, tablets, computers, recurring monthly subscription fees, operating systems and to generate market share. Or it's being used as a loss-leader in order to attract a buyer; making all the investors and shareholders rich while the songwriters, publishers, artists and music creators get little to nothing. The artist is a commodity being aggregated to provide the impression of breadth in a music catalog.[14]

These concerns have been voiced not only by journalists and commentators but also by many successful artists. Writing for the *Guardian* in 2013, musician and composer David Byrne points out how musicians such as Damon Krukowski, David Lowery, and others would receive less than twenty dollars, even after being played a million times on Pandora's streaming service. Byrne concludes with this calculation: "For a band of four people that makes a 15% royalty from Spotify streams, it would take 236,549,020 streams for each person to earn a minimum wage of $15,080 (£9,435) a year. For perspective, Daft Punk's song of the summer, 'Get Lucky', reached 104,760,000

Spotify streams by the end of August: the two Daft Punk guys stand to make somewhere around $13,000 each."[15]

Byrne also astutely observes that artists who had become successful before the digital revolution and online streaming trends were still able to command larger audiences. Even if these artists give their recorded music away for free, they can earn money in other ways, such as concerts and merchandising. However, for new and emerging artists, it has become increasingly difficult to break through and make money off their work. To reiterate film producer Ted Hope's quote, the main beneficiaries of the digital economy so far have been not the artists but the online platforms and channels hosting the content, the hardware manufactures, and the rights aggregators.[16]

As has already been documented, digital streaming and downloads are also increasingly becoming the way most consumers watch films and videos. According to research by PricewaterhouseCoopers, "electronic home video" revenue—which includes subscription video-on-demand and cable-on-demand—has surpassed physical home video in 2016, and film streaming and download revenues will have exceeded those of theatrical cinema distribution in the United States by 2017.[17] For the industry, these developments mean that they will have to adapt their distribution practices to these new realities; for creative artists—especially independent film and media-makers—this raises some essential questions about further consequences these developments might bring:

> If, for instance, the future of the movie business comes to rely on the income from Netflix's $8-a-month-streaming-service as a way to fund all films and TV production, then things will change very quickly. As with music, that model doesn't seem sustainable if it becomes the dominant form of consumption. . . . The inevitable result would seem to be that the Internet will suck the creative content out of the whole world until nothing is left.[18]

The impossibility of becoming a "middle-class" artist in this environment has been echoed in articles and discussions about the livelihoods of independent filmmakers:

> The income disparity in this country, which is the worst it's been since 1928, mirrors the current budget disparity between studio films

and independent films. . . . While the middle class in our society has
disappeared, so has the middle class in the world of filmmaking.[19]

Further acquisitions of new media platforms and enterprises by the
media conglomerates and new consolidations would once again reaffirm
Elbersee's blockbuster theory.[20] This would focus the audience's attention
on franchised mainstream industry content within a few major channels,
while independent niches would have an increasingly harder time reach-
ing any sizeable audience. In this scenario, independent creators may no
longer be able to make a living from their work. These are certainly valid
reasons for concern, but the overall picture is more complex and offers
a variety of different perspectives. As previous examples from emerg-
ing and transmedia practices have shown, some independent film- and
media-makers were able to create successful professional models in this
new environment—whether by using the new technology and means to
build their own brand and distribution system independent of the main-
stream, or by engaging in a symbiotic, hybrid relationship with main-
stream distribution and marketing channels. Once again, in this view,
"independent" does not have to mean in opposition to the mainstream,
but a situation where the creator is able to control and decide the extent
to which they are willing to engage with the mainstream industry's pro-
duction and distribution systems, while maintaining creative control.
YouTube, Netflix, and Amazon are catchall hubs, where independently
produced films and videos can easily get lost, unless they have built an
audience and fan following. Various VOD services, social media chan-
nels, and inexpensive or free software, however, enable creators to mar-
ket and sell their films directly to viewers and build their own audience
networks; furthermore, digital technology allows them to do this without
having to rely on big budgets.

Arguably, the main challenge for independent creators who do not have
the backing of a mainstream media company—even if it is only a small,
specialized division of a conglomerate—is to convince an audience that is
offered abundant choices that their work is worth paying for. This leads to
a larger argument about creative work valued only as a commodity that
the viewer purchases. If one uses sales figures as a standard to compare the
conglomerates' blockbusters and franchises with independent content,
the independents inevitably lose. However, the value of a film or video
for an independent filmmaker is not only measured in monetary terms,

as a commodity, but can transmute into various other purposes: to build popularity, a brand, name recognition, engagement, audience interaction, awareness, etc. For the audience to be willing to pay for independently produced content, the work needs to rise to a point of visibility and popularity that meets a perceived monetary value from the viewer's point-of-view. Alternately, the creators can use the work as a marketing tool, or give it away for free, and find other means of income, whether through selling other products, advertising and sponsorships, or donations and crowdfunding. Thus, the film or video stops being just a product and has the potential to disrupt the prevailing commodity-based mass-media model of production and distribution.

In other words, a lot of criticism of the digital economy stems from the illusive idea that the old linear mass-media distribution formats (theatrical, DVD, TV) would be seamlessly supplanted by the new ones—online streaming and downloads—while giving creators more choices and rewards. This has obviously not happened, and with the further growth of content, concentrated in fewer massive channels, it is likely to continue to reduce the revenue share that independent creators will get paid. All this confirms the need for independents to forego the old models in favor of new approaches, custom-tailored to the type of work they produce and to the audience they want to reach.

The previous "one-size-fits-all" model of independent filmmaking has already been displaced by something new, but presently there is no standardized, universal model or solution. Today's independent media-makers have to create individual strategies of how to reach, engage, and build their audiences. It is ludicrous to hold up the online video success of Freddie Wong's approach, for example, to an experimental filmmaker, or Hal Hartley's Kickstarter success to a fledgling new media endeavor. If there is a common factor to these success stories, it is that each one of them has built a relationship and strong bond with their core audiences and has extended their practice beyond the making of a project, into marketing and distribution, matching their audience's expectations.

More direct communication between creators and audiences and the disruption of the traditional, commodity-based mass-media system allows for the envisioning of another communication model between media creators and audiences:

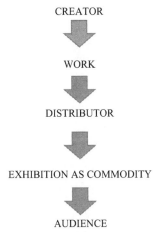

FIGURE 6.1 Traditional linear commodity-based mass media model

FIGURE 6.2 New communication and distribution model between media creators and audiences

The perceived threat that independently produced content could completely disappear has largely been overstated. Discussions about the dichotomy between the niches and the mainstream, the long tail and the blockbuster, have habitually been reductive and one-dimensional. As Henry Jenkins points out in *Spreadable Media: Creating Value and Meaning in a Networked Culture*:

> missing from these arguments is a simple reality: most people do not engage with only niche material or only mass-media material. People

use media texts both to enjoy shared cultural experiences and to differentiate themselves from mass tastes. Mass-media content often becomes spreadable because its relative ubiquity provides common ground for conversation with a wide variety of people. Niche content, on the other hand, spreads because it helps people communicate their more particular interests and sensibilities, to distinguish themselves from most others.[21]

As has been detailed earlier, certain genres—such as short web comedy, animation, horror, or science fiction—tend to have larger and more easily identifiable audiences. This makes it simpler for their creators to find and reach potential fans through social media and online platforms. The hardest hit and more difficult to adapt to the new realities will be—and already are—broad dramatic genres and art cinema, aimed at sophisticated cinephiles and more mature viewers. Most of these films have already a hard time finding commercial distribution or significant audiences beyond film festival circuits. Besides technological changes, other reasons, such as cultural shifts and broad changes in audience tastes, have contributed to this decline. However, even if these audiences are shrinking, they still do exist, and filmmakers and producers of such films can employ alternate means in order to reach them. Film festival circuits, various film organizations, critics, and curators' choices and dialogues, while valuable, have often become insulated from the broader popular culture and have failed to attract larger numbers of younger viewers with different media consumption habits. Though a few filmmakers will likely still be discovered through the traditional festival and art house film circuit and have their films become the next *Beasts of The Southern Wild* (2012) or *Whiplash* (2014), for most young independent filmmakers it would be sensible to search for new and more direct ways to reach and engage audiences. It is undoubtedly a challenge to cut through the present information and media overload, but the Internet, mobile technology, and social media allow for immediate and global ways of communication. Once the creator opens up new ways of thinking, beyond the paradigm of artistic work being reproduced and sold only as a commodity, it becomes possible to experiment and explore new ways of audience interaction and exchange.

How web series creators use YouTube

Source: Nordicity survey of independent web series creators, 2014

Tools for Interacting with audiences

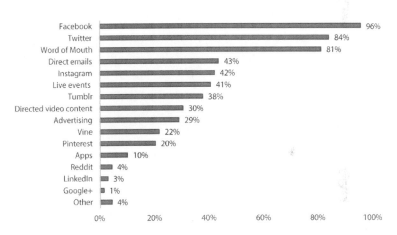

Source: Nordicity survey of independent web series creators, 2014 - responses may not sum to 100%

FIGURE 6.3 How independent web series creators use YouTube and interact with their audiences—based on Nordicity survey of independent web series creators in Ontario, Canada, 2014[22]

Audience interaction initially depends on the development and reach of a given social network, which is why Facebook and Twitter are at the top. In time, however, this could shift to other platforms or new social media channels; frequent algorithm changes on Facebook and Twitter make it increasingly harder for creators to interact with fans if there is no significant funding to support advertising on these networks.

▶ NOTES

1 Ted Hope, "Say Goodbye to Bizarro World: Time to Make Business of Art," *Truly Free Film,* October 2, 2013, http://trulyfreefilm.hopeforfilm.com/2013/10/say-goodbye-to-bizarro-world-time-to-make-business-of-art.html.

2 Cable News Network, "CNN Transcript—Special Event: Lars Ulrich, Roger McGuinn Testify before Senate Judiciary Committee on Downloading Music on the Internet—July 11, 2000," *CNN,* July 11, 2000, http://www.cnn.com/TRANSCRIPTS/0007/11/se.01.html.

3 Steven Johnson, "The Creative Apocalypse That Wasn't," *The New York Times Magazine,* August 19, 2015, http://www.nytimes.com/2015/08/23/magazine/the-creative-apocalypse-that-wasnt.html.

4 Ibid.

5 Jason Bailey, "Lynch, Waters, Soderbergh: A Generation of MIA Filmmakers," *Flavorwire,* December 9, 2014, http://flavorwire.com/?p=492985.

6 Johnson, "The Creative Apocalypse That Wasn't."

7 Jan Jasper, August 19, 2015 (comment on Steven Johnson, "The Creative Apocalypse That Wasn't," August 19, 2015, http://www.nytimes.com/2015/08/23/magazine/the-creative-apocalypse-that-wasnt.html).

8 Jason Bailey, "New York Times Magazine: Wrong on the Arts, Wrong on Data Journalism," *Flavorwire,* August 26, 2015, http://flavorwire.com/534772/so-about-that-ny-times-magazine-piece-on-the-creative-apocalypse-that-wasnt/.

9 Chris Anderson, "The Long Tail," *WIRED,* October 10, 2004, http://archive.wired.com/wired/archive/12.10/tail.html.

10 Chris Anderson, "Does the Long Tail Create Bigger Hits or Smaller Ones?" *The Long Tail—Chris Anderson's blog,* November 15, 2008, http://www.longtail.com/the_long_tail/2008/11/does-the-long-t.html.

11 Hope, "Say Goodbye to Bizarro World: Time to Make Business of Art."

12 Paul Resnikoff, "The 13 Most Insidious, Pervasive Lies of the Music Industry," *Digital Music News,* September 25, 2013, http://www.digitalmusicnews.com/2013/09/25/lies/.

13 Ibid.

14 Jeff Price, "Why the Music Industry Doesn't Care about Selling Music Anymore . . . ," *Digital Music New,* October 2, 2013, http://www.digitalmusicnews.com/2013/10/02/doesntcare/.

15 David Byrne, "David Byrne: 'The Internet Will Suck All Creative Content out of the World," *The Guardian*, October 11, 2013, http://www.theguardian.com/music/2013/oct/11/david-byrne-internet-content-world.

16 Hope, "Say Goodbye to Bizarro World: Time to Make Business of Art."

17 "The Future Will Be Streamed and Downloaded," *GoldRush Entertainment*, July 10, 2014, http://goldrushentertainment.com/the-future-will-be-streamed-and-downloaded/.

18 Byrne, "David Byrne: 'The Internet Will Suck all the Creative Content Out of the World."

19 William Dickerson, "How Can Middle-Class Filmmakers Make a Living?" *Indiewire*, October 26, 2015, http://www.indiewire.com/article/how-can-middle-class-filmmakers-make-a-living-20151026.

20 Anita Elberse, *Blockbusters: Hit-Making, Risk-Taking, and the Big Business of Entertainment* (New York: Henry Holt and Co., 2013).

21 Henry Jenkins, Sam Ford, and Joshua Green, *Spreadable Media: Creating Value and Meaning in a Networked Culture* (New York: New York University Press, 2013), 241.

22 Nordicity survey of independent web series creators in Ontario, Canada, 2014; Independent Webseries Creators of Canada—Créateurs Indépendants de Séries Web du Canada, industry profile of independent web series.

▶ BIBLIOGRAPHY

Anderson, Chris. "Does the Long Tail Create Bigger Hits or Smaller Ones?" *The Long Tail—Chris Anderson's Blog*. November 15, 2008. http://www.longtail.com/the_long_tail/2008/11/does-the-long-t.html.

Anderson, Chris. "The Long Tail." *WIRED*. October 10, 2004. http://archive.wired.com/wired/archive/12.10/tail.html.

Bailey, Jason. "Lynch, Waters, Soderbergh: A Generation of MIA Filmmakers." *Flavorwire*. December 9, 2014. http://flavorwire.com/?p=492985.

Bailey, Jason. "New York Times Magazine: Wrong on the Arts, Wrong on Data Journalism." *Flavorwire*. August 26, 2015. http://flavorwire.com/534772/so-about-that-ny-times-magazine-piece-on-the-creative-apocalypse-that-wasnt/.

Byrne, David. "David Byrne: 'The Internet Will Suck All Creative Content out of the World." *The Guardian*. October 11, 2013. http://www.theguardian.com/music/2013/oct/11/david-byrne-internet-content-world.

Cable News Network. "CNN Transcript—Special Event: Lars Ulrich, Roger McGuinn Testify before Senate Judiciary Committee on Downloading Music on the Internet—July 11, 2000." *CNN.* July 11, 2000. http://www.cnn.com/TRANSCRIPTS/0007/11/se.01.html.

Christian, Aymar J. "Joe Swanberg, Intimacy, and the Digital Aesthetic." *Cinema Journal* 50 (Summer 2011): 117–135. doi:10.1353/cj.2011.0049.

Daly, Kristen. "New Mode of Cinema: How Digital Technologies Are Changing Aesthetics and Style." *Kinephanos* 1 (December 2009). http://www.kinephanos.ca/2009/new-mode-of-cinema-how-digital-technologies-are-changing-aesthetics-and-style/.

Denson, Shane, and Andreas Jahn-Sudmann. "Digital Seriality: On the Serial Aesthetics and Practice of Digital Games." *Eludamos Journal for Computer Game Culture* 7, no. 1 (2013): 1–32. http://www.eludamos.org/index.php/eludamos/article/view/vol7no1–1.

Dickerson, William. "How Can Middle-Class Filmmakers Make a Living?" *Indiewire.* October 26, 2015. http://www.indiewire.com/article/how-can-middle-class-filmmakers-make-a-living-20151026.

Elberse, Anita. *Blockbusters: Hit-Making, Risk-Taking, and the Big Business of Entertainment.* New York: Henry Holt and Co., 2013.

Farhad, Manjoo. "Why Movie Streaming Sites So Fail to Satisfy." *The New York Times.* March 26, 2014. http://www.nytimes.com/2014/03/27/technology/personaltech/why-movie-streaming-services-are-unsatisfying-and-will-stay-so.html.

Fu, W.W., and Clarice C. Sim. "Aggregate Bandwagon Effect on Online Videos' Viewership: Value Uncertainty, Popularity Cues, and Heuristics." *Journal of the American Society for Information Science and Technology* 62 (December 2011): 2382–2395. doi:10.1002/asi.21641.

"The Future Will Be Streamed and Downloaded." *GoldRush Entertainment.* July 10, 2014. http://goldrushentertainment.com/the-future-will-be-streamed-and-downloaded/.

Hope, Ted. "Say Goodbye to Bizarro World: Time to Make Business of Art." *Truly Free Film.* October 2, 2013. http://trulyfreefilm.hopeforfilm.com/2013/10/say-goodbye-to-bizarro-world-time-to-make-business-of-art.html.

Jenkins, Henry, Sam Ford, and Joshua Green. *Spreadable Media Creating Value and Meaning in a Networked Culture.* New York: New York University Press, 2013.

Johnson, Steven. "The Creative Apocalypse That Wasn't." *The New York Times Magazine*. August 19, 2015. http://www.nytimes.com/2015/08/23/magazine/the-creative-apocalypse-that-wasnt.html.

"Movies Directly from the Creators | Reelhouse." *Reelhouse*. Accessed March 29, 2015. https://www.reelhouse.org.

Napoli, Philip M. *Audience Evolution New Technologies and the Transformation of Media Audiences*. New York: Columbia University Press, 2011.

Price, Jeff. "Why the Music Industry Doesn't Care about Selling Music Anymore . . ." *Digital Music News*. October 2, 2013. http://www.digitalmusicnews.com/2013/10/02/doesntcare/.

Reiss, Jon. *Think outside the Box Office: The Ultimate Guide to Film Distribution in the Digital Era*. Los Angeles: Hybrid Cinema Publishing, 2010.

Resnikoff, Paul. "The 13 Most Insidious, Pervasive Lies of the Music Industry." *Digital Music News*. September 25, 2013. http://www.digitalmusicnews.com/2013/09/25/lies/.

"Survey of Independent Web Series Creators in Ontario, Canada." Final Report, Nordicity June 23, 2014. Independent Web series Creators of Canada—Créateurs Indépendants de Séries Web du Canada.

Ulin, Jeff. *The Business of Media Distribution: Monetizing Film, TV and Video Content in an Online World. 2nd, Rev. Ed*, 2nd ed. Burlington, MA: Focal Press, 2014.

Vernallis, Carol. *Unruly Media: YouTube, Music Video, and the New Digital Cinema*. New York: Oxford University Press, 2013.

Webster, James G., and Thomas B. Ksiazek. "The Dynamics of Audience Fragmentation: Public Attention in an Age of Digital Media." *Journal of Communication* 62 (February 2012): 39–56. doi:10.1111/j.1460–2466.2011.01616.x.

Welsh, Josh. "Studying the Economics of Independent Film: A Proposal." *The Huffington Post*. October 22, 2011. http://www.huffingtonpost.com/josh-welsh/studying-the-economics-of_b_1026877.html.

"Why Filmmaking Cannot Be a Hobby." *Filmmaker Magazine*. April 9, 2014. http://filmmakermagazine.com/25958-why-filmmaking-cannot-be-a-hobby/.

Wyatt, Justin. *High Concept: Movies and Marketing in Hollywood*. Austin: University of Texas Press, 1994.

▶ FILMOGRAPHY

12 Years a Slave. Directed by Steve McQueen. 2013. Century City, CA: 20th Century Fox, 2014. DVD.

American Hustle. Directed by David O. Russell. 2013. Culver City, CA: Sony Pictures Home Entertainment, 2014. DVD.

Beasts of the Southern Wild. Directed by Benh Zeitlin. 2012. Century City, CA: Fox Searchlight, 2012. DVD.

Blair Witch Project, The. Directed by Daniel Myrick and Eduardo Sánchez. 1999. New York, NY: Lionsgate, 1999. DVD.

Blood Simple. Directed by Joel Cohen. 1984. Universal City, CA: Universal, 2001. DVD.

Blue Velvet. Directed by David Lynch. 1986. New York, NY: MGM, 2002. DVD.

Dallas Buyers Club. Directed by Jean-Marc Vallée. 2013. Los Angeles, CA: Focus Features, 2014. Film.

Do the Right Thing. Directed by Spike Lee. 1989. Universal City, CA: Universal Studios, 2012. DVD.

Eraserhead. Directed by David Lynch. 1977. New York, NY: Criterion Collection, 2014. DVD.

Pulp Fiction. Directed by Quentin Tarantino. 1994. New York, NY: Lionsgate, 2011. DVD.

Whiplash. Directed by Damien Chazelle. 2014. Culver City, CA: Sony Pictures, 2015. Film.

Wolf of Wall Street, The. Directed by Martin Scorsese. 2013. Los Angeles, CA: Paramount, 2014. DVD.

Section 2

Storytelling across Media Platforms

7

New Ways of Storytelling: Transmedia and Cross-Media Concepts

Transmedia is generally defined as the practice of spreading content over multiple delivery channels, such as film, television, mobile devices, books, magazines, online platforms, etc., in order to create a more immersive experience for the audience. This allows the viewers to enter the story-world through multiple media platforms and story "entry points," expanding on the characters, story, and themes of the main narrative. A transmedia project will usually allow for some level of audience participation and interactivity, whether only to comment and exchange information, or to actively partake and contribute to the project.

In a transmedia project, the sum of its parts is always bigger than each individual part, but each individual part, while creating its own unique contribution to the overall project, has to also contain the key premises of the main story. This allows the user to comprehend the main idea of a project without having to consume all of its channels and platforms. For example, a film can be the central part of a transmedia project, while social media, blogs, and games expand secondary storylines and characters. This gives more depth and background to the story and characters of the film, while allowing viewers to have a more participatory role. The viewers will experience a deeper, more fulfilling involvement if they view all of the project's elements, but even

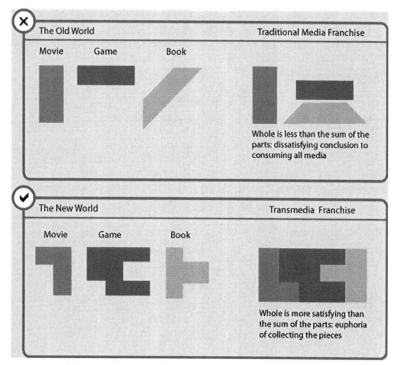

FIGURE 7.1 What is transmedia? Image by Robert Pratten.[1]

if they consume only some—or even only one of its channels—they will still be able to understand the main premise of the project and to follow its story.

Most observers in academia and the industry differentiate cross-media from transmedia concepts. Cross-media is generally defined as the practice of creating related content and distributing it on multiple channels and platforms in order to maximize its impact and revenue potential. The content usually revolves around a brand or main storyline, and the different uses of media platforms do not necessarily build on each other. The story-world and characters in cross-media do not expand through the various channels but point from one medium to another, while in a transmedia project each medium augments and enriches the user's experience: "The crucial difference between transmedia storytelling and multiplatform storytelling is the attempt to create synergy between the content and a focus on an emotional, participatory experience for the audience."[2]

These differences, however, can often be perfunctory and difficult to establish. Some media-makers and commentators blur these lines or use the terminologies

interchangeably, while the industry also uses terms like multi-platform content, or multi-channel and integrated marketing, all with very fluid descriptions and expectations. Some media professionals and academics have criticized the definitions of transmedia and cross-media as too "elastic or vague," but transmedia proponents have considered this a virtue: "this very expansiveness is what allows us to bring many different voices to the table, to map diverse kinds of experiments, and to promote new innovations and explorations."[3]

Creating story-worlds across multiple media channels is not an entirely new concept tied exclusively to the Internet. However, it has gained renewed traction over the past decade with the explosion of new technologies and media forms. Most commentators trace the modern idea of cross-media storytelling to the concept of Japan's anime "media-mix" from the 1960s. This concoction franchised various characters from comic books to animation, toys, and merchandise, while expanding their original story-worlds.[4] Others have posited the origins of transmedia even earlier, with literary sources that have originated within oral traditions and transitioned into written forms, and later into modern media, such as film, TV, and radio.[5] It is debatable to what extent these literary practices relate to the contemporary ideas of trans- or cross-media or should be considered merely adaptations of a successful character or work's main plotlines into different forms of media. Such is the case, for example, with Sir Arthur Conan Doyle's Sherlock Holmes character, which has been a popular mainstay for more than a century, from books, to radio, TV, and movies.[6] In each of the various formats, some aspects of the character and original story may have changed; however, the main premise of the original books remained the same, and, arguably, the many new incarnations of the genial detective have not substantially added to the story or expanded its original story universe.

Thus, it would seem more appropriate to think of these examples as versions and modifications of one story into different media formats, adding more contemporary formal elements and references over time. Even Guy Richie's ultra-kinetic Sherlock Holmes movies (2009 and 2011), starring Robert Downey Jr., while highly stylized, still adhere to the original Sherlock Holmes narrative. It is only with the BBC series *Sherlock* (2010–), starring Benedict Cumberbatch, where the character gets transposed into a contemporary setting, that Doyle's stories expand beyond their original ideas and further spread through other media, that we get a sense of a richer, extended story-world, resembling a cross-media experience.

The term "transmedia" was initially conceived by media scholar Henry Jenkins. Following his research on fan communities and convergence culture,

he originally presented his definition of transmedia storytelling in a 2003 analysis of the expanded universe of the *Matrix* film franchise, published in *Technological Review*.[7] Most of Jenkins's research on transmedia is based on fans' interactions with mainstream media, such as movies or TV. These fan-based interactions comment, re-mix, and re-purpose the original content, thereby contributing to, and expanding, the original story-world. This leads to increased fan participation and, in turn, pushes the industry to react and adapt its narrative and production strategies, spreading content across multiple media platforms.[8]

Various examples of transmedia practices in the mainstream industry include the Marvel universe of superheroes, which spreads from comic books over movies and TV to games and social media; the transmedia campaigns for movies such as *Batman* or *Hunger Games*; or HBO's TV series *Game of Thrones*, AMC's *The Walking Dead*, etc. All of these instances are primarily examples of using transmedia for marketing or franchising purposes, with the goal to increase viewer interest, immersion, and involvement. As the advertising and marketing budgets for these projects are very high—sometimes reaching up to $100 million—the media conglomerates have to rely on methods that can be scaled, repeated, and standardized in order to measure the financial impact of these efforts. Most blockbuster movie releases or TV show launches are now accompanied by some form of cross-media marketing and promotion, using multiple media channels, along with traditional advertising, social media, and other publicity tools.

The blurring of lines between storytelling, entertainment, marketing, and user engagement and participation has been astutely observed by Jenkins, as well as writer and digital culture commentator Frank Rose, among others.[9] The key terms that Jenkins and Rose use to describe these new realities of media production and consumption are *convergence* and *immersion*—the basic idea being that all media forms are merging into one ubiquitous immersive experience: "an ongoing process occurring at various intersections of media technologies, industry, content and audiences."[10]

It is perhaps less important whether we can clearly define these new practices as trans-, cross-, or integrated media creation, but more how they use storytelling systems to connect the various media channels for content convergence and audience immersion. The rise and spread of digital technology and the Internet continue to change the traditional media production and distribution models. Various media channels, social media

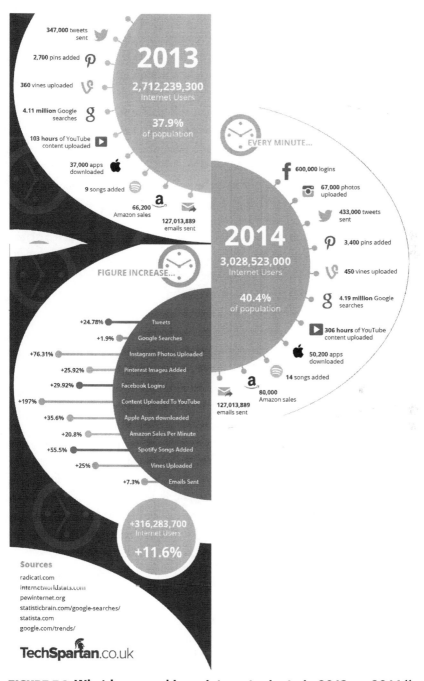

FIGURE 7.2 What happened in an internet minute in 2013 vs. 2014.[11]

platforms, mobile screens and applications, as well as console and casual games have inundated users with content. On average, in every minute of 2014, 306 new hours of content were uploaded on YouTube, 433,000 tweets were sent on Twitter, 67,000 photos were uploaded on Instagram, 600,000 log-ins clicked on Facebook, etc.—all increasing by more than 30 percent since 2013.[12]

It has become unmanageable to follow or consume even a small part of this mind-boggling and constantly growing volume of media. While there has never been more content and opportunities to create it, most projects have an increasingly difficult time finding and reaching an audience. Viewers have become oversaturated, with progressively shorter attention spans. With the exception of the ubiquitous conglomerates' blockbusters and franchises, consumers are generally more insulated within their narrow personal tastes and interests. The sheer amount of media actually makes it less likely now than ever that a viewer can "stumble upon"—or have the inclination and patience to search for—new and unfamiliar content, unless it has been recommended and "shared" by his or her peers through social media networks.

It is difficult to predict further developments and outcomes that this unstable transition and disruption of more "traditional" models of film and media production and distribution might produce. Many practices, technologies, and platforms that were new and popular less than a decade ago are already obsolete or have been replaced by newer ones, whether this is the DVD format or the once ubiquitous MySpace website. What has remained constant, however, is the desire to tell stories, the impact that storytelling can have on the audience, and our need to communicate with each other—regardless of the format. As Rose and others have argued, it is a basic human feature to communicate through stories—to create story patterns—in order to make sense of our shared experiences.[13] This used to be done from one source— the storyteller—through one medium, but it is now increasingly becoming a participatory effort, shared between creators and audiences, using various forms of media.

Content creators, producers, and distributors have been searching for new means to reach this increasingly fragmented, overwhelmed, and distracted audience. The concept of immersing viewers into story-worlds, spread across multiple media platforms, rather than through one central channel alone, gives viewers opportunities to engage with the content in a different

way: it offers them a model of "multi-verse" or "fragmented" storytelling, more closely matching the ways in which audiences currently consume media. The millennial viewer is likely to stream a program online, continue watching on his or her mobile device, exchange information about it via Twitter, and engage with secondary content through social games, websites, Instagram, Vine, Snapchat, Facebook, live events, etc.

Whether used primarily for marketing and branding purposes, or as a new form of storytelling and audience engagement, creators are exploring a range of strategies to achieve their goals. This is why trans- or cross-media has become a more fluid concept, meaning different things to different people, and encompassing a wide range of practices. However, the common thread still remains that a project spreads its content and manifold storylines across multiple platforms in order to reach, engage, and immerse the audience.

Not every project has to be a transmedia project of course, or is suitable to be presented in such a way, but almost every project can benefit from some aspect of it—whether the goal is to attract an audience, market or brand the content, or expand its popularity, or as a new storytelling methodology. This holds particularly true for independent film and media-makers. Considering their limited means and budgets, especially for promotion and distribution, if they adhere to the traditional production and distribution practices, they are likely to fail in this new, disruptive media environment. As conglomerates dominate media channels with their blockbusters and franchises, trans- and cross-media strategies become powerful, arguably even essential, tools for independents to distinguish their productions and reach potential viewers. Because of their sheer size, business tactics, and massive overhead costs, large corporations can generally only adopt established, one-size-fits-all practices, while independents can design custom-tailored strategies and experiment with different approaches. This allows independent media-makers to find their niche and potentially thrive in this new environment, without necessarily having to struggle to become "scalable properties" for the conglomerates' mass-market.

Such customized approaches, while fostering more genuine and direct user participation and engagement, also allow for a variety of diverse content on smaller scales to survive and flourish, using distinctly different models from the dominant corporate media products. Most YouTube content creators,

for instance, do not use YouTube alone, but use a variety of platforms to reach and communicate with their audiences. To put it in the terms of the new media creators: "We have niche audiences and know how to speak to them in their own language. Broadcasters want broad appeal. I can tell you how many people watched today, when they dropped out, their age and gender. That's what the Internet allows you to do—an immediate connection to audience."[14]

For simplicity's sake, we will refer to all the various types of multi-platform content creation from here on as transmedia. Various scholars and practitioners have introduced a range of definitions and distinctions between different types of transmedia projects, but they all mostly fall into three main categories: transmedia for marketing and branding, transmedia for documentaries and social action, and original storytelling through transmedia. The distinction is primarily defined by the objective of the project, which then determines its story-world, design, and media platforms that are being used.

Most transmedia forms are extensions of a main, central project, whether it is a film, a TV series, a game, a book, a product, brand identity creation, a documentary, or a social or educational engagement tool. Only original storytelling through transmedia does not have a "center"; instead, it actually uses all the various media platforms to tell the story through them. This aspect of transmedia is perhaps the most innovative and interesting new format, but also the most challenging. While there have been quite a few instances of original transmedia storytelling, one is still hard-pressed to find significant and successful examples that have resonated with audiences. What follows are some instances of each of the various transmedia practices as they have been utilized by the mainstream industry and by the independents.

Transmedia marketing for high-concept blockbusters are elaborate, big-budget productions, conceived and produced by agencies specializing in transmedia marketing and executed by either the studios themselves or contracted production entities. These transmedia campaigns precede the release of the blockbuster movie or TV series in order to build viewer anticipation, but they can also follow after the film or series end, for franchising purposes. Such transmedia franchise campaigns generally aim to bridge the time and retain the core fans' interest until the next installment is released. *The Matrix* and *Star Wars* film franchises had extended their stories across

other media platforms after the initial films, thus continuing to engage fans with the stories until the next sequel in the movie series would come out. Similar examples include *Pirates of the Caribbean, Avatar,* Marvel superheroes, *Hunger Games,* and others. For the studios, this practice has become a combination of promotion and marketing, fan engagement, and commercial franchising; it also offers prospects of auxiliary revenue streams through sales of related merchandise and products.

A notable creative and successful transmedia project extension is the campaign for AMC's TV series *The Walking Dead* (2010–). Based on the comic book serial written by Robert Kirkman, the series portrays the struggle between zombies and human survivors in the US heartland after a zombie apocalypse. Like the comic book, the TV series became a huge success, drawing in record audiences. To enhance the viewers' experience and engagement with the series, AMC developed a number of story extensions across multiple media platforms. In 2011, AMC started a thirty-minute companion talk show, *Talking Dead,* hosted by comedian Chris Hardwick, with actors as well as fans and the series' production crewmembers contributing. The show was also complemented by "Story Sync," an application that allows users to post live comments on episodes and communicate with other fans. Besides the usual fans' social media engagement through Twitter and Facebook, the series used a Facebook-based social game as well. In *The Walking Dead Social Game* players have to defend their own camp against the zombies, with the help of their Facebook contacts.

In addition, AMC produced exclusive online-only webisodes (web episodes), which extend the main narrative threads, as well as a series of special videos with interviews, trailers, and behind-the-scenes content. Also in 2011, the company TelltaleGame introduced a console-based *Walking Dead* episodic video game series. The game became a huge success, with millions of downloads. This was followed by mobile games and fan-based quizzes and contests on the series' website. To round it up, real-life events were introduced, such as "Zombie walks" and the "Walking Dead Escape" at the San Diego 2012 Comic-Con. Fans have also been invited to become extras in the series, if they complete training at the AMC "Zombie School."

The story world of the series has spread over an impressive amount of media channels, with each contributing another aspect to the overall narrative and allowing for a different way in which the user can engage with the content.

The diversity of channels and storylines, however, does not by itself guarantee user immersion and satisfaction. The success of all these elements, as well as the TV series itself, is also due to the consistency of the narrative, design, and characterizations, with each part leading back to the initial core vision and mythology of the comic books.

HBO's hugely popular TV series *Game of Thrones* (2011–) was first introduced, and later expanded, through a highly creative transmedia campaign. The TV series, based on the popular fantasy book series *A Song of Ice and Fire* by George R. R. Martin, follows the rise and fall of several noble houses competing for power in the fictional lands of Westeros and Essos. The challenge for HBO was how to market the TV series to viewers not familiar with Martin's work, without alienating longtime fans of the books. The writer himself was very protective of his creation, so the marketing campaign had to take that into account as well. The marketing agency Campfire, which already had experience with transmedia campaigns, developed the strategy for the promotion of the series. Given the limitations imposed by the writer, Campfire created a campaign closely related to the books and their story-world. In the books, "Maesters" are an order of scholars, healers, and advisors to the nobility of Westeros. Every Maester must forge a chain. Each link in that chain represents his mastery of a specific craft, like medicine, statesmanship, etc. Campfire created the website the Maester's Path, where visitors were invited to take a journey to become Maesters themselves; they could "complete their chains" by engaging in *Game of Thrones*–related challenges. Each challenge was inspired by the five senses. Answers to the challenges unlocked rewards and clues to the next challenge. As part of their quest, visitors were also asked to invite five friends to take the "Maester's Path" as well, thereby extending the game to new followers.

Mirroring the books' ideas, Campfire based their concept on the five senses. They reached out to influential journalists, bloggers, and core fans of the book series, which had large numbers of followers. The "influencers" received an elaborate antique box with custom-made scents, inspired by the regions of Westeros. The idea to send them a physical object instead of something online gave the gesture increased significance and attention. The influencers shared the content of the boxes through "unboxing" videos, blogs, and articles, spreading the information to their followers; this campaign was related to the first sense, smell.

The second sense, sound, was introduced through "The Inn at the Cross-roads," which is a recurring location in the books. Located on the Maester's Path website, the Inn was an interactive sound environment that let visitors listen in on the conversations of various patrons and innkeepers. The third sense was sight. Through a first-person virtual reality, visitors to the Maester's Path website could walk the path of the "Night's Watch" soldiers, who guard the wall of ice that separates Westeros from the "wild of the Northern Lands." A player's goal would be to spot invaders from the North and blow a horn to sound the alarm. Through the game, users would learn the history of the wall and engage in social interactions with other guards, collecting clues along the way.

An application for the iPhone and iPad was created to simulate the fourth sense, touch. The app provided fans with climate-driven storytelling experiences; it also gave users a foretaste of the series through video stills from the show before its premiere. The fifth and final sense was taste. By this time the campaign had already created considerable interest and media buzz. Celebrity chef Tom Colicchio was asked to create a series of regional dishes inspired by the "seven kingdoms of Westeros." A new recipe video featuring the chef was released daily. Food trucks were posted in New York and Los Angeles, and clues to the truck locations were disclosed through Twitter and Facebook. The food was served free of charge, alongside menus containing hidden messages that linked back to the Maester's Path website challenges. This resulted in long lines of fans waiting in anticipation, which, in turn, attracted the attention of passers-by and was followed by widespread publicity in the mainstream press.

New challenges on the website were introduced weekly, along with social media engagements and interactions between fans and influencers. The Maester's Path website was the center of the campaign, introducing new visitors to the world of *Game of Thrones*, while also providing deeper engagement to longtime fans through the weekly challenges. News and clues for core fans were also posted on various other fan portals, such as WinterIsComing.net. The transmedia campaign generated significant interest and anticipation for the TV series. Over eight million viewers tuned in to watch the season premiere. The campaign received so much attention that HBO continued the momentum to launch the season-two DVD and Blu-ray box set, and the lead-up to the third season. The TV series became one of the most popular series on US television, while the transmedia campaign continued to supplement the successive seasons.[15]

Many blockbuster films, as well as popular console games, employ a similar variety of transmedia marketing and franchising strategies. These usually include alternate reality games (ARGs), which means interactive and networked narrative threads that use real-world events to introduce the brand and story through a mixture of challenges, games, and clues. They gradually expand onto online platforms and social media, leading up to the premiere of the next installment of the franchise or launch of a new game or product. Examples include Lionsgate's *The Hunger Games* campaigns (2012–2015); 42 Entertainment's *Why So Serious* campaign for the Batman sequel, *The Dark Knight* (2008); the *I Love Bees* transmedia prequel to the Xbox game *Halo 2* (2004); Starlight Runner's campaigns for the *Spider-man, Men in Black*, and *Pirates of the Caribbean* movie franchises; and many others.

It is important to note that these campaigns are typically aimed at millennials and are representative of the movie genres and products that this audience is most likely to consume. All of the preceding transmedia examples are based on previously successful, branded stories and characters, which already had a base of loyal core fans. In these cases, the marketing task is usually to expand this fan base if a project transitions from one medium into another—from a book to a TV series, to a film and/or a game—or to continue interest in a successful franchise within the same medium (for example, *Star Wars* or *Avatar*). It is, of course, much more difficult to build a brand and following for a project from zero—which is exactly what independent film and media-makers most often have to do.

The independent film that arguably had one of the most successful transmedia marketing campaigns was actually made before social media even existed. It employed only the Internet to create its mythology and brand identity and reach its audience. Daniel Myrick and Eduardo Sanchez, film school graduates from the University of Central Florida, came up with the concept for *The Blair Witch Project* in 1997. After making a short mockumentary[16] about the history of the Blair Witch, they managed to screen it at the then-fledgling cable TV station the Independent Film Channel (IFC), which could only be seen by a limited number of subscribers in Manhattan. In spite of that, the short's broadcast at IFC's weekly *Split Screen* series, devoted to independent films, garnered considerable interest, with many viewers contacting the channel to find out whether the story was true.

In 1998, Sanchez created the Blair Witch website, before their planned feature film was even completed. The site almost immediately started getting views and online traffic, and soon it became the center of the Blair Witch "universe" and marketing campaign. The key concept of the film was that the protagonists, who were making a documentary on the Blair Witch, went missing, and the actual film was the footage that they had left behind. The website promoted and reinforced the impression that there really was a Blair Witch, and it posted seemingly real videos and documents explaining the backstory of the events leading up to the disappearance of the main characters. Through guerilla marketing, mostly online, along with stickers, "missing persons" flyers, and other low-tech means, the filmmakers managed to arouse considerable interest within the film establishment and media.

The first screening of *The Blair Witch Project* was at the Sundance film festival's midnight program in January 1999. While the filmmakers' grassroots campaign managed to lure all major independent distributors to the screening, most of them did not realize the film's potential; as has been noted, even Miramax's head acquisition executive at the time, Jason Blum, was not impressed. However, one small independent distribution company, Artisan Entertainment, did acquire the film for a reported million dollars.[17] Artisan and the filmmakers agreed to continue the marketing campaign in the same vein the filmmakers had started it. During the next six months, they expanded the online campaign into what would now be called transmedia marketing, steadily building a larger fan base and a cult status for the film. When the film premiered in June 1999, viewers queued for hours for tickets. The film grossed $1.5 million on its opening weekend, playing on only twenty-seven screens. *The Blair Witch Project* ended up making $250 million at the box office, while Artisan had spent only an additional million dollars in total to market and promote the film. The return-on-investment on this small independent movie, made for $35,000, compared to the average studio blockbuster, still remains staggering.

The center throughout the campaign continued to be the main website, but the content spread across blogs, Internet chat rooms, and other websites. A variety of trailers were posted online, each shot in the same fragmented POV-style as the film, fostering interest, but withholding most information. Artisan and the filmmakers introduced various artifacts and designs connected to the mythology of the story, which were successfully sold on the online marketplace eBay. The distributors even managed to get the Internet

Movie Database (imdb.com), the prevalent movie information website, to initially list the film's three protagonists as "missing."

Artisan also focused on presenting the Blair Witch mythos through popular youth channels of the time, such as MTV and the Sci-Fi TV network, as well as influential bloggers and college campuses. At the same time, a spate of fan-based sites sprung up online, commenting and contributing to the story. Many commentators have observed that most of these "fan sites" appeared to be, at least initially, created by Artisan to fuel further interest and buzz. Throughout the campaign, the essential element was the mystery of whether the story was true, and the feeling that the audience shared a secret, which they themselves had discovered. Thus, by avoiding mainstream advertising, Artisan not only saved money but made the campaign much more effective. Before the film's theatrical premiere, a Blair Witch book and comic book were announced, the film's soundtrack was released, and a TV special was produced for the Sci-Fi channel, *The Curse of the Blair Witch Project* (1999).

It is significant to highlight once more that *The Blair Witch Project* was in the horror genre, which is generally very popular with young audiences and does not require movie stars to be successful. This had been already proven with low-budget hits like *Halloween* (1978), *Friday the 13th* (1980), *The Evil Dead* (1981), *Nightmare on Elm Street* (1984), etc. That fact alone, however, cannot explain why *The Blair Witch Project* has become such an exceptional cult phenomenon. The reason for this can be found in the film's unique and original concept at the time, which resonated with its contemporary young audience. The innovative transmedia marketing campaign managed to attract and engage that audience, while at the same time extending and enhancing the iconography and mythology of the film. On the film's opening weekend, Artisan took out a full-page ad in *Variety* magazine, "simply noting the [Blair Witch] website and the number of hits to date: 21,222,589."[18]

More recently, independent films like *Iron Sky* (Vuorensola, 2012), *The Cosmonaut* (Alcala, 2013), or *What We Do in the Shadows* (Clement and Vaititi, 2015), to name a few, have used similar transmedia marketing strategies. They used the Internet, along with various social media channels, and often also incorporated crowdfunding and crowdsourcing practices for fundraising, as well as fan-building and outreach purposes. Each film has

created a unique and innovative campaign, reflecting the film's particular genre, story-world, and design. The creators of *Iron Sky* went even further by developing a sequel, *Iron Sky 2: The Coming Race* (2016).

In all these cases, transmedia served the purpose to attract, grow, and engage the audience; this, in turn, enhanced the reach and visibility of each of the films. In these times of media over-abundance, such small independent films would never be able to have the same amount of exposure and impact with a traditional film release alone. This writer could offer a similar example with his micro-budget futuristic feature film *Zenith* (2010), which, thanks to its transmedia marketing and story expansion, managed to receive millions of downloads worldwide. All of the aforementioned films operate within genres that are popular among online forums and blogs, and millennials in general. *Zenith* played with the concepts of conspiracy theories and ideas of a dystopian future; *Iron Sky* is a sci-fi parody about Nazis who had fled to the dark side of the moon and are invading Earth in the future; *The Cosmonaut* is a sci-fi drama about a cosmonaut, who after being lost in space, returns to an empty Earth; while *What We Do in the Shadows* is a comedy about ancient vampires coping with the vagaries of contemporary life.

In order to create successful transmedia marketing campaigns, it is vital for independent film and media-makers to identify and reach their projects' anticipated core audiences. The expectation is that, if the project catches their attention, the core audiences' engagement will grow, and interest for the film will spread. The number of people who will engage with a project on a deep level is usually not high, but they become the critical mass of core fans, who will advance and spread the content and interest for the main project (the film, series, or other). Core fans follow and engage with multiple channels and platforms, containing teasers, ARGs, as well as extended story-worlds, characters, and various interactive components.

For certain genres, such as sci-fi or horror, this is of course easier to do than, for example, for an experimental art house film. However, even a broader, artistic film can use similar strategies. Such a project would generally depend more on critical praise, film festivals, and similar mainstream recognition, building a core following for the filmmaker or artist, rather than for one individual project only. Once the artist has such a

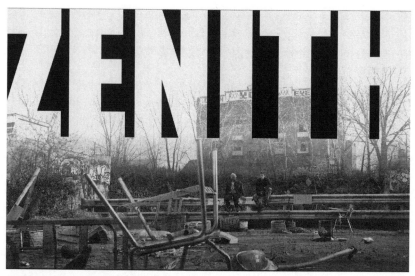

FIGURE 7.3 *Zenith* **cover image**

following, transmedia strategies can then help to popularize his or her next projects, enhance the communication with fans, and broaden the artist's reach. Such is the case, for example, with the musician and artist Amanda Palmer.

Palmer, who performs in the small niche genre of "cabaret punk" music, was able to raise over one million dollars through Kickstarter for her album and tour.[19] This was possible because of her direct communication with her fans (she had amassed over half a million Twitter followers over time), as well as her associations with various other artists. These associations resulted in the creation of a mix of music, art, video, books, and performance. All these works were done in collaboration, or were inspired by Palmer and her musical themes, and offered to Kickstarter contributors as funding rewards, thus creating a transmedia extension of her original content.

Audience engagement with multi-platform content can be effectively summed up with the following image:

The two pyramids show that the vast majority of viewers prefer a passive experience (the "lean-back" experience of watching film or TV). However, the spread of a concept, a project—or a "meme"—usually starts from the

THE RULES OF DIGITAL ENGAGEMENT

FIGURE 7.4 The rules of digital engagement. Image created by Mike Dicks, Descience Limited[20]

top, from users who relate to the content at the deepest level (the "producers"), contributing and interacting with the project creators, followed by the "players," who are less involved than the "producers," but still more participatory oriented than the inactive viewers. Recognition and reception of content generally flows from this top 25 percent down to the larger, passive audience through their recommendations and communication.

Word of mouth is still the most effective marketing tool, and with the rise of social media it has become omnipresent, enabling popular content to become "viral" (or "spreadable," in Jenkins' terms).[21] Once the amount of passive consumers reaches critical mass, social media presence of a project or artist can seem ubiquitous, spilling over into mainstream media coverage, as was the case with *Paranormal Activity*, Lena Dunham, or the many YouTube and Vine celebrities. In many cases, however, content does not even need to become "viral," as long as the creators have sufficient support from their core fans—the "producers," who are engaged beyond the level of passive consumers.

Deep engagement is also important for the success of documentary or social-issue-centered transmedia projects. Here, the "producers"—who are engaged with, and contribute to, the actual content—are not as much the target audience but people affected by the problems or issues the project is trying to address, as well as supporters of a cause, or activists fighting for change. Documentary filmmakers are thus able to expand their linear stories to reveal deeper backstories and immerse the audience with the topics, characters, and communities of the projects, which can then lead to calls for action and change. There have been many examples of these types of projects lately, ranging from simple online extensions of feature documentaries to serialized content across platforms. Their goal is usually not commercial but educational or activist in nature, and their success measured by their social impact rather than through revenues.

The basic mission of documentaries, which has been to inform and educate the audience in a deeper, more meaningful way than news stories, is now often not enough. Information is abundant and more than accessible through the variety of media we consume; any subject searched online will most likely yield dozens of videos and websites. Documentarians are increasingly challenged to create greater impact with their films, not just to present facts and stories. Given that transmedia project extensions offer audiences opportunties to participate and be actively involved, and the fact that most documentary and social issue projects are funded by non-profit foundations and grants, there have been rising expectations for documentaries to have some transmedia extention component beyond the film or series. A good early example of a successful documentary extension that led the audience to engage deeper with the film's subjects, had a positive impact, and fostered actual change was the campaign *Kids with Cameras*.

Kids with Cameras was an extension of the Academy Award–winning documentary feature *Born into Brothels* (Briski and Kauffman, 2004). The film chronicles the lives of children of prostitutes and their mothers in the red light district of India's Calcutta. The filmmakers inspired a group of talented kids to discover photography and document their surroundings, trying to help them to a better life. The campaign *Kids with Cameras* was started in order to raise money and awareness for the children through sales of their photography prints. The children's work was exhibited in galleries, in museums, and at film festivals in India, Europe, and the United States; updated information was posted, and donations were collected online, while a book

of their work was created. Sales of the prints and books supported the education of the children, and also eventually enabled the filmmakers to raise $1.2 million to start Hope House, a safe haven for other children of Calcutta prostitutes. The purpose of Hope House was to provide an "opportunity for the children to learn, thrive and lead future generations."[22]

The non-profit organization Breakthrough.tv offers another example of how transmedia campaigns can be used to address human rights, discrimination, and domestic violence issues. The company operates both in the United States and in India. While its US-based transmedia projects use gaming, video, and online and social media platforms, its projects in India are adapted to the prevalent local technology and customs, primarily relying on mobile phones and direct action. Breakthrough.tv has been recognized for its successful anti-rape campaign *Ring the Bell*, which was aimed at challenging violence against women. Other campaigns include *ICED*, an online video game, where the player becomes an illegal immigrant and tries to navigate all the different issues related to that experience; in *America 2049*, they created an alternate reality game on Facebook and integrated it with multimedia and interactive features, historical facts, clues planted across the Internet, and real-life events at cultural institutions nationwide in order to highlight themes related to human rights and democracy. A similar organization, which only focuses on gaming, is Games for Change. It facilitates the creation and distribution of social impact games that serve as tools for humanitarian and educational efforts, sometimes collaborating with filmmakers and organizations on multi-level educational projects.

Multiple documentary storylines, non-linear narratives, as well as entire communities can nowadays be presented more effectively online and through transmedia, rather than through a traditional film or TV. Such is the case with the interactive documentary *Gaza Sderot: Life in Spite of Everything* (Szalat, Ronez, Lotz, 2008). Using a location-based model of storytelling, the viewer can click on a map, showing the border between Palestine and Israel. On one side is the Palestinian city of Gaza, and on the other the Israeli village of Sderot. The towns are less than a mile apart, with Gaza suffering Israeli blockades, while Sderot is often targeted by Palestinian rocket fire. From October 26 to December 23, 2008, two video interviews—one from Gaza and one from Sderot—were shot and posted daily to the website. Eventually, all these short videos became an overarching narrative of "life in

spite of everything"—how ordinary people on both sides of the conflict live their daily lives, providing deeper insight into the human side of the political conflict.

Besides navigating the maps to see the videos, viewers can scroll through an interactive grid of interviewee faces, or click on theme tags to learn more about the conflict and the protagonists.[23] A similar case of multi-strand storytelling is the project *Dadaab Stories* (Jones, Copeland, 2013), which features videos, news, poetry, music, and stills from Dadaab, the world's largest refugee camp. The videos and interviews were shot by the filmmakers, as well as Dadaab residents. The numerous protagonists present manifold individual stories, which together create a complex narrative about what life in a refugee camp actually looks like. The intricacies and details of this project would have been difficult to reproduce to equal effect in a linear narrative.

The National Film Board of Canada (NFB) has also produced a variety of interactive, online, or multi-platform documentaries through its NFB/Interactive division: *Bear 71* (Mendes, Allison, 2012), which features a map of Canada's Banff National Park, where users can click and follow the movements of "Bear 71" by scrolling over the cameras, and also look at other users by activating the computer's webcam. Bear 71 was a real grizzly bear who was collared at the age of three and whose whole life was recorded via trail cameras. The larger idea of the project was to explore human and animal relationships, and the effects that human settlements and technology have on wildlife. Another NFB interactive project, *Welcome to Pine Point* (Shoebridge, Simons, 2011), chronicles and investigates the past and memories of residents from the former mining community through video, audio, music, stills, and interviews—which, taken together, explore a larger theme of how we remember the past; in *A Journal of Insomnia* (Duverneix, Choinière, Lambert, Braun, 2013), users can follow four protagonists or thousands of online contributions about sleeplessness.

Similarly, the company Submarine Channel produced the interactive online transmedia documentaries *Collapsus* (2010), *Unspeak* (2013), and *The Last Hijack Interactive* (2014). *Collapsus* surveys themes and problems relating to fossil fuel energy production and consumption by combining an interactive website platform with animation, maps, fictional stories, and documentary interviews; *Unspeak* investigates the manipulative uses of language through short videos, data visualization, and a participatory dictionary; while *The Last Hijack Interactive*, another "online transmedia experience,"[24] is about

piracy in Somalia, where the interface allows users to view the same story from multiple perspectives. All these projects were conceptualized and directed by independent filmmaker Tommy Pallotta, who had previously produced and contributed to Richard Linklater's films *Waking Life* (2001) and *A Scanner Darkly* (2006).

Some of these projects could also be considered original transmedia storytelling practices, as they use the various strands and channels to tell the entire story, without a main, central storyline or media format. Undeniably creative and innovative in the use of storytelling techniques and online platforms, many of these projects have received critical praise and awards but had quite limited audience reach and impact. Arguably, this can be explained by the absence of established distribution and publicity models for such new formats. However, this could also be at least partly attributed to their lack of adequate social media integration and limited use of other channels to promote and spread the word beyond the initial, mostly experimental audience engagement and interaction. Since funding for these projects is generally not commercial in nature, it usually concludes when the production is finished, rather than continuing through the distribution stage. Consequently, this discourages the creators from investing additional time and energy into distribution and promotion and, in that way, tends to contribute quite significantly to the relative obscurity of these projects beyond the small circles of online documentary and transmedia enthusiasts.

While often groundbreaking and exciting, all these new documentary-related transmedia practices have also raised numerous questions, which still remain to be answered:

> Who are the audiences engaging with these new works? How many
> of them are there? And if they're watching on iPhones, iPads and
> new computers, who is being left out? Is money being siphoned away
> from conventional production to the websites and apps that, in many
> cases, are supposed to be extensions of those projects? And for the
> filmmakers themselves, are they being pushed towards media-making
> in ways they aren't suited?[25]

A more defined need for transmedia practices is evident in the world of product advertising and corporate branding. Digital video recorders and various ad-blocking software allow consumers to skip or block ads, whether

they are watching television or perusing online content. Because of this, as well as media oversaturation, audience fragmentation, and general viewer attitude shifts, traditional mass media models of advertising have progressively become less effective. Studies have shown that this is especially true for younger audiences, who are the prime targets for most advertisers; only 1 percent of millennials say that a compelling ad will make them buy something,[26] and, with every new generation watching less and less regular TV programming, advertisers increasingly have to devise new strategies in order to reach consumers and build brand loyalty.[27] Due to their prevalent use of digital and social media tools, younger consumers expect more "engaged" and "participatory" experiences in the way they use and relate to brands and products.

The thirty-second TV ad is still present but has been augmented or supplanted by immersive and transmedia storytelling concepts, aimed at creating "branded content" in order to more proficiently raise visibility for brands and sell commodities. Jeff Gomez and his company Starlight Runner

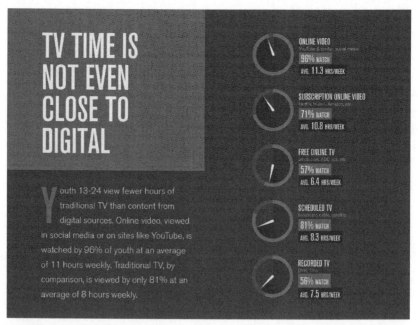

FIGURE 7.5 13–24 year olds view fewer hours of traditional TV than content from digital sources. Image by DEFY Media, 2015 Acumen Constant Content Report.[28]

FIGURE 7.6 Network usage among 18–24 year olds. Image by DEFY Media, 2015 Acumen Constant Content Report.[29]

have been in the forefront of using transmedia for branded content, marketing, and advertising since 2000. Gomez defines transmedia as "the process of conveying messages, themes or story lines to a mass audience through the artful and well-planned use of multiple media platforms. It is both a technique and philosophy of communications and brand extension that enriches and broadens the lifecycle of creative content."[30] Other agencies, like Campfire and 42 Entertainment, have followed, and today most advertising firms have specialized transmedia (or "multi-platform digital marketing") divisions.

The challenge of these transmedia concepts is twofold: to reach and engage the consumers through a rich, immersive story-world, while staying consistent to the original brand identity, but also to market the product, without alienating the audience by making the advertising and marketing aspect of the project overtly obvious. Many observers have agreed that the key to the success of these projects is to "listen to the consumers"[31] and then to "create and implement interactive endeavors to unite the audience of the property with the canonical narrative" of the brand.[32]

In 2001, the German car manufacturer BMW produced a series of eight high-concept short films for the Internet under the title *The Hire*. Each of the shorts was directed by an established director, such as John Franken-heimer, Ang Lee, Guy Ritchie, Alejandro Iñárritu, and John Woo. All the films starred Clive Owen as the "Driver," who gets hired by various people to transport someone or something of vital importance for the clients. Each of the films featured an original story filled with action and car chases, showcasing the various performance aspects of BMW cars. After the first initial episodes, BMW's sales numbers went up by 12 percent.[33] The films were watched over eleven million times in four months. Two million people registered with the website and spread its popularity further by forwarding links to the site to their friends. Low-budget "sub-plot films" were shot on consumer camcorders and posted online in order to fill the gaps in between the main short films; they were part of an ARG, featuring a man following the "Driver," and leaving clues for the viewers, which eventually lead to a promotional party in Las Vegas.

Another ARG let viewers discover links through various websites and then solve different puzzles, which were part of a contest, where the winner would win an actual BMW. Over a period of four years, the series has been watched over one hundred million times and has become a landmark in branded entertainment. The success of *The Hire* popular-ized digital marketing through storytelling, which, with the expansion of new media channels, further advanced various multi-platform formats for advertising. *The Hire* also influenced a range of other franchises and projects: inspired by the BMW campaign, Audi created the ARG cam-paign *The Art of the Heist* in 2005 in order to promote their release of the Audi A3. French film director Luc Besson created the movie fran-chise *The Transporter* (2002–2015), which, as he admitted, was entirely inspired by *The Hire*.[34]

Many other branded transmedia campaigns followed. The after-shave brand Old Spice created a campaign featuring the football star Isaiah Mustafa directly interacting with consumers across a range of different media plat-forms; Axe deodorant created the *Axe Anarchy Graphic Novel* campaign, featuring storylines and characters suggested by fans; McDonald's created *The Lost Ring* alternate reality game around the 2008 Olympics to drive consumers to search for clues and visit its restaurant chains; the mobile phone company Nokia created a series of different transmedia projects and ARGs in order to promote its brand and technology; while Lego *Bionicle,*

Mattel *Hot Wheels*, Microsoft's *Halo*, and Coca-Cola's *Happiness Factory* campaigns all employed a remarkable range of story-world and character-building practices and techniques across multiple channels for their transmedia campaigns.

Such transmedia practices can also be successfully employed by independent film and media-makers trying to build or expand their brands. Distribution advisor and consultant Peter Broderick describes two such successful examples on his blog, centered on the documentaries *Forks over Knives* (2011) and *Hungry for Change* (2012). Based on the book *The China Study* by T. Colin Campbell and Thomas M. Campbell II, which outlines how a plant-based diet can prevent or even reverse diseases, Brian Wendel, a dedicated vegan, along with producer John Corry and filmmaker Lee Fulkerson set out to make *Forks over Knives*. They raised funding for the film from private investors; instead of relying on film festivals and traditional documentary distribution methods, they directly targeted their core audience.

Local Whole Foods stores co-sponsored numerous advance screenings of the documentary across the country, marketing the film to their customers. This way, the filmmakers started building word-of-mouth and interest for the film. Instead of selling *Forks over Knives* to a distribution company, the filmmakers hired an experienced consultant for the theatrical distribution and rented a theater in Portland, Oregon, showing the film for a week to demonstrate to other exhibitors its theatrical potential. The film made $13,000 in the first week, and was held over four more weeks; it opened later in ninety more theaters in the United States and Canada, and eventually screened at over five hundred "semi-theatrical" or "non-theatrical" venues. "After grossing over $700,000 in theatres, the film has sold over 180,000 DVDs, (and) become a *New York Times* bestselling book."[35]

The filmmakers engaged their audience primarily through Facebook (over 670,000 likes as of this writing), and newsletters, regularly sent out to their 70,000+ subscribers. Viewers were invited to sign up for the newsletter on the *Forks over Knives* website, which included original, as well as third-party, content. Expanding their concept onto other media platforms, the filmmakers released the book *Forks over Knives: The Plant-Based Way to Health*, which stayed on the *New York Times* bestseller list for fifty-nine weeks. Soon they followed with the *Forks over Knives Cookbook*, along with other related merchandise, which they sold directly from their website. Together with the *Engine 2 Diet Team*, which is featured in the documentary, they have

also organized weekend immersion workshops in healthy cooking, *Farms 2 Forks*, attended by hundreds of people each. As Broderick notes, the filmmakers did not initially set out to build a brand, but they gradually expanded the story through multiple platforms, building on their results: "The film, the books, and the weekend retreats have reinforced each other, achieving critical mass with the Forks Over Knives brand."[36]

A similar example of independent filmmakers who successfully marketed and branded their content through platform extensions is the documentary *Hungry for Change*. Made by the husband-and-wife team James Colquhoun and Laurentine Ten Bosch, it follows their 2008 documentary, *Food Matters*, which sold over 230,000 DVDs. Through that documentary, the filmmakers gathered a loyal core audience, offering them regularly updated, dynamic, and useful content through their website *foodmatters.com*. In 2011, the filmmakers experimented with showing the film for free online for eight days on their website, which resulted in a big spike of DVD sales and over thirty-seven thousand new members joining their mailing list.[37]

Their second film, *Hungry for Change*, exposes the deceptive practices of the weight loss and food industries, and it advocates for a healthier, natural diet. When the film was completed in 2012, they released excerpts and trailers online and partnered with various food and nutritional experts featured in the film, who promoted the documentary to their own followers. Through their and their partners' online outlets, the filmmakers announced that the film would have an exclusive online world premiere on March 21, 2012, and would be streaming for free for ten days. The results were remarkable, with over half a million views from over 150 countries, accomplished without any paid advertising. This, in turn, led to a significant increase in new subscribers to their website and, eventually, in DVD and recipe book sales, totaling over $1 million in sales during the first fourteen days of the film's release. As Broderick again notes, the benefits of this approach to media making and distribution go beyond revenues. The filmmakers were motivated to get their message about a healthy diet and lifestyle to as many people as they could; the free screenings allowed more people to see their film and to build awareness of their concept, thus allowing them "to develop a truly interactive relationship with their audience. They talk directly to their followers who tell them what they want. This knowledge has enabled them to make and market films that meet their followers' needs and continue to be seen by more and more people."[38]

These cross-distribution strategies are ideal for specialized, utilitarian topics, whether it is about food, dieting, exercising, learning, or other similar content. Transmedia marketing concepts, along with digital production tools, crowdfunding, and social media platforms and direct-sales software empower independent media producers working in this field like never before, making them increasingly less dependent on intermediaries, and capable to reach and communicate with their audience and customers directly.

Another, altogether new, concept is the idea of using transmedia as the only storytelling tool, building and spreading the story across platforms, without having any actual "center." Experimental at this point by definition, this concept encompasses a very broad range of different practices, with varying results. Some include virtual reality applications in game-like real-life environments, while others mix non-linear narrative strands through a variety of channels and platforms, combining all kinds of media and audience engagement techniques, from video, audio, text, games, and ARGs, to immersive live performances. Some projects primarily gravitate toward artistic experimentation, while others explore the storytelling possibilities of new technologies. Fostered and supported mostly through foundations and festivals, such as the Sundance Film Festival's *New Frontier* program, or the Tribeca Film Festival's New Media Fund and *Storyscapes* section, the larger impact and implications of these forms still remain to be seen. The optimistic exuberance and hope of some observers and creators that this is the inevitable "future of storytelling," at least in this particular form, still appears to be an overstatement.

The independent transmedia project that is often singled out for its successful and highly creative use of multiple media platforms for storytelling and audience engagement is the series *The Lizzie Bennet Diaries*, or *LBD* (Hank Green, Bernie Su, 2012–2013). *LBD* is a modern adaptation of Jane Austen's popular nineteenth-century romance novel *Pride and Prejudice*. Set among the privileged British upper class, the book follows Elizabeth Bennet, the second of Mr. and Mrs. Bennet's five unmarried daughters, as she deals with romance, maturation, social norms, and family expectations. In the transmedia project, Elizabeth becomes Lizzie, and the classical plot, as well as characters, get transferred into the twenty-first century. The story of *LBD* was told in the form of video blogs (vlogs), accompanied by social media platforms, such as Twitter, Tumblr, Lookbook, Pinterest, and others, which together created a vast and interconnected story-universe.

In the transmedia project, Lizzie Bennet is a twenty-four-year-old gradu-
ate student of mass communication. Her vlog was initially introduced as
part of her student thesis project, but it was actually about her daily private
life. During the one hundred episodes of *LBD*, other characters appeared,
including her sisters and friends, who could each be followed through their
own YouTube channels, as well as individual social media "handles" and
accounts. The characters would communicate with each other through
these accounts, while the viewers could choose whom they wanted to follow,
and which interactions to give preference to. Besides the common social
media communication channels, the *LBD* creators ingeniously used various
specialized platforms, like creating a fashion blog on Pinterest for Lizzie's
sister Jane, or an account on the free dating site OkCupid for the character
George Wickham, as well as their professional profiles on LinkedIn. All the
various platforms had to be rich in content, constantly updated, and to stay
true to each of the protagonists' characters and habits. In the transmedia
project, the novel's linear story was modified into individual storylines and
broken into a plethora of interconnected communication pieces. *LBD*'s
modernized contemporary settings made the characters more relatable
to a young audience, who were using the same communication tools and
memes as the story's characters they were following. Viewers were encour-
aged to put the story together the way they liked it, following the entire
series through the characters' individual channels, or only selected vlogs
and social media platforms.

The Lizzie Bennet Diaries received the Creative Arts Emmy for Original
Interactive Programming, and, although the series officially ended in 2013,
the project has continued to evolve through fan-based participation and
contributions to this date. The creators started production on *LBD* with no
budget and only a video camera in a living room. At the end of the series,
they launched a Kickstarter campaign in order to make a DVD set with
every episode of the series and its spinoffs; their goal was to raise $60,000,
but they ended up raising over $460,000.[39]

In spite of the success of this example, it is important to understand the
complexity and enormous time and energy that go into a transmedia pro-
duction. *LBD* co-creator Bernard Su has commented on how difficult this
process really was, calling it "draining," and stating, "it's hard enough to be
ourselves on social media, and now you are asking a group of writers to run
13 different social media accounts. . . . You can't just bring in a PR person to

come and tweet as Lizzie [the main character], because you don't want to break the canon."[40] The project became profitable after the Kickstarter campaign, along with YouTube ads, merchandise sales, and other spin-offs, but, according to Su, the enormous amount of work that went into the transmedia part of the project was never appropriately financially rewarded.

His following transmedia project, *Emma Approved*, was deliberately designed in a way "to solve this problem of spending all this creative energy on interactive content."[41] Based on Austen's novel *Emma*, the project again updates the characters into contemporary settings, following "the iconic Emma Woodhouse, re-imagined as a young brilliant entrepreneur who runs a life coaching and matchmaking business with her business partner and lifelong friend Alex Knightley."[42] This time, though, there were only two main YouTube channels, and half the amount of characters, as compared to *LBD*. This simplified and reduced the maze of social media content and platforms. Also, the series was integrated with brands (Samsung Mobile and various online clothing outfits), opening another revenue stream that was not available for *LBD*. Each time a viewer would click and buy an item, the creators would get a percentage, which ended up generating significant revenue for the project. The brands were used by the protagonists and seamlessly integrated into the story, not making it look like advertising or product placement to the viewers. For the brands, of course, this was a form of transmedia marketing and branded storytelling, providing a mutually beneficial synergy between the project's creators and the companies.

The individualized and custom-tailored approach to these transmedia projects, along with their appropriation of well-known and established characters and stories, provides insight into their success. In many ways, this can be regarded as another type of a franchise model, where independent media-makers use renowned sources from the public domain and creatively modernize and re-purpose them into another setting. For such projects to work, they have to find organic, individual approaches to their stories, as well as media channels and platforms appropriate to the audience they want to reach. Many independents have failed because they have tried to emulate the mainstream industry, searching for a common "one size fits all" solution for transmedia concepts, regardless of the nature of the project and its story and goal, thereby undermining their unique individual advantages.

Commentators who stipulate that every transmedia project should follow the same formula—for example, spreading over x exact number of platforms in such-and-such a way, including this or that interactive game, and the same specific social media channels, regardless of content, project goals, and target audiences—usually do not have any real experience in transmedia storytelling, and only recite random formulas they have read about. We are just beginning to explore all the creative aspects transmedia concepts have to offer, and while these practices are becoming increasingly needed and popular, one should not underestimate the creative challenges of working with rapidly changing technologies, and the amount of work involved in each of these projects, especially for independent creators, who usually have to work with limited budgets and resources.

▶ NOTES

1 Figure 7.1. Robert Pratten, *Getting Started with Transmedia Storytelling: A Practical Guide for Beginners*, 2nd ed (CreateSpace Independent Publishing Platform, 2015), 2.

2 Pratten, *Transmedia Storytelling*, 3.

3 Henry Jenkins, "Hollywood Goes 'Transmedia,'" *Confessions of an AcaFan*, April 27, 2010, http://henryjenkins.org/2010/04/hollywood_goes_transmedia.html

4 Henry Jenkins, *Convergence Culture: Where Old and New Media Collide* (New York: New York University Press, 2006), 110.

5 Karen Prior, "The New, Old Way to Tell Stories: With Input from the Audience," *The Atlantic*, October 18, 2013, http://www.theatlantic.com/entertainment/archive/2013/10/the-new-old-way-to-tell-stories-with-input-from-the-audience/280682/.

6 "Sherlock Holmes," *Transmedia and Crossmedia Convergence in a Connected World*, accessed October 14, 2015, http://convergenceishere.weebly.com/sherlock-holmes.html.

7 Henry Jenkins, "Why the Matrix Matters," *MIT Technology Review*, November 6, 2003, http://www.technologyreview.com/view/402277/why-the-matrix-matters/.

8 Aurore Gallarino, "Henry Jenkins Explains His Vision of Transmedia and Audience Engagement," *Transmedia Lab*, accessed October 14, 2015, http://www.transmedialab.org/en/events/henry-jenkins-explains-his-vision-of-transmedia-and-audience-engagement/.

9 Frank Rose, *The Art of Immersion: How the Digital Generation Is Remaking Hollywood, Madison Avenue, and the Way We Tell Stories* (New York: W. W. Norton & Company, 2012).

10 Henry Jenkins, *Fans, Bloggers, and Gamers: Exploring Participatory Culture* (New York: New York University Press, 2006), 154.

11 Figure 7.2. Jade Waddy, "In An Internet Minute-2013 VS 2014," http://www.techspartan.co.uk/features/internet-minute-2013-vs-2014-infographic/.

12 Bob Hutchins, "How the World Uses the Internet in 60 Seconds [INFOGRAPHIC]," *Social Media Today*, January 9, 2015, http://www.socialmediatoday.com/content/how-world-uses-internet-60-seconds-infographic.

13 Rose, *The Art of Immersion*.

14 Nordicity, "Industry Profile of the Independent Web Series Creators of Ontario," *Ontario Media Development Corporation* (May 30, 2014): 27, http://www.omdc.on.ca/Assets/Research/Research+Reports/Industry+Profile+of+the+Independent+Web+Series+Creators+of+Ontario/Industry+Profile+of+the+Independent+Web+Series+Creators+of+Ontario.pdf.

15 "Game of Thrones," *Campfire*, accessed October 14, 2015, http://campfirenyc.com/work/hbo-game-of-thrones.

16 A mockumentary is a type of film or television show in which fictional events are presented in documentary style.

17 Paul Clinton, "Fact and Fiction: 'Blair Witch' Team Gets Happy Ending," *CNN*, July 15, 1999, http://www.cnn.com/SHOWBIZ/Movies/9907/15/blairwitch/.

18 Neil Davidson, "The Blair Witch Project: The Best Viral Marketing Campaign of All Time," *MWP Digital Media*, August 4, 2013, http://mwpdigitalmedia.com/blog/the-blair-witch-project-the-best-viral-marketing-campaign-of-all-time/.

19 Amanda Palmer, "Amanda Palmer: The New RECORD, ART BOOK, and TOUR," *Kickstarter*, April 30, 2012, https://www.kickstarter.com/projects/amandapalmer/amanda-palmer-the-new-record-art-book-and-tour.

20 Figure 7.4. Mike Dicks: "The Rules of Digital Engagement," *Descience Limited*, http://www.descience.co.uk/.

21 Henry Jenkins and Sam Ford, *Spreadable Media: Creating Value and Meaning in a Networked Culture* (New York: New York University Press, 2013).

22 "History," *Kids with Cameras*, accessed October 15, 2015, http://www.kids-with-cameras.org/calcutta/.

23 "Gaza Sderot—Life in Spite of Everything," *Gaza Sderot*, April 14, 2009, http://gaza-sderot.arte.tv/.

24 "Last Hijack Interactive," *Last Hijack Interactive*, accessed October 15, 2015, http://lasthijack.submarinechannel.com/.

25 Anthony Kaufman, "Transmedia Documentaries Are Sexy, but Who's Watching?" *Indiewire*, June 24, 2014, http://www.indiewire.com/article/transmedia-documentaries-are-sexy-but-whos-watching.

26 Frank Rose, "How to Harness the Power of Immersive Media (infographic)," *Deep Media*, February 9, 2015, http://www.deepmediaonline.com/deepmedia/2015/02/strategy-business-how-to-harness-the-power-of-immersive-media.html.

27 DEFY Media, "Millennials Ages 13–24 Declare It's Not Just the Cord, TV Content Doesn't Cut It," *DEFY Media*, March 3, 2015, http://www.defymedia.com/2015/03/03/millennials-ages-13–24-declare-just-cord-tv-content-doesnt-cut/.

28 Figure 7.5. DEFY Media, Acumen Constant Content Report, Executive Summary, 2015, http://www.defymedia.com/acumen/.

29 Figure 7.6. Ibid.

30 "Transmedia Services," *Starlight Runner*, accessed October 15, 2015, http://www.starlightrunner.com/transmedia.

31 Ibid.

32 Producers Guild of America, "Code of Credits—New Media," *Producers Guild of America*, accessed October 15, 2015, http://www.producersguild.org/?page=coc_nm#transmedia.

33 Horatiu Boeriu, "BMW to Bring Back BMW Films," *BMWBLOG*, February 15, 2014, http://www.bmwblog.com/2014/02/15/bmw-bring-back-bmw-films/.

34 "The Transporter Movie," *The Transporter*, accessed October 15, 2015, http://www.thetransportermovie.net/#!the-transporter-about/c1enr

35 Peter Broderick, "The Distribution Bulletin Issue #19," *Paradigm Consulting*, September 11, 2012, http://www.peterbroderick.com/distributionbulletins/files/748c288e8ec708ffa44f1655c3b60cbf-21.html.

36 Ibid.

37 Peter Broderick, "The Distribution Bulletin Issue #14," *Paradigm Consulting*, January 11, 2011, http://www.peterbroderick.com/distributionbulletins/files/47cea5ca884d84a0e1ed01f23ef06d3d-16.html.

38 Broderick, "The Distribution Bulletin Issue #18," *Paradigm Consulting*, April 26, 2012. http://www.peterbroderick.com/distributionbulletins/files/dab0b3638aee0 a2f75999397dbd5a9e4 -20.html.

39 Pemberly Digital "The Lizzie Bennet Diaries DVD . . . and More! Update 1: THANK YOU OH MY GOD!"*Kickstarter,* March 22, 2013, https://www.kick-starter.com/projects/pemberleydigital/the-lizzie-bennet-diaries-dvdand-more/ posts/435025.

40 Fruzsina Eördögh, "Transmedia Shows Are Winning the Internet," *Motherboard*, April 10, 2014, http://motherboard.vice.com/read/transmedia-shows-are-winning-the-internet.

41 Ibid.

42 "Emma Approved." *Pemberley Digital,* accessed October 15, 2015, http://www. pemberleydigital.com/emma-approved/.

▶ BIBLIOGRAPHY

"About the Transporter Movie." *The Transporter*. Accessed October 15, 2015. http://www.thetransportermovie.net/#!the-transporter-about/c1enr.

Barnes, Brooke. "How 'Hunger Games' Built up Must-See Fever." *The New York Times*. March 18, 2012. http://www.nytimes.com/2012/03/19/business/media/how-hunger-games-built-up-must-see-fever.html.

Berkson, Alan. "Brands, Narratives and Story Worlds—Part 1." *Intelligent Catalyst* (blog). October 18, 2012. http://blog.intelligistgroup.com/brands-narratives-and-story-worlds-part-1/.

Boeriu, Horatiu. "BMW to Bring Back BMW Films." *BMWBLOG*. February 15, 2014. http://www.bmwblog.com/2014/02/15/bmw-bring-back-bmw-films.

Broderick, Peter. "The Distribution Bulletin Issue #14." *Paradigm Consulting*. January 11, 2011. http://www.peterbroderick.com/distributionbulletins/files/47cea5 ca884d84a0e1ed01f23ef06d3d-16.html.

Broderick, Peter. "The Distribution Bulletin Issue #18." *Paradigm Consulting*. April 26, 2012. http://www.peterbroderick.com/distributionbulletins/files/dab0b3638aee 0a2f75999397dbd5a9e4–20.html.

Broderick, Peter. "The Distribution Bulletin Issue #19." *Paradigm Consulting*. September 11, 2012. http://www.peterbroderick.com/distributionbulletins/files/74 8c288e8ec708ffa44f1655c3b60cbf-21.html.

"Case Studies." *Transmedia and Crossmedia Convergence in a Connected World*. n.d. http://convergenceishere.weebly.com/case-studies.html.

Clinton, Paul. "Fact and Fiction: 'Blair Witch' Team Gets Happy Ending." *CNN*. July 15, 1999. http://www.cnn.com/SHOWBIZ/Movies/9907/15/blairwitch/.

Davidson, Neil. "The Blair Witch Project: The Best Viral Marketing Campaign of All Time." *MWP Digital Media*. August 4, 2013. http://mwpdigitalmedia.com/blog/the-blair-witch-project-the-best-viral-marketing-campaign-of-all-time/.

Dawkins, Richard. *The Selfish Gene*, 2nd ed. Oxford: Oxford University Press, 1990.

DEFY Media. "Millennials Ages 13–24 Declare It's Not Just the Cord, TV Content Doesn't Cut It." *DEFY Media*. March 3, 2015. http://www.defymedia.com/2015/03/03/millennials-ages-13–24-declare-just-cord-tv-content-doesnt-cut/.

"Emma Approved." *Pemberley Digital*. Accessed October 15, 2015. http://www.pemberleydigital.com/emma-approved.

Eördögh, Fruzsina. "Transmedia Shows Are Winning the Internet." *Motherboard*. April 10, 2014. http://motherboard.vice.com/read/transmedia-shows-are-winning-the-internet.

Gallarino, Aurore. "Henry Jenkins Explains His Vision of Transmedia and Audience Engagement." *Transmedia Lab*. Accessed October 14, 2015. http://www.transmedialab.org/en/events/henry-jenkins-explains-his-vision-of-transmedia-and-audience-engagement/.

"Game of Thrones." *Campfire*. Accessed October 14, 2015. http://campfirenyc.com/work/hbo-game-of-thrones.

"Gaza Sderot—Life in Spite of Everything." *Gaza Sderot*. April 14, 2009. http://gaza-sderot.arte.tv/.

Hespos, Tom. "BMW Films: The Ultimate Marketing Scheme." *IMediaConnection*. July 10, 2002. http://www.imediaconnection.com/content/546.asp.

Higley, Sarah Lynn, and Jeffrey Andrew Weinstock, eds. *Nothing That Is: Millennial Cinema and the Blair Witch Controversies*. Detroit: Wayne State University Press, 2004.

"History." *Kids with Cameras*. Accessed October 15, 2015. www.kids-with-cameras.org/calcutta/.

Hoefs, Laura. "Cross-platform Storytelling." *StoryDisruptive*. November 19, 2014. http://storydisruptive.com/tag/cross-platform-storytelling/.

Hutchins, Bob. "How the World Uses the Internet in 60 Seconds [Infographic]." *Social Media Today*. January 9, 2015. http://www.socialmediatoday.com/content/how-world-uses-internet-60-seconds-infographic.

Jenkins, Henry. "Why the Matrix Matters." *MIT Technology Review*. November 6, 2003. http://www.technologyreview.com/view/402277/why-the-matrix-matters/.

Jenkins, Henry. *Convergence Culture: Where Old and New Media Collide*. New York: New York University Press, 2006.

Jenkins, Henry. *Fans, Bloggers, and Gamers: Exploring Participatory Culture*. New York: New York University Press, 2006.

Jenkins, Henry. "Photoshop for Democracy: The New Relationship between Politics and Popular Culture." In *Convergence Culture: Where Old and New Media Collide*. New York: New York University Press, 2006, 206–239.

Jenkins, Henry. "2010 April." *Confessions of an Aca-Fan—The Official Weblog of Henry Jenkins*. April 2010. http://henryjenkins.org/2010/04.

Jenkins, Henry. "Hollywood Goes 'Transmedia.'" *Confessions of an Aca-Fan—The Official Weblog of Henry Jenkins*. April 27, 2010. http://henryjenkins.org/2010/04/hollywood_goes_transmedia.html.

Jenkins, Henry. "Highlights from the 'Rethinking Intermediality in the Digital Age' Conference." *Confessions of an Aca-Fan—The Official Weblog of Henry Jenkins*. December 19, 2013. http://henryjenkins.org/2013/12/highlights-from-the-rethinking-intermediality-in-the-digital-age-conference.html.

Jenkins, Henry, Mizuko Itō, and Danah Boyd. *Participatory Culture in a Networked Era: A Conversation on Youth, Learning, Commerce, and Politics*. Malden, MA: Policy Press, 2015.

Jenkins, Henry, and Sam Ford. *Spreadable Media: Creating Value and Meaning in a Networked Culture*. New York: New York University Press, 2013.

Kaufmann, Anthony. "Transmedia Documentaries Are Sexy, but Who's Watching?" *Indiewire*. June 24, 2013. http://www.indiewire.com/article/transmedia-documentaries-are-sexy-but-whos-watching?page=2.

Kiley, David. "A New Kind of Car Chase." *Bloomberg*. May 15, 2005. http://www.bloomberg.com/bw/stories/2005-05-15/a-new-kind-of-car-chase.

"Last Hijack Interactive." *Last Hijack Interactive*. Accessed October 15, 2015. http://lasthijack.submarinechannel.com/.

Levy, Steven. "Google's Bleeding Edge Interactive Movie Format Blows Minds, Seduces Hollywood A Listers." *Medium.* November 6, 2014. https://medium.com/backchannel/google-taps-hollywood-a-list-for-360-interactive-short-b36e7fb35b5f.

Mathijs, Ernest, and Jamie Sexton. "Fandom and Subculture." In *Cult Cinema*, edited by Ernest Mathijs and Jamie Sexton. Malden, MA: John Wiley & Sons Ltd, 2011, 57–66.

Moloney, Kevin. "What Is Transmedia Storytelling?" *Transmedia Journalism.* Accessed November 15, 2015. http://transmediajournalism.org/contexts/what-is-transmedia-storytelling/.

Nordicity. "Industry Profile of the Independent Web Series Creators of Ontario." *Ontario Media Development Corporation.* May 30, 2014. http://www.omdc.on.ca/Assets/Research/Research+Reports/Industry+Profile+of+the+Independent+Web+Series+Creators+of+Ontario/Industry+Profile+of+the+Independent+Web+Series+Creators+of+Ontario.pdf.

Palmer, Amanda. "Amanda Palmer: The New RECORD, ART BOOK, and TOUR." *Kickstarter.* April 30, 2012. https://www.kickstarter.com/projects/amandapalmer/amanda-palmer-the-new-record-art-book-and-tour.

Pemberley Digital. "The Lizzie Bennet Diaries DVD . . . and More! Update 1: THANK YOU OH MY GOD!" *Kickstarter.* March 22, 2013. https://www.kickstarter.com/projects/pemberleydigital/the-lizzie-bennet-diaries-dvdand-more/posts/435025.

Perlmutter, Tom. "The Interactive Documentary: A Transformative Art Form." *Policy Options.* November 2, 2014. http://policyoptions.irpp.org/issues/policyflix/perlmutter/.

Peters, Steve. "Uncapping the Ride—BMW Endgame Gives Hope." *UnFiction Alternate Reality Gaming* (blog). January 12, 2003. http://www.unfiction.com/compendium/2003/01/12/uncapping-the-ride-bmw-endgame-gives-hope/.

Pratten, Robert. *Getting Started with Transmedia Storytelling: A Practical Guide for Beginners*, 2nd ed. CreateSpace Independent Publishing Platform, 2015.

Prior, Karen. "The New, Old Way to Tell Stories: With Input from the Audience." *The Atlantic.* October 18, 2013. http://www.theatlantic.com/entertainment/archive/2013/10/the-new-old-way-to-tell-stories-with-input-from-the-audience/280682.

Producers Guild of America. "Code of Credits—New Media." *Producers Guild of America.* Accessed October 15, 2015. http://www.producersguild.org/?page=coc_nm#transmedia.

Robinson, Lee. "Transmedia or Social Media? Storyworld Expansion across Social Networks." *Bellyfeel.* April 30, 3015. http://www.bellyfeel.co.uk/2015/04/transmedia-or-social-media-storyworld-expansion-across-social-networks/.

Rose, Frank. *The Art of Immersion: How the Digital Generation Is Remaking Hollywood, Madison Avenue, and the Way We Tell Stories.* New York: W.W. Norton & Co, 2012.

Rose, Frank. "Behind the Immersiveness Trend: Why Now?" *Deep Media.* December 17, 2013. http://www.deepmediaonline.com/deepmedia/2013/12/behind-the-immersiveness-trend-why-now.html.

Rose, Frank. "How to Harness the Power of Immersive Media [Infographic]." *Deep Media.* February 9, 2015. http://www.deepmediaonline.com/deepmedia/2015/02/strategy-business-how-to-harness-the-power-of-immersive-media.html.

Rose, Frank. "The Power of Immersive Media." *Strategy+business.* February 9, 2015. http://www.strategy-business.com/article/00308?gko=92656.

Rushkoff, Douglas. *Present Shock: When Everything Happens Now.* New York: Penguin Group, 2013.

Rutledge, Pamela. "Every Brand Is a Story but Does that Make It 'Transmedia'?" *The Media Psychology Blog.* April 19, 2015. http://mprcenter.org/blog/2015/04/every-brand-is-a-story-but-does-that-make-it-transmedia/?hvid=3vO9U.

"Sherlock Holmes." *Transmedia and Crossmedia Convergence in a Connected World.* Accessed October 14, 2015. http://convergenceishere.weebly.com/sherlock-holmes.html.

Somaiya, Ravi. "The Times Partners with Google on Virtual Reality Project." *The New York Times.* October 20, 2015. http://www.nytimes.com/2015/10/21/business/media/the-times-partners-with-google-on-virtual-reality-project.html?ref=movies.

Swallow Prior, Karen. "The New, Old Way to Tell Stories: With Input from the Audience." *The Atlantic.* October 18, 2013. http://www.theatlantic.com/entertainment/archive/2013/10/the-new-old-way-to-tell-stories-with-input-from-the-audience/280682/.

"Transmedia Services." *Starlight Runner Entertainment.* Accessed October 15, 2015. http://www.starlightrunner.com/transmedia.

Travers, Ben. "Steven Soderbergh Developing Choose-Your-Own-Adventure HB." *Indiewire.* September 24, 2015. http://www.indiewire.com/article/steven-soderbergh-developing-choose-your-own-adventure-hbo-project-with-sharon-stone-20150924.

Van Geel, Jeroen. "Aristotle's Storytelling Framework for Interactive Products." *Johnny Holland* | *It's All about Interaction.* January 20, 2011. http://johnnyholland.org/2011/01/aristotle%E2%80%99s-storytelling-framework-for-interactive-products/.

Wolting, Femke. "Hijacking Cinema: Advice on Transmedia Storytelling." *Movie-Maker Magazine.* November 3, 2014. http://www.moviemaker.com/archives/moviemaking/directing/last-hijack-transmedia-storytelling/.

▶ FILMOGRAPHY

Avatar. Directed by James Cameron. 2009. Los Angeles, CA: 20th Century Fox, 2010. DVD.

Bear 71. Directed by Leanne Allison and Jeremy Mendes. 2012. http://bear71.nfb.ca/#/bear71

Blair Witch Project, The. Directed by Daniel Myrick and Eduardo Sánchez. 1999. New York, NY: Lions Gate, 1999. DVD.

Born into Brothels. Directed by Zana Briski and Ross Kauffman. 2004. New York, NY: Image/Thinkfilms, 2006. DVD.

Collapsus. Directed by Tommy Pallotta. 2010. http://www.collapsus.com.

Cosmonaut, The. Directed by Nicolás Alcalá. 2013. http://en.cosmonautexperience.com/watch_it_now.

Curse of the Blair Witch Project, The. Directed by Daniel Myrick and Eduard Sanchez. New York, NY: Sci-Fi Channel, July 11, 1999.

Dadaab Stories. Directed by K. Ryan Jones. 2013. http://www.dadaabstories.org/, Film.

Dark Knight, The. Directed by Chistopher Nolan. 2008. Burbank, CA: Warner Home Video, 2008. DVD.

Emma Approved. Directed by Bernie Su. 2013–2014. Santa Monica, CA: Pemberley Digital, Series.

Evil Dead, The. Directed by Sam Raimi. 1981. Troy, MI: Anchor Bay Entertainment, 2007. DVD.

Food Matters. Directed by James Colquhoun, and Laurentine Ten Bosch. 2008. Warren, NJ: Passion River Films, 2009. DVD.

Forks over Knives. Directed by Lee Fulkerson. 2011. New York, NY: Virgil Films & Entertainment, 2011. DVD.

Friday the 13th. Directed by Sean S. Cunningham. 1980. Hollywood, CA: Paramount, 1999. DVD.

Game of Thrones. Directed by David Benioff and D.B. Weiss. 2011 — Present. New York, NY: HBO Studios, 2012. TV Series.

Gaza Sderot: Life in Spite of Everything. Directed by Robby Elmaliah and Khalil al Muzayyen. 2008. http://gaza-sderot.arte.tv.

Halloween. Directed by John Carpenter. 1978. Troy, MI: Anchor Bay Entertainment, 2007. DVD.

Hunger Games, The. Directed by Gary Ross. 2012. New York, NY: Lionsgate, 2012. DVD.

Hungry for Change. Directed by James Colquhoun, Laurentine Ten Bosch and Carlo Ledesma. 2012. Century City, CA: Docurama, 2012. DVD.

Iron Sky. Directed by Timo Vuorensola. 2012. Toronto, Canada: Entertainment One, 2012. DVD.

Iron Sky: The Coming Race. Directed by Timo Vuorensola. 2016. Finland: Energia Productions, Film.

A Journal of Insomnia. Directed by Bruno Choinière, Thibaut Duverneix, Philippe Lambert and Guillaume Braun. 2013. http://insomnia.nfb.ca/#/insomnia.

Last Hijack. Directed by Femke Wolting and Tommy Pallotta. 2014. http://lasthijack.com.

Lizzie Bennet Diaries: The Complete Series, The. Directed by Bernie Su. 2012. Santa Monica, CA: Pemberley Digital, 2013. DVD.

Matrix, The. Directed by The Wachowskis. 1999. Burbank, CA: Warner Home Video, 1999. DVD.

Men in Black. Directed by Barry Sonnenfeld. 1997. Culver City, CA: Sony Pictures Home Entertainment, 2008. DVD.

A Nightmare on Elm Street. Directed by Wes Craven. 1984. Los Angeles, CA: New Line Home Video, 2001. DVD.

Paranormal Activity. Directed by Oren Peli. 2009. Hollywood, CA: Paramount, 2009. DVD.

Pirates of the Caribbean: Dead Man's Chest. Directed by Gore Verbinski. 2006. Burbank, CA: Walt Disney Studios Home Entertainment, 2006. DVD.

A Scanner Darkly. Directed by Richard Linklater. 2006. Burbank, CA: Warner Home Video, 2006. Film.

Sherlock. Directed by Mark Gatiss. 2010 — Present. London, England: BBC Home Entertainment, 2010. TV Series.

Sherlock Holmes. Directed by Guy Ritchie. 2009. Burbank, CA: Warner Home Video, 2010. DVD.

Spiderman. Directed by Sam Raimi. 2002. Culver City, CA: Sony Pictures Home Entertainment, 2002. DVD.

Star Wars. Directed by George Lucas. 1977. Century City, CA: 20th Century Fox Video, 2006. DVD.

Transporter, The. Directed by Corey Yuen and Louis Leterrier. 2002. Century City, CA: Fox Home Entertainment, 2003. DVD.

Unspeak. Directed by Steven Poole. 2013. unspeak.submarinechannel.com.

Waking Life. Directed by Richard Linklater. 2001. Century City, CA: Fox Searchlight, 2002. DVD.

Walking Dead, The. Directed by Frank Darabont. 2010 — Present. Troy, MI: AMC and Anchor Bay Entertainment, 2011. TV Series.

Welcome to Pine Point. Directed by Paul Shoebridge and Michael Simons. 2011. http://pinepoint.nfb.ca/#/pinepoint.

What We Do in the Shadows. Directed by Jemaine Clement and Taika Waititi. 2014. Hollywood, CA: Paramount, 2015. DVD.

Zenith. Directed by Vladan Nikolic. 2010. New York, NY: Cinema Purgatorio. Film.

8

Project Development

Creating multi-platform projects can be challenging on many levels. Some practitioners and commentators have argued that any story can become a transmedia project. While that may be true in some regard, for it to be effective and engaging, the project must include manifold narrative strands as well as various entry points and opportunities for audience engagement. Stories that can be serialized, containing strong supporting characters beyond the main protagonist and antagonist, with rich back-stories expanding through multiple angles that give viewers opportunities to interact and "talk back," are considered strong elements for transmedia development.[1]

When writing a story for film or TV, the creators usually follow the dramatic narrative rules and conventions of the format. During the production, the visual storytelling language of film is observed and followed but less attention is paid to how the audience will consume the content beyond whether it will be shown in a movie theater or on a TV screen. Some consideration is given to what the main distribution channels will be—if the primary exhibition medium is the theatrical screen (which can tolerate wider long shots and rely on a more detailed visual aesthetic and spectacular images) or content made for TV (which generally tends to favor medium-sized shots and is more dialogue-based than cinema). This has somewhat changed as the screens on which we watch content have alternately become smaller (the

tablet and the phone) and bigger (the large HD TV screen), but such considerations are still quite sporadic.

Whether on TV or in movie theaters, the creators generally attempt to elicit an emotional response from the audience—the media platform serves only as the vessel in which content is delivered. In a transmedia project, however, the audience's relation to content and platforms, and their experience with them, can be more complex. A new aspect—audience engagement—enters the equation. Now the story does not only develop according to its dramaturgical logic and story arc, but will also change depending on how the viewer experiences it. In other words, when crafting the story, the creator must take into account the audience's experience with each platform or channel, and provide at least some choices for interaction. Thus, it is not just about the viewer's involvement with the story but also about the user's engagement with it. Viewers can now not only follow the main story on a TV screen but continue to explore it on other platforms, such as online video, audio podcasts, blogs, and social media; and interact with the content through games, feedback, and comments; or even provide their own creative input. Each platform or channel contributes to the overall story but also provides a new, unique, and different experience.

In order for a multi-platform project to be able to effectively engage the audience, its narrative layers have to be appropriate to the media platforms and channels where they unfold. A viewer's experience of watching a film or performance in a theater is a communal experience, which differs from watching the film or a recorded performance alone at home on a big TV, and would again change if one would watch the same content on a phone. Each of these screens provides another level of involvement—from being part of a group in a theater to the most personal space of the phone screen. In this context, an epic battle will play much better on the big screen, while an intimate conversation, where the viewer can listen in and interact with it, will have a much bigger impact when experienced on one's own phone. Thus, the platform has to match the content. If the platform does not fit the narrative thread and the user's anticipated experience, there is no real engagement, and the project misses its mark. It distances the viewers from the content, rather than immersing them deeper into the story-world.

Trying to conceptualize a transmedia project can be overwhelming; the first question is where to begin. Starting a project by focusing first on the technology and media channels generally leads to technologically sophisticated

but superficial projects that have no impact beyond a momentary novelty. Such projects might serve as a short-lived promotional strategy for a particular technology being used—like a new software or social media channel—but are usually not satisfying beyond that. For most transmedia projects, it is more sensible to answer the following questions before developing the technological framework:

1. What kind of project is it? (Is it an extension of another, main project, like a film or TV series? A transmedia franchise? A social engagement tool?)

2. What is the goal of the project (i.e., increasing the audience for a film or TV series, selling a product, experimenting with a new form of storytelling, raising awareness about a community or issue, etc.)?

3. What is the story? (What is the basic premise and genre: is it a teenage comedy, horror, relationship drama, healthy living documentary series, etc.?)

4. Who is the core audience the project is trying to reach (i.e., fifteen- to twenty-five-year-old science-fiction fans, teenage girls, people concerned about climate change, etc.)?

Detailed answers to these core question should determine the approach to the project: which media platforms and channels to use (those used by the target audience); how to spread and extend the project across platforms (what makes sense in relation to the genre, type of storytelling, and possibilities given by the project's story-world); what options to create for audience participation and interaction, and how these interactions affect the project's unfolding over time (too many choices can become overwhelming and unmanageable for the creators, while too few can be uninteresting for the users); what is the timeline of the project—a month, a year, or is it open-ended? It is vital to define when a project ends; otherwise, it will eventually become too hard to steer and manage. If the project runs out of steam prematurely, its goals and purpose collapse over time, causing it to fail. This has been a problem with quite a few independently produced transmedia projects which did not clearly define timelines and, thus, ran out of money, time, or energy before they were able to sufficiently engage their audiences.

Answering the basic questions first also ensures that the measurement of the success of a project is accurate. Not every transmedia project's goal is to

make money; that can be left to other means: the selling of a film or video, for example, if the transmedia project is an extension of it, or advertising, sponsorships, product placement, or sales; if the project has been funded up front through grants or crowdfunding, revenue generation might not even be an issue. In marketing terms, a transmedia project can also be measured solely in terms of if and how much it has increased the fan following for a film, video, or TV project, or how much it has helped sell a product or drive traffic to a website, or how much it has spurred action related to a social cause.

It is important to reaffirm once again that not every media project needs to be a transmedia project, but arguably every project—especially an independent one—can benefit in some way from expansion across platforms and channels. Many linear stories made for film or television work perfectly well within one medium, but even these projects can expand their audiences—enhancing or spreading their impact and reach—through multiple channels for more effective marketing and distribution purposes. The richer the story-world and the more opportunities the audience has to engage and interact with the content, the more likely it is that the project's reach will expand and have a larger impact in the current landscape of media overload and content saturation—or, to re-phrase this concept in Henry Jenkins's terms, "If it doesn't spread, it's dead."[2]

▶ DEFINING THE GOAL

In his extensive book *Getting Started in Transmedia Storytelling*, transmedia producer Robert Pratten divides goals for transmedia projects into two main categories: artistic and commercial.[3] While this is accurate, it is useful to define these categories in more detail: commercial goals are primarily centered around sales, marketing, branding, and promotion—e.g., expanding audiences; bridging gaps between main event releases of franchised content, such as movies or series seasons, in order to maintain viewer awareness and interest; or creating or enhancing a product's branding and sales through consumer engagement with a multi-platform story-world. Artistic projects, on the other hand, tend to focus on experiments with new forms of storytelling, using technology to create alternative narrative structures, and exploring new models of audience interaction. A third kind—which could be described as artistic but is more accurately put into a separate category— distinguishes itself by its emphasis on documentary storytelling; focus on

education, real-life and social issues; and goals to raise awareness of specific topics, have an impact on public discourse, and often also generate support for certain forms of activism.

Within these three main categories, the creators should clearly define the specific goal of the transmedia project—which could be to expand the audience base from an older audience to a younger one; or to provide interim content that will keep the audience engaged over a period of time until the release of another episode or film installment; or to increase awareness among affluent middle-class consumers about where and how the products they purchase have been made; etc. The more specific and detailed the goal, the easier it will be to envision and create the transmedia world. It will also be much easier to define the success criteria of the project. Pratten adds that, if the project is personal, artistic, and experimental in nature, the creator might often not be inclined to think about or define these goals and its parameters exactly. Many such projects get abandoned before they are finished or launched because the creators run out of energy and enthusiasm during the process. As Pratten argues: "I strongly recommend that you set yourself some SMART goals: Specific, Measurable, Attainable, Realistic and Timely. That is, be pragmatic and specific about what you can achieve with the resources you have."[4]

▶ NARRATIVE PATTERNS

The traditional dramatic construction of film is also present within a transmedia framework. Storylines and experiences are organized in narrative patterns and constructed and held together by plot, theme, and characters. The plot is usually thought of as a series of conflicts that disrupt the equilibrium. These conflicts set the story in motion and move it forward. Plot can also be defined as the obstacles, put in front of the protagonists, that they must overcome in order to return to the equilibrium. Once again, we use the dramatic terms of the protagonist's objective (the *goal*), desire (*motivation*), and the presence of the antagonist(s), who stands in the way of the protagonist achieving his or her goal. This creates conflict for the protagonist to surmount and also produces dramatic tension that keeps the viewer engaged with the story. Not all transmedia projects adhere to a literal adoption and presentation of traditional cinematic narrative constructions, but many—if not most—use similar concepts, which allow the viewer to experience the story as a journey with an emotional arc. Oftentimes, a transmedia

story-world only adds multiple choices in story developments and possible endings to an otherwise conventional story structure.

The theme of a story or underlying idea distinguishes itself by its broader relevance: Why is this story worth telling, and what does it mean in a larger context? Almost all films—with the exception of exploitation genres like pornography or slasher movies, where the plot only serves the function of connecting the graphic scenes—have a theme or underlying idea. Even a simple B-movie plot like two men robbing a bank and getting caught by the police has an underlying idea: this could be "crime doesn't pay" or "the poor have no other choice but to rob banks." The underlying idea informs the stylistic choices of a director, more than the plot alone. The same plot can have different underlying ideas, depending on the execution. For example, films based on books, while telling the same story plot-wise, often have different themes. Kubrick's film *The Shining* (1980), for instance, arguably has a different theme than the Stephen King novel on which it is based. Both have the same plot—a writer takes his family to an isolated hotel where he gradually goes mad and becomes violent, while his psychic son experiences horrifying visions of the past and future. While the book focuses more on the son and its theme serves as metaphor for the innocence and intuitive knowledge of childhood, the film focuses more on the father—the creative mind that cannot create any more—in this case, a writer who cannot write and whose mind gradually collapses.

While most narrative patterns center around a protagonist striving toward a goal, overcoming obstacles, and trying to restore equilibrium, there are certain specific narrative constructions or "genres" that can be discerned, such as solving a mystery (a particulary well-suited genre for transmedia projects); chase and pursuit; a journey or "road movie"; coming-of-age stories; stories of personal growth and experiences; comedies of situations or manners; and romance and relationships. In films, while the narrative structure can favor the protagonist, most plots are presented "objectively," where the viewers are given the possibility to follow parallel storylines, arranged through a series of cause-and-effect scenes, delineated by time and space. Some stories, however, are deliberately told from the protagonist's internal, subjective perspective—*Birdman* (2014), *Beasts of the Southern Wild* (2012), *Eternal Sunshine of the Spotless Mind* (2004), *Donnie Darko* (2001), etc. This approach can also lend itself to experimentation by questioning the trustworthiness of the storyteller—such as in *Fight Club* (1999) or *Rashomon* (1950). Other films break the linear storytelling structure altogether, along

with the rules of time-space continuum and cause and effect, such as *Memento* (2000), *21 Grams* (2003), *Pulp Fiction* (1994), etc. Some films are more meditative than plot-based, exploring the characters' inner lives, or an abstract conceptual idea. Such are the films of Terrence Malick, Andrei Tarkovsky, Chantal Akerman, or David Lynch, Alejandro Jodorowsky, and Luis Bunuel with their surrealist frameworks.

Transmedia approaches to storytelling can function within each of these genres, but because of its multi-platform and non-linear nature, they can also combine different techniques. While the main narrative can be told "objectively" through one of the commonly used narrative genres, other media channels can carry "subjective" narrative threads, told through the character's own POVs. This can open multiple interpretations and give additional details in relation to the main narrative. The project creators can give viewers the option to participate by giving them choices to interact with the narrative: find clues, solve mysteries, communicate with the characters, and become part of the story, rather than just passive observers. While the possibilities of story expansion through multiple media channels and narrative cross-sections are almost limitless, one has to be careful to stay consistent and true to the general tone and type of story and characters. Creators have to weigh how much story expansion and narrative crossover is useful and effective, as each one will require additional time and effort for conceptualization, writing, and production.

A narrative approach of particular interest to transmedia storytelling is based on multiple intersecting storylines and protagonists. In cinema, such narrative techniques can be found in the films of Robert Altman (*Nashville* [1975], *Short Cuts* [1993], *Gosford Park* [2001], etc.), in P. T. Anderson's *Magnolia* (1999), Steven Soderbergh's *Traffic* (2000), and Iñárritu's *Babel* (2006) and *Amores Perros* (2000). While the many narrative strands crisscross in a film, they still have to obey the rules of a linear time-based medium, where the viewer watches a movie from beginning to end. A transmedia structure provides much more flexibility in how these multiple stories can be presented and organized. A particularly interesting device for this type of storytelling in transmedia is provided through a location-based storytelling framework. Networks of online maps and/or grids serve as connecting tissue for multiple protagonists and storylines, while the viewer can choose which stories and characters to follow, and how to connect them. This structure allows viewers to interact with the story and enables them to create their own narratives, based on their interests and preferences.

Examples of such transmedia projects include *The David Lynch Interview Project*, Submarine Channel's *Collapsus*, Arte TV's *Gaza Sderot* project, or FilmAid's *Dadaab Stories*, among others.

Each individual story within a project can have its own dynamics, plot, and theme, while the overarching theme of the project can have a different meaning—the individual stories, when taken all together, prompt a new interpretation of the underlying idea. In David Lynch's *Interview Project*, each individual interview has its own different story and history of one character, but, taken together, they become an impression of life in the United States outside of its urban centers. Similarly, the *Dadaab Stories* project presents numerous unique personal storylines, each with its own dramatic arc, but, all together, they represent a testament of life in a refugee camp. Not only does this storytelling framework allow creators more freedom than a linear film or TV series, as they can explore many more strands of stories, details, and characters, it also makes it possible to connect these stories to background information, history, and data. Simply clicking a link can open up new content and background information, which the viewers can navigate based on their own interests, rather than solely being based on the story's inherent plot structure—something that would be impossible to construct within the traditional narrative confines of a linear plot.

Some observers place particular emphasis on transmedia projects that employ new technologies to explore the boundaries of traditional narrative structures, or new ways to expand them. These approaches are usually branded by the catchall phrase "experimental narratives." They include a variety of storytelling methods, using various technologies for presentation and audience interaction, as well as live performances and events. Situated at the crossroads of innovation and experimentation, they do not have a clear place within the existing media structures and are thus generally presented in specialized sections at film festivals or at museums and art galleries. These projects are seen by some as being at the forefront of a new way of storytelling, while others dismiss them as momentary fads with no larger significance. It is almost impossible to categorize all these projects under one umbrella, as they differ widely, except for the fact that they all aspire to break new ground in media and storytelling practices. Recent such projects include *Code* (2014), a non-linear documentary assembled from code, consisting of 3-D scanned conversations between artists and hackers, which the viewer can navigate through; BeAnotherLab's *Embodied Narratives* (2015), a virtual reality experience, which allows the user "to inhabit the body and

life story of another person, while interacting with artifacts from their life";[5] Karim Ben Khelifa's *The Enemy* (2015), another virtual reality project "at the crossroads of neuroscience, artificial intelligence, and storytelling,"[6] presenting world conflicts and their participants to users and investigating the user's limits of empathy to the protagonists; or Brett Gaylor's *Do Not Track* (2015), a personalized interactive documentary series about privacy and the web economy, which reveals how much data is collected from the viewer through the Internet; and many others.

A transmedia project's overall concept and idea should correspond to its goals. Once this is clearly defined, it is time to explore and consider the various narrative patterns and genres, and to determine how the story will unfold. Much like when planning a film, before writing a full script and considering its execution, one should write a short synopsis, outlining the main conflicts and developments of the story. While this is an open, creative process, one should always keep in mind the purpose and objective, as well as the type of the project that is being created, and connect this to its plot and theme. For instance, if the goal of the project is to expand the audience of a film through additional media channels, it does not make much sense to create unrelated and completely new independent content and characters. Instead, one should expand on the existing storylines, and, if new story elements are introduced, they should serve as story entry-points or expansions that lead back to the main narrative. On the other hand, if the goal of the transmedia project is to deepen the engagement of the audience with a main project (the film, series, book, etc.) and further immerse them into the story-world, the emphasis should be on interactivity rather than on new storylines alone. If the aim of the project is to explore new narrative techniques and technologies, the story and plot will be dictated by the theme— like investigating limits of empathy in *The Enemy*, or online surveillance in *Do Not Track*. If the objective of a project is to influence action for social change, the theme and plot elements have to be conducive to that purpose, and the story should not be only a passive lean-back viewing experience.

A transmedia project's story-world should include a multitude of secondary characters and interrelated back-stories that can link to histories, data and information, as well as other related content, allowing supplementary stories to be derived from the main plot and narratives, which can be expanded further. Links can lead to websites and wikis with additional information on places and people, as well as historical facts related to the story. Viewers' online choices can be sampled into data, which can be visualized in graphs

and charts; protagonists can have their own online video diaries, online feeds, or social media channels; alternative plots can spin off on online video platforms like YouTube and Vimeo; users can comment and suggest future story developments; location-based games relating to the main plot can be played by users in real environments, using their phones; etc. It is not necessary for a project to spread over all available platforms, but only those that relate to the goal, theme, story, and audience the project aims to reach. Not every project has to have game components or extensive interactive choices or has to use a multitude of social media channels—it may develop over only three platforms, or it might spread to dozens—but that should be determined by the nature of the project and grow organically from its theme and story.

Another important aspect to consider is what will keep the project going and the audience interested in it over time. There has to be sufficient new material released over the lifespan of the project in order to keep the viewers engaged for the duration of the project. In that sense, a transmedia project is more similar to a TV series with its many sub-plots and characters that can keep evolving and changing, rather than a single movie with one story arc. It is key to create strong and memorable characters, which the viewers will be interested in following, and a rich story-world, which will entice the audience to explore its many facets. This will keep the viewers coming back to the project and eventually create a true fan base, which can then spread the content further through word-of-mouth and social media, thus enhancing the following and extending the project's reach. Though the novelty of a project's design or technology might attract instant attention, it will not be able to sustain the audience's interest over time. As outlined in Chapter 6, an excellent example of a technologically simple but tremendously effective transmedia project is Hank Green and Bernie Su's Emmy Award-winning *The Lizzie Bennet Diaries.* Made independently on a ultra-low budget, using only available online and social media channels, *The Lizzie Bennet Diaries'* success rests on its imaginative characters and clever use of media channels to tell their stories.

▶ WORLD & TONE OF THE STORY: CHARACTER DEVELOPMENT

A story-world is usually easiest understood in the context of a fictional, mythical universe, such as the *Star Wars* saga or *The Lord of the Rings* trilogy. Based on Joseph Campbell's writings about the universality of mythological

narratives across cultures and societies, the narrative of a mythical "Hero's journey" emerges. Campbell formulated the theory that mythological narratives from around the world, which have survived for millennia, all share the same fundamental structure, which Campbell called the *monomyth*: "A hero ventures forth from the world of common day into a region of supernatural wonder: fabulous forces are there encountered and a decisive victory is won: the hero comes back from this mysterious adventure with the power to bestow boons on his fellow man."[7] Campbell continues to outline seventeen stages of the monomyth; many contemporary writers and filmmakers—including George Lucas—have adopted this structure to create their fictional univereses.

The story-world is the setting where the story unfolds—it is not the same as the story, nor is it just the background, but it is the environment that envelops the story and main characters, containing a variety of possibilities for numerous narratives, details and sub-stories, myths, and secondary characters. It is much easier to notice this in the case of a science-fiction or fantasy world, such as the *Game of Thrones* or *Star Trek* universes, where entire worlds with customs, designs, and habits are created, than in a contemporary, realistic setting. However, the story-world would exist regardless of genre: if it is a story about a ten-year-old boy, the story-world becomes his environment, from his parents to his pet, from his pals to his neighbors, from his home to his imagination, all affected by specific location and detail: Is he growing up in a poor family in rural England or in a rich brahmin family in Mumbai, India? Or are both boys protagonists in a multi-perspective narrative? The story-world is comprised of all the various elements that allow us to create stories connected to the protagonist and secondary characters, which surround him or her. Whatever the specific case may be, it is essential that the story-world is consistent and believable to the audience. This is why the fantastical story-worlds of *Star Wars* or *Lord of the Rings* are built on ancient myths and tales, with protagonists and antagonists embodying what Campbell has called "archetypal" characters—character traits which are easily recognizable to audiences, as they have been expressed in stories throughout history, symbolizing the fight between good and evil, light and darkness, innocence and temptation, etc.

In a linear narrative, the world of the story is often spoken of as the story-universe; in a transmedia project, the term "story multi-verse" is often used, as transmedia allows for non-linear stories with various entry and exit points, as well as possible different story outcomes to exist simultaneously,

FIGURE 8.1 The hero's journey[8]

depending on the user interface and interaction. The project creators need to define the specific time and place of the story, the histories and/or mythologies surrounding the story, as well as the past and present conditions of the characters. For this, it is generally useful to create character biographies and back-stories, which span their entire lives. While it is likely most of this information will not be seen in the actual project, it will help create believable protagonists whose actions are grounded in their personalities, rather than just devices used to prop up the story's conflicts. The character can be two- or three-dimensional, but should never be one-dimensional. Each character has to have some flaw or weakness—even Superman loses his powers when faced with Kryptonite. A plot-driven genre narrative, like horror or action/ adventure, is usually populated by two-dimensional characters, while a

drama or personal narrative generally relies on three-dimensional—more complex, realistic, and nuanced—characters, which are harder to place in simple categories of good and bad.

A transmedia project that relies less on story elements and more on user experiences can define its world by the environment in which it exists—whether it is the service or rewards it offers, the competition and context in which it operates, or the benefits it provides to the user. This is frequently the case with story-extensions through alternate reality games (ARGs), which often operate in real environments and spaces. Here, the user becomes the protagonist, looking for clues to solve puzzles and mysteries, which eventually reward the user with unique access or special admission to a product or franchise. Such transmedia strategies are usually employed for commercial projects with marketing, branding, and franchising goals.

The project creators have to define a coherent *tone* for the project—in the broadest sense, this means its overall look and design. Similar to a film's cinematic choices—comprised of art direction, lighting, cinematography, sets, props, and costumes—a transmedia project needs its own "look" and "feel," which has to be reflected in all design choices and remain consistent across all platforms. For example, a comedy might be bright and colorful and rely on a playful look and design elements, while a mystery thriller could be dark and monochromatic and emphasize baroque or gothic design. The tone of a transmedia project is created not only through cinematic stylistic elements but also by the many other possible facets it can employ such as fonts and buttons, web design, the look and feel of mobile applications, gaming interfaces, etc. A larger-scale transmedia campaign, where separate departments handle each of its different components, has to ensure that the different key creators communicate with one another and stay true to the original vision, both in terms of story and character and in terms of tone and look of the project.

Another aspect to consider is the degree of appropriate user interaction and how it can affect the project and all of its elements. Transmedia often encourages viewers and users to participate in a project's development or expansion through creative input and collaboration. While this can certainly enhance the users' experience along with their engagement and loyalty to a project, the creators have to make sure that this does not disrupt or contradict the project's tone and story-world. In other words, while a project can offer users abundant choices of interaction and participation, the creators

still need to ensure that these contributions do not jeopardize the project's integrity and push it into disarray. This can be avoided by simple design choices. For instance, if users are allowed to choose any color for a character to wear, the creators will have no control over the outcome; however, if users are only given the choice between red and green, the creators will be able to steer the project within the planned design framework. Similarly, if the users can click or vote to place a character on any path within the story, the creators will not be able to manage the plot, but if users can choose only specific paths, which eventually lead to the same one or two outcomes, the creators will, once again, remain in control of the project's story and theme, while still offering users ample choices for engagement and interactivity.

The process of creating a transmedia project can start from any of its main components. It can begin with the story premise and then expand into the world of the story, or it can start with the storyworld and then extract the individual storyline(s), plots, and themes. If the creator imagines a building with a dozen apartments, each one with different residents and their own stories, the project can start with the building—the overarching theme— and then focus on each indvidual apartment, their tenants (characters), and their stories (plots and conflicts). One could also, of course, approach this in the opposite way—start in one apartment, with its individual story-arc first, and then follow with the neighbors and their stories, ultimately extrapolating their relationships.

The story (or stories) can similarly relate to the viewer experience(s). We can start with the story first, then determine how the viewer will experience it or vice-versa. When creating our transmedia building project, we can write out the script first, using the multi-person/multi-perspective narrative genre, then think about the best way for the viewer to experience them; or we could design the interface first, based on how we want the viewer to engage with the project and write the plot and characters in detail afterward—like a website, with multiple interactive videos for each apartment and floor of the building which the viewer can navigate through. The different approaches and preferences will often depend on the creator's background—filmmakers will most likely start with the story and characters, while gamers and designers might be inclined to first focus on the user experience and interface. Every story can be presented in a variety of different ways and experienced in multiple forms—through audio, video, text, social media, gaming, etc.—depending on the goal and scope of the project and its budget and timeline.

▶ STORY ARC & PLOT POINTS

> While it's nice to think you might write a story independently of the platform, it's not entirely possible if you want to maximize the audience experience. You only have to take the example of great books that don't translate to movies—the problem is not the story but the failure to adapt it to the platform.
>
> Robert Pratten[9]

A film's plot-driven linear story usually starts with an inciting incident that sets the story in motion. It begins the conflict and forces the protagonist to take action. If the protagonist misses his train, gets stuck in the train station, and witnesses a robbery, his actions could range from trying to stop the robbers, to saving an innocent victim, or to simply trying to escape. From here, the protagonist—driven by his motivation—progresses on a journey through the story that usually consists of overcoming a series of progressively more difficult obstacles in order to realize his objective. The story is generally considered to unfold in three or five acts:

1. Introduction and the inciting incident

2. Rising action

3. Climax

4. Declining Action

5. Resolution or dénouement (a three-act structure would include only introduction, climax, and resolution).

The screenplay is organized in scenes, delineated by locations and continuous time; each scene has to serve a purpose: to drive the story forward and to communicate essential information about the characters and their actions through visuals and dialogue. Beats or plot-points are usually considered to be the smallest dramatic elements within scenes that move the action forward or change its direction. Imagine our protagonist is chasing the train-station robbers when he accidentally meets his "love interest"; in act 2, it is then subsequently revealed that she was actually the one who organized the robbery. By this point in the story, the protagonist has already formed an attachment to her and is now

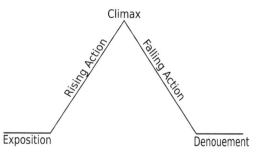

FIGURE 8.2 Freytag's Pyramid[11]

faced with the dilemma of whether to hand her over to the police or try to rehabilitate her.

The basic dramatic arc of a linear story is commonly referred to as "Freytag's Pyramid," based on the nineteenth-century German playwright and novelist Gustav Freytag's extensive analysis of the five-act dramatic structure.[10]

A transmedia project can work with similar dramatic structures, but in a multi-linear or non-linear fashion. Throughout the timeline of a story, new plot-points can be introduced—obstacles, which the protagonist needs to master, as well as twists and turns in the plot that take the storylines in new directions. Side-plots and complementary characters can be introduced, augmenting the main narrative, as well as user-centered interactive experiences. As previously stated, it is vital to remain consistent with the theme, characters, and plot of the main story throughout all of these developments and story expansions. Twists and turning points that are too coincidental or unbelievable or that clash with the main theme and/or the protagonist's motivations and objective will pull the audience out of the story and eventually alienate them. For instance, it would be completely implausible if our protagonist who had witnessed the robbery—a shy and timid man—midway through the story turns into a skillful combatant who easily overpowers the robbers.

Story plot-points in a transmedia project often translate into "calls to action." A call to action is a term stemming from the worlds of marketing and advertising, usually involving a slogan or design element, which invites the user or customer to make an instantaneous choice—to click a button, to purchase something, or to discover a new experience. In the transmedia environment, a plot-point becomes a call to action when it invites the

viewer to cross to another platform or media channel. In our fictional train robbery project, when the protagonist discovers the fact that his love interest is the mastermind behind the robbery (a plot point), a link might pop up leading the viewer to a social media channel, where the audience can discuss and vote for what they think the protagonist should do—in this way, the plot point becomes a call to action. Some viewers will choose to click the link and join the discussion, while others might choose to ignore it and continue following the story. In many commercial or commercially sponsored projects, such as marketing and franchise-based transmedia, some plot points and calls-to-action are required at certain points of the story and timeline— i.e., if the audience has to be prompted to buy a product or to see a particular brand. Such elements have to be seamlessly integrated into the theme and plot of the story; otherwise, they could be perceived as crass attempts to sell something and will disrupt the narrative and distance the viewer.

Besides writing scripts for the main story, secondary storylines, and complementary experiences, one should create an equivalent to "beat sheets." In the world of film and TV, beat sheets are usually lists of key moments when the story changes or progresses to the next level. Similarly, a transmedia project template—commonly referred to as transmedia "bible"—should include this as well; however, such a list would include not only the key points of the main story but also the calls-to-action where the story transitions or connects to other platforms and/or changes the user experience. It is also worthwhile to create charts and diagrams of key and secondary plot-points, tracing the characters' journeys and changes, as well as story-crossovers, expansions, relations, and interactions over the project's timeline.

In transmedia, an alternate narrative approach to the three- or five-act structure would be to give the viewer two or more choices of how the story can develop; this is a common strategy for interactive videos and games. Numerous different proprietary systems for the creation of interactive content have emerged in the past years. Using any of these systems, the creators can make videos with two or more options to how a story can evolve, progress, and end. This will be based on the viewers' selections, as well as potential links to various other content, such as websites, maps, games, or social media. The software interface usually has customizable pre-set options that allow the creator to work out numerous different scenarios, with varying degrees of complexity. An example of an online platform is Interlude— created by Israeli musician and tech entrepreneur Yoni Bloch in 2010— which lets creators make and upload interactive videos from their video

footage and other media. This platform uses branching "nodes" of different video streams, which allow for a change in viewer perspective and story outcomes.

Pratten refers to this approach of multi-strand narratives as branching storylines, which correspond to a "choose your own adventure" type of story.[12] While this approach is interactive and technologically appealing, it does not necessarily guarantee increased or effective audience engagement with the story. It will work best if the viewer wants to have a "lean-in" experience, and not a passive "lean-back" one. With this approach, the story options and outcomes must be sufficiently plentiful and interesting in order to be immersive and maintain the viewer's interest; this often requires the project creators to produce an excessive amount of content, much of which the viewer may never even see or experience.

Multi-strand storytelling methods with their multiple possible story outcomes can be compared to the story concepts and structure of games. While it can work for short-term ARGs (alternate reality games) or similar projects, so far it has not proven to be a more effective way to construct plot-based narratives than traditional linear storylines. The likely reason for this is that audiences have different expectations from a film or video than a game; fusing a linear time-based story with interactive choices does not increase the appeal of the narrative. Audiences watch a film or video precisely because they want to have a passive viewing experience. They want to absorb the story, be engrossed by it, and connect with the protagonist on an emotional level. The interactive content of a game, where the player is part of the story and has to navigate through it, has a different dynamic. These preferences might change for future audiences, who will be progressively more used to interacting with content through mobile screens. Presently, however, millennials and Generation Z viewers still prefer to passively binge-watch linear storylines in film and TV series and to use interactive content separately. Thus, to sustain audience interest in a narrative project over time, it is generally more effective to use interactive multi-strand narrative structures for secondary content and story expansions, rather than as the main device to develop the story and plot.

Other non-linear storytelling strategies frequently used in transmedia can be described as "open" and multi-layered, or "deep" and non-sequential. Most of these approaches create multiple separate storylines, which can be explored individually, leading from one character to the next, or from one

Linear Storyline

Branching Narrative

Open or Non-sequential Storylines

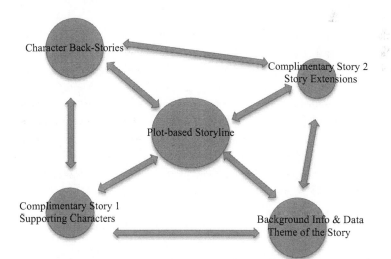

FIGURE 8.3 Linear story, branching narratives, and open story-worlds

plot to the other. Viewers can choose which ones they want to explore, or, if it is a mystery-based story, how deep down the rabbit hole they want to go. Projects like the NFB's *Highrise* series or David Lynch's *Interview Project* would fall into this category, as well as various virtual-reality, ARG, and real-life location-based experiences and interactions where the viewers are free to explore the project on their own terms (Ben Khelifa's *The Enemy* or BeAnotherLab's *Embodied Narratives* are both examples of this). As opposed to the multi-strand, branching narrative of interactive video, where the viewer has multiple choices for one story, non-sequential and multi-layered approaches offer many separate storylines, which can be combined, connected, and explored in different ways. To the viewer, this creates more of an effect of personal discovery and relation to the story-world, which is arguably more effective in the context of transmedia storytelling than the branching narrative approach.

▶ ELEMENTS OF THE "TRANSMEDIA BIBLE"

Once the goal of the project and its main theme, story arc, characters, plot-points, and overall tone are defined, it is time to write out the full scripts and move into the detailed planning stage, including design choices and timelines. The general tone and visual approach should have already been decided. At this stage, this approach would be applied to each individual medium, and the various brand and/or style guides and interfaces conceptualized. Features such as art direction, color palette, lighting design, textures, logos, graphics, font specs, and other design and graphic elements need to be specified. Throughout this planning and mapping stage, it is useful to include plenty of visuals and mood-boards to illustrate the look and feel of each story and platform. In some instances, logos, design elements, and interfaces will need to be adjusted for the various channels—for example, a website's visual layout and interface will look different on a mobile phone than on a computer screen and will again change throughout various video segments, games, and live events.

Video and audio elements, including music and sound design, need to be determined, as well as casting choices and locations. Specific solutions will of course depend on the creativity of the makers, as well as the budget, time-lines, and available resources, but all the elements and aesthetic choices should always be consistent with the fundamental features—the goal, theme, and story of the project. Another aspect that should be defined early

on is the scope of the project: How local or global does it aim to be—will the content be only in English? Will the marketing target select countries and audiences only and, if so, which ones? How ambitious will the production of the videos, websites, interactive games, etc. aim to be? Answers to these questions should provide information about what is possible or not within the constraints of a particular budget and timelines. Defining the scope early on is also important in order to prevent the project from becoming overly ambitious and complicated, which can make it run out of time, money, and resources, and force it to collapse because of that.

The design of the project's technical interface starts with the visualization of the *user's journey*—the way in which users or viewers will be able to enter and navigate the storylines, as well as the various platforms and channels that are offered to them. The user's journey follows the story-arc and emotional engagement of the viewer with it, while the *experience design* provides the link between the story elements and the design of the technical components. The user's journey and the experience design determine the actual technical specifications and building—or programming requirements—of the project. As a whole, these elements create what is commonly referred to as a project's *story architecture*. The mapping of the story architecture usually starts with outlining entry points into the story, story arcs with plot points and calls-to-action where the story transitions or crisscrosses to other platforms, and user interaction scenarios, as well as what type of experiences all this will offer to the viewer.

Entry points into a story could be various media channels, such as Twitter, Facebook, Snapchat, or Vine, offering story-extensions (posts from the characters' POVs, for instance), crisscrossing at various plot-points and leading into YouTube video channels, offering the primary story content through web videos, which, in turn, connect to secondary storylines and deeper engagement with the main stories through websites, podcasts, scheduled location-based real-life events, games, etc. The planned rollout of each platform and its content will be closely related to the project's timeline. Viewers could, of course, also start their journey on any of the platforms, whenever they become aware of the project, especially if the project gains more traction during its later stages. Whatever the case may be, the creators have to define what kind of experience each of the platforms offer, and how they relate to each other. As previously discussed, independently produced transmedia projects that do not have an established fan following or brand recognition usually have to plan for much longer lead-in periods—the

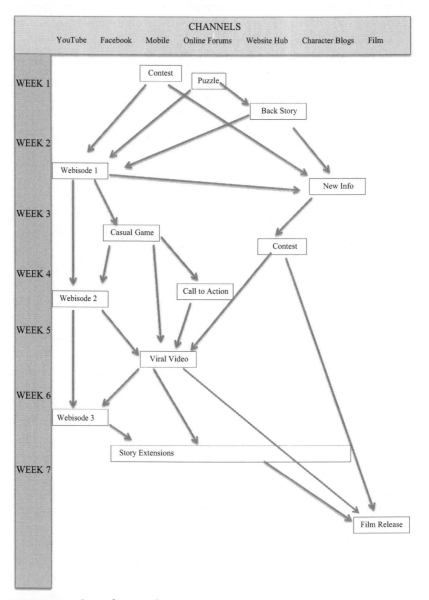

FIGURE 8.4 Sample user journey

"brand" here also meaning a well-known character, artist, or actor, not just a product or story franchise. New projects, usually working with limited budgets, will need to dedicate a substantial amount of time—as well as unique and creative ideas—to promotion, marketing, and outreach in order to cut through the media noise, attract attention, and build an audience.

Once the framework for the story architecture is outlined, the creators have to decide on the media platforms that will be used and the content that needs to be produced for each one. Available platforms that host user-generated content, such as YouTube, Vimeo, Vine, or Snapchat, offer the advantage of a large base of already existing viewers, which can make it easier for a new project to be discovered. For example, a project that includes short comedy animation videos could easily tap into some of the existing audiences on these platforms and introduce them to other related content. Many projects have used these strategies successfully, building substantial fan-bases with short videos on these channels, and then expanding to other platforms with more diverse content. YouTube is still the prime destination for video creators. Its spread and popularity have only increased over time, while the technical quality of the uploaded videos is consistently improving. Creators can reach a potentially massive audience, manage their online presence, and collect ad revenue. While all these benefits are indisputable, and while creators can monitor certain data about the audience's viewing habits and locations, these insights are still limited. Personal data about the fans and users and their contacts and addresses are mostly collected and aggregated by YouTube, and not by the project creators.

Hence, using a YouTube channel or similar platform to present a project to a potentially large global audience and build a following is an effective strategy, but one should also connect and link it to the project's own website or hub, which can have more unique, versatile, and deeper content. This allows project creators to collect their own data on viewers, such as email addresses, social media handles, and content preferences, and build their own databases and lists of followers. They can then use this data to alert and invite fans to upcoming events and releases, and also engage them with future new projects and crowdfunding campaigns. Using this method, the creators have more control and direct access to their core fans and do not depend solely on the platforms they use. This is especially important if the project's business model depends on revenue generated through some form of merchandising and product sales. One could, of course, design and use only unique proprietary platforms, but this would require a much bigger

marketing effort and budget, and it would be counter-productive in many other ways (excluding some viewers, eliminating the community-aspect of YouTube and similar channels, etc.)

Other issues to be considered relate to the use of technology, especially in terms of coding and programming. Various available commercial and open-source software applications allow media-makers to create interactive and multi-platform content without having to build exclusive solutions, which require coding and programming skills. While high-concept, big-budget commercial projects will most likely prefer to build their own proprietary technology, which can then later also be licensed to others, independent media-makers usually will not be able to afford such solutions, as they require expensive, custom-made hardware-based configurations. This is especially evident in the world of console-based games, which often require budgets equivalent to major Hollywood movies. Such components are typically out of reach for independently produced transmedia projects. Unless there is a way for independent media-makers to license such technology, or partner with a company that can produce it, independents have to rely on simpler tools.

Software that can be used for image creation and alteration, audio and video recording, editing, animation and special effects, website-building and mobile applications programming, interactive video and content creation tools, as well as applications for the making of online and mobile games are readily available and are generally inexpensive or free. While they are becoming increasingly more user-friendly, simpler to run, and more sophisticated and customizable, they still have some limitations. In order to be accessible and inexpensive, pre-programmed solutions can generally operate with only a finite number of selections and choices—even if these options can seem to be quite abundant. If a project needs custom-tailored and unique technical solutions, it will require more sophisticated programming, coding, and possibly also hardware-related applications (such as VR headsets, gaming consoles, robotic components, or drones, etc.).

An important aspect of story architecture and experience design is the project's time management. Project management covers all the features associated with content creation and distribution, media platform integration, the functioning of the programs and devices where the content will be running, as well as audience interaction and feedback. Because of the multi-faceted nature and inherent complexity of transmedia projects, this can be quite

challenging. Large-scale complex projects often use a content manage-
ment system (CMS), which is an application that lets the user post, edit,
and modify multi-platform content from one central interface. If a proj-
ect's budget is small and cannot support a unique customized CMS, vari-
ous commercially available software applications can be used to sync and
pre-program posts and online interactions. Instead of having to duplicate
and post content on several social media platforms on specific dates and
times, this can be synced through one central interface. Similarly, various
triggers and prompts ("if this / then that"—for example, if a viewer sends
a comment, he or she will get an email reward) can be pre-programmed in
order to simplify, monitor, and streamline the rollout process of the various
content strands of the project ahead of time.

The next step is to make a list of all the media content that needs to be
created along with precise production timelines—the length of the pre-
production period; the amount of time needed for the actual production
and post-production; and when the content will be ready to be released.
Different media requires different production schedules, diverse levels of
complexity and involvement, teams and budgets, as well as varying lengths
of production time. This all should be taken into account in order to deter-
mine the project's timelines. Films or videos with many characters and loca-
tions will take longer to produce than a simple one-character video diary;
live events will be more labor-intensive than the creation of online commu-
nity hubs; animation will be more complicated and time-consuming than a
series of still images; etc.

While the budget usually does dictate the physical and aesthetic confines of
a project, this does not mean that one always has to settle for less. However,
creators should be realistic in terms of what can be accomplished with the
available funds, time, and tools, and then search for the best possible solu-
tions within those boundaries. In filmmaking, it is generally understood that
the production time, budget, and quality are inextricably linked and the lack
of one of these elements will affect the other two. If there is not a decent
budget, the work has to be done quickly, causing the quality to suffer; if high
quality is a priority with a low budget, more production time will be needed,
but more production time increases the budget, etc. The solution to this puz-
zle is to adapt the project's story to the existing budget, and, if necessary, to
shorten the timeline and maximize what can be achieved with available tools
and media platforms. Every story can be told in many different ways, and
budgetary restrictions often force creators to come up with more inventive

solutions. With an independently produced, low-budget transmedia project, it is most sensible to start with low-cost content creation first, build a fan following, and only then try to fundraise and move to larger, more ambitious formats. With available technology—even if it is just an iPhone camera; a free YouTube, Vine, or Snapchat channel; and social media—it is quite possible to do this without any budget: All that's needed is time.

It should be quite evident by now that a transmedia project is complex and time-consuming. Even a simple film with a linear storyline will require a team of people to make it. A bare-bones film crew could consist of only a cinematographer and a sound mixer. Similarly, a basic transmedia team could consist of only two or three members, dividing their roles as designers and content creators. It is, however, more common to think of the project team as a crew of people with clearly delineated roles and functions. Similar to a film crew, each aspect of the production would be handled by a specialized department, and each department headed by a key creative collaborator. In film, these would be the director, cinematographer, art director, production designer, costume designer, casting director, and management team—the line producer, production manager, assistant director, etc. A transmedia team would most likely also include similar staff, as well as other partners, specific to the platforms and channels being used. The producer and director would generally be the ones fleshing out the concept and story together with the writer, and determining the goal, budget, and scope of the project. Based on media and platform requirements, they would then hire key collaborators. Those could include additional writers to write scripts for the diverse content that needs to be produced for various channels; additional producing and management staff; cast and crew for video or film shoots; multi-platform designers, who implement the look, experience, and architecture of the project; technology developers, who create and code hardware and software needed for the project; social media coordinators, who supervise and coordinate social media campaigns and audience feedback and communication; animators; game designers; and others.

Similar to a Hollywood blockbuster production, on a large transmedia project the team can include dozens, even hundreds, of people, with each department hiring entire crews. The team structure has almost a military-style, top-down hierarchy of departments and crewmembers, headed by the producer and director. In such instances, most of the work would usually be outsourced by the main creators to outside companies, each specializing in a particular medium; a film production company would make only the film components,

while a design firm would create all the web and application design elements, and a gaming company would focus on the game and interactive components of the project. When a project is sectioned out like this, it is even more important for the creators to monitor everything closely in order to maintain consistency of all of the story and design elements across the different segments.

Although most independently produced transmedia projects will not be able to afford such large crews, it is possible to build strategic partnerships with other companies that can provide such specialized services in exchange for shared ownership of the project. Even if a project is small and the budget very low, it is essential to have at least a small team of key collaborators. Similar to ultra-low-budget filmmaking, it is possible to engage people to work for very little money, in exchange for a credit on the production, if they believe in a project and are excited to creatively contribute to it. Here, it is again essential to plan the project well. It is hard for people to contribute their time, and work for little or no pay over long periods of time, without clear end dates. Even if those contributors were initially excited about a project, this would eventually wear them out. However, if their contributions are solicited within a finite, shorter amount of time, and the results of their work can be implemented efficiently, even a no-budget production can engage a multitude of talented artists, collaborators, and contributors.

Clear timelines need to be defined, both in terms of the project itself and in relation to the development and production of content for each of the platforms being used. It is essential to define a clear end-point for when the project is to be completed. This might seem obvious at first, but, as transmedia projects spread over many channels, some secondary content—such as project updates, games, or audience interactions—might continue after the main storylines have ended. Ideally, the project should be constructed in such a way that, if it becomes successful, the audience can continue to interact with it, even without the creators having to post new content. This is, of course, the case with the Hollywood blockbusters *Star Wars*, *Star Trek*, and various other sci-fi and superhero franchises, each with their multitude of fan-based creations and extensions. A successful example of an independently produced transmedia project, where audiences continued to engage with the project and add their own content after its official completion date, is, once again, *The Lizzie Bennett Diaries*.

The actual duration of a transmedia project, meaning the time it takes for the story to develop from beginning to end, is usually conceptualized in a

different way than a linear time-based story. Some elements—such as videos, podcasts, or live performances—will, of course, also unfold in a linear manner. Other content, however, such as puzzles, games, blog posts, web-based interactions, etc., can be consumed by the viewers on their own schedules. The total duration of the project can be looked at as the time it takes the user to complete his or her journey through the world of the story. In more open and non-sequential transmedia projects, however, it is more useful to think of this as the time in which new content is being posted by the creators. Once the last piece of the story is published and the creators cease to actively post new content or feedback—even if the audience continues to do so—the project is considered to be finished.

From the point-of-view of the user's journey, a project can last from a few minutes—like as a simple alternate reality game—to days, weeks, months, or even years. From the creator's perspective, the project's timeline starts once the content goes "live"—meaning the audience can discover, view, and consume it—and will last until the very last part is released. In both aspects, it is advisable to plan on manageable and limited time-periods, whether this means days, weeks, or months—depending on the goal of the project. The timeline should have all the key plot points and calls to action clearly mapped out, as these will be the deadlines for when each particular platform's content must be finished and ready to be released. Nevertheless, one should also take into account certain flexibility in between these points, where the creators could adjust the flow of content, story arc, and audience interaction, based on viewer engagement and analytics. For example, if a project is rolling out elements on three different platforms—YouTube, Facebook, and Vine—but after the first two weeks it becomes apparent that the majority of viewers engage with the content through Vine and Facebook, while traffic on YouTube is negligible in spite of marketing efforts, it would be a waste of time and resources to continue to treat all three platforms equally; instead, the creators should focus more attention on Vine and Facebook, and less on YouTube. This is especially relevant for projects with limited budgets and means.

Other timelines relate to the production of content. As has been outlined, each platform will require a different production timeline, depending on the amount of content, complexity, and scope of production. Various particular logistics also enter the equation here; for example, if the project has planned twelve web video episodes, it would make the most sense to produce them all at once and then release them according to the project's pre-planned timeline. If the videos were a central part of the story, this would make

sense; but if the videos are just secondary content and story extensions (like a film or TV series), it might be more sensible to produce a few episodes first and see how much traction and engagement they will get before producing the rest. A call to action, where viewers at points in the story can influence the next episodes (if there is a contest or campaign as to what the protagonist should do at an important plot point of the story), can also affect the scheduling of the different production segments.

When planning a film project, the organization always breaks down into the same stages: development, which includes securing and finalizing the script, and attaching the lead actors and director to the project; obtaining the financing for the film; the pre-production (putting together full cast and crew, locations, equipment, etc.); production (the actual shoot); post-production (editing, sound mixing, and mastering); and exhibition and distribution. A transmedia project generally breaks down in similar stages, but it can branch into numerous additional strands, depending on the intricacy of the project, and how many content strands and media platforms are involved. Finally, the timing of the release of the various parts of the project will also be critical to its success and impact—how much time to leave for the audience to acquaint themselves with the project, at what intervals to release the main content, when to cross over to other media channels, etc. This will be discussed in more detail in the following chapter. Even if a project is entirely non-commercial in nature, and done solely for artistic purposes, it is still advisable to map out the vital points of its development and production in order to assure that it will be successfully completed.

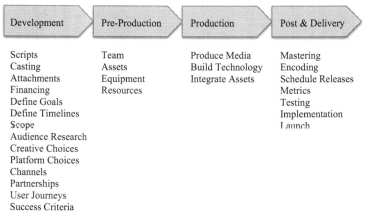

FIGURE 8.5 Transmedia production stages

Below is an example of two simple diagrams outlining the user journey framework and story-world for the transmedia campaign for the independently produced low-budget feature film *Zenith* (2010), created by the author. The goal of the transmedia project was to increase audience awareness and interest in the film but also to experiment with story expansion through transmedia. Audiences could watch the film alone or only interact with some of its transmedia elements, but exploring both the film and its transmedia extensions would provide for a richer experience and a much deeper understanding of the story and theme of the project. The feature film was intentionally left open-ended, allowing for multiple interpretations, while the transmedia storyline followed the deep, non-sequential open framework, allowing viewers to explore the story-world in any way they wanted. This all tied back to the main underlying idea of the project: framed by a futuristic dystopian narrative and centering on conspiracy theories, the project actually investigated how interpretations and manipulations of external realities affect our internal worlds, the narratives we create, and our concepts of reality.

The first diagram shows the general concept of the pre-release transmedia marketing campaign, integrating websites with the short videos from—or

FIGURE 8.6 The general framework for the "Project Zenith" user experience

"ZENITH" – Map

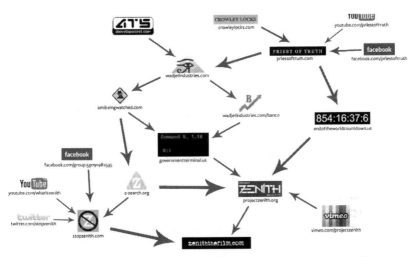

FIGURE 8.7 The "Project Zenith" website maze: the transmedia team ended up creating a total of forty-six content-rich websites, each one focusing on a different strand of the story-world, expanding or complementing its main themes.

related to—the film, and with social media. The second, more elaborate diagram maps the potential user journey through the maze of websites connected to the story-world, allowing the user to dig increasingly deeper into the fictional conspiracy of "Zenith" and discover the many plot-points, ideas, and meanings behind it.

▶ NOTES

1 The term "transmedia" here is applied once again in a broader sense, encompassing cross-media and multi-platform narrative concepts as well, and defined primarily by its spread and expansion across media channels.

2 Henry Jenkins, Sam Ford, and Joshua Green, *Spreadable Media: Creating Value and Meaning in a Networked Culture* (New York: New York University Press, 2013), 1.

3 Robert Pratten, *Getting Started with Transmedia Storytelling: A Practical Guide for Beginners*, 2nd ed (CreateSpace Independent Publishing Platform, 2015), 44.

4 Pratten, *Getting Started with Transmedia Storytelling*, 45.

5 "The Machine to Be Another—Embodied Narratives," Tribeca Film Festival, April 17, 2015, https://tribecafilm.com/filmguide/the-machine-to-be-another-embodied-narratives-2015.

6 "The Enemy," Tribeca Film Festival, April 17, 2015, https://tribecafilm.com/filmguide/enemy-2015.

7 Joseph Campbell, *The Hero with a Thousand Faces* (Princeton, NJ: Princeton University Press, 1972), 30.

8 Figure 8.1. "Hero's Journey," digital image, Wikimedia Commons, accessed January 11, 2016, https://commons.wikimedia.org/wiki/File:Heroesjourney.svg#/media/File:Heroesjourney.svg.

9 Pratten, *Getting Started with Transmedia Storytelling*, 23.

10 Gustav Freytag, *Freytag's Technique of the Drama: An Authorized Translation from the Sixth German Edition, by Elias J. Macewan* (Chicago: Scott, Foresman and Company, 1968).

11 Figure 8.2. "Freytag Pyramid," digital image, Wikimedia Commons, accessed January 11, 2016, https://commons.wikimedia.org/wiki/File:Freytags_pyramid.svg.

12 Pratten, *Getting Started with Transmedia Storytelling*, 28.

▶ BIBLIOGRAPHY

Bernardo, Nuno. *Transmedia 2.0: How to Create an Entertainment Brand Using a Transmedial Approach to Storytelling*. Lisbon, Portugal: Beactive Books, 2014.

Campbell, Joseph. *The Hero with a Thousand Faces*, 2nd ed. Princeton, NJ: Princeton University Press, 1972.

"The Enemy." *Tribeca Film Festival*. Last modified April 17, 2015. https://tribecafilm.com/filmguide/enemy-2015.

Freytag, Gustav. *Freytag's Technique of the Drama: An Authorized Translation from the Sixth German Edition, by Elias J. Macewan*, 3rd ed. Chicago: Scott, Foresman and Company, 1968.

Jenkins, Henry, Sam Ford, and Joshua Green. *Spreadable Media Creating Value and Meaning in a Networked Culture*. New York: New York University Press, 2013.

"The Machine to Be Another—Embodied Narratives." *Tribeca Film Festival*. Last modified April 17, 2015. https://tribecafilm.com/filmguide/the-machine-to-be-another-embodied-narratives-2015.

Pratten, Robert. *Getting Started with Transmedia Storytelling: A Practical Guide for Beginners*, 2nd ed. CreateSpace Independent Publishing Platform, 2015.

Rose, Frank. *The Art of Immersion: How the Digital Generation Is Remaking Hollywood, Madison Avenue, and the Way We Tell Stories*. New York: W.W. Norton & Co, 2012.

Rushkoff, Douglas. *Present Shock: When Everything Happens Now*. New York: Penguin Group, 2013.

▶ FILMOGRAPHY

21 Grams. Directed by Alejandro González Iñárritu. 2003. Universal City, CA: Focus Features, 2006. DVD.

Amores Perros. Directed by Alejandro González Iñárritu. 2000. Santa Monica, CA: Lionsgate, 2001. DVD.

Babel. Directed by Alejandro González Iñárritu. 2006. Burbank, CA: Warner Bros., 2007. DVD.

Beasts of the Southern Wild. Directed by Benh Zeitlin. 2012. Century City, CA: Fox Searchlight, 2012. DVD.

Birdman. Directed by Alejandro González Iñárritu. 2014. Century City, CA: 20th Century Fox, 2015. DVD.

Donnie Darko. Directed by Richard Kelly. 2001. Century City, CA: 20th Century Fox, 2005. DVD.

Eternal Sunshine of the Spotless Mind. Directed by Michel Gondry. 2004. Universal City, CA: Focus Features, 2004. DVD.

Fight Club. Directed by David Fincher. 1999. Century City, CA: 20th Century Fox, 2000. DVD.

Gosford Park. Directed by Robert Altman. 2001. Universal City, CA: Universal Studios, 2002. DVD.

Magnolia. Directed by P.T. Anderson. 1999. Burbank, CA: New Line Home Video, 2007. DVD.

Memento. Directed by Christopher Nolan. 2000. Santa Monica, CA: Lionsgate, 2000. DVD.

Nashville. Directed by Robert Altman. 1975. Los Angeles, CA: Paramount, 2000. DVD.

Pulp Fiction. Directed by Quentin Tarantino. 1994. Santa Monica, CA: Lionsgate, 2011. DVD.

Rashomon. Directed by Akira Kurosawa. 1950. New York, NY: Criterion Collection, 2012. DVD.

Shining, The. Directed by Stanley Kubrick. 1980. Burbank, CA: Warner Home Video, 2010. DVD.

Short Cuts. Directed by Robert Altman. 1993. New York, NY: Criterion Collection, 2004. DVD.

Traffic. Directed by Steven Soderbergh. 1999. Universal City, CA: Universal Studios, 2001. DVD.

Zenith. Directed by Vladan Nikolic. 2010. New York, NY: Cinema Purgatorio, 2010.

9

Project Organization

The overall organization of a transmedia project is inextricably linked to the goal and nature of the project, which also relate to the pertinent revenue and funding models. As outlined earlier, most projects generally fall into either the commercial or the artistic category. Commercial transmedia projects rely on generating revenue through some type of sales, or on the basis of subscription to a service. Alternately, if they are merely transmedia marketing projects—like an advertising campaign—a brand or company can pay for them. Artistic projects often rely on the project being fully funded up front, and giving the finished product away for free. Such is the case with many grant-funded or crowdfunded works. It is also possible for artistic projects to combine various funding and revenue sources—for example, crowdfunding the production, but then also selling films or videos connected to the work, or some accompanying merchandise. All of these models can employ a variety of funding sources and methods. Outlined below are some of the most common ways of funding transmedia.

▶ FUNDING & ORGANIZATION MODELS

Grants

While state-sponsored grants for media arts projects—including transmedia and other new media forms—exist in most developed countries, they have

been substantially reduced on the federal level in the United States over the past decades. Such grants still exist on local city and state levels—for example, in New York through the New York State Council for the Arts (NYSCA), or in California through Cal Humanities—as well as through various non-profit organizations, such as the Sundance Institute, the Tribeca Film Institute, Creative Capital, or the Independent Television Service (ITVS). All of these grants are competitive and relatively small in terms of amounts of money, compared to state funds in other affluent countries, like Germany, the Netherlands, or Canada. Canada's National Film Board's (NFB) budget for interactive media projects in the past few years amounted to 20 percent of its total operating budget, with each of the projects they financed averaging ca. $300,000 per production.[1] The results of this investment were that the NFB has, arguably, produced more groundbreaking transmedia and interactive projects overall than any other country or production entity in recent years, and it is currently in the forefront of new, emerging, and experimental media forms.

Grants are the primary sources of financing for artistic transmedia projects that experiment with narrative form, content, or the use of new technologies, as well as for documentary and social activism oriented transmedia. Besides researching all transmedia and new media grant-funding opportunities, project creators should also investigate grants available for their particular theme or subject, regardless of the medium. For example, some organizations might give grants to projects based on issues that they deem important, rather than the form or medium the project is realized in. Social issues—such as homelessness, urban renewal, poverty, pollution, or historical or educational topics—might qualify for such support. Other grant-related funding opportunities include collaborations and co-productions with international artists and companies, who might be able to apply for state funding in their country of residence and operation.

Like any other financing source, grants should be approached with careful planning. It will be difficult for inexperienced media-makers or those just starting out to get a grant at the development or planning stage of production. It is more likely that they will be able to expect some support at a later stage or to get funds to finish and/or release the work when it is possible to show the project as a work-in-progress. Thus, creators should expect to have to finance the early production stages either out of their own pockets, through crowdfunding, or through the help of outside investors. However, that does not mean that they should not apply for grants even in the early stages of development; it is useful to make the grant-giving organizations

aware of a project and to re-apply once the work progresses to the next phase, as most grants allow for multiple applications over time. This way, grant foundations are able to see that the creators are dedicated to the project, and that they are making progress with it.

For most projects, grants will be only one part of the financing structure. Besides the monetary reward, grants provide a certain level of validation to a project and open doors to other possible funding sources. They also help the creators to start establishing relationships with the grant-giving foundations, which are essential for long-term career development and future growth. Similarly, grant-funded projects sponsored by these organizations increase the likelihood of the project premiering at a prestigious venue or festival and getting more publicity and press exposure. While specific grant applications will vary in terms of what they require, all of them will need an outline, similar to the one the transmedia bible contains—the theme, story arc, main characters, platforms, etc. Creators are also usually asked to provide a budget estimate, along with a statement about why the project is significant and unique, and what makes them particularly qualified to execute it. It is useful to extract a general template based on the transmedia bible, with these additions, and to adjust it as needed for each specific grant.

Crowdfunding

Most independent transmedia creators rely on the rewards-based crowdfunding model, using a platform like Kickstarter or Indiegogo to solicit funds for their project. The key to a successful crowdfunding campaign is to approach it with full dedication and commitment, just as one would approach the actual production. In other words, it should be planned and executed carefully, with realistic goals in mind. The first question to ask is if the project or its creators have a sizable following and/or communities that will realistically be sufficiently enthusiastic about the project to financially support it. If this is not the case, the first step should be to build such a community and following; otherwise, the crowdfunding campaign will be a wasted opportunity.

An entirely new occupational field of crowdfunding consultants and specialists has emerged who purport to help creators reach their goals. While it can certainly be beneficial to employ specialists who have experience with crowdfunding campaigns, it is sensible to weigh how much their services will cost, how this will affect the crowdfunding goal (in other words, how

much of the total budget would go to these fundraisers), and whether the creators could do this by themselves, with the help of their core production team and/or volunteers. In either case, however, one should plan on assembling a team to help with the campaign. Once again, it is typically not a task a single individual can handle efficiently.

The other advantage of crowdfunding is that, besides being a funding tool, it is also a means for audience building and engagement. By identifying and reaching out to potential audiences, who might enjoy and support a particular project, the creators are not only raising money for it but also starting their project's marketing campaign. Let us assume the project creators have no substantial following besides friends and family—while this is a nice place to start, it most likely will not be enough to raise more than a few thousand dollars. If that amount is the goal, however, then the best scenario would be to ask them to donate to the project instead of having to spend extraneous time and effort on the crowdfunding campaign, and losing 5 to 10 percent of the funds raised to the crowdfunding website and the payment processing service.

Instead, one should identify the likely core fans for the project, starting by defining the genre and the likely audiences. As has been outlined in earlier chapters, this will be easier for some projects than for others—genres like horror, sci-fi, teenage romance and comedy, as well as certain documentary and social action topics relevant to particular communities (e.g., air quality in specific cities, increasing visibility of transgender youth, exposing public school issues in a certain state, etc.) will have advantages over broader themes and stories. Beware of making sweeping assumptions such as thinking, "This project is a relationship drama, and everyone has been in a relationship; therefore, everyone will be interested in this project." Generalizations like these are usually wishful thinking by the creators and are too broad to be of any use for audience building and/or crowdfunding. Of course the theme of a project can be more general and still worthwhile to produce; however, the creators need to acknowledge that it will be more difficult to identify likely viewers and thus more challenging to crowdfund for the project. As a general rule, it can be helpful to try to attach someone who has at least a small following and is able to generate publicity (an actor, performer, musician, artist, etc.) to participate and promote the project—or to start small, with inexpensive media first, and try to build interest through word of mouth and social media. If there are no clear target audiences, and the project and creators are not able to create a reliable fan base before

commencing crowdfunding (and production), one may have to rethink the entire approach. Sometimes it might be better and more productive to find other means of financing, or to refocus the project altogether, if there is not enough traction or the obstacles seem to be too high to overcome.

If the project creators have been able to identify their potential audience, they need to find out where they "hang out." Creators can look to Facebook groups, YouTube channels, and blogs and other websites for places in which they might congregate. Especially for crowdfunding purposes, the communication between the project creators and their potential viewers has to be unpretentious, genuine, and evenhanded. In other words, the potential viewers, who the creator hopes to reach and transform into core fans, have to become as enthusiastic about the project as the creators themselves. This only happens if everyone involved feels as though they are part of the same community. The creators let the fans "inside" and thereby allow them to become part of something bigger than if they were just onlookers, passively observing from afar.

Much like with grants, in most cases crowdfunding does not cover the entire budget of a transmedia project. Sometimes it will cover the development or the finishing phases of production and the release, or it can cover one part of the transmedia world—a film, a web series, or a game. Before starting the crowdfunding campaign, it is useful to think about which part of the project the crowdfunding campaign would be the most helpful for, or for which aspect of the project it would be the most difficult to raise money in any other way. Media forms considered to be expensive to produce are generally film, video, animation, and gaming. However, it is easier to solicit funds for such media in early stages, based on story, cast, and the creators' past work, than for other more ephemeral transmedia elements. Once parts of a project can be shown to potential backers, it becomes more likely that creators can also raise money for interactive segments, live events, social media storytelling and marketing, as well as promotion and distribution.

Rewards-based crowdfunding is generally not a method that can be used over and over again, so it is important to target the stage of the project where it will be the most valuable and produce the best results. Some film- and media-makers have had multiple crowdfunding campaigns for the same project—sometimes to cover different stages of the production like finishing funds and/or project distribution—usually, though, this happens when the media-makers have exhausted all other options. Other creators have

managed crowdfunding campaigns for multiple projects—generally one building on the success of another previous one. Still, there is only so much the creators can expect from their fan-base, even if it is large. It is difficult to keep going back to the same people for more money for each new project or stage of the production.

Once the funding goal, strategy, and target audience for the crowdfunding campaign are defined, it is time to proceed with the detailed planning. The funders' rewards levels need to be determined, as well as what they will receive in return for their pledges. The most common pledge levels are usually between $10 and $50, while a few higher-end tiers are usually offered as well: $500, $1,000, or even $5,000 or $10,000 can be seen in some crowdfunding efforts. For pledging such high amounts, backers are usually presented with a co-producing title, and/or some type of unique access or benefit associated with the project. Most rewards—aside from copies or digital downloads of the project itself—carry a symbolic significance and experience related to the project. The rewards should be unique and attractive to the backers, but also easy to deliver. Digital downloads or a day on the set of the production will be much easier to supply and manage than physical merchandise, such as T-shirts or coffee mugs, which would need to be manufactured and shipped. According to Kickstarter, if a project manages to reach 30 percent of its fundraising goal, it has a 90 percent chance of being successfully funded. The most common pledge amount is generally $25, with an average of eighty-five backers per project and an average pledge amount of $70. Using simple math, multiplying eighty-five backers with $70 results in a reachable average of $5,950 for a film or media project.[2] While this might be a worthwhile funding goal for a short film, that sum would hardly be worth the required time and effort to mount a campaign for a transmedia project.

As discussed in Chapter 5, the duration of a crowdfunding campaign can vary from one to sixty days, with thirty days being considered the most ideal time frame. Other important elements for a successful campaign include a clearly stated goal, how much money is needed and for what specific purpose, and documentation of how the money will be spent. A clear and concise description of the project is needed, as well as a video, where the creators and/or cast address the potential donors directly. These videos play an important part in the process; they have to be personal, engaging, and passionate, telling the back-story of the project, introducing the creative team, and emphasizing exactly why it is important for the project to be made. Other video materials—such as previous work, testimonials,

taped rehearsals, etc.—are also helpful. Regular project updates and new materials should be posted throughout the duration of the campaign. The campaign should also be integrated with social media channels like Facebook and Twitter. While social media has become a necessary communication tool, direct outreach, such as through emails and live events, is still the most effective way of getting people's attention. It is advisable to create some memorable actions or events, at least in the beginning, in the middle, and toward the end of the campaign, mobilizing and engaging all supporters, while providing them with unique and interesting content.

Although crowdfunding platforms offer possibilities for project discovery (most of them have "staff picks," and users can search by genre or type of project), it is best not to rely too much on that. The creators have to run their own marketing and outreach campaign, which in terms of scope and intensity should match a launch campaign for the project's commercial release. Given that the planning, execution, and follow-up for a crowdfunding campaign is a production in itself, and will last a total of at least two to three months, it is, once again, essential to make it worthwhile, and to set ambitious but achievable goals. Crowdfunding is not a magic bullet, but, if it is done well, it can play a significant part in the realization of a project.

Media and Technology Companies

The earlier outlined way of funding film projects by pre-selling them to film and TV distributors—selling the rights to distribute a film in different territories before the film has been produced—is usually based exclusively on the script and cast. In order for such a deal to be made, the distributor or sales company will typically require that certain elements—such as a specific director, lead cast, or content—be attached and included in the project. If the producer changes or fails to deliver the project with these agreed-upon elements, the distributor can withhold the funds, and the deal would collapse. Once a pre-sales contract is signed, the buyer would usually pay a 20 percent deposit for the film, with the remaining 80 percent due upon the delivery of the finished film. The producer would then borrow the rest of the money needed for the actual production. A variation of the pre-sale option is the "negative pick-up" deal—a contract between the content producer and a TV network or film distributor, who agrees to purchase the project from the producer for a fixed sum of money at a specified "delivery date." Once again, this can only happen if the network or film distributor believes in the commercial potential of the project, which means that the project has to have writers

and directors with successful commercial track records, as well as popular and established actors involved. The advantage for the project creators with a pre-sales or negative pick-up deal is that they only have to produce and deliver the project on time and on budget, and do not have to worry about its promotion, distribution, or marketing. The disadvantage is that the creators will have no control over how the project will actually be exhibited and distributed. If the network or distributor deems that there is not sufficient audience interest for the project, it can cancel the show or decide not to invest any money into its promotion, marketing, and distribution.

Transmedia projects generally do not have an established commercial distribution system, so these types of funding tend to work only for projects that have a film or TV series at its center, and where the transmedia components serve only as extension or complementary part to the main content and platform. In order to obtain pre-sales, the project creators would still have to attach celebrity actors or other commercial elements. For independents, it has become more difficult to secure this type of financing, as sales companies and distributors are asking for increasingly bigger "marquee names," in order to secure pre-sales, which, in turn, drives budgets ever higher. In this sense, the transmedia aspect of a film or series can possibly serve as an additional selling point for specific genres—for example, if the genre is comedy or horror, and the creators or their previous projects have a large fan following within the genre. However, a transmedia extension is usually not the key incentive for a distributor to make a pre-sales or negative pick up deal.

Distributors and TV networks, while still entrenched in the old world of traditional mass-media production and distribution, have started paying more attention to younger audiences, creating online channels and extensions in order to reach them. They are also trying to respond to rising competition from online technology companies, which have started producing their own original content. While this opens new opportunities for transmedia creators, the industry is still far away from making any radical or broad changes to its prevailing practices. The big media companies are slow to move forward and generally only accept new models when they become inevitable. The entertainment industry had to eventually acknowledge and respond to the ubiquity and ease of online streaming, mobile technology, shifting consumer habits, and the tech companies—such as Google's YouTube as well as Amazon and Netflix—moving into content production; however, they are still mostly trying to preserve the status quo as much as possible, rather than leading the way forward.

For transmedia creators, it is still more feasible to create their own path to success than to rely on being able to tap into the traditional film and TV funding models, such as pre-sales and negative pick-up deals. This means basically building their own brands through available, mostly free or customized, online and social media platforms. If their projects reach a critical mass of fans and audiences, then it is possible to move to the next level—to license or expand their content to a film studio or TV network. Alternately, creators can also target and pitch directly to emerging online mainstream content production platforms, such as Amazon Studios, Netflix, or Hulu. Most of them, however, are also primarily looking for serialized content similar to TV, rather than for new forms, like integrated transmedia experiences. Within such an environment, it is usually questionable how inventive or innovative project creators can be with their productions. The media world is still distinctly divided between the "old" and "new" models. Even though the old model is spreading onto new delivery channels, it is still holding onto—and trying to preserve—the same systems in terms of content and its delivery, funding, and monetizing options. The practices of large media corporations are mostly mirrored by the major mainstream online media platforms; they are rarely willing to experiment outside of the confines of standardized, repeatable practices. In the world of serialized TV, this means genres, such as courtroom dramas, police procedurals, sitcoms, reality TV, etc. In the film business, the franchised movie series model dominates, which has become quite similar to the structure of a TV series, only with each episode being a much higher-budgeted 3D film spectacle, released once every year, instead of once every week. In other words, the studios, TV networks, as well as the major technology companies moving into original content production all compete within the same traditional formats and genres, only transposing them onto new online delivery channels.

The distinct new, and predominantly online, media world has emerged as a consequence of technological innovation but also because independent media-makers have instinctively embraced the new opportunities for storytelling, community building, and interactive communications. The variety of content styles, methods, means, and delivery channels therein, each with its own way of operating—adventurous, untested, and without a universally adoptable strategy—has left each project to prove its potential for mass popularity and salability. Only once such potential becomes actualized can the creators expect to be able to access the much bigger funding opportunities that media conglomerates or large technology companies can offer—provided, of course, that this is their goal.

From a conglomerate's point-of-view, it seems to make perfect sense that every independent project creator would want to embrace more funding and bigger exhibition, marketing, and distribution opportunities. From the creator's point-of-view, however, this outlook can be more complicated. On first impression, one would of course consider accepting more money and exposure that a conglomerate can offer—that would seem to be the goal that any independent media maker would want to reach—similar to the view, which many in the film industry still hold, that any filmmaker who is independent is so only because he or she cannot make it to Hollywood. Otherwise, why would anybody want to be an independent? The real question, though, would be this: If independent media-makers can be sufficiently successful on their own terms, how much do they really gain from being funded by the industry? In some circumstances, they certainly would benefit, but there are many aspects that should be carefully considered. The first issue will inevitably be about power relations—how much control over a project would the creators have to cede to the studio, and what will they gain in return? The second question is, how will this reflect on the creator's work and practices? Some independent filmmakers have successfully transitioned to the industry; others have not. In the world of transmedia, this becomes even more complicated, as transmedia within the industry is presently primarily defined as marketing and advertising practices, with storytelling only being a part of that. Finally, certain types of new content creators, such as YouTube or Vine online stars, with their particular styles and audience relations can lose their standing and credibility with their fans by trying to adapt to the standardized world of mainstream media.

Like some other successful creators in the new online media environment, filmmaker and gamer Freddie Wong was able to do what he wants and likes, and along the way create his own transmedia brand. Though he did not originally aspire to be an online star, Wong was successful in achieving the moniker regardless. Once his name became known, he was offered deals with the media platform Hulu and the studio Lionsgate, allowing him to continue his work on a bigger scale, but without creative interference by the studios. On the surface at least, this looks like a perfect example of an independent media-maker becoming successful by his own means and subsequently being discovered and funded by the industry.

Another, different example of a small independent project gaining mainstream attention is the independent documentary and transmedia project *Indiegame* (2012), by first-time filmmakers Lisanne Pajot and James

Swirsky. The duo raised the money for their project through Kickstarter and produced, directed, shot, edited, and self-distributed the film. The film documents the travails of independent game developers, who sacrifice enormously in order to bring their visions and ideas to life. Not surprisingly, from its inception, the film received strong interest and support from its niche audience—the sizeable gaming community—but it also won film festival awards and critical praise. After screening at the Sundance Film festival in 2012, the renowned producer Scott Rudin (*The Matrix*, *The Social Network*, *The Girl with the Dragon Tattoo*, etc.) optioned the documentary in order to develop it into a half-hour long fictional TV series for HBO. The news was immediately and enthusiastically reported all over the entertainment press, but there was no follow up, and today—years later—it is unclear if the series is still in development, or has been abandoned by the network.[3] Regardless of what happens in this particular case, it is common knowledge that many projects languish in studio development for years, and many more never get made. That is actually one of the major reasons why independent film- and media-making exists in the first place. It is indisputable that a large media conglomerate can potentially give a project or its creator more visibility and media exposure, as well as higher budgets, but the conglomerate will have its own priorities and will not necessarily end up supporting every project it buys or options. In this time of many other conceivable opportunities, independent media-makers should weigh all of their options carefully, as media conglomerate-based funding is by no means the only choice.

In summary, funding options—such as pre-sales, negative pick-ups, or licensing deals from distributors, sales companies, TV networks, or the major technology companies—are unlikely for new and emerging independent media-makers and transmedia projects. If transmedia creators aspire to this type of funding, they will still need to focus on a film or TV series—or their online equivalents—as the primary media form and attach major commercial talent to the project. Alternately, they can build their brand online and try to negotiate such financing deals if their brand reaches a level of mass appeal that media companies would consider commercially viable for them to invest in.

Private Equity Investors

This type of financing is the hardest to obtain, even for more high-profile independent film or media projects. Private equity financing is investment by a high net-worth individual or company that specializes in high-risk film and entertainment investing, or is looking to diversify their portfolio.

Traditionally, within the entertainment industry, private investments are more common to finance large entities, such as studios or media companies, planning to produce several films and/or TV series over a set period of several years, within a fixed budget range (for example, one film or TV series each year, in the budget range of US$5–10 million, over a period of five years). In order to solicit such investments, the producers need to provide a realistic business plan and secure distribution for their projects up front. The investors would usually have a say which projects will get approved for production. Their approval will generally be based on commercial prospects, such as story and talent attachments.

For individual investors to put their money into only one project, without any distribution agreements in place, becomes the riskiest investment of all. In such cases, there are no guarantees that the investors will recoup any of their funds, and they could lose their entire investment. Some producers are able to solicit such investments through personal contacts, but, because of its high risk factor, this is not a standard practice. Furthermore, because of SEC (Security and Exchange) regulations, producers have to limit the amount of investors they can solicit funds from; otherwise they would have to register and file legal documents with the SEC, which is a costly and complicated process. Various online platforms have sought to simplify and streamline this process and create a way for investors to connect with project creators. This is based on assumptions that there are affluent people who would like to invest in media projects, but do not have the access to viable projects and creators; on the other side, there are obviously abundant numbers of media creators looking for investors. So far, however, no such platform has managed to find a truly efficient way to facilitate this exchange. It remains to be seen whether equity-based crowdfunding will change that.

While securing private equity-based financing is difficult for independent film and media projects, it is even more difficult for a transmedia project. Similar to media company funding, projects that have a film or TV series at its center and that include celebrity attachments would have a higher chance of attracting investors. Another possibility for transmedia funding would be for project creators to approach technology investment firms, such as venture capital funds and angel investors. Given that the vast majority of these investors narrowly specialize in funding startup Internet businesses and new technology developers, the project would have to be built around—or feature prominently—a new software, mobile application, or technical solution, and have a clear business strategy. Independent transmedia project

creators could also forge strategic alliances with Internet start-ups that would want to build their brand and marketing campaigns through transmedia storylines, and use that as a basis to solicit financing from venture capital funds. Big marketing and advertising agencies have already seized a large part of that market, but it is still possible to explore opportunities with smaller and emergent startup businesses.

Sponsorship-Based Financing

The simplest way to think of sponsorship-based financing is as another form of advertising. In its basic form, the model is quite similar to the traditional advertising model, where a company hires an agency to do market research, create or support a brand, and produce commercials for print and TV. Instead of relying only on thirty-second TV ads, many brands have increasingly turned to agencies with transmedia backgrounds to create immersive multi-platform storytelling experiences. These experiences are built around the brand and product that is being marketed. Some might include simple ARGs, while others will create elaborate story-worlds. A decade ago, this approach was still looked upon by many brands and companies as somewhat esoteric and experimental, but nowadays this has changed. With the advance of DVRs (digital video recorders) and ad-blocking software, it has become much easier for consumers to skip traditional ads, and increasingly more difficult for companies to get their PR messages through to consumers. The idea behind transmedia marketing is that storylines with interesting characters, spreading across media platforms, are more likely to reach consumers, since they will want to engage with the content, and not run away from it—like they would from the formulaic bland proclamations of TV advertising spots. Companies like Jeff Gomez's Starlight Runner, or the agency Campfire, have specialized in this type of content creation for various clients, from products such as Coca-Cola (Starlight's *Happiness Factory* project) or Audi (Campfire's *The Heist*) to various Hollywood movie franchises and TV series.

Popular terms related to this type of transmedia production are branded entertainment and multi-platform digital marketing. The goal of these projects is usually not to generate revenue but to increase the sales and visibility of a brand or product. Thus, the company will fund the transmedia campaign, which the agency will execute. Based on the brand, and in consultation with the company, the agency would develop the concept, story-world, design, etc. Once the company approves the concept, the agency may hire

various sub-contractors, as needed—such as a video production company or game designers—in order to realize the project across the various platforms. Budgets for these types of campaigns are usually quite substantial, as they involve a lot of production elements, time, and people. Branded entertainment has also progressed in the world of web series and shows, with many projects directly linking their content to their sponsors' sites, often in the form of e-commerce, where the viewers can click and buy a product they have just seen in the video. While this might seem like an ideal synergy model between creators and brands, it can also alienate some viewers, as it can often be perceived that the entire project is nothing more than another form of advertising. Many YouTube personalities, whose web shows are centered on advice on various topics, from makeup to fashion, while connected to—and endorsing—various brands, still have to be careful not to appear as being paid for by these brands. Bernie Su's follow-up transmedia series to *The Lizzie Bennett Diaries* (*LBD*), *Emma Approved*, had much better brand integration with its sponsors than *LBD*, and enabled direct sales opportunities for its sponsors' products, but—at least to some extent because of its more obvious commercial aspect—failed to get the same traction and fan following that *LBD* did.[4]

Transmedia funding and production for marketing and branded content can often provide a solid framework for a company's business model. Regular incomes from clients can cover expenses and operational costs, freeing the company to then develop other more artistic and creative projects. The catch here is that this is a highly specialized market, where the creators need to have close ties to advertising agencies, brands, and marketing firms in order to achieve recognition and get hired. Furthermore, these types of transmedia campaigns are highly demanding and time consuming, so it is usually quite difficult to be able to set aside time and resources to develop other projects.

Another aspect of sponsorship financing is the use of product placement and brand support for an independent narrative. Many Hollywood movie franchises receive millions of dollars from companies to show their brands on screen. Whenever a product label is visible or is talked about on screen, it is certain that someone has paid for it. While it is standard practice for the industry to solicit product placements for their movies, this is much harder for independents. Brands are inherently conservative, and they are more likely to spend millions of dollars to get some exposure in a Superman or Batman movie than a few hundred dollars to be featured in an independent

film. Ads and banners for online sponsorships generally pay miniscule amounts of money (often only one cent per click) and are worthwhile only if a project has more than a million views. However, there are other ways in which independents can think about company sponsorships and product placement. Smaller, local, and specialized companies are more likely to be willing to sponsor independent projects. While it is unlikely for a huge chain like Domino's Pizza to pay money for screen exposure in an independent film or video, it is more likely to get such investment from a small local pizza place in the city where the film is shooting. What would be even more likely—instead of getting money—is to negotiate free pizzas for catering during the shoot. Although this is not cash for the production, it still does contribute toward the funding of the project. Similarly, deals can be made for a lot of different means the production might need, from vehicles to office space and equipment.

Company sponsorships for independent projects are conceivable if a project has very specialized niche-market appeal—like for fans of baseball, or horse racing, fly-fishing, skate boarding, etc. If the content of the project does not clash with the image the brand seeks to cultivate, companies could see this as a good opportunity to expand their visibility and reach. Of course, in some cases, this might also lead to certain conflicts of interest—for example, if a project is critical of some aspects related to the interests of the company or brand, it might insist on changes in content. A noteworthy example of both how difficult it is for an independent project to secure sponsorships and how it is ultimately possible to do so is Morgan Spurlock's *The Greatest Movie Ever Sold* (2011). An independent documentary project, which got funded entirely through sponsorships, it actually debates the culture of ubiquitous branding and product placement in media and our environment. The film follows its creator as he talks to numerous companies to sponsor his movie (and is rejected by most of them), while engaging various notable speakers, including Noam Chomsky and Ralph Nader, with the topics of entertainment branding and commercialism. Spurlock eventually succeeds in finding a major sponsor in the pomegranate juice company Pom Wonderful, as well as some other smaller sponsors. While he did have to sign nondisparagement clauses with the companies, he still managed to retain rights to the final cut of the film.[5]

Sponsorship-based financing and branded entertainment continue to spread, allowing even formats, which never before had commercial prospects on their own, to be sponsored by companies and brands. Short, funny

home videos used to be submitted to TV shows, which utilized them for content but kept the revenues for themselves. Later, such content was posted on YouTube by its creators for entertainment purposes only. Nowadays, entrepreneurial amateurs who succeed at attaining sizeable followings are able to monetize their content on their own. The patriarch of the *Eh-Bee Family*, Andres, worked in market research and decided to create short, funny videos of himself and his family and post them on Vine.[6] Within a year, they had over two million followers on Vine and spread their content to YouTube, and then onto other social media channels. Altogether, they managed to exceed twelve million followers across the different platforms.[7] Apparently using his market research background, Andres was able to analyze their market reach and successfully offer top brands—such as Nestle, Johnson & Johnson, Toyota, Disney, etc.—opportunities to sponsor their "family friendly content."[8]

Ultimately, most transmedia projects would use a combination of funding sources and methods, depending on the nature of the project and its goal and subject matter. The independent films and transmedia projects *Iron Sky* (2012) and *The Cosmonaut* (2013) both used a combination of crowdfunding and other sources to finance their productions. *Iron Sky* received substantial funding for its US$10 million budget from the state film fund of Finland, and then raised the additional funds needed through a combination of rewards and equity-based crowdfunding. Similarly, the Spanish independent feature *The Cosmonaut* raised its entire US$1 million budget through a mix of equity and rewards-based crowdfunding. The New Zealand film and transmedia horror comedy *What We Do in the Shadows* (2014) was financed through the New Zealand film fund, and then raised over US$440,000 for its US distribution through Kickstarter.[9] For US independents, state film funds are not available, unless they are international co-productions, where the international co-producers could apply for their national funds, or if they are documentaries eligible for foundation grants. Equity crowdfunding was not an option for US independents until recently, but this is now changing. It is also possible to fund projects from revenue received from direct sales to fans. In the old model, this would be primarily from DVD and ticket sales, but it can now be realized through merchandise and product sales. Such sales approaches include the successful distribution strategies of the projects *Food for Change* and *Forks over Knives*—as detailed in Chapter 5—which have evolved into brands themselves, launching a variety of secondary products, from books, to paid-for events, to mobile apps.

Projections and Budgeting

Budgeting is frequently the aspect of production planning that mystifies inexperienced film- and media-makers the most. It is difficult enough to create a budget projection for a single-strand project, like a film, but it becomes even more complicated to do this for a multifaceted transmedia project. However, it can also be a very good exercise, which, if done properly, can often push the creators to re-think whether they really need all those multiple storylines, sophisticated games, and platforms they have envisioned, or if they should scale the project down to a more manageable size. After all, it is much easier to imagine things than to actually bring them to fruition. Every budget will be different and will require a lot of research and cost comparisons by contacting vendors, production, and equipment rental facilities; negotiating crew member rates; etc.

The first step in creating a budget is usually to do a "breakdown" of all the elements of the script—how many platforms will be used, and what is needed for each one? If creating a series of short videos, one must consider how many scenes there will be; how many days of shooting; how many locations, characters, props; what kind of equipment will be needed; etc. Similarly, what are the line items needed to produce other content, such as websites and blogs (such as writer's fees and technical expenses, like website creation and hosting fees); how much will the team members be paid for their work; etc.? While there are no simple formulas for how to calculate these costs, it is important to understand that most projects could be budgeted at multiple different levels, depending on the scale and scope of the production. A simple love story happening in five locations on two platforms—film and social media—could cost a few million dollars or a few hundred, depending on the type of production (high-end cameras, union crews, and top-paid actors vs. consumer camcorders, minimal crew, and unknown talent). Similarly, a special-effects-based action-packed video could easily be budgeted at a million dollars, or, again, cost only thousands or less, if it were done by Freddie Wong and his team of special effects experts, with their own equipment.

Commercial, revenue-based projects can aspire to higher budgets, while more artistic and experimental work that has no expectation to generate profits would have to expect more moderate funding goals. The creators should tailor the budget to the financing entities they plan to approach, and to the budgets these entities generally support. In most cases, it is useful

to initially make two budgets as templates and then adjust them as the fundraising campaign progresses: one being the realistically ideal budget, covering the cost of production and paying the team's salaries; the other, the "bare-bones" budget, which would be the absolutely lowest amount of money a project could be made for. As discussed previously, this is usually the point where creators might consider alternative approaches to their story and project, trying to fit it to the funding they can expect to raise. If a project's actual budget would be $300,000 but after assessing all possible funding resources, including crowdfunding and even personal assets, the creators conclude that they can raise only $100,000, what should be done? The answer is for creators to gauge what concessions they could make without compromising the project's main goal and idea. Is it, for instance, possible to cut the production time, use a smaller team, or simplify the project layout? Can cheaper equipment be used; can favors be called in for services, such as post-production and design; etc.?

If a project will be developed, produced, and released in stages, it still needs to be budgeted for each of the steps. If the creators start the project by using inexpensive and accessible means, such as a vlog and social media, to introduce the project and start building the audience, their costs might be negligible at first, but if they plan on eventually expanding to more platforms, such as film, video, gaming, and live events, they should make a preliminary budget of how much money they would need to raise to accomplish this. The ideal or realistic budget is the one that should be submitted to potential funders, each one of course tweaked to fit the demands of the particular funder, while the "bare-bones" one should remain unseen until all regular financing avenues have been exhausted. Doing a project on a miniscule budget will most likely mean asking for many favors and sacrifices from everyone involved with the project, so it should be the last resort, not the first one to rush to.

For most funding resources, such as grant applications or even media companies that could finance a project, it is sufficient to submit the so-called budget top-sheet only. This is basically a one- to two-page summary of all the costs, according to each category, such as salaries for writers, director, producers, and cast, and production costs for each department and service— camera, art department, locations, editors, animators, music, licensing costs, etc. If a detailed project breakdown and budget are done, it is easy to carry over these numbers to the top sheet; if not, the top sheet can at least give a basic estimate of the cost of the production. Even if the budget

top sheet is only a rough estimate, there still has to be some logic on which it is based. It is easy to see why a simple project with two actors over two free media platforms could cost only a few hundred dollars, but if a science-fiction project spreading over a dozen platforms, with special effects, is budgeted at only a thousand dollars, it will need an explanation.

Most budgets are divided into two parts: "above the line" (ATL) and "below the line" (BTL). Above-the-line costs refer to all charges associated with payments and travel and living expenses for the management team (writers, director, producers) and the cast. Below-the-line costs denote fees paid to the production crew and the technical costs of the production, from equipment to insurance and legal fees. The ratio between ATL and BTL costs can vary, but it is usually in the range of 25–35 percent for ATL and 65–75 percent for BTL. The below-the-line costs are easier to ascertain, as they will depend on tangible production logistics, while the above-the-line salaries and payments are more flexible, depending on the status and demands of the talent and creators. If the cast of the project is made up of union members, there will be specific salaries that will have to be paid to them, according to the project's budget level and union rules. Similar considerations might affect the writers and other crew members.

If there are no such rules to follow, the producers can determine the salaries according to the budget and what the project can afford. The general rule in such circumstances—at least on independent projects—would be to pay everyone the same "scaled" amount, according to the position they hold. The head of each department would get the same flat fee, the first assistants of each of the departments a slightly lower fee, but, again, the same amounts across the board, and so on, down through all the production ranks. Even if these amounts are miniscule, it is important that all members of the team feel that they are being treated fairly and their contribution is being acknowledged—especially on ultra-low-budget productions. Another strategy for micro-budgeted profit-based projects is to defer a percentage of the team's salaries until the project is completed and can earn some money. For example, if the total compensation for the director were $10,000, he or she would agree to be paid only $5,000 and have the rest of the salary deferred until the project makes a profit. Of course, as there is no guarantee that a project will actually make money, there is always the risk that deferred salaries would never be paid out. Key creative team members might agree to these terms nevertheless, if they are eager to get a credit on the production and believe in its quality and success.

Sometimes it can help the fundraising efforts if the creators agree to defer part of their compensation in order to get a project financed. This would show the creators' commitment to the project in tight budgeting situations, or if the funders are in doubt whether to support a project. However, the creators should not assume that if they agree not to take any money for themselves up front, this would increase their chances to get funded—on the contrary, it would look unprofessional, and as if they were not taking their work seriously.

When presenting the budget to a potential funder, it can be useful to highlight any resources or special advantages the creators have over competitors who are also applying for the same sources of financing. For example, inexperienced media-makers often do not consider the fact that they own a high-end camera or editing equipment as assets, and do not list these as values in their budgets. It is a basic fact that if they did not own the equipment, they would have to spend a few thousand dollars on buying or renting it. Such items should usually be listed as in-kind contributions, and their value noted in the budget. Sometimes, such assets can add up significantly—if the creators own most of the equipment needed for the production, have free access to major locations, and can strike deals with other companies that would give them access to services in exchange for potential future profits (like a music or sound studio, a special effects company, etc.), they could have a significant percentage of their budget already covered, even without having raised any cash. This should make their project more feasible and appealing to funders.

Budgets can be structured in different ways, depending on the elements that are needed and the media and platforms that are included in the project. It is generally recommended to create one master budget that would include all the different parts, but then break down each separate media platform into its own section. Professional budgeting software programs can be purchased, but most are designed only for film and TV production. Google Docs or MS Excel Spreadsheets can serve the same function; the most important aspect is that the budget is clear and easy to understand. Since these are budget projections, which are done in order to raise the actual financing and before all the details of the production are known, many items will be calculated based on assumptions. This is why the projected budget also always includes a contingency section—typically ranging from 5 to 15 percent of the total budget—which leaves the producers some leeway to adjust the budget later, depending on the actualities of the production and monies raised.

TABLE 9.1 Sample Budget Top Sheet

<<<< *BUDGET* >>>>

Program: YourDotCom
Format: HD Video, Interactive
 Web platform

Research:	6 Months
Prep & Prototype	6 Months
Production	3 Months
Post	3 Months
Tech	2 Months
TOTAL:	20 Months

Budget date: 8/1/2015

	ABOVE THE LINE	**TOTAL BUDGET**
1000	Pre-Production and Development	64,500
2000	Producing Staff	123,800
3000	Rights, Music & Talent	—
	TOTAL ABOVE THE LINE (A)	**188,300**

	BELOW THE LINE	**TOTAL BUDGET**
4000	Crew & Personnel	166,850
5000	Production Expenses	312,400
6000	Travel and related expenses	23,500
7000	Post-production	43,250
8000	Insurance	12,000
9000	Office & Administration costs	15,500
10000	Other Required Items	5,000
	SUB TOTAL	578,500
	TOTAL BELOW THE LINE (B)	**578,500**

SUBTOTAL (ATL + BTL)		**766,800**
CONTINGENCY	10.0%	69,090
FISCAL SPONSOR FEE	5.0%	38,000
GRAND TOTAL		**873,890**

Distribution and Revenue Models

The budget of a transmedia project and its fundraising methods and sources are closely related to the nature of the project, and whether or not it is expected to generate revenue. Naturally, if the nature of a project is purely artistic or experimental, without any commercial aspirations, this will limit

some of the likely forms of financing; it would also relieve the creators from pressures related to distribution and revenue generation. In either case, though, it is useful to set certain benchmarks to determine whether the project has actually reached its objective.

In order to define attainable and—at least to some extent—measurable criteria for the success of a transmedia project, it is useful to go back to the overall goals of the project and to break them down further, into more detailed points. If the goal of a project is social action, is it to inform audiences who are unaware of an issue, or to solidify existing support; if the goal is to market a product, is it to increase a particular audience—i.e., male or female, young or old, etc.—or to attract a new one from a particular socioeconomic segment; if the goal is to experiment with storytelling, is it to expand a known genre or narrative convention, or to experiment with a new technology in order to see if it can serve as a storytelling tool; etc.?

If a project's primary goal is commercial in nature, the creators need to define how it will generate revenue. However, even if the goal is not ultimately commercial, it can still use potential revenue streams—if there are any—as funding sources. The most obvious source of revenue would be to distribute, sell, or license a principal element of a transmedia project with conventional marketing and distribution potential to third parties, or directly to the viewers. Such an element could be a film, a video or TV series, a game, a book, etc. As discussed in Chapter 5, cross-distribution models and strategies make it possible for project creators to have more control over the distribution process and to combine traditional and new models. They can sell or license distribution windows and territories to specialized distributors for various media, while also letting users stream or download content from hubs or websites, which the creators own or control. The project's main website or hub can serve as a pay-per-view or pay-per-use service. Products relating to the themes, characters, and storylines of the project can be sold on the website. Additional products could include applications, videos, books, access to events, as well as services, which are offered on the site. Projects that manage to accumulate a sizeable following of passionate fans can often also sell collection sets of DVDs or Blu-ray DVDs. Online streaming has become the dominant way of how viewers watch content, but many still like to own a physical object of their favorite film or series, rather than only a digital file.

Projects that offer free media use and access can monetize their value by offering specialized, "deeper" content on a subscription basis. In order for

such models to work, they have to be on a level unique from their competition and offer the users some tangible benefits. For example, a project that has frequent updates—like exclusive diet recommendations, health-related stories, and related subject matter—would provide its users with a reason to visit the site often and consume the free media. However, only subscribers could access more helpful information, such as expert advice or custom-tailored individual health and dieting programs. In this model, the free portion of the project would serve as marketing tool and enticement for viewers to visit the site, while the subscription would provide the revenue, which could also be combined with various sponsorship types. Constant updates of content and the flexibility to tailor it to the users' individual needs provide a critical advantage to a transmedia project over similar content offered in a "static" format like a video or a book. If a project uses unique or proprietary platforms, services, or technological solutions, it is also possible to sell or license the entire system to a third party.

A transmedia project could also follow a similar path to monetization like an online start-up, offering free content in order to amass viewers, collect their information and viewing habits, and then sell it. If the audience or subscription base is large enough, it becomes a database of potential value to a third party—a studio, technology company, or conglomerate division—which could purchase the entire service. Alternately, it would be possible to link the transmedia hub to existing services and businesses, which have an interest in the project's particular demographic, for a fee. Such an approach could be considered another variation of the sponsorship-based model. As has already been outlined, other forms of sponsorship financing are also possible: text-based or rich media advertising online, throughout the project with banner ads; linking with, or working for, company or brand sponsors; or by utilizing product placement.

Traditional ways in which a project's success would be measured are key performance indicators (KPI) and/or the return on investment (ROI). KPIs are generally metrics used to evaluate the overall performance or success in relation to the stated objectives of a project or organization. In this instance, it would correspond to what was defined at the outset of the transmedia project as its goal. KPIs could include measuring website traffic or audience engagement on social media—assessing "hits" and "likes," as well as user interaction, product sales, campaign donations, or feedback to various initiatives. It is always important to clearly and accurately define the metrics of measurement. For example, nowadays it is almost impossible to avoid fake

"likes" and followers in social media, even if the creators have not solicited them. A lot of traffic gets automatically generated, even in legitimate advertising campaigns on Twitter or Facebook. These simulations are spawned in order to obscure the sham and origins of the counterfeiters. Companies, which are usually based in developing nations, employ "click-farms" (people paid to do this)—or software—that can artificially increase the number of "likes" and generate fake comments and reviews. Such enterprises have multiplied over the years, as social media traffic and online comments have become the defining features that advertisers, funders, and audiences rely on.[10] Thus, trusting numbers only as KPIs in this case can be misleading.[11] Instead, it would be more useful to analyze audience engagement with the content and social media posts, along with data where the viewers and users come from, who they are, how they respond to the project and to each other, etc.

While it is relatively easy to monitor online traffic through services such as Google analytics, or other proprietary data analysis software and tools, there are still numerous impediments to getting accurate information. Many people could click on a video, for example, but this still would not necessarily mean that they now have an increased awareness of the project, or that they will be likely to re-visit the site. Similarly, a lot of views for a free video will not automatically translate into product sales—even if the video becomes "viral." Sometimes it is difficult to gauge why a project at a given moment has more views and engagement than at others, as this is often a consequence of a variety of factors outside of the creators' control (a momentary change in current trends; other projects released at similar times; word-of-mouth; etc.). It is particularly difficult to evaluate the success of social-action based projects, which aim to generate an impact on their viewers beyond just watching the show but to participate and take action to help alleviate a certain problem, or to spread awareness about it. The broader the theme or scope of a project is (like saving the environment, or alleviating poverty), the harder it is to measure its effect. Even if a project appears to have moved audiences to action, it is often the result of a cumulative effort of many different projects, legislation, and work by various organizations that eventually all together have had an effect beyond each individual project's measurable success.

In order to resolve such ambiguities and to make project assessments more efficient, it is important to make the measurement of KPIs an ongoing process, not just something that is done at the very end. Besides providing

a better overall assessment, KPIs are also helpful in identifying potential problems and making improvements during the project's rollout. For example, if a project is live on three platforms, but only one gets viewer traffic, it is critical to not only notice this but also analyze why that could be the case and to try to find a solution for how this could be improved—or, if it does not improve over time, re-focus energy and assets onto other platforms and means of engagement. It is vital for transmedia projects—especially for independents—to be flexible and able to adjust during the course of the timeline. The only way to do this efficiently is to continually monitor KPIs and to change unproductive elements.

Return on investment is easy to understand as a measurement tool. However, the creators should clearly define the variables, such as length of time of the project's rollout and distribution, and when ROI can be expected. Examples of other factors that could play a part in the ROI calculation and should thus be taken into account are delayed production costs, payments of deferred salaries, and various particular expenses associated with delivery materials necessary for sales and distribution (like subtitling for foreign markets, close-captioning, additional mastering formats, specific insurance requirements, etc.). For artistic or experimental non-commercial projects, such valuations would not be applicable. Nevertheless, it would still be useful for the creators to establish some way in which they can measure the success of the project—some questions to consider are the following: Did it increase the visibility of the artist? Did it manage to introduce the creators to new audiences, funding organizations, or other types of support, which they could use for their future projects, etc.?

The definition of success for an independent project should not be only based on the expectation of the content going viral, having millions of followers, and leading to a deal with a major studio—not only is this unrealistic, but it would almost inevitably lead to disappointment. No project can convincingly plan to become the next *The Blair Witch Project* or *Paranormal Activity*, and most creators will not have a following of millions of passionate fans. However, they can still have relatively ambitious expectations—to return all investments with some profits and gain a following, and, based on that success, they could be able to produce a follow-up project with a higher budget and perhaps with the support of a major media company or distributor. While it is always easy to imagine that a project can become a huge success, it is also a good idea to consider if that does not happen, then what is the worst-case scenario? In other words, "Why are we doing this?"

Transmedia creators must carefully think through all their options, as an independent transmedia project is a commitment—one even bigger than an independent feature film.

Moreover, not every project needs to become a huge success in order to be worthwhile. Reasons to create a transmedia project could be to enable the creators to gain more experience with a medium, or to work with talented collaborators, or to enable them to add another item to their resumes, which would further their careers, or just because they "had to"—the story needed to be told, and no one else could (or wanted to) do it; all of these would be legitimate motives. Whatever the reason—and whatever the outcome—arguably the most important aspect will be to finish the project. Even if it does not turn out the way it was initially envisioned, as long as it is finished, it can have a life of its own in some form; it can be screened and exhibited and, hopefully, will find its audience. If it is never completed— whether this is due to lack of funding, loss of interest by the creators, or just incompetence—the amount of time and commitment from everyone involved would have been given in vain, and, in the end, there would be nothing to show for all of that effort. This is why, even if it is an artistic, experimental, micro-budgeted project, it is still worthwhile to institute some measurement of success and to think all these issues through carefully before beginning the production.

▶ AUDIENCE BUILDING & ENGAGEMENT

Identifying and building the audience for a transmedia project can be approached from different angles, depending on the nature of the project: If the work is focused on a creative and artistic theme and premise, the creators would need to identify their potential audience and, consequently, how to reach them and attract them to the project. If the transmedia campaign is an extension of an existing brand, or supposed to market a product, the creators would need to analyze the market and competition, as well as consumer habits, needs, and behavior patterns, and tailor the message to them. In order to achieve this, large advertising and marketing agencies typically resort to extensive market research, centered on demographic and psychographic data. Demographic research would focus on quantifiable characteristics of the targeted market groups, such as gender, ethnicity, age, education, social status, and income levels, while psychographic studies would center on users' personal habits and patterns

of behavior, such as opinions, values, interests, attitudes, and lifestyles. Research methods would include poring over statistical data from a variety of sources, as well as conducting surveys and interviews with representative audience members.

Digital technology has enabled new ways of data extraction and collection. Particularly useful is the data derived from users' existing consumer habits, such as purchasing or membership histories, which can be accessed through the users' online records. Some companies keep this data for their own internal use only, while others offer and sell—usually anonymous—user data patterns to outside agencies. For user surveys, in order to measure audience preferences and tastes, how the questions are formulated is of particular importance. A question could be posed asking if a viewer likes a film, or how the viewer would describe his or her personal relationship to a character's choices or the themes of the film, etc. If a company or agency has access to exact records of their audiences' viewing habits, as well as a precise classification of the content they consume, they are generally able to gain a competitive edge. As outlined in Chapter 3, it has been amply documented how Netflix used its distinctive system of content description—a show is classified not only as horror or comedy but as "mind-bending" or "irreverent"—along with users' star ratings and recommendations, to analyze viewers' habits and behavior, which guided their decisions in film and TV show acquisitions. Furthermore, when creating their own, original productions, their thorough data collection also helped them to select the right content to match their viewers' preferences.[12]

Considerations of who the audience is and what it responds to is equally important to both the industry and independents; however, independents will have a harder time researching and collecting relevant data about their prospective viewers. Assuming that the independent creators have a miniscule budget or no budget for methodical audience research, they will have to rely mostly on free and publicly available resources. A good place to start is to find other projects with similar themes and storylines and analyze who their audiences are. Besides looking at content for comparison, one should also attempt to match the scope and budget level of a project. It is useless to compare two similarly themed romantic comedies, if one stars Tom Hanks and Meg Ryan and was made for US$65 million, while the other will have two unknown actors and will be produced on iPhones for a few hundred dollars.

Scouring film, TV, and media industry publications and blogs will most likely divulge some facts about viewers and fans of a particular project. Looking at their social media interactions will reveal even more about who the fans are and where they fit in terms of age group, interests, lifestyles, geographic locations, etc. Clearly defined genres will make it again easier to do the research—it is simpler to identify sci-fi or romance fans than to deduce why specific audiences liked a particular film in a broad, dramatic genre. One could argue that a specific combination of factors has to converge in order for any project to be successful—such as story, actors, execution, and style, as well as a particular moment in time when a project gets released. As much as this is most likely accurate, it does not help in determining who the target audience for a future project would be, and how to approach them. For transmedia that serves a marketing function, this becomes even more challenging, as the makers have to not only clearly identify and define the consumers but also custom tailor how the message—the story, characters, genre—will be delivered to them. As much as media is a business, it is unlike producing cars, clothes, or phones. It still relies on the art of storytelling, and the uncertainty of what an audience will like, and to what extent. This ambiguity is one of the reasons why the media industry generally relies predominantly on the system of celebrity actors (or celebrity "personalities") as their guarantee for success; it is considered to be the only assurance that viewers will come out to see a film or show. As much as this assumption has been proven wrong time and again by big-budget Hollywood flops, it is the only way in which an uncertain industry, which basically gambles tens or hundreds of millions of dollars on each new project, can reassure itself.

To find and engage audiences, independents could certainly also benefit from using, adapting, or updating characters and storylines that audiences are familiar with, be it Shakespeare, Sherlock Holmes, or one of Jane Austen's romantic characters. Many well-known plots and storylines are in the public domain and can be adapted to new and contemporary settings. Like Hollywood franchises and remakes, independents could rely on the familiarity of certain characters with their existing fan-bases to build on. Whatever content is being used, however, it is sensible to keep in mind that some genres and topics are better left to the industry, while others are naturally more suitable for independent productions. High-concept, special-effects-based action spectacles are the domain of the big studios and hard to compete with. Broad genres—such as romantic comedies or biopics—are generally more dependent on star actors. The more "niche" a subject and story can be, the more the independent production will have an edge over the industry.

Very specific locales, environments, and often-underserved characters will be able to target underserved audiences as well. For example, Hollywood will make yet another broad formulaic romantic comedy, targeting all audiences everywhere, while the independents can distinguish themselves by specific flavor and focus—a romantic comedy set among Latino emigrants in Queens, NY, middle-class Indians in New Jersey, or skateboarders in Venice Beach, etc. The specificity of setting and characters provides not only distinctiveness in terms of story but also a much more easily identifiable core target audience. The broad overall genre (in this case, romantic comedy) allows for a broader audience to identify with the story elements and to potentially spread further and eventually gain general appeal—small independent romantic comedies like *The Brothers McMullen* (1995), *My Big Fat Greek Wedding* (2002), or *Once* (2007) were all set within very specific milieus and became big hits and financial successes.

A misconception to steer clear from, however, is that audiences will necessarily like stories that are similar to their experiences—sometimes this is true, but it depends entirely on the context. If someone is stuck with a job they hate and a relationship they want to escape from, they are unlikely to be the first ones to rush to see a drama about a character who hates his job and does not know how to end a relationship he is stuck in. On the other hand, suburban teenagers hanging out in malls are likely to want to see a story about suburban teenagers hanging out in malls that they can relate to. Often times independent transmedia creators will simply have to make certain assumptions about the audience, based on the data they can acquire. Some creators might focus only on the project, not worry about the audience in advance, and only think about its marketing once their work is done. In the past, this was quite common, as the distributors would focus on marketing and identifying and targeting the audience for the project. However, in the current environment of content overload, independent creators are increasingly expected to handle these tasks as well, at least up to the point when (or if) a project gains a viable mass following and commercial distributors would be interested in stepping in. In that sense, the problem with ignoring advance research and projections is that the objective of identifying the audience for independents is not so much to tailor the message to the consumers as it is to clarify which channels to use to reach prospective viewers. Once the creators have a sense of who their primary audience is likely to be, they will also know which are the best ways to deliver content to them—in other words, how to format the stories, and which platforms to use for distribution. Otherwise, they might waste their meager resources on

the wrong channels and miss valuable opportunities. In such cases, a project is often unsuccessful not because it is poorly executed but because it fails to reach the right viewers, who might have appreciated it.

While all these strategies help in identifying potential viewers and ways to reach them, they still do not address the subject of what type of content they will most likely respond to—or how to engage them. There is of course no formula that will guarantee success in terms of how the audience will respond to the main theme and story of a project. Nevertheless, the creators can identify ways in which they can maximize the possibilities for viewers to discover a project. Once audiences discover it, they should have access to means to continue and expand their experiences, and to interact with the story, its creators, and the fan community, and to contribute to it. In summary, the central part of the story is generally the least effectible—viewers will like it or not—but what can be customized and improved are the entryways to the project, as well as opportunities for further immersion and engagement. Transmedia projects typically balance between various levels of passive and active viewer experiences; as has been argued, the majority of viewers will prefer to consume content passively, and only a minority of passionate fans will go to the ultimate levels of engagement with it. These super-fans are, of course, important because they are the ones most likely to spread the word-of-mouth and invite others to the project, but even the passive viewers—if they like it—will usually appreciate secondary content and the opportunity for community-based sharing and exchange of comments and information.

Transmedia producer Robert Pratten, in his book *Getting Started in Transmedia Storytelling*, breaks down engagement into three main stages: discovery, experience, and exploration.[13] Each one leads to increased interest and further engagement with the project. The discovery stage involves first getting the attention of potential viewers and, second, giving them enough information that would be sufficiently attractive and interesting for them to continue to the main experience, platforms, and storylines. For instance, the first piece of media distributed through various channels used by the potential audience would be a teaser—free content that demands low levels of involvement, and whose purpose it is to make the viewer aware of the project. This is subsequently followed by trailers, which give more information and introduce the genre, look, and feel of the project, inviting the potential viewer to make the effort and experience the full story. Teasers and trailers can consist of a few short videos but could also be elaborate introductory

story fragments, dispersed over multiple channels, repeating key plot messages and representative imagery, enticing the viewer to explore the content ever further. ARGs as well as social media messages, contests, games, and live events can all be part of this stage. An entire storyline or medium can serve as discovery for the next stage. For example, a series of podcasts can serve to introduce a blog, which contains the teaser to a web series, which is the trailer that leads to a film. This initial phase should not be underestimated, as it will likely determine the success potential and initial scope of the project.

The industry can rely on big marketing budgets to plaster its teasers and trailers across all available media channels, repeatedly targeting consumers with their messages from billboards to cell phones, but independents will have to be much more selective and creative with their strategies and limited means. It is almost impossible not to know when the new *Star Wars* or *Jurassic World* installment is being released, but it will be very hard to pierce through the media noise and reach potential viewers for a small independent project. This pattern can also be observed in the next stage, which is the rollout of the main project—the blockbuster movie will open in thousands of theaters. If the movie had an efficient marketing campaign, it will lure audiences and be able to earn substantial box office revenue in the first week of its release, even if the subsequent viewers' reception will not be as good. By the time the word-of-mouth spreads through social media and other means, the movie will have already made tens of millions of dollars. As opposed to other commodities, where consumers have the option to get their money back if they dislike a product, they cannot get a refund for a bad movie—so the marketing campaign, hype, and viewer anticipation become key to a movie's success—or, at least, they can save it from being a complete financial failure. Independents do not have that luxury; they have to fight harder for audience attention, and deliver the goods. They usually have to start small, and only if they hit a nerve with the audience are they able to expand to a wider viewership.

After the discovery stage, the main experience—the central storylines— would be released (the web series, film, website hub, or game, etc.). The rollout of the main storylines should be accompanied or closely followed by the exploration stage, allowing viewers to delve deeper into the content. Integrated social media channels and other platforms should connect to the main experience and allow viewers to interact with it. Throughout these stages the project creators should follow and measure audience traffic

and interaction with the stages of the project and its platforms and story branches. This would be the second level, or "interactive content," while the final level—the "deep content"—would offer the core fans opportunities to creatively contribute to the project and become "producers." This can involve various strategies, from user-generated video uploads, textual contributions, and personal responses to the project's themes and storylines, to remixes and mash-ups of existing content.

As Pratten clarifies, there are various barriers an independent creator needs to overcome in order to reach the audience. These include the difficulty to gain access to potential viewers; the perceived genre inferiority of an independent project; whether the creators are known to the audience or not; and, finally, the fee the viewer needs to pay to access the content. The creators can scale each of these barriers during the discovery stage through content teasers, trailers, festival and critical exposure, expert recommendations, and positive reviews, and by giving content away for free. If these parts are done well, the creators will manage to break through the noise and glut of media content and generate interest. After that, however, the success of the project will mostly depend on the execution of the main story and how it resonates with the viewers: "It's only when the audience touches the target content that it can see it for what it is. If your Discovery content has done its job then the audience's expectations will be met or exceeded. But if you have deceived or misled them then they'll be disappointed."[14]

▶ MEDIA PLATFORMS

The terms "media platforms" and "channels" have become staples in transmedia terminology and are often used interchangeably, or with different meanings. A certain general distinction between channels and platforms could be made as follows: a media channel refers to the delivery method—TV, cinema, podcast, e-book, comic book, etc.—while a media platform would imply a combination of delivery channel, technology, and the medium being used. In this sense, a media platform would be more distinctive than a media channel. For example, YouTube, Vimeo, and iTunes all deliver video—so from the standpoint of medium and channel, they are the same—but each one uses a different technology and systemic approach to do that, so they would actually be classified as different media platforms. Furthermore, formats such as QuickTime or Flash, AIFF, MP3 or ACC audio, TIFF or JPG files, etc. can specify how each medium (video, audio, still images,

etc.) will be encoded and presented, while the various devices—iPhones, Android phones, Mac or PC, Xbox, cable TV, etc.—will specify how the media can be consumed.

Over which platforms and channels a transmedia project should spread will depend on a variety of factors including project goals, nature of the story, and audience expectations, as well as budget, scope, and available time and resources to realize the project. The Producer's Guild of America (PGA)— the trade organization representing TV, film, and new media producers— had notably added the title of transmedia producer to its accepted producing credits in 2010, defining it as producing a project that consists "of three (or more) narrative storylines existing within the same fictional universe"[15] on different media platforms: "As technology evolves, it's no longer adequate to think of a project as simply a television show or a movie; we now understand that the audience will want to experience that content across several platforms—online, mobile, VOD, Blu-Ray, and now iPad—often with different or additional material."[16]

While the choice of media platforms and channels should be selective, and there are no predetermined right answers, one still has to keep in mind that the different channels and platforms have different properties—these can be divided based on whether they are intended for active or passive consumption, or single, personal, or collective experiences, and how much time and effort they request from the viewer, as well as from the producer, to create each experience.

Text and Images

Produced inexpensively, text-and-image-based storytelling can employ various different platforms and channels, both on- and offline, from physical books, magazines, comic books, and fanzines, to electronic versions—e-books and comic books, blogs, wikis, and websites. Of course, electronic versions of books and comics are cheaper to make and distribute; however, there is an argument to be made that the physical object will be imbued with a larger significance in this time, when most of our communication and content have become digital. This is why some transmedia producers and agencies have insisted on creating physical artifacts rather than virtual or electronic ones in order to attract more attention for a project—like in the previously cited case of Campfire's transmedia campaign for *Game of Thrones*. This approach is similar to the added significance a

hand-written letter received in the mail would get now, compared to just another email.

Single images can tell stories as well. This has been amply demonstrated with the popularity of the social media platform Pinterest, the ubiquitous sharing of images on a variety of other platforms, but also with concepts relying on the properties of the single image, and short textual storyline—both present a specific moment frozen in time, which invites the viewer to imagine and construct the bigger picture, and possibly to explore the theme further. Such has been the case with the exceptionally successful project *Humans of New York* (*HONY*). Started in 2010 as a Facebook-based project by photographer Brandon Stanton, *HONY* was an ongoing series of still-image portraits and short interviews of a variety of ordinary people with extraordinary stories, taken on the streets of New York. The Facebook page amassed over sixteen million followers, and the project spread over other channels, including a book, which spent over twenty-nine weeks on the *New York Times* bestsellers list.[17] The project spawned numerous copycats, from the *Humans of Tehran* to the *Humans of Mumbai*.

Illustrations and graphic novels can serve as starting points for transmedia stories and establish its visual universe, as well as its tone and mood. Many extremely successful franchises have started as comic books—from the Marvel and DC superheroes, to *Walking Dead* and Japanese anime. Although a physical publication has its advantages, it would be expensive for independent transmedia creators to produce material comic books, so most will be made as website-based graphic novels or digital downloads. Similarly, it would be time-consuming and costly to publish a physical book, unless, of course, the book has already been published and can serve as starting point for a story expansion across other channels and platforms. Some audiences still favor graphic novels or textual storytelling to other forms of media; while these formats can be central or starting points, they can also serve as supplementary content, bridging or extending other media forms—such as a film, TV, or web series—into textual or graphic content. Besides fictional or documentary storylines, they can also offer background information, as well as in-depth narrative descriptions and documentation. These formats can be consumed on most channels, devices, and delivery platforms—from printed matter, computers, tablets, and mobile phones, to various social media channels, and even live presentations, such as shows and appearances in galleries, book stores, museums, and libraries, for instance.

Video and Audio

With the advance of high-speed online streaming, video has become omni-present on the Internet—consumed on laptops, desktops, tablets, and mobile phones, beamed and streamed to HD TVs and other screens as well. Short video content that can be easily shared by users is still the most popular online format. For a video to become viral or spreadable, it generally has to entertain, awe the viewers, or make them laugh—less common, but also possible, is for a video to spread by enraging or shocking audiences. For YouTube, the mass-market for short shareable videos, the recommended length for such content would usually be somewhere between twenty seconds and three minutes. However, other platforms, such as Vine and Snap-chat, have altered these standards. Given that most viewers increasingly watch this type of content on mobile devices, videos have become shorter and instantly get to the point. Viral videos can be a great way of building a brand—whether it is introducing a lead character or an online "personality," or in order to raise awareness about a project—but it can only work if the content of the video falls within one of the categories mentioned above: funny, outrageous, or surprising.

Another effective tool for web videos is animation. Short, funny animated videos with a surprising twist or punch-line are easily shareable and have the potential to go viral. Animation can also be used together with interactive applications and in combination with games. While high-end animation can be expensive, open-source online tools make it possible to create 2D or even 3D animation without a big budget. As has been amply demonstrated with the previous examples, from Vine celebrities to the *Eh-bee Family*, in order to be successful, the content of the videos has to immediately grab the viewers' attention and match—or exceed—their expectations within the given genre. Short videos, produced with the aim of being shared—and to hopefully achieve viral status—should be released once the entire transmedia concept and strategy have been thought out and designed; otherwise, they will serve no tangible purpose. A stand-alone web video, even if it goes viral, will have no effect, unless it can lead to the next level of engagement with the project or brand. There are plenty of funny videos online with dogs and cats, or hilarious situations and incidents, with millions of views but not much else to show for it.

Freddie Wong's *Video Game High School* and *The Lizzie Bennett Diaries* (*LBD*) are examples of another form of web video—the web series, or webisodes—sometimes also termed mobisodes, if they are primarily produced for mobile

screens. Their serialized content revolves around the same set of characters or situations and resembles the TV series format, adjusted in length to be consumed online—usually three to ten minutes per episode. Their popularity and reach have spread more significantly quite recently. Most independent content creators, as well as those in the industry, were looking at them as shorter replicas of the TV series on a different delivery platform. Audiences were unlikely to pay for this content; thus, it was expected—or hoped for—that advertising would come in and underwrite these productions, as it did with television. However, this did not happen—at least not to the extent that it could viably support these productions as a new, entirely autonomous form and branch of the industry. Instead, independent creators found a variety of ways to produce and use web series for a range of ends and purposes. It has become accepted practice that the content should be delivered for free—revenue could be potentially generated from advertising (if the series had over a million subscribers)—or from sponsorships, if the creators were able to solicit them. The web series could also just be one part of a larger transmedia project, or even just a marketing tool, with the financing and revenue coming from other sources—whether that is from selling a product (a film, a book, tickets to an event, etc.) or receiving money up front from crowdfunding or grants.

Web series are typically not as expensive to produce as film and TV productions. Costs can range from almost nothing—in the case of video-diary web series like *LBD*, or the early viral YouTube series *lonelygirl15*,[18] as well as numerous "lifestyle advice" online series—to more elaborate productions, resembling traditional TV sitcoms or dramatic series, but with lower budgets. A few popular web series have been able to transition to television once they became very successful, such as *High Maintenance*, created by husband-and-wife team Ben Sinclair and Katja Blichfeld, which originally ran only on the online platform Vimeo, and was then acquired by HBO.[19] Overall, such occasions have been rare; however, now that major platforms—such as Amazon, Netflix, and Hulu, as well as the studios' online units—are developing their own original web series content, this field is likely to change. Furthermore, the increased blurring of lines between cable television, pay-per-view channels, and online platforms as delivery methods and devices will most likely—at least to some extent—modify and combine the different formats.

Remarkably, many practices and conventions got transferred and duplicated indiscriminately and without much consideration from TV to the new

online environment. Such was the case with web series release schedules; for quite a while, most online series creators would release new webisodes once a week at a given time, just like a TV schedule, although that was not required or justified by any conceivable logic. Only once web series became part of larger transmedia projects, and mainstream companies such as Netflix introduced alternative, disruptive practices, did these habits change. Netflix not only modified the customary TV practice of producing a TV series pilot in order to measure its audience reception before green-lighting a full season for a series but altered the entire TV production and distribution model. Netflix produced a series' season all at once without relying on the pilot and also made the entire season immediately available to the audience, which led to the habit known as "binge-watching," where viewers would watch an entire season in uninterrupted succession. This does not mean that every online series should follow the same model, but it illustrates how thinking outside of the box can lead to better and more efficient results in a different media environment. A subscription-based online media channel that does not depend on advertising and time-and-date audience measurements can follow a different content-distribution model. Similarly, each web series can make its content available based on the timelines and logic of the project—as well as audience expectations and its retention and growth prospects—rather than preconceived conventions. In other words, for some web series, it will make sense to release all episodes at once, while, for others, it might be more effective to release them on daily, weekly, or even fluctuating schedules, synchronized with plot points and calls to action on other platforms.

Audio content can be a cost effective way to produce serialized, engaging stories, as well as sound environments and designs, linked and connected to physical spaces and locations. This format can be streamed or downloaded online through podcasts—regularly scheduled programs resembling radio shows, consisting of talk and discussion—such as interviews, commentary, or reportage, for example, as well as music. Audio can also be connected with social media, gaming, or GPS-based applications and integrated with other media content and platforms. Many projects have used significant audio elements to augment reality-based, GPS-driven games, or to enhance sound-based experiences through website and other online components.

Sound can be as strong an experience as images, or even stronger, as it is more abstract and evocative, but because of the way we experience it—more subliminal, pervasive, and surrounding us all the time—it seems less "direct"

than the image does, and thus project creators frequently pay less atten-
tion to it. This is why sound is most often an accompanying element in
a transmedia project and rarely its central part. However, if it is used in a
creative and imaginative way, it can anchor a project's theme and storylines
effectively. For example, the Guggenheim museum's multiplatform proj-
ect *Stillspotting NYC* centered on sound but also used video, site-specific
events, interactive maps, mobile media, location-based audience engage-
ment, and online data studies and visualizations to construct a story about
noise levels (employing an online "interactive noise map") and "still spots"
or places of respite in New York City.[20]

Film and TV

Distinctions between film, video, and TV have become confusing and gen-
erally semantic rather than substantial, as these forms have overlapped and
merged to such an extent that they are now differentiated mostly through
genre and formal approaches only. Would a project creator who makes a
short video for the web be a video-maker and not a filmmaker; and why
would a creator who shoots a long-form video on an iPhone be a filmmaker,
and not a video-maker? Instead of debating these details, it might be more
useful to distinguish film and TV from video as formats with corresponding
delivery channels. In other words, films are still made with the intention to
screen first in theaters, in festivals, and on bigger screens, while TV content
is a format produced for television distribution first. Of course, such defini-
tions become problematic as well, when scrutinized further, as many feature
films nowadays will play online only, and TV channels have their online
divisions as well, where they might screen some of their content exclusively.
Thus, "film" and "television" in this context really refers to their traditional
mass media formats: short and feature narrative and documentary films,
and the various TV genres, such as the serialized drama, the sitcom, the talk
show, reality show, etc. All of these forms are generally considered "lean-
back," passive experiences, although nowadays most films and TV shows
also have "second-screen" supplementary content, which are typically social
media channels, where audience members can exchange comments or learn
more information about the shows.

With the explosion of the various forms of media production and online
content competing for audience attention (and money), the industry has
to work hard to distinguish its productions and maintain reasons for view-
ers to go to movie theaters, pay for television, or pay to watch a film on

video-on-demand. This has led to increasingly more focus on spectacle-based entertainment: from mounting budgets and special-effects-driven high-production values, and technologies such as 3D, IMAX, surround sound, etc., to the cultivation of celebrity culture across all media forms. All these elements distinguish industry-produced movies and TV from independent productions and online content, which generally have smaller budgets, lower production values, and less access to celebrities. From the independent media creator's perspective, it is therefore more sensible to focus on niche content and cultivating his or her own audiences, rather than trying to compete with the studios.

Independent feature films still hold a distinct place within the world of the many media platforms; they are often the central or most important part of a transmedia project. If a film is well executed, and can find its audience, it can also still be a significant revenue generator, in spite of the overall trend of diminishing returns for smaller independent films. Additionally, a feature film could also be used as a promotional tool and given away for free, in order to further a transmedia project's visibility or brand. While digital technology has significantly reduced the technical cost of making a film, other factors such as locations, cast and crew salaries, longer production times, etc. should be taken into account. Compared to other media forms and platforms, the feature film will usually be more demanding in terms of funding, resources, as well as time and effort. Short films, on the other hand, as a format, have really become indistinguishable from other web videos. The only variance one could point out between the two is that short films are considered to be calling cards for film students and young filmmakers who are aspiring to make feature films and other long-form content. Such short films are primarily aimed at film festivals, where they screen before they end up online; as such, they do not really have commercial distribution potential but can serve promotional and marketing purposes for their creators or could be used as such for a brand or larger project as well.

Television content is usually pitched and packaged exclusively through entertainment agencies specializing in these formats, which makes access difficult for independent creators. Typically, only a studio or other large media entity is able to produce TV content as part of a transmedia project. In most cases, the transmedia project will serve only as a marketing or franchising component for a TV show or series, rather than the TV content being a part of a larger transmedia concept. For independent creators without direct access to TV network executives, it is more realistic to use

webisodes and online platforms to build their brand, rather than trying to get their content to television; if, however, they manage to accrue a sizeable audience and fan following, that can easily change.

Interactive Content

Interactive content is generally considered to be content that invites the viewer to have a "lean-in" experience and become a "user." The most common interactive element of a transmedia project is games, which provide an excellent opportunity not only for interactivity but also for deeper immersion with the story. Games can vary in scope and complexity, from simple puzzles and contests to advanced, multi-player games and console-based gaming applications. Games that can be created and played with minimal technical devices and tools are usually labeled as casual games. These are simple web-based or mobile application games that allow the user to solve puzzles or advance through levels of game-based challenges. Free open-source or inexpensive proprietary software can deliver easy ways to create basic games, even for creators with little or no experience in game design applications. Many mobile applications allow users to experience hybrid worlds, blending real physical spaces with virtual objects and characters, using GPS and QR (quick response) codes. Such applications are often used in site-specific and location-based storytelling approaches, as in the example of *Stillspotting NYC*, where they are integrated with other storytelling tools and platforms, serving the overall theme and premise of the project.

Alternate reality games, or ARGs, are a more intricate form of casual games. These usually include a combination of tasks that users need to perform online and in real life in order to overcome challenges and accomplish certain objectives. The fulfillment of these goals is typically connected to some reward and linked to the user advancing to the next level or platform of a project. ARGs have become common ways of marketing big-budget franchised entertainment, such as the Marvel universe, Disney characters, or blockbuster movies. While ARGs are an effective way to engage core fans of established brands, it is much more difficult to motivate users to interact in this way with a new, unknown project. Independent media creators have to be mindful of the amount of effort they ask their users to put into the game and whether they will be willing to do that. If viewers are sufficiently intrigued with an unsolved mystery in a new project's storyline, they might be tempted to play a casual online game to discover more clues in order to open new doors and go further into the storyline. It is quite unlikely,

however, that many of them would engage with an ARG that would ask them to leave their homes and go to actual locations at certain times to hunt for the clues—they would do it for a Batman or Star Wars ARG, but not for a new, unknown project.

Similar considerations should be paid to the overall approach and choice between active vs. passive consumption of transmedia content; the fact that many interactive options are offered to viewers does not necessarily mean that they will use them. If the requirements of the viewers' time and efforts needed to engage with the project are deemed to be too high, they will be likely to abandon it. It is useful here to, once again, distinguish the conceptual difference between story and experience. If viewers watch a short video, they will follow a story; if that video is interactive, however, they will be making choices that will affect the outcome of the story, making it closer to the experience of playing a game than to the passive viewing experience of a film. Unless the premise of a project is based on the usage or experimentation with interactive tools—and that becomes the primary reason why audiences would engage with it—it is more likely that viewers will be willing to first engage with a project by passively following a plot and characters. Gradually this can expand further to include interactive experiences, which will enhance the audience's involvement—but only once they are lured into the story-world, and willing to spend more time and effort to dive deeper into it.

A simple way of building low-level interactivity into a project is by engaging viewers to comment, choose, and make suggestions through social media. This requires generating plenty of enticing complementary content, building on the main story, and inviting viewers to participate in a shared exchange—asking them to say what they think of a character's actions, to comment on themes or backstories presented in the project, or to make suggestions for future developments. For each of the levels of interactive engagement, it is essential to specify objectives and goals, and the way in which they relate to other aspects of the project, such as the different media platforms and content strands.

High-end, console-driven personal and multi-player 3D video games are a genre in itself. They require high production values and big budgets and are usually produced by large agencies and companies specializing in game design and applications creation. Transmedia project creators could partner with game design companies, if such a game is essential, and share

ownership of the content. Alternately, they could approach game designers at a later stage of the project in order to develop more elaborate gaming applications for future iterations. Many observers have commented that game designers working in their medium have a more instinctive grasp of non-linear transmedia storytelling than filmmakers or other media creators, as multi-strand non-linear storylines are intrinsic to the creation of video games. This is certainly true on the level of transmedia as interactive experiences, but not necessarily in all storytelling aspects. Transmedia storytelling involves crafting a story that should immerse the viewer by just following its basic elements, such as plot, characters, story arc, climax, and conclusion, and not simply because the user has the opportunity to affect a variety of different story outcomes. A video game is still a different individual experience, just like any other format, which has its own logic and objectives. A transmedia project can strive to have similar user experiences but can also achieve audience immersion and engagement through different means.

Various other technological innovations, such as virtual reality (VR) and augmented reality (AR), offer more and more opportunities for user immersion into simulated worlds and expanded realities. VR has already advanced past its experimental stages and has been integrated into the world of video gaming. As an experience, it will certainly open entirely new possibilities; its full potential as a storytelling tool, however, still remains to be seen. Augmented reality, which connects the online world with physical objects and spaces, has been used in some ARG- and location-based transmedia projects. It has the potential to grow tremendously as the technology develops further, blurring the lines between physical and online interactions and experiences.

Live Events and Performance

A live performance or gathering—such as a concert, play, fan congregation, art installation, party, etc.—can be used as a live-event component of a transmedia project. One of the advantages of having some kind of live-event element is that it can create or expand a community in a physical way—e.g., online fans meeting in person in order to connect with each other and share their experiences related to the themes, characters, and storylines of the project. A whole category of fandom subcultures has sprung up, where fans interact through "cosplaying"—wearing costumes of their favorite characters from popular shows, comic books, or movies. The best-known fan conventions have become the various comic-cons, dedicated to comics, anime,

manga, video games, toys, TV shows, and movies. Started in San Diego in the 1970s, they have since spread in various forms throughout the world.[21] Similarly, some fan gatherings include live-action role-playing games, like the *Walking Dead* zombie walkathons. Most of these types of gatherings are dedicated to big mainstream brands and franchises, but they can be organized for smaller-scaled projects as well. Other fan assemblies could include fundraising campaigns, film or trailer premieres, website launches with after-parties, and essentially any themed events that would connect fans with each other, the project, and, possibly, also with actors, participants, and the creators. Campfire's transmedia campaign for the *Game of Thrones* series launch, as described in Chapter 7, is an excellent example of integrating online story-worlds and games with real-life experiences, such as tasting food from food trucks on the streets of New York and Los Angeles.

The other advantage of live events is that they provide the viewers with unique experiences. As audiences spend most of their times in front of various screens and in virtual worlds, live events have become increasingly more memorable and valued. Even if there is a live video stream of an event, it is not the same as sharing the experience in person, being present at the event, and participating in it. Images and sound can be duplicated and reproduced, but the original experience of "being there" cannot—even if the participants at the event will spend most of their time looking at their phone screens, recording, posting, and sharing the live content on social media (which, again, becomes another valuable part of user-generated content that spreads the transmedia experience). It is useful to include live events at various stages of the transmedia project—for example, at the beginning and at its peak—or to mark key plot points or calls to action. Events do require a separate set of planning, logistics, and organization, and often a considerable budget to produce them.

A particularly interesting form of transmedia-related live events are interactive or immersive theater performances. Such theater generally breaks the "fourth wall," which traditionally separates the audience from the performers, who are on stage in a designed fictionalized setting and do not interact with the viewers. In an interactive or immersive performance, audience members become participants in the play. They can be asked to be part of the story, converse with the actors, change the course of the play, or discuss its themes and ideas with the performers. The company Punchdrunk has developed a hugely popular and influential form of immersive theater. They have "pioneered a game changing form of immersive theatre in which

roaming audiences experience epic storytelling inside sensory theatrical worlds. . . . [Their] transformative productions . . . focus as much on the audience and the performance space as on the performers and narrative."[22]

In their most popular immersive performance, *Sleep No More*, Punchdrunk presented Shakespeare's classic tragedy Macbeth as a site-specific performance through the lens of a Hitchcockian film noir. Audiences were free to wander through the space and world of the story, covering several building floors, one hundred rooms, with hundreds of actors performing in costume. Viewers could choose their own paths through the story, experiencing it in a non-linear fashion, depending on which rooms they would decide to visit, and which aspects of the extremely elaborate set design they would focus on. They could follow one character or many, discover clues to the story's plot, or just observe whichever scenes they would find the most interesting. The distinction between audience members and performers—besides costumes—was that audience members were wearing masks. This also made it impossible for one viewer to gauge the reaction and response of another, turning the play into a truly individual experience, where each audience member could have seen a different story, or even multiple different stories, if they would choose to come back and see the play again, but visit different rooms.

Originally premiering in London in 2003, *Sleep No More* opened in 2011 at the McKittrick Hotel in New York. Without any paid advertising, only through word-of-mouth recommendations, the play has managed to become a phenomenon—winning the Drama Desk Award for Unique Theatrical Experience, and selling out almost every performance for five years. Subsequently, the group has also opened a themed bar and restaurant.[23]

▶ NOTES

1 Kristy Hutter, "A Documentary like No other Documentary," *Macleans*, January 18, 2012, http://www.macleans.ca/culture/movies/a-documentary-like-no-other-documentary/.

2 Devon Glenn, "TFF 2012: Kickstarter's Elisabeth Holm Explains How to Fund a Film on Kickstarter," *Adweek*, April 24, 2012, http://www.adweek.com/socialtimes/tff-2012-kickstarters-elisabeth-holm-explains-how-to-fund-a-film-on-kickstarter/95825.

3 Mike Fleming Jr., "Sundance: HBO and Scott Rudin to Turn Docu 'Indie Game' Into Series," *Deadline*, January 22, 2012, http://deadline.com/2012/01/sundance-hbo-and-scott-rudin-to-turn-docu-indie-game-into-series-218634/.

4 Katie Buenneke, "Why Emma Approved Didn't Work as Well as the Lizzie Bennet Diaries Did," *L.A. Weekly*, April 7, 2014, http://www.laweekly.com/arts/why-emma-approved-didnt-work-as-well-as-the-lizzie-bennet-diaries-did-4499200.

5 David Carr, "Financing the Hand That Slaps (or Nibbles) You," *The New York Times*, April 15, 2011, http://www.nytimes.com/2011/04/17/movies/selling-morgan-spurlocks-greatest-movie-ever-sold.html.

6 Lesley Kennedy, "Move Over, BatDad! Meet Vine's Latest Hilarious Family," *Today*, February 27, 2014, http://www.today.com/parents/move-over-batdad-meet-vines-latest-hilarious-family-2D12183367.

7 Social Media," *Eh-Bee Family*, accessed January 22, 2016, http://www.ehbeefamily.com/.

8 "Branded Examples," *Eh Bee Family*, accessed January 22, 2016, http://www.ehbeefamily.com/branded-examples.html.

9 Jemaine Clement, "What We Do in the Shadows: The American Release," *Kickstarter*, last modified December 28, 2015, https://www.kickstarter.com/projects/1423546688/what-we-do-in-the-shadows-the-american-release/description.

10 Jaron Schneider, "Has Facebook's 'Suggested Pages' Spawned a New Haven for Spammers?" *The Next Web*, January 23, 2014, http://thenextweb.com/facebook/2014/01/23/likes-lies-perfectly-honest-businesses-can-overrun-facebook-spammers/.

11 Andrew Smith, "Twitter Is Teetering Because It Has Turned into One Big Pyramid Scheme," *The Guardian*, November 6, 2015, http://www.theguardian.com/commentisfree/2015/nov/06/twitter-teetering-pyramid-scheme-social-media.

12 Andrew Leonard, "How Netflix Is Turning Viewers into Puppets," *Salon*, February 1, 2013, http://www.salon.com/2013/02/01/how_netflix_is_turning_viewers_into_puppets/.

13 Robert Pratten, *Getting Started with Transmedia Storytelling: A Practical Guide for Beginners* (CreateSpace Independent Publishing Platform, 2015), 93.

14 Pratten, *Getting Started with Transmedia Storytelling*, 142.

15 "PGA Board of Directors Approves Addition of Transmedia Producer to Guild's Producers Code of Credits," *Producers Guild of America*, April 6, 2010, http://

www.producersguild.org/news/39637/General-PGA-Board-of-Directors-Approves-Addition-of-Transmedia-Produce.htm.

16 Ibid.

17 Brandon Stanton, "Humans of New York," *Humans of New York*, last modified January 21, 2016, http://www.humansofnewyork.com/.

18 YouTube, "Lonelygirl15," *YouTube*, last modified December 8, 2008, https://www.youtube.com/user/lonelygirl15.

19 Elizabeth Wagmeister, "High Maintenance: HBO Brings Web Series to TV," *Variety*, April 20, 2015, http://variety.com/2015/tv/news/high-maintenance-hbo-web-series-tv-1201475800/.

20 "still () spotting nyc," *The Guggenheim*, accessed January 22, 2016, http://stillspotting.guggenheim.org/.

21 "About Comic-Con International," *Comic-Con International: San Diego*, accessed January 22, 2016, http://www.comic-con.org/about.

22 "Punchdrunk—About," *Punchdrunk*, accessed January 22, 2016, http://punchdrunk.com/company.

23 Alexis Soloski, "Sleep No More: From Avant Garde Theatre to Commercial Blockbuster," *The Guardian*, March 31, 2015, http://www.theguardian.com/stage/2015/mar/31/sleep-no-more-avant-garde-theatre-new-york.

▶ BIBLIOGRAPHY

"About Comic-Con International." *Comic-Con International: San Diego*. Accessed January 22, 2016. http://www.comic-con.org/about.

"About—Indie Game: The Movie—A Video Game Documentary." *Indie Game: The Movie*. 2012. http://www.indiegamethemovie.com/about/.

Alois, J.D. "War Bonds for Iron Sky on Invesdor." *Crowdfund Insider*. September 27, 2015. http://www.crowdfundinsider.com/2015/09/74983-war-bonds-for-iron-sky-on-invesdor/.

"Branded Examples." *Eh-Bee Family*. Accessed January 22, 2016. http://www.ehbeefamily.com/branded-examples.html.

Buenneke, Katie. "Why Emma Approved Didn't Work as Well as the Lizzie Bennet Diaries Did." *L.A. Weekly*. April 7, 2014. http://www.laweekly.com/arts/why-emma-approved-didnt-work-as-well-as-the-lizzie-bennet-diaries-did-4499200.

Carr, David. "Financing the Hand That Slaps (or Nibbles) You." *The New York Times.* April 15, 2011. http://www.nytimes.com/2011/04/17/movies/selling-morgan-spurlocks-greatest-movie-ever-sold.html.

Clement, Jemaine. "What We Do in the Shadows: The American Release." *Kickstarter.* Last modified December 28, 2015. https://www.kickstarter.com/projects/1423546688/what-we-do-in-the-shadows-the-american-release/description.

Fleming Jr., Mike. "Sundance: HBO and Scott Rudin to Turn Docu 'Indie Game' into Series." *Deadline.* January 22, 2012. http://deadline.com/2012/01/sundance-hbo-and-scott-rudin-to-turn-docu-indie-game-into-series-218634/.

Glenn, Devon. "TFF 2012: Kickstarter's Elisabeth Holm Explains How to Fund a Film on Kickstarter." *Adweek.* April 24, 2012. http://www.adweek.com/socialtimes/tff-2012-kickstarters-elisabeth-holm-explains-how-to-fund-a-film-on-kickstarter/95825.

Hutter, Kristy. "A Documentary like No Other Documentary." *Macleans.* January 18, 2012. http://www.macleans.ca/culture/movies/a-documentary-like-no-other-documentary/.

Kennedy, Lesley. "Move over, BatDad! Meet Vine's Latest Hilarious Family." *Today.* February 27, 2014. http://www.today.com/parents/move-over-batdad-meet-vines-latest-hilarious-family-2D12183367.

Leonard, Andrew. "How Netflix Is Turning Viewers into Puppets." *Salon.* February 1, 2013. http://www.salon.com/2013/02/01/how_netflix_is_turning_viewers_into_puppets/.

"PGA Board of Directors Approves Addition of Transmedia Producer to Guild's Producers Code of Credits." *Producers Guild of America.* April 6, 2010. http://www.producersguild.org/news/39637/General-PGA-Board-of-Directors-Approves-Addition-of-Transmedia-Produce.htm.

Pratten, Robert. *Getting Started with Transmedia Storytelling: A Practical Guide for Beginners*, 2nd ed. CreateSpace Independent Publishing Platform, 2015.

"Punchdrunk—About." *Punchdrunk.* Accessed January 22, 2016. http://punchdrunk.com/company.

Riot Cinema Collective. "The Cosmonaut." *The Cosmonaut.* Accessed January 22, 2016. http://en.cosmonautexperience.com/.

Schneider, Jaron. "Has Facebook's 'Suggested Pages' Spawned a New Haven for Spammers?" *The Next Web.* January 23, 2014. http://thenextweb.com/facebook/2014/01/23/likes-lies-perfectly-honest-businesses-can-overrun-facebook-spammers/.

Smith, Andrew. "Twitter Is Teetering Because It Has Turned into One Big Pyramid Scheme." *The Guardian*. November 6, 2015. http://www.theguardian.com/commentisfree/2015/nov/06/twitter-teetering-pyramid-scheme-social-media.

"Social Media." *Eh-Bee Family*. Accessed January 22, 2016. http://www.ehbeefamily.com/social-media.html.

Soloski, Alexis. "Sleep No More: From Avant Garde Theatre to Commercial Blockbuster." *The Guardian*. March 31, 2015. http://www.theguardian.com/stage/2015/mar/31/sleep-no-more-avant-garde-theatre-new-york.

Stanton, Brandon. "Humans of New York." *Humans of New York*. Last modified January 21, 2016. http://www.humansofnewyork.com/.

"Still () Spotting NYC." *The Guggenheim*. Accessed January 22, 2016. http://stillspotting.guggenheim.org/.

Wagmeister, Elizabeth. "High Maintenance: HBO Brings Web Series to TV." *Variety*. April 20, 2015. http://variety.com/2015/tv/news/high-maintenance-hbo-web-series-tv-1201475800/.

YouTube. "Lonelygirl15." *YouTube*. Last modified December 8, 2008. https://www.youtube.com/user/lonelygirl15.

▶ FILMOGRAPHY

Brothers McMullen, The. Directed by Edward Burns. 1995. Century City, CA: Fox Searchlight, 2000. DVD.

Game of Thrones. Directed by David Benioff and D.B. Weiss. 2011 — Present. New York, NY: HBO Studios, 2012. TV Series.

Greatest Movie Ever Sold, The. Directed by Morgan Spurlock. 2011. Culver City, CA: Sony Pictures Classics, 2011. DVD.

My Big Fat Greek Wedding. Directed by Joel Zwick. 2002. New York, NY: HBO Home Video, 2003. DVD.

Once. Directed by John Carney. 2007. Century City, CA: Fox Searchlight, 2007. DVD.

What We Do in the Shadows. Directed by Jemaine Clement and Taika Waititi. 2014. Los Angeles, CA: Paramount, 2015. DVD.

10
What Does the Future Hold

Digital technologies, tied to the Internet, could produce a vastly more competitive and vibrant market for building and cultivating culture; that market could include a much wider and more diverse range of creators; those creators could produce and distribute a much more vibrant range of creativity; and depending upon a few important factors, those creators could earn more on average from this system than creators do today—all so long as the RCAs of our day don't use the law to protect themselves against this competition.

Lawrence Lessig[1]

The tension between the sprawling amount of media production and consumption on one side, and capital concentration and the narrowing of commercial distribution and marketing options on the other, has considerably affected how content is produced and consumed, and will most likely intensify further. The Internet has already transformed itself substantially over the past two decades, not least in terms of commercialization and monopolization. Consumer convenience and relative indifference to these issues make it possible to imagine a future where we would use one search engine and order everything from one online company through its various subsidiaries. Even more than the consolidation of other media forms, the

corporatization of the Internet threatens to undermine the initial promise of the new technology. This does not mean that independent media production would completely disappear, but it could become irrelevant. After all, how many viewers watch public access television—in spite of its admirable mission—and how much of an impact does it truly have?

When looking toward future developments in film and media, many observers focus primarily on technical changes. However, past experiences have repeatedly shown that it is inadequate to speculate about technology without considering larger economic, cultural, and industry trends. The invention of film, radio broadcast, television, and consumer video had all been initially hailed as innovative and democratizing forces that would usher in new eras of content production and consumption, tackling new stories from previously unseen angles, and empowering a slew of new voices and creators. However, the initial burst of creativity and production was eventually followed by the typical practices of capital and power centralization and consolidation, with the competitors—the independents—forced to move to the margins. "New media inaugurate periods of instability within markets. The earliest days of radio saw the introduction of scores of amateur technocrats . . . until corporations gradually took over market share, with the help of the Federal Communications Commission."[2] In his essay, "Beyond Big Video: The Instability of Independent Networks in a New Media Market," Christian Aymar, referencing numerous classical scholarly works on the topic, summarizes these developments and highlights the power of film and television to deliver massively influential messages and meanings, which reaffirm—or sometimes challenge—the dominant political, cultural, and economic structures of their times, whatever the dominant political or ideological structure may be: "Television's mass (and massive) distribution system allows it to control messages: distribution has always been political."[3] In a time when the audience's attention is shifting from television to the Internet as the most influential medium, so is the industry's focus.

By the early 2000s, corporate consolidations, mergers, and acquisitions had already created what some observers have termed an "oligopoly" in film and media production, with six corporations accounting for over 90 percent of all revenues in film and media production and distribution:

> The media oligopoly (and its constituent divisions) exhibits the classic features of oligopoly: there is a limited degree of product-based competition; and the lead firms regularly co-operate to enhance the

exposure and value of their products. Together, these firms control the most lucrative domains of media and entertainment (namely, films, music, radio, cable television, newspapers, magazines and books) in the US, and increasingly in Europe, as well as emerging markets across Asia and Latin America.[4]

In his analysis, Andrew Currah argues that the studios are trying to preserve this oligopolistic structure in the digital age by insisting on a centralized server-client online architecture (rather than the peer-to-peer based sharing model), which allows for tighter control of digital commodities and attempts to minimize the disruptive potential of the Internet on their practices.[5]

The renowned law professor Lawrence Lessig has written extensively on how media conglomerates have used legal means to expand the duration of copyright from thirty-two to ninety-five years and to extend their rights in terms of power, scope, and reach of their ownership of intellectual property, thereby stifling innovation and limiting competition.[6] This unprecedented control over licensing rights translates into billion-dollar values for their existing libraries of media content—the thousands of films, TV shows, music recordings, characters, and stories they own—as well as fees for derivative works, which are based on this content. Most critics of these practices do not advocate for complete abandonment of copyright rules and intellectual property laws but argue for a modified approach, one allowing for easier access and spread of content and more appropriate for the opportunities the Internet provides. Related discussions within the mainstream media, however, have been (mostly) reduced to a pro-online vs. anti-online piracy discourse.

Complicating the media distribution and consumption debate even further is the semantics of media ownership; what constitutes ownership of a piece of media in the digital realm is different than owning a physical object. As Dan Hunter, the dean of Swinburne Law School, observes:

> In the good old days, you purchased a CD, which meant that you owned the medium outright and had an authorized copy that you could do anything you liked with, subject to copyright. . . . For example, you could give it away to a friend, or resell it, or whatever. These days we live in a world where we generally license copyright content, like games and music. This means you're given a limited right

> to do things with the content—generally this is limited to playing it on
> a small number of devices—and you definitely can't resell the content
> or even give it away. You haven't really bought the song, you've
> bought a contract to play the thing for a while.[7]

In other words, if you legally purchase a Kindle book or digitally download
a film, you are not able to give or loan them to a friend—as you could with
a printed book or a DVD. However, you could most likely find the film or
book online and download and share it (illegally) for free. Another interesting
aspect to contemplate here is what happens if (and why) an old film—or other
content—cannot be found and purchased legally anywhere but can be down-
loaded for free illegally. It is evident that the most popular pirated and shared
online content is current Hollywood movies and music hits rather than old
media, but it is arguable whether this is only a consequence of the existence of
peer-to-peer file-sharing technology or the conglomerates' unwillingness to
change their distribution practices in order to limit innovation and preserve
their dominance. Either way, as digital technology and the Internet are pri-
mary tools for independent creators, the issues and outcomes of these debates
will affect the future of independent media production and distribution.

Further regulation of the Internet can make it ever harder for independent
media-makers and smaller distributors to reach an audience. The term "net
neutrality" was coined by Columbia University media law professor Tim Wu in
2003 to describe the principle that all Internet data should be treated the same
by Internet service providers, regardless of content, platform, or mode of com-
munication.[8] Media conglomerates and telecommunication providers have
contested this view, arguing that companies that are willing to pay for a prior-
ity faster-streaming service should be allowed to do so, and that this would, in
turn, enable Internet innovation and the growth of broadband infrastructure.
Internet activists, hackers, and open-network supporters have been exceed-
ingly pessimistic about the future of a free and open Internet. Peter Sunde, one
of the founders of the notorious file-sharing website Pirate Bay, commented:

> We haven't had an open internet for a long time. . . . We have never
> seen this amount of centralization, extreme inequality, extreme
> capitalism in any system before. But according to the marketing done
> by people like Mark Zuckerberg and companies like Google, it's all to
> help with the open network and to spread democracy, and so on. At
> the same time, they are capitalistic monopolies. So it's like trusting the
> enemy to do the good deeds.[9]

Overall, the specialty independent film and media markets remain in flux, with old and new models co-existing and clashing, prompting both positive and negative comments and predictions—from disruptive innovation to disappointed resignation. By 2016, the Sundance Film Festival (along with others) had once again prompted many industry trade articles about noteworthy sales of independent feature films to distributors: specialized studio divisions, and new niche distributors with access to money from various other ventures, and digital aggregator services moving further into acquisition rather than licensing—from major services like Amazon and Netflix, to smaller "boutique" enterprises.[10] Their models might be different, with Netflix and Amazon more interested in attracting subscribers or selling tablets, but they have become the new players in the specialty film business, able to pay top prices for eye-catching content. The 2008 crash of independent film distribution is in the past, as the business is awash with new money—but that could easily change again. There is still substantial excitement to discover the next big indie hit within what are perceived to be commercial genres or celebrity actor showcases, even though many of the prominent recent acquisitions of such films have failed at the box office. The other big trend being highlighted is the expansion of television series—which are also moving to film festivals—even into the Sundance Film Festival's prime programming, prompting some observers to comment that the film festival will need to change its name.[11]

Evidently, the glut of film production is not subsiding; many of these higher-end independent productions are inescapably destined to fail commercially among the excess of product, even if they become critically acclaimed. How long this will be able to continue is anybody's guess. A good way to gauge this might again be to look back and observe what happened with the music industry. The most likely outcome will be that the conglomerates will remain on top, adapting their business practices to the shifting media realities. This means adjusting release strategies and increasingly focusing on foreign markets with their blockbuster entertainment, while independents—at least, those continuing to operate within these traditional film specialty models—will have a continually difficult time making a return on their investments and operating as sustainable businesses. Arguably, these types of independent films will get financed and produced while there is fresh money—mostly from other sources than filmmaking—pouring into the business. This will persist as long as independent filmmaking continues to be perceived as something glamorous and sexy by outsiders with deep pockets (or, in the case of foreign productions, is subsidized by states through taxpayers' money). A few new filmmakers will still have the advantage of continuing to use these

models—if they win awards or critical or audience interest for their first indie movie—to break through into mainstream Hollywood production. However, it is deemed universally unlikely by most industry insiders, as well as critics and outside observers that the heyday of independent filmmaking will return in its original "author-driven cinema" form.[12]

Digital technology is in many ways unique in that it has enabled an unprecedented shift to new forms of production and consumption of content, making both more accessible than ever. Technologically, artificial intelligence, robotics, the Internet of Things, big data, smartphones, 3D printing, and formats like virtual reality (VR) and holographic projections (getting rid of the constraints of a screen)—once considered science fiction—now seem to be realistic upcoming trends. VR, which has been constantly improving over the past decade, is the format the industry seems to be the most excited about. Not only did Facebook buy Occulus Rift's VR technology for two billion dollars, but its CEO Mark Zuckerberg confirmed that he believes VR to be the

> next major computing and communication platform, and that immersive 360 video is the next logical evolution from video. Looking at Generation Z, those born in the late 90's/early 00's, they have never known a world that isn't digitally interconnected. Many have grown up and never known a time where we weren't sharing moments and experiencing other people's lives vicariously through social media. It only makes sense that the next logical evolution of that is immersive media.[13]

Whether VR will be more than a tool to experience simulated spaces and realities and be able to be used effectively for storytelling purposes, or will become just another alternative technology—like 3D video—will soon become clear. Similarly, there continues to be a lot of hype surrounding the "Internet of Things"—physical objects and devices networked with software and electronics, which make it possible to collect and exchange data between real spaces and computer-based systems, creating opportunities for new forms of immersive storytelling.[14]

It would be naïve to presume that decades from now, we will continue to use the same media forms and formats we use today—after all, film has been around for only somewhat longer than a century, and electronic media even less than that. Instead of being preoccupied with what new technologies will come, one can rest assured that storytelling practices will

continue—certainly shaped and expressed through new formats, but still operating within the same logic of stories that came before—comic, tragic, suspenseful, empathic, educational, etc. What is arguably more important is to ensure that a diversity of media content can continue to be produced and is able to reach audiences in these new environments as well. With media and technology conglomerates and their products dominating the market, and an overabundance of media content competing for viewer time and exposure, it is essential to continuously explore not only new technologies for storytelling but also new models of media financing and distribution.

▶ NOTES

1 Lawrence Lessig, *Free Culture: How Big Media Uses Technology and the Law to Lock down Culture and Control Creativity* (New York: Penguin Press, 2004), 9.

2 Aymar J. Christian, "Beyond Big Video: The Instability of Independent Networks in a New Media Market," *Continuum* 26, no. 1 (2012): 75, doi:10.1080/10304312.2012.630137.

3 Christian, "Beyond big video," 76.

4 Andrew Currah, "Hollywood versus the Internet: The Media and Entertainment Industries in a Digital and Networked Economy," *Journal of Economic Geography* 6, no. 4 (2006): 441, doi:10.1093/jeg/lbl006.

5 Ibid.

6 Lessig, *Free Culture*, 135–139.

7 Adrienne LaFrance, "What Happens to Your Movies If Amazon Goes Out of Business?" *The Atlantic*, October 7, 2015, http://www.theatlantic.com/technology/archive/2015/10/when-amazon-dies/409387/.

8 Tim Wu, "Network Neutrality, Broadband Discrimination," *SSRN Electronic Journal* 2 (2003): 145, doi:10.2139/ssrn.388863.

9 Joost Mollen, "Pirate Bay Founder: 'I Have Given Up,'" *Motherboard*, December 11, 2015, http://motherboard.vice.com/read/pirate-bay-founder-peter-sunde-i-have-given-up.

10 Brent Lang, "Sundance Preview: Why It Remains Prime Film Festival for Talent," *Variety*, January 20, 2016, http://variety.com/2016/film/festivals/sundance-preview-film-festival-1201682435/.

11 Ibid.

12 Anthony Kaufman (writer, teacher, festival programmer), Interview with the Author, New York City, May 21, 2015; Hal Hartley (filmmaker), Interview with the Author, New York City, May 25, 2015; Peter Broderick (film distribution strategist and consultant, writer), Interview with the Author, New York City, June 3, 2015; Brian Newman (film distribution consultant), Interview with the Author, New York City, June 3, 2015; Jim Browne (film distributor, Argot Pictures), Interview with the Author, New York City, June 14, 2015; Jim Stark (producer), Interview with the Author, June 26, 2015.

13 Will Mason, "Study Shows Generation Z Loves VR, but Games Might Not Be the First Thing on Their Minds," *UploadVR*, November 23, 2015, http://uploadvr.com/gen-z-vr-study/.

14 John Du Pre Gauntt, "Storytelling for the Internet of Things," *Medium*, April 27, 2015, https://medium.com/iot-storytelling/storytelling-for-the-internet-of-things-7bc3d9e083dc/.

▶ BIBLIOGRAPHY

Alba, Davey. "YouTube's Grand Plan to Make VR Accessible to Everybody." *WIRED*. November 5, 2015. http://www.wired.com/2015/11/youtube-360-virtual-reality-video/.

Burris, Daniel. "The Internet of Things Is Far Bigger than Anyone Realizes." *WIRED*. November 2014. http://www.wired.com/insights/2014/11/the-internet-of-things-bigger/.

Cartel, Mike. "Why VR 'Storytelling' Does Not Currently Work: And Can It Ever Work?" *Medium*. January 11, 2016. https://medium.com/@cartelmike/why-vr-storytelling-does-not-currently-work-and-can-it-ever-work-728ff15efb1c.

Cellan-Jones, Rory. "2016: The Year When VR Goes from Virtual to Reality." *BBC News*. January 1, 2016. http://www.bbc.com/news/technology-35205783.

Christian, Aymar J. "Beyond Big Video: The Instability of Independent Networks in a New Media Market." *Continuum* 26, no. 1 (2012): 73–87. doi:10.1080/10304312.2012.630137.

Cone, Justin. "Virtual Reality Is Not Filmmaking." *Motionographer*. August 3, 2015. http://motionographer.com/2015/08/03/virtual-reality-is-not-filmmaking/.

Currah, Andrew. "Hollywood versus the Internet: The Media and Entertainment Industries in a Digital and Networked Economy." *Journal of Economic Geography* 6, no. 4 (2006): 439–468. doi:10.1093/jeg/lbl006.

Du Pre Gauntt, John. "Storytelling for the Internet of Things." *Medium*. April 27, 2015. https://medium.com/iot-storytelling/storytelling-for-the-internet-of-things-7bc3d9e083dc#.4w3mwaqjw.

LaFrance, Adrienne. "What Happens to Your Movies If Amazon Goes Out of Business?" *The Atlantic*. October 7, 2015. http://www.theatlantic.com/technology/archive/2015/10/when-amazon-dies/409387/.

Lang, Brent. "Sundance Preview: Why It Remains Prime Film Festival for Talent." *Variety*. January 20, 2016. http://variety.com/2016/film/festivals/sundance-preview-film-festival-1201682435/.

Lee, Dave. "YouTube to Launch Subscription Service." *BBC News*. October 21, 2015. http://www.bbc.com/news/technology-34596219.

Lessig, Lawrence. *Free Culture: How Big Media Uses Technology and the Law to Lock down Culture and Control Creativity*. New York: Penguin Press, 2004.

Levy, Steven. "Google's Bleeding Edge Interactive Movie Format Blows Minds, Seduces Hollywood a Listers." *Medium*. November 6, 2014. https://medium.com/backchannel/google-taps-hollywood-a-list-for-360-interactive-short-b36e7fb35b5f.

Manly, Lorne. "A Virtual Reality Revolution, Coming to a Headset near You." *The New York Times*. November 19, 2015. http://www.nytimes.com/2015/11/22/arts/a-virtual-reality-revolution-coming-to-a-headset-near-you.html.

Mason, Paul. "The End of Capitalism Has Begun." *The Guardian*. July 17, 2015. http://www.theguardian.com/books/2015/jul/17/postcapitalism-end-of-capitalism-begun.

Mason, Will. "Study Shows Generation Z Loves VR, but Games Might Not Be the First Thing on Their Minds." *UploadVR*. November 23, 2015. http://uploadvr.com/gen-z-vr-study/.

Mollen, Joost. "Pirate Bay Founder: 'I Have Given up'." *Motherboard*. December 11, 2015. http://motherboard.vice.com/read/pirate-bay-founder-peter-sunde-i-have-given-up.

Moynihan, Tim. "The NYT Is about to Launch VR's Big Mainstream Moment." *WIRED*. October 21, 2015. http://www.wired.com/2015/10/the-nyts-new-project-will-be-vrs-first-mainstream-moment/.

Pullen, John. "I Finally Tried Virtual Reality and It Brought Me to Tears." *TIME*. January 8, 2016. http://time.com/4172998/virtual-reality-oculus-rift-htc-vive-ces/.

Somaiya, Ravi. "The Times Partners with Google on Virtual Reality Project." *The New York Times*. October 20, 2015. http://www.nytimes.com/2015/10/21/business/media/the-times-partners-with-google-on-virtual-reality-project.html.

Wingfield, Nick. "In Virtual Reality Headsets, Investors Glimpse the Future." *The New York Times*. December 13, 2015. http://www.nytimes.com/2015/12/14/technology/in-virtual-reality-headsets-investors-glimpse-the-future.html.

Wu, Tim. "Network Neutrality, Broadband Discrimination." *SSRN Electronic Journal* 2 (2003): 141–180. doi:10.2139/ssrn.388863.

Acknowledgements

A range of people have inspired, supported, and contributed to this book. In particular, I want to thank my research assistants Raphael Wustner, Moreno Belic, and Elyse Marcus for their work; Jim Stark, Hal Hartley, Peter Broderick, Anthony Kaufman, Brian Newman, and Jim Browne for the interviews; Robert Pratten for his generosity and insight; Mike Dicks for creating a new diagram of his famous digital engagement pyramid for this book; DEFY Media, Crowdfunder, Tech Spartan, and IWCC/Nordicity for their diagrams; Marcus Turner for his review and comments; Emily McCloskey and David Williams for their help and guidance; Lance Weiler, Jeff Gomez, Sheng Rong, Lam Wai Keung, Ken Anderson, Caitlin Burns, and Jenn Begeal for inspiration; Branko Bjelajac for pushing me to write the book; Jackie Battenfield for her advice; and Dusica for her support.

About the Author

Vladan Nikolic is an independent filmmaker and associate professor at the School of Media Studies at The New School in New York City, where he teaches filmmaking and transmedia production classes. He has made numerous narrative feature films and documentaries, which have screened, won awards, and received critical acclaim in the United States and internationally, including at the Venice Film Festival, Tribeca NY, Barcelona, Geneva, Moscow, London, etc. Mr. Nikolic was among the digital filmmaking pioneers in the 1990s, shooting his feature *Burn* in 1996 on consumer camcorders, and teaching the first digital filmmaking courses at The New School and at NYU. In 2009, he directed and produced the feature film *Zenith*, which is also part of an extensive transmedia project. The film has been released in a unique and innovative way, combining theatrical, video, and online releases over multiple platforms, receiving millions of downloads and a cult following. Vladan has worked and consulted on a variety of transmedia projects since, from film-related to educational platforms, and taught international classes and seminars on transmedia, including in Shanghai, China, and at the Hong Kong Design Institute.

Index

Note: page numbers in *italic* indicate figures